Producing for Profit

In *Producing for Profit: A Practical Guide to Making Independent and Studio Films*, Andrew Stevens provides real-world examples and his own proven techniques for success that can turn passion into profit. Far more than just theory, the book outlines practical applications that filmmakers of all levels can use to succeed in today's ever-changing marketplace. Readers will learn how to develop screenplays that are commercial, and how to negotiate, finance, cast, produce, sell, distribute, and market a film that will make a *profit*. The book contains numerous examples from the author's own films, including sample budgets, schedules, and a variety of industry-standard contracts. This is the definitive book that every producer must have!

Andrew Stevens has mastered almost every aspect of the entertainment business, from creative filmmaker, writer, director, and producer, to corporate executive, leader in trade and union negotiations and collective bargaining, the creative development and physical production of motion pictures, as well as film sales, distribution, finance, publicity, and marketing. He has produced and financed over 175 motion pictures, including the hit comedy *The Whole Nine Yards* and the cult classic *Boondock Saints*. His films have generated over $1 billion in worldwide revenues. He is a former award-winning and Golden Globe-nominated actor and continues to be active in the motion picture business in addition to being an author, educator, motivational speaker, and industry consultant. He served for a decade on the board of directors of the International Film and Television Alliance (formerly the American Film Marketing Association) and also served as chairman of the Independent Producers Association (IPA).

Producing for Profit

A Practical Guide to Making Independent and Studio Films

Andrew Stevens

Routledge
Taylor & Francis Group

NEW YORK AND LONDON

First published 2016
by Routledge
711 Third Avenue, New York, NY 10017

and by Routledge
2 Park Square, Milton Park, Abingdon, Oxon OX14 4RN

Routledge is an imprint of the Taylor & Francis Group, an informa business

Library of Congress Cataloging in Publication Data
A catalog record for this book has been requested

ISBN: 978-1-138-12105-8 (hbk)
ISBN: 978-1-138-12104-1 (pbk)
ISBN: 978-1-315-65129-3 (ebk)

Typeset in Garamond
by Keystroke, Station Road, Codsall, Wolverhampton

Contents

Foreword

Roger Corman

For more than fifty years, I have nurtured new talent and young filmmakers in the independent film business. As a producer of more than three hundred independent movies, I have had the good fortune of working with such up-and-coming actors as Jack Nicholson and Sandra Bullock, and filmmakers who have gone on to be among the premier filmmakers in the mainstream studio industry, such as James Cameron, Martin Scorsese, Francis Ford Coppola, Jonathan Demme, and Ron Howard. In 2009, at the annual Governors Awards, I was honored by the Academy of Motion Picture Arts and Sciences (AMPAS) with an honorary Oscar, where I cited film as the only true modern art form and saluted and challenged independent film-makers to keep gambling and to keep taking chances.

Of all the people who have done work for me and for whom I have been credited as mentoring over the years, Andrew Stevens is unique in that he started as an actor of note, moved on to be quite a proficient writer and director, and subsequently became an enormously prolific motion picture producer. As if that weren't enough, he then entered the foreign sales and distribution realm and over the years built several foreign sales and distribution companies that were as competitive as any in the independent film business.

Andrew was quite a quick study on the business side and served with me for many years on the board of directors of the Independent Film and Television Alliance (IFTA) (formerly the American Film Marketing Association). He is that unique multi-hyphenate hybrid of a creative film-maker and an astute businessman who has embodied the independent spirit and fought to keep that spirit alive.

When I first met Andrew in 1988, I hired him to act in a film called *The Terror Within*, starring opposite George Kennedy. When I wanted to make a sequel and realized that Andrew had been moving towards writing, directing, and producing, I made a deal with him to write, direct, and star in the sequel. Both films were very successful for me. Andrew recently called to my attention that, over the years, we have collaborated on twenty-six independent movies, in which Andrew has served in multiple capacities. On three films, he was solely an actor; on some he was an actor/producer;

on others he was an actor/director; and on some we made co-production deals in which Andrew produced the films independently, and my company was the domestic distributor while Andrew's retained and distributed foreign rights.

On a personal note, I remember a week in the mid-1990s when Andrew was directing a family film for me called *The Skateboard Kid 2*. My thirteen-year-old daughter Mary wanted to be in the movie, so I called Andrew and asked him if there might be a role for her. Andrew assured me that an appropriate role would be waiting for my daughter when she arrived on set that Saturday. I dropped Mary off on set and she spent the day with Andrew as her director in her film debut. Since we weren't clear what time the filming would finish that day, Andrew then drove Mary from the set to a restaurant at the top of Mulholland Drive and delivered her to my wife and me, having had the time of her life that day in Andrew's capable hands.

I'm proud to see that Andrew has continued my tradition of hiring upcoming aspiring filmmakers and that he is also responsible for the careers of many new writers, producers, and directors. In reading Andrew's book, I was quite impressed by his knowledge and perspective on the business, and particularly the independent film production business. His ability to impart information to the reader or student in a way that offers new insights as well as a wealth of marvelous anecdotes from his real-life experiences make this book a worthwhile and enjoyable read.

My only regret is that Andrew and I didn't meet ten or fifteen years earlier, because most certainly we would have made exponentially more than twenty-six films together if we had.

Prologue

I've been a professional in the entertainment industry for more than four decades. I served on the board of directors of the Independent Film and Television Alliance (IFTA) from 2001 through 2009. I also served for several years as vice chairman, and then chairman, of the Independent Producers Association (IPA), which from time to time has been active in collective bargaining for independent producers and production companies. I have been involved in many guild negotiations with both the Screen Actors Guild (SAG) and the Directors Guild of America (DGA) on behalf of the constituency of the IPA, and I was one of the architects of the current DGA/IPA multi-tiered low-budget agreement (available on the DGA website).

I have been a member of the Academy of Motion Picture Arts and Sciences since 1979, the Screen Actors Guild since 1973, the Directors Guild of America from 1991 to 2008, SAG–AFTRA since 1973, and the American Society of Composers and Publishers (ASCAP) and Broadcast Music, Inc. (BMI).

Through a series of fluke events, during my senior year of high school in Memphis, Tennessee, I fell in love with the theater. I moved to Los Angeles as soon as I graduated and began studying and working as an actor.

I was fortunate enough to become an established and successful actor, starring in four network television series, five television miniseries, dozens of television movies and episodes, and more than fifty feature films. As a young actor, I also gained the invaluable experience of working with a galaxy of top industry stars and professionals. I received a Golden Globe nomination for my performance in the Vietnam War drama *The Boys in Company C* and was named "Star of Tomorrow" by the National Association of Theatre Owners in 1981 for my performance in *The Seduction*. I also won the Los Angeles Drama Critics Circle Award for my stage performance in the U.S. premiere of John Godber's *Bouncers* in Los Angeles.

I was also part of the last generation of actors who were signed to term studio contracts, and was, for a few years, a contract player at Universal Studios. By 1979, I had starred in a number of feature films and was invited to join the Academy of Motion Picture Arts and Sciences (whose members,

among other things, nominate, vote for, and determine the Academy Awards). My sponsors were Rock Hudson and James Stewart.

Although I continued acting as my predominant profession through 1992, by the late 1980s I had turned my aspirations to writing, producing, and directing.

In 1988, during a union strike when very few entertainment industry people were working, I was offered the lead role in a B-movie for the legendary Roger Corman called *The Terror Within*—a horror movie whose main special effect was a man in a rubber monster suit. I accepted the job, and apparently the film did quite well, because a year later Roger called and asked me to meet with him regarding making a sequel, offering me the same deal he had made Ron Howard. (Ron had appeared as an actor in Corman's *Grand Theft Auto*, and Roger, knowing Ron's directorial aspirations, contracted him to write, star in, and direct the sequel, *Eat My Dust*, and he offered me the same deal to write, direct, and star in the sequel to *The Terror Within*). When I agreed to make *The Terror Within II*, I requested a second-picture deal along the lines of other deals I knew Corman had made with certain other independent producers. The second picture was to be a co-production between him and me, whereby he would finance $300,000 in exchange for all domestic rights and I would finance $250,000 in exchange for all foreign rights. Roger agreed.

As a first-time director, my number-one objective was to find a director of photography (DP) who could light and shoot the rubber-suited monsters in the film in a creative way, so the audience wouldn't see how truly bad the suits were. I scoured numerous DP reels at Corman Studios and finally a second-unit reel shot by a young Polish kid drew my attention. The sequence featured an actress dancing in a night club, but the set was lit with very dramatic backlight, cross-light, and diffusion, so that you couldn't make out any of the actress's distinct body parts. I immediately thought, *This is the guy I have to have to shoot my movie and disguise these horrible rubber monster suits.* I called the kid in for a meeting and hired him on the spot. His name was Janusz Kaminski. He won an Oscar for *Schindler's List* four years later, then won another for *Saving Private Ryan*, having become Steven Spielberg's favored DP.

As insightful as I was to recognize Janusz's talent, I made a faux pas of equal import on the same film. During the casting process, I auditioned many actors and actresses. A young actress who was very green and had not yet had a professional break came in to read for one of the roles. I felt that another actress gave a stronger audition and didn't hire the young neophyte, whose name happened to be Halle Berry.

Once I got this first film under my belt as a director, I used it to get other directing gigs, in both independent feature films and episodic television. Concurrently, having now written a script that was produced, I used my new-found credibility and my writing skills to create a series of very successful independent films. Once I had created my own film

company I began directing features solely for myself and ceased working for hire.

At the same time that I was branching out as a writer, director, and producer, I started studying the independent film model in the international marketplace and realized that approximately 65 percent of the revenues for independent films came from sales to foreign territories (those outside of North America). I traveled to the Cannes and Milan film markets, as well as the American Film Market (AFM) in Santa Monica, California, on a regular basis, performing due diligence and studying the global marketplace (more on this later).

A year or so later, after learning the foreign sales ropes, I went back to Roger Corman and told him I was ready to exercise the clause in our contract to make our second film, the co-production. I made the movie, and I owned the foreign rights to the film free and clear.

The picture was so successful for Roger that he agreed to do three more pictures under the same terms. Suddenly I owned and controlled the foreign rights for four films, and, along with two partners, I entered the foreign sales and production business virtually overnight. We created a company called Sunset Films International for the purpose of marketing and selling not only our own film productions but films that we would acquire as sales agents from outside producers and charge them a sales/distribution fee and market expenses. Foreign pre-sales also served as collateral for a component of financing pictures. At this time, in early 1993, I formally quit acting as my main profession, although I've since done the occasional cameo appearance.

I committed all my time and resources to foreign sales, financing, developing, producing, writing, and directing projects for my own company. I began traveling to the major international foreign sales film markets, selling all rights in all territories and all media worldwide, and cultivated relationships with buyers all over the world. During approximately one year at Sunset Films International, I produced seven in-house films and acquired twelve others for foreign distribution.

Since my partners at Sunset Films were nonexclusive and had other outside film ventures, I also pursued ventures with another producing partner. Based on my now very savvy, empirical knowledge of the independent marketplace, I convinced him that we should personally finance our own pictures, because I now firmly believed in what I could produce and sell in the global marketplace and for what price. We each put up personal money and made a picture, which we sold for double our investment before we had even finished post-production. We put our personal money back in our pockets and made a second film on the profits from the first. We sold that film for double and suddenly had not only profit but a production fund derived from profits generated by the two films. We made a third film in the same manner; on the fourth, we decided to step up to a bigger budget and a star cast, which enabled us to triple our return. Our little "mom and

pop" business was so successful that we decided to pool our resources exclusively and form a new full-service production, finance, and foreign sales company. At that time, I sold my shares in Sunset Films International to my former partners and started a new company—Royal Oaks Entertainment.

At Royal Oaks, our mandate was to get as many domestic pre-sales for straight-to-home-entertainment films as possible and fill them as quickly as possible, since we realized that the domestic market, as it existed at the time, was soon going to change, to the detriment of the independent producer. Under the Royal Oaks auspices, I made multiple domestic (United States and Canada) pre-sales for films that had not yet been produced. Pre-sales were very important to me, since bank financing was essential for a production slate of more than fifty-six films in three years, and I needed both foreign and domestic pre-sale contracts as collateral for bank loans. I then set about quickly filling those pre-sale purchase orders, actually making the films I had pre-sold and collecting on the contracts before the business changed and the various home entertainment companies went out of business.

For the remainder of the collateral for the financing of the movies, I would create a concept that was commercial on a worldwide basis, based on the type of product that my most lucrative international buyers were looking for. I had three distinct lines of film product: thrillers, family films, and action films. For the better part of eight years, I conceived, marketed, pre-sold, financed, and produced on average almost twenty films a year. Under the Royal Oaks' auspices, we also acquired another fourteen titles for foreign distribution, amassing seventy films over just three years. I also found myself running and administering a company with over twenty employees. I had no formal business training, having worked on the creative side of the business my entire adult life, so I had to learn on the job. However, with the crazy cast of characters I was now dealing with, my bachelor's degree in psychology was probably more useful than I ever imagined it would be.

The Cannes Film Market (Marché du Film) is a large trade show coinciding yearly with the Cannes Film Festival, where movies are sold prior to and overlapping with the glitz and glamor of the festival screenings. In mid-1997, after returning from the market, I noticed a distinct change in trends in the independent foreign sales marketplace. Suddenly, a couple of competitor companies that had previously made films similar to those I was making debuted independent films for sale in the international marketplace with big-star names in low-budget productions. At the time, it was irrelevant that most of these big stars were appearing in films that were either pet projects or art house, noncommercial films, because the star value transcended the generally noncommercial nature of the pictures. I suggested to my partner that we should change our business plan and bring in someone who had talent relations with movie stars, which we did. By the fall of 1997, we had collectively

formed Franchise Pictures, and shortly thereafter its sister company, Phoenician Entertainment.

Within the course of the next year and a half, Franchise and Phoenician consolidated under one roof, one of the partners was bought out of the collective companies, I ceased operations of Royal Oaks and began functioning as president and chief operating officer of both Franchise and Phoenician. Again, I created three distinct brands and product lines of movies.

The first comprised studio theatrical pictures, branded as Franchise Pictures through an output deal with Warner Bros. These movies—which require large print, advertising, and media (P&A) expenditures—are the longest payback to the banks for production loans, plus the additional loan from the studios for the P&A funds. In some cases, a film might cost $25 million to produce, and the P&A expenditure might be $35 million or more.

The second product line comprised art house, or specialty, films, which I branded as Franchise Classics Pictures. These were predominantly smaller, noncommercial films with star names that had festival and/or art house appeal.

Franchise Classics came about in an interesting way. Having produced four pictures in three years that screened or competed in the Sundance Film Festival, as well as many other festivals around the world, I began to believe that there was collusion among domestic buyers, judging from the identical deal terms they would, with only rare exceptions, offer independents. We have all heard or read about the bidding wars that have taken place on certain films discovered at film festivals, but, in my experience, the usual players at the time (Fox Searchlight, Sony Classics, Paramount Classics, Lionsgate, and others) all had a standard offer that they would make for most art house/specialty films: $250,000 plus a $500,000 P&A commitment, which would buy a very small vanity theatrical release. The distributor would then have the option to build on—or "platform"—from the initial small release and expand the number of theaters and release dates. This would happen only if the picture were performing successfully and warranted the advertising and media expenditure that it would take to expand the number of screens.

After a $250,000 advance and a "royalty" participation thereafter, the reality is that, with only rare exceptions, no producer would ever see another dime beyond the initial advance. The response was uniform: "We're not Sony, we're Sony Classics," or "We're not Fox, we're Fox Searchlight," or "Universal Focus," or "Paramount Classics" (at that time). "We don't have that kind of money, we're a specialty division." A lightbulb lit up above my head and I immediately created "Franchise Classics." Thereafter, when I negotiated with agents, attorneys, and managers, I would stick to the mantra: "I can't pay your talent any substantial money. This isn't a Franchise Pictures film, it's a Franchise *Classics* film." In almost all cases, it worked. We then created talent pools and profit participations for actors, writers,

and directors, without paying big upfront salaries for talent. The trade-off for getting star talent to work cheaply, so that the films could be made cost-effectively, was making pet projects—art house and specialty films that were not mainstream commercial undertakings, such as *The Big Kahuna*, starring Kevin Spacey and Danny DeVito, which was made for a net $1.8 million, and *Things You Can Tell Just by Looking at Her*, starring Glenn Close, Holly Hunter, Cameron Diaz, and Calista Flockhart, which was made for under $2.5 million.

The third product line comprised non-theatrical, straight-to-home-entertainment films, under the Phoenician Entertainment brand. The straight-to-DVD line provided instant cash flow. If international buyers wanted *The Whole Nine Yards*, with Bruce Willis and Matthew Perry, they would need to buy a number of straight-to-DVD titles along with it. Films like *Storm Catcher*, starring Dolph Lundgren, *Gale Force*, starring Treat Williams, and *Air Rage*, starring Ice-T, were instantly profitable and often had no bank loan, which provided a much faster return on investment and unencumbered cash flow to the company.

During my five and a half years at the Franchise Pictures companies, I produced, executive produced, and/or financed and handled the foreign sales on approximately seventy-five pictures of all genres and sizes, with budgets ranging from $60,000 to $70 million. We made close to twenty mainstream theatrical features, including: *The Whole Nine Yards* and *The Whole Ten Yards*, *The Pledge*, starring Jack Nicholson and directed by Sean Penn, and *City by the Sea*, starring Robert De Niro, all through Warner Bros.; *Half Past Dead*, starring Steven Seagal, through Sony Screen Gems; and *Caveman's Valentine*, starring Samuel L. Jackson, through Universal; as well as numerous Franchise Classics films and a steady stream of straight-to-DVD pictures.

I left Franchise Pictures in December 2002, and the following year embarked on financing and producing films through my personal auspices, initially through foreign and/or domestic pre-sales coupled with subsidies and often with an equity component. I have produced or financed over thirty-five films since 2003. I finance a film only when:

- I know there is a specific market desire for it;
- there are specific buyers for it;
- I know what I can sell it for, within a very small variance; and
- I can produce it for a profit margin (I will go into detail about this in subsequent chapters).

In my experience, the key to successful survival in the entertainment business is doing ongoing due diligence and updating one's knowledge of the current marketplace, as well as anticipating new trends. An independent producer must be able to shift strategies constantly and fluidly, and reinvent as the business changes on a continuum. In the span of my

entertainment career, I have functioned in almost every imaginable capacity of filmmaking, from conceiving an idea to writing a story or screenplay, to creating advertising and publicity campaigns for the marketing and sales of pictures, as well as pre-selling films before they were made, financing pictures in many forms, brokering subsidies and rebates from various states and foreign countries, producing, directing, acting, editing, art directing, post-producing, composing songs and music, delivering elements to buyers worldwide, collecting payments on contracts, distributing films, and grooming and selling libraries. I have interfaced with the lowest level of guerrilla independent filmmaking as well as the highest level of studio theatrical releases.

My goal in writing this book is to use my knowledge and experience to inspire and teach aspiring filmmakers by explaining the *reality* rather than the *theory* of making independent movies. In 2008, I wrote a two-year, fully accredited college degree program offering an associate of applied arts degree in motion picture production. I have incorporated much of that material into this book, based on my experience of actually making films over the course of four decades. I hope you find it insightful and can use it as a guide to understanding filmmaking in a way that enables you to have a focused and linear plan from the beginning and safeguards you from making naive or uneducated mistakes.

What Is a Producer?

If you ask twenty different people in the entertainment industry, you might get twenty different answers. In feature films, the producer, in the mainstream, traditional sense, is a creative and business-minded general who interfaces with agents, attorneys, managers, financiers, and distributors on the administrative side, and then with writers, directors, actors, and technical crew on the creative and physical production side.

Essential Responsibilities

Below is a list of everything a producer should do, though only a handful possesses the knowledge and applicable skill sets.

Unless an employee for hire, the producer is commonly involved in procuring the financing and distribution of the motion picture. Generally, he or she hires the director and the writer, oversees the casting and reports to the studio or distributor. The producer is the "last man standing" when wrap is called at the end of production and all other itinerant employees go on to their next job. The director then works with an editor and edits his or her *director's cut*, but unless that director is a very prominent, established, *star* director, he or she will not be granted final cut. The producer then performs the final cut in accordance with the expectations of the distributors, buyers, or financiers, usually in accordance with their notes and requested changes. Sometimes the producer and director present a unified front and collaborate through the final cut, and sometimes the director may have an agenda that is in conflict with the producer's delivery obligations, in which case the producer steps in to recut the film accordingly.

A true producer should be a good communicator, charismatic leader, and confident decision-maker on all fronts. A producer should understand story and structure and be able to give astute and insightful creative notes on a story, treatment, or screenplay. A producer must also suggest or dictate and implement script changes and revisions, in order to solve not only creative issues but the limitations of the budget and physical production of the picture as well. A producer should understand camera, shots, angles, coverage, special effects, actors' performances, and all facets of post-production

and music. A producer should be well versed in the vernacular of the director, so that he or she can effectively communicate with the director and his or her crew. In cases where the producer must make an overriding decision, he or she must understand what shots or scenes are absolutely necessary to complete or tell the story cinematically, and what shots and/or scenes might be eliminated in order to meet the exigencies of production and the constraints of time, budget, and schedule. In post-production, a producer must understand and speak the technical language of labs, editors, digital and emerging media, music, special visual effects, and sound processes.

Look at it this way: each film has a finite box (i.e., the budget and schedule) within which it must operate in order to be successfully completed and profitable. A producer must be able to multi-task and make immediate, spontaneous decisions when necessary and stick to them, based on his or her global knowledge of what will ultimately best serve the film, while at the same time staying within the *box* he or she has created or been given. A producer must be versatile and innovative when dealing with crises as they arise. A producer must possess tremendous financial knowledge in terms of budgeting and finance, negotiating skills (to save money), and the malleability to borrow from one category in order to have additional money to spend in another, without compromising the ultimate quality of the picture. An independent producer should have knowledge of non-union crews and talent, as well as all applicable union and guild contracts and collective bargaining agreements and levels or tiers for each. (In Chapter 10, I will go into more detail on lower-budget union tiers, which allow union pictures to be produced more cost-effectively.)

A good producer should have a strong editorial sense and knowledge. Unless a director has final cut, the producer follows the director into the editing room to execute the producer's cut, or the cut desired by the production company, distributor, or studio. The producer should be skilled and able to communicate concisely, using the language and terminology of film editing, and have a working knowledge of how to cut a motion picture dynamically. A producer should understand creative editorial techniques, such as transposing the order of scenes, using flashbacks or flash-forwards, intercutting, creating moments by double-cuts, changing frame rate, and myriad other effective editorial devices. A producer should have a strong knowledge of music, as well as special effects. A musical score is critical to almost every film. Music underscores, supports, and enhances emotion and adds subliminal depth to an audience's perceptions, as well as to actors' performances. Often the internal pace or sustained tension of a picture is created, dictated, or greatly enhanced by music. Judiciously knowing when a scene might play better or more effectively "dry"—without music—is valuable as well.

Special effects and new media and technology have evolved quickly over the last ten years and are continuing to evolve. A producer should stay abreast of current technologies and computer-generated imagery (CGI)

techniques, as well as all new and emerging technologies and forms of new media. On the technical side, a producer should also be knowledgeable in all technical elements of filmmaking, and the constantly emerging digital formats and new resolutions from 4K and future successor formats. A producer should also be knowledgeable about all current and new, emerging sound formats as well as new and emerging post-production and digital delivery formats. (The foregoing knowledge is essential for every picture that is produced.)

A producer should have good relationships with at least one insurance company that provides production, negative, and errors and omissions (E&O) insurance for films, and must stay aware of the best prevailing rates. A producer should have at least a cursory legal knowledge and must be able to read and understand contracts, as well as nuances to which a producer, production company, distributor, or studio might ultimately be legally bound. A good producer must be able to hold firm in such knowledge when negotiating with agents, managers, or attorneys who may represent talent, as well as during negotiations with crew, vendors, and unions.

Explaining the Producer's Role to Laymen

How does one explain job descriptions in moviemaking to people not in the film business? I have often likened making a film to building a house. The architectural plans are the screenplay. The builder is the producer. The foreman overseeing the job and instructing the subcontractors is the director (admittedly not the best analogy for a director, but one that a non-entertainment person understands). The budget for building a home is very similar to a motion picture budget. Both contain bids, estimates, and prices from vendors, crews, and subcontractors on material, equipment, and other components, which all appear as line items in a budget. Both builders and producers move money around within their respective budgets—that is, costs that might be less than originally estimated in certain categories might be used to cover costs that may be higher than originally estimated in others. Ideally, global costs will balance out in the end, and the film (or house) will be finished on budget, on time, and on schedule.

For the producer and home builder, there are always occurrences beyond their control that affect time, schedule, and budget. This is why all industry-standard film budgets and most home construction budgets include a contingency, which in the case of film is usually 10 percent. Both film projects and real estate projects should have insurance policies for protection in the event of accident or disaster; and in the case of a motion picture, there is often reinsurance, in the form of a completion bond, which guarantees completion of the film if the producer or director should fail. Building a film, like building a house, requires a strong, definitive leader with a vision and the ability to get it done on time and on budget. A good producer must be adept at maintaining the vision and aesthetics of the

director and screenwriter, just as a good builder adheres to the aesthetics and materials required to carry out an architect's plans and vision.

My goals are to demystify the movie business and how it really works; to teach the reader how to do cursory due diligence or market research; and to offer guidance on how to tap into the marketplace in order to get your film made and distributed and make a profit.

Inexperience and the Three Rs

Just as there are countless men and women of all ages running around Hollywood and New York (and anywhere else that has an entertainment hub) claiming to be writers, directors, actors, and actresses, there are proportionate numbers of those who run around claiming to be producers. A person might try their entire life to get a script made into a movie and never succeed. As with any business opportunity, often one must adhere to what I call the "three Rs": being at the Right place at the Right time, and being Ready. If you happen to be at the right place at the right time but you are not ready to assume all the responsibilities required of a producer, and you do not possess the underlying knowledge to do so, an opportunity may be squandered and never come again.

I once read a quote from someone who advised people who aspire to be in the movie business to tell others, "I am a producer." Further, if asked what they have produced, they were advised to say, "I have many projects in development at this time." An inexperienced and naive aspiring producer may be associated with or attached to any number of scripts but possess no knowledge or expertise of how to get a movie made, what constitutes a commercial and saleable film in the foreign and domestic marketplaces, and generally is unaware of current market values. These people have likely never produced a film yet put together voluminous lists of attachments, such as directors, line producers, co-producers, directors of photography, art directors, composers, and others, which I usually consider to be *encumbrances*, not *value added*. I don't want any attachments. Why? Because I want to hire my own people with whom I have relationships and whom I trust. With only rare exception, in the independent film world, I personally don't trust anyone's taste or experience other than my own. Most often, inexperienced people's salary expectations are also out of line and unrealistic. Anyone who comes to me with a "packaged" picture, with predetermined department heads (other than possibly a director), is an immediate turnoff. I generally won't even look at the material. If a director is attached, I make sure that his or her expectations and capabilities are realistic and sound, and that we share the same vision. Otherwise, I want my own production people, whom I trust.

Budgets created by inexperienced "producers" are almost uniformly unrealistic. Those with no experience or expertise have no clue as to what can actually be done and for what price. They have usually paid someone equally

uninformed to create a budget for them based on very little, if any, realistic knowledge, and they almost always err vastly, on either the high or the low side. Also, in many cases, essential line items have been omitted and essential elements necessary to complete delivery of a film are nowhere to be found. I trust only *my* budgets, *my* expertise, and *my* knowledge of vendor deals, rates, and prices, based on *my* experience and knowledge. My advice is never trust someone else's "budget." Create your own.

The same can be said for schedules, which are almost always pie-in-the-sky, with an unrealistic number of shooting days (usually far too many). There is an art to creating a schedule, based on consolidating and possibly "cheating" certain locations in order to group blocks of scenes together and reduce company moves, as well as shortening actors' and stunt players' schedules and manipulating their days worked wherever possible, in what is called a *day out of days*, into a more cost-effective shooting plan.

Most people with a "great script" who claim to be producers have probably been turned down by almost everyone, and there is generally a good reason for it. (Note, however, that there are exceptions to every rule. So, no matter what anyone's past experience dictates, and no matter what holds true 99 percent of the time, something that goes against all conventional knowledge, wisdom, and experience may occur.)

Employees

A generally misunderstood fact is that *the majority of producers are employees*. Almost all studio pictures (with the exception of negative pickups, meaning payment on delivery of a completed picture by a distributor or production company for a specific sum of money in return for specific rights) are produced by employees of the studios or their various affiliated or subsidiary entities that are formed for the purpose of the production of their movies. This is true for the majority of the network producers as well. Likewise, the Producers Guild of America (PGA) comprises, almost entirely, "employee producers" who rely on studios, networks, and production companies to pay them salaries and make pension, health, and welfare contributions to the PGA, which affords them a medical plan as well as disability and retirement benefits. These producers are dependent upon "pitching" (orally presenting) their projects, scripts, or story ideas to studio or network executives or financiers, in the hope that the studio or network will pay for the development of a screenplay and, if they're lucky, the subsequent production of the film or television show, thereby by creating employment for the producer. Often, producers are also simply hired by the majors and networks for green-lit projects (those that have already received approval of production finance, thereby allowing them to move forward from the development phase to pre-production and ultimately into production). However, studio or television employee producers are at the mercy and whim of corporate executives, and vulnerable to the frequent regime

changes at most networks and studios. New executives often toss out projects developed by their predecessors.

Although less prevalent today than in days past, certain high-level studio producers have overall deals that pay for their overheads, recoupable against producer fees when pictures are actually made. There is nothing wrong with being an employee producer, but you must understand that your fate rests in the hands of other people, and their decisions directly affect your livelihood. It is important to note that, unlike independent entrepreneur producers, employee producers rarely, if ever, risk their own money or their own personal livelihood on the production of a film, and they are almost entirely reliant on the creative and financial decision-making of the major studios, production companies, networks, or risk-taking independent companies that hire them.

In the past decade or so, as the entertainment business has consolidated, many former high-level studio producers who formerly had overhead deals that have expired, are now freelance independent producers. This has been a rude awakening for many big-name producers who once relied on studio dollars to fund their overheads, including cushy offices and staffs.

I have done many negative pickup deals with studios, and their business-affairs executives and attorneys have often used my expertise to produce films far more cost-effectively than they ever could have under a studio's auspices. An independent producer can find ways to produce a film non-union, whereas a studio cannot, as all studios are signatories to the major unions' collective bargaining agreements. From 2005 to 2009, I produced fifteen films independently and sold them as negative pickups to Sony Home Entertainment. Sometimes negative pickups are structured prior to, or even during, production, and sometimes they occur after a studio or distributor has viewed the finished film.

The Independent Entrepreneur Producers

A true independent producer is, by my definition, an entrepreneur who is not reliant on a studio and/or network for the financing of a picture. Independent producers are innovative go-getters who explore every possible avenue for the development and financing of independent motion pictures. Those avenues include both foreign and domestic sales and pre-sales, subsidies and/or tax rebates, private equity, limited partnerships, co-productions, venture capital, deferments, and usually a combination of the above. Occasionally, as I have often done, an independent producer will take a personal financial risk and invest personal funds in the financing or co-financing of a film. The independent entrepreneur producer must have knowledge of the current foreign and domestic marketplace, as well as available subsidies and how to secure them. The independent entrepreneur producer is a tenacious street fighter who continually bucks the system and exists in spite of the odds. Independent entrepreneur producers are most often the *employer*,

not the *employee*, as well as the final decision-maker, and quite often (sometimes with partners) the owner of the completed film, the copyright, and the distribution rights. Decide who you are and which you are content with being. The independent entrepreneur producer is the victor over, not the victim of, the whims and decisions of others. They retain control over their own fate, and create their own destiny, fortune, and livelihood.

Producer Credits: What Do They Mean in Film?

Producer

I have given a fairly extensive overview of what I believe are the definition, scope, and duties of the producer as well as the knowledge that I believe is essential for a producer to be viable and successful. As evidenced by the proliferation of producer credits over the past two decades, the entertainment industry has gone "producer credit crazy"—on some projects, I have seen as many as twenty credited "producers" of various types. Both the PGA and the Academy of Motion Picture Arts and Sciences have, in recent years, tried to limit excessive numbers of credited "producers." While I agree with limiting the number of gratuitous credits in order to protect the integrity of my profession, unfortunately this has become a double-edged sword, with some bona fide producers suffering unfairly. For instance, in 2004, the Academy declared that Bob Yari, although a credited producer on the film *Crash*, was deemed ineligible to receive an Oscar along with the other producers. Had Yari not read the screenplay, understood and shared the vision of the film with other filmmakers, and personally financed and arranged for the distribution of the picture, there would have been no *Crash*, no fees or salaries paid to the other producers, and certainly no Oscar for anyone. That his vital contribution was slighted and negated by mainstream "employees" (i.e., the film's other producers, whom Yari hired and paid) clearly illustrates that most producers for hire do not understand the independent world and the essential role played by independent entrepreneur producers.

Executive Producer

In years past, an executive producer was traditionally the money person, or the person responsible for bringing the financing and/or distribution to the picture. More recently, executive producer credits have lost their meaning, and they are frequently used like trading cards. Often established line producers who are trying to "move up" in their perception within the industry ask for an executive producer credit, rather than a line producer credit. Often an actor may be accorded a gratuitous executive producer credit as an inducement to sign up to a project. Occasionally a writer or director may be accorded an executive producer credit for a number of reasons. In film,

there is no longer a clear definition of the function of an executive producer. Again, in film, the *producer* is the "go to" person. However, there have been times when I have been the go-to person on films that already had producer credits promised to other people who were attached to the project, and consequently I accepted an executive producer credit as a compromise. Also, some foreign subsidy regulations allow executive producer credits to be accorded only to non-nationals, as is the case with Canadian content pictures. In series television, however, "executive producer" usually denotes creative writers/producers.

My executive producer credits have usually been the result of situations in which: I have been a key creative producer, but the producer credits were overloaded or simply unavailable; I've provided a key component of financing for the pictures; or I have been integrally involved in film setup, post-production sales, or distribution.

In television, however, executive producer credits are the most important and prestigious credits, as they often denote the writers and/or writer/ showrunner who are the creative driving forces behind the series or miniseries. In most TV shows or miniseries you will see numerous executive producer credits, usually accorded to writers.

Co-executive Producer, Associate Producer, Co-producer

The co-executive producer, associate producer, and co-producer have no clear, delineated functions. Credits are free and are often given in lieu of financial compensation, or to throw a bone to someone who may have found the script, brought in an actor or other component of a deal, or is on staff at a particular company involved in the film.

I have seen these credits given to everyone from assistants, personal trainers, and personal chefs to boyfriends, girlfriends, husbands, wives, lovers, and various others who serve no real or specific producer function. They are also often given to people who have tried and failed to get a project made, yet somehow remain contractually "attached" to it, and so receive a gratuitous credit despite playing no role in the actual production process.

Credits also often serve as barter to save money in a variety of ways. For instance, I have frequently given an actor an executive producer credit as an inducement to get him or her to work for less money, or as a way to bifurcate his or her salary, thus reducing the pension, health, and welfare contribution that must be paid on the acting portion of the salary. For example, as of 2015, if an actor's deal calls for payment of $100,000, 17.3 percent—or $17,300—would be due to the Screen Actors Guild as the pension, health, and welfare contribution. However, by paying the same person $50,000 as an actor and $50,000 as an executive producer, the pension, health, and welfare contribution is payable on only $50,000, saving the company $8650.

Line Producer

Traditionally a line producer is the "nuts and bolts" guy or girl with the real physical production knowledge. Along with the producer, the line producer drafts the budget, collaborates with the first assistant director to create the shooting schedule, negotiates with the below-the-line crew and vendors, and oversees set operations, paperwork, and the wrap-out of the picture. He or she is a glorification of what a unit production manager used to be.

Generally, in my smaller independent films, I use a line producer whom I've worked with many times in the past, and between us we perform almost every production role. A good, solid, knowledgeable line producer who can multi-task is a valuable asset. Under the producer's supervision, a line producer also holds the purse strings and is the key person for keeping the picture on track, on time, and, most importantly, on budget. Along with the producer, he or she must be able to anticipate overages before they occur and to come up with spur-of-the-moment, innovative ideas to curtail potential financial overruns. A good line producer should also be able to hold back a "secondary contingency" in each line item of the budget and possess the ability to move things around within the budget when necessary without increasing the bottom-line cost. (This secondary contingency is derived by negotiating less than what is budgeted in every category whenever possible.) On films that have completion bonds, a line producer, in addition to the producer and director, is often required to sign an inducement letter with the bond company (which I will discuss in a later chapter). Inducement letters attest that the signers have read the script, reviewed the schedule and budget of the picture, and believe, in their professional knowledge and expertise, that the picture, as scripted, can be produced within the bonded shooting schedule and budget, and that they will do everything in their professional capacity to see that the picture conforms substantially not only to the screenplay but to the budget and schedule.

In today's higher-budgeted films, you will find executive producers, co-executive producers, associate producers, co-producers, occasionally supervising producers, a line producer, producer(s), a unit production manager, production coordinators, production secretaries, and more production-related credits. These credits indicate far too many people and way too much baggage and overheads for a small independent film (unless they are merely gratuitous credits and none of the people receiving them actually has any authority over the production).

In 1978, I starred opposite Kirk Douglas in *The Fury*, directed by Brian De Palma. I remember thinking, in my youthful naivety, that the executive producer, Ron Preissman, was the boss, since I was impressed by the "executive" in his title. My misconception was quickly corrected by the feisty Frank Yablans (former president of Paramount Studios), who informed me that *he* was the producer, the boss, the chief, while Preissman worked for *him*. He explained: "The producer is king; everyone else is his subject."

Changes to the Independent Marketplace

By the late 1990s, the domestic home video market had started to change dramatically. Executives at the major studios realized that films made for straight distribution to home video, a business that had largely been dominated by independent producers and distributors, were quite lucrative. They multiplied their production slates, not only to produce new direct-to-home video entertainment, but also to cannibalize their libraries and make sequels and remakes of their own "branded" content (i.e., previously successful films that already had some awareness in the marketplace).

In the early 1990s, there were independently owned home video retail and rental stores on virtually every street corner in America, until the juggernaut that Blockbuster became put almost all of the independent stores out of business and changed the course of free enterprise in the home entertainment business for ever. At that time, there were also many independent home video distributors.

When heads of the major studios figured out the cash cow that was the home entertainment business (i.e., straight-to-video productions with no theatrical release or P&A expenditures), they more than doubled their production slates, took over the market share, and then slashed the unit price of the VHS cassette (and later DVD), making it extremely difficult for any independents to compete. Almost all of the independent video distributors were put out of business by the majors, who had vast libraries from which to cull sequels and remakes of titles with which audiences were already familiar. For example, I made a small family film in the 1990s called *Invisible Mom*, starring Dee Wallace-Stone (star of *E.T.*, *The Howling*, and *The Frighteners*). The retail price for a VHS cassette at that time was $89.95. All of a sudden, Disney began putting straight-to-video sequels, such as *Pocahontas II*, on the market at a $19.95 price point. These sequels had brand awareness from the theatrical releases and benefited from the publicity and marketing of the original films; they had trusted "brand" logos, such as Disney; and they had hugely reduced unit prices. The majors took over the marketplace and crushed the independent producers, home video distributors, and independent retail stores, with no intervention or regulation from the federal government; before long, the entire business was virtually

monopolized. The studios first moved into the domestic home entertainment market and then into every territory worldwide. Then they cut the unit price per VHS dramatically, and the home entertainment business all over the globe became all about shelf space.

Historical Context

To understand the historical context and the devastating blows to the independents and free enterprise that the blindly naive U.S. government continues to allow, consider the following. In the 1940s, the studios indirectly controlled almost all independently owned theaters. They did this by selling "blocks" of their films (usually ten) to the theaters, which was known as "block booking." If these theater owners didn't accept the blocks (which could comprise several B as well as A movies), they got no films at all. That would mean no star talent to attract audiences. What resulted was the legal case *United States v. Paramount Pictures, Inc., et al.*, in which the U.S. government filed an antitrust suit against the studios and alleged that studio control over distribution *and* exhibition was, according to the Sherman Antitrust Act, an illegal restraint of trade. Basically, the government gave the studios an ultimatum: they must divest themselves of either their distribution arms or their theaters.

There was also, until recently, a federal mandate that required broadcasters to air a certain portion of independent programming. But that mandate eventually expired and nothing replaced it. At the time of writing, there was no requirement for independent programming in the United States, and just six major conglomerates owned every conceivable form of production and distribution, on a global scale. Think of this. What is more onerous and devastating to the restraint of free trade: the studios that owned a chain of movie theaters or the conglomerates that today own the studios, networks, and international distribution in most major territories worldwide, television stations, radio stations, and all of the major internet search engines and websites?

How much more devastating to small business and independent production could these behemoth monopolies be? The "conglomerates," as they exist today, are so much greater and more powerfully glaring monopolies than any studio that owned a chain of cinemas, yet our government has turned a blind eye, at the expense of free enterprise and the protection of small businesses and individuals, as antitrust laws are violated. Washington is a corrupt place where you have to "pay to play," which means that lobbyists are paid to bring issues to the attention of congressmen and senators, who, in turn, expect political contributions when they devote their time and energy to a concern.

The Independent Film and Television Alliance (IFTA), whose board I served on for almost a decade, is a trade organization that fights for the rights of independents. It is up against the conglomerates, which have huge

budgets for their lobbyists in Washington, but hopefully there will be governmental intervention sooner rather than later. Interestingly, in industry vernacular, the studios used to be referred to as the "majors." Now the Hollywood trade press refers to them, more fittingly, as the "conglomerates." The six major vertically integrated conglomerates are Viacom (which split from CBS in 2005), CBS Corporation, the Walt Disney Company, 21st Century Fox/News Corporation, Sony, and Time Warner. (A list of these major entertainment conglomerates and their holdings, as of 2013 writing, can be found in Appendix A.)

Monopolies versus Independent Free Trade

Even more frightening is a specific breakdown of what the conglomerates actually own. As an example, I offer a list of Time Warner's assets in 2013.

- Cable channels:
 - Adult Swim
 - Boomerang
 - Cartoon Network
 - CETV
 - Cinemax
 - CNN
 - CNN Headline News
 - CNN Mobile
 - CNN Radio
 - GameTap
 - HBO
 - iN Demand
 - Metro Sports
 - New York 1 News
 - Peachtree TV
 - Pogo
 - Road Runner
 - TBS Superstation
 - Time Warner Cable
 - TNT
 - Toonami
 - TruTV (with Liberty Media)
 - Turner Classic Movies
- Film/TV production and dis-tribution:
 - Castlerock Entertainment
 - The CW Network
 - Hanna-Barbera Cartoons

- HBO Independent Productions
- Kids' WB!
- New Line Cinema
- Telepictures Productions
- Turner Original Productions
- Warner Bros. Studios
- Warner Home Video
- WB Domestic Pay-TV
- WB International Cinemas
- WB Interactive
- Online services:
 - ADTECH
 - Advertising.com
 - Amazon.com (partial)
 - AOL.com Portal
 - AOL Europe
 - AOL Instant Messenger
 - AOL MovieFone
 - CompuServe Interactive Services
 - Digital City
 - GameDaily.com
 - iAmaze
 - ICQ
 - Lightingcast
 - MapQuest.com
 - NASCAR.com
 - Netscape Communications

- Netscape Netcenter Portal
- PGA.com
- Quack.com
- Relegence
- Spinner.com
- TACODA
- Third Screen Media
- Truveo
- Userplane
- WBshop.com
- Weblogs, Inc.
- Winamp
- Xdrive

- Other entities:

 - American Family Publishers (partial)
 - Turner Home Satellite
 - WB Recreation Enterprises Theme Parks

- Magazines:

 - *4x4*
 - *Aeroplane Monthly*
 - *Amateur Gardening*
 - *Amateur Photographer*
 - *Ambientes*
 - *Audi Magazine*
 - *Balance*
 - *Beautiful Kitchens*
 - *Bride to Be*
 - *Caravan Magazine*
 - *Chat*
 - *Chat – It's Fate*
 - *Chilango*
 - *Coastal Living*
 - *Cooking Light*
 - *Country Homes/Interiors*
 - *Country Life*
 - *Cycle Sport*
 - *Cycling Weekly*
 - *DC Comics*
 - *Decanter*
 - *Entertainment Weekly*
 - *Essence*
 - *Eventing*
 - *EXP*
 - *Expansion*
 - *Family Circle*
 - *Fortune*
 - *Golf Magazine*
 - *Guitar*
 - *Health*
 - *Hi-Fi News*
 - *Hippocrates*
 - *Home and Garden*
 - *IDC*
 - *Ideal Style*
 - *InStyle*
 - *International Boat Industry*
 - *Life and Style*
 - *Mad Magazine*
 - *Manufatura*
 - *Money*
 - *Mountain Bike Rider*
 - *MiniWorld*
 - *NME*
 - *Now*
 - *Nuts*
 - *Obras*
 - *People*
 - *Pick Me Up*
 - *Practical Parenting*
 - *Prediction*
 - *Quién*
 - *Racecar Engineering*
 - *Real Simple*
 - *Rugby World*
 - *Ships Monthly*
 - *Shoot Monthly*
 - *Soaplife*
 - *Southern Accents*
 - *Southern Living*
 - *Sports Illustrated*
 - *SI for Kids*
 - *Sporting Gun*
 - *Stamp Magazine*
 - *Sunset*
 - *SuperBike Magazine*
 - *The Railway Magazine*

- *Teen People*
- *Time*
- *TV and Satellite Week*
- *TV Easy*
- *TVTimes*
- *Vertigo*
- *Vuelo*
- *Wallpaper*
- *Web User*
- *Wedding*

- *What Digital Camera*
- *What's on TV*
- *Who Weekly*
- *Wildstorm*
- *Woman's Own*
- *Woman's Weekly*
- *Yachting World*
- *Yachts*
- *Your Yacht*

The stance of IFTA—as it fights for the rights of the independents, free trade, fair trade, and free enterprise—is paraphrased below (but most of the original language is used).

The freedom to create and distribute movies and TV shows is threatened by a handful of giant media companies that want to control both programming and all the distribution channels in order to protect their own marketplace positions.

From 1995 through 2010, the share of independent TV production on prime-time television fell from 50 percent to 18 percent. Why? Because a few giant media conglomerates—News Corp., NBC/Universal, Disney, Time Warner, Viacom—combined TV and cable networks, movie studios and distribution channels to control as much of our entertainment system as possible, leaving independents gasping for air time. The result: less quality programming for the public and fewer options for creative, talented people across the world.

While independent producers and distributors have been pushed out of the marketplace, the Federal Communications Commission (FCC) has chosen not to address the issue, despite simple solutions for relief to ensure the survival of diversity in programming.

But the prospects for independents can be improved. The FCC can require broadcast and cable stations to air a minimum amount of programming from diverse sources, which would give independents the opportunity to break through the consolidated entertainment marketplace.

This doesn't just affect television and film. Today, the history of television tells us that the future of the internet is also at risk as huge telecom and cable companies strike deals to secure program supply for the broadband networks they control. Without help, this last open frontier for independent voices may also be fenced off to protect these giant companies' investments.

Join the fight for independents! Protect the public's access to challenging films and entertaining television in theaters, on TV, and over the internet. Write to the FCC, asking them to protect the public's access to independent film and TV programs by requiring media conglomerates to air a minimum amount of independently created programming. Help preserve quality, creativity, and democracy in media!

More than just preserving quality, creativity, and democracy, divesting the conglomerates would preserve any individual's right to create his or her own film, television show, entertainment project, or entertainment company, without being an employee puppet within the studio/conglomerate system.

Here is an even bigger travesty. After the conglomerates, unchecked by the federal government, were allowed to monopolize every imaginable form of media and distribution outlet, they fired their employees in droves, while CEOs and key executives continued to make millions per year in bloated salaries and stock options. The February 15, 2009, issue of the *Hollywood Reporter* stated that "Media and entertainment firms have continued to announce job cuts since the start of the year," with the Disney/ABC TV Group cutting another 400 jobs, Warner Bros. another 800, AOL another 700, Clear Channel another 1850, Tribune another 300, Bloomberg another 100, and Warner Bros. Cable another 1250, all in the first five weeks of 2009.

Home Entertainment Consolidation

As Blockbuster monopolized the domestic video rental outlets and, concurrently, sell-through (the discount sale of videocassettes and later DVDs) evolved, it and eventually Wal-Mart became the major retail sales outlets for home video product. As all of the independent, straight-to-video distributors and retail stores were put out of business one by one, Blockbuster created an acquisitions arm called DEJ Productions. Its mandate was threefold:

- to acquire all the domestic rights for independent films that DEJ, a Blockbuster subsidiary, would own;
- to create its own library; and
- to promote and distribute these films through its massive chain and use its in-store promotional advantage to induce consumers to buy and rent its own acquired product.

In the same era, HBO acquired a certain number of independent films for "premieres," meaning those films would premiere on HBO before they were exhibited anywhere else in the domestic territory (if not the world). HBO was very discerning and specifically acquired action and thriller films that were consistently true to the genre. Incidentally, out of seventy films that my company Royal Oaks Entertainment produced or acquired, only three sold as HBO premieres: *Grid Runners*, *Crash Dive*, and *The White Raven*, each of which I happened to direct. I sold many films to HBO as a producer at Franchise Pictures, from *Mercy*, starring Ellen Barkin, and *A Murder of Crows*, starring Cuba Gooding Jr., to *The Confession*, starring Alec Baldwin.

As Blockbuster was losing many of the best independent films to HBO, it created its own strategy to compete. For a brief period, Blockbuster and DEJ acquired independent films for "premieres" as well, meaning that the films would debut exclusively in Blockbuster stores before distribution in other markets. Selling a film as a "premiere" to either Blockbuster or HBO meant substantially more money for the producer.

One of the Blockbuster domestic "premiere" acquisitions was the popular cult film *The Boondock Saints*, which I executive produced (providing the financing and foreign and domestic sales for the picture). It was never released theatrically in the United States; instead, it was acquired as a straight-to-VHS/Blockbuster world premiere for a one-year term. The film was extremely successful for Blockbuster, and when the one-year term expired, I offered the company an extension, as well as DVD rights. Blockbuster's executives declined to extend the term, saying that they believed that everyone who would ever want to see the film had already seen it. Similarly, they declined to acquire DVD rights, stating that they were not in the DVD business. (The DVD format was in its infancy at the time. Players cost $1200–$1500, the image was often pixelated and erratic, and the discs would frequently freeze.) Consquently, a small, domestic home video company bought the DVD rights for a minimal sum, because there were no other offers. That company held off on the distribution of the film until DVD matured as a format, then it released it through Fox, making millions of dollars that Blockbuster could have had.

By 2001, HBO had stopped buying premiere movies from independents, focusing instead on original content and series events for its network. By 2005, after several poor management decisions, falling stock prices, and failure to meet its bank covenants, DEJ was sold. Blockbuster stopped paying to acquire independent films and began a revenue share model with studios. This approach has subsequently allowed the company to stock more copies of new releases. By 2003, fueled in no small part by the dramatic drop in the retail price of DVD players, DVD became the viable successor format to VHS, and by 2006, as announced by the Hollywood trade publications, the demise of VHS had become official.

Major television networks have rarely bought independent films for network broadcast. Over time, the cable networks increasingly curtailed their purchase of independent films in favor of studio output deals and original programming. As described above, middle-tier buyers for independent product in the domestic market, who previously were the mainstay for independent film sales domestically, have decreased substantially or ceased to exist. The few survivors have been the very smart DVD distributors, genre arms of the majors and mini-majors, and the innovative independents who have figured out new models of distribution strategy, such as the enormously successful "faith-based" films like *Facing the Giants* and *Fireproof*.

While the above events were happening in the United States, very similar circumstances were unfolding abroad.

The Independent Film & Television Alliance (IFTA) has taken the following stance on behalf of its members:

> These days, IFTA's members are virtually unable to license their films and programs to a number of television channels in the United States because the studios, broadcast and cable networks have combined into the large conglomerates mentioned above. Furthermore, these same forces threaten the opportunities for independent programs on the internet.
>
> IFTA has voiced its concerns about the negative effect of media consolidation on the public's access to independent and diverse programs to Congress, the Federal Communications Commission, and the presidential administration. To increase awareness of this vital issue, it has also launched a website: www.FightForIndependents.org.

Keeping Abreast of the Changing World

The terrorist attack on U.S. soil on September 11, 2001, was a seminal event worldwide, and nothing in the entertainment business has been the same since. The early 2000s saw a series of calamities that affected the international independent film-buying marketplace. Leo Kirsch, who was the largest media mogul in Germany (at that time the most lucrative territory for U.S. independent film sales), and his Kirsch Media companies went bankrupt. For at least a couple of years, Germany virtually ceased buying independent film product for its domestic television service. (German sales have since resumed, but to a much smaller degree than before.)

Silvio Berlusconi's last two tenures as prime minister of Italy and his legal indictments for fraud and embezzlement had an extremely detrimental impact on U.S. independent film sales in Italy. Italian television is a very difficult sale in today's market, leaving much smaller dollars, if any, for an initial Italian video sale and the hope of a future television sale.

For years, the competition between the leading satellite networks in Spain kept the prices competitive for independent films, but the prices dropped considerably when these stations merged.

Korea, which had a large but short-lived home video boom during the 1990s, was a huge market for American-made independent films during that decade. A few years later, though, the Korean home video market crashed. With the exception of very low-level genre films, the country stopped buying almost all straight-to-DVD films and focused instead on purchasing major studio theatrical releases with large P&A to support their domestic theatrical releases.

Japan, which has always been a mercurial market, started garnering better box office and generating higher returns on local Japanese product, and even Korean product, than American films, with far cheaper acquisition prices than it had been paying for U.S. movies.

Also bear in mind that costs are incurred for *dubbing* into the local language for every sale to a Western European territory. Smaller territories incur lower costs for *subtitling* into the local language.

Coupled with all the above, reality programs saturated the world in the 2000s. As successful as *Big Brother*, *The Amazing Race*, *Survivor*, and numerous other reality shows have been in the United States, they have been equally successful abroad. Foreign countries began producing their own reality programs in their own languages, with no dubbing or sub-titling necessary, and these were not dependent on traditional stories or screenplays. Such shows can be shot quickly and cheaply, without the costly cinematic production values of feature films. These foreign territories now own the productions outright, and they often attain higher TV ratings than U.S. movies.

In short, over the past fifteen years, the global marketplace has shrunk and consolidated, making it all the more critical for independents to produce cost-effective pictures with the right cast and of the right genre for the global marketplace.

In previous years, an independent producer could often make the right film for the wrong price with the wrong cast and get away with it (or the wrong film with the right cast for the right price and get away with it). Today, however, all three elements are critical for the independent producer. One must make the right film for the right price with the right cast or run the risk of losing money. This means that maximizing production values and recruiting a star-name cast within the most cost-effective budget is essential for the recoupment of investment and profit. (I will discuss finance based on the current global marketplace in a later chapter.)

The April 10, 2008, edition of the *Hollywood Reporter* stated, "The dead zone for single-picture financing lies in the $3 million–$10 million budget range. Once a budget increases beyond $10 million ('more money, less risk'), paradoxically, it gets easier." Again, the domestic studio theatrical release is what the foreign markets key off of for larger films, and it only gets easier if it happens to be the right picture, and if a studio happens to pick it up, and if it supplies the P&A funds, and if it distributes the film in a meaningful way. And if not, guess what? In 2016, the dead zone was more like the $1 million–$3 million budget range. This means even the larger independent film companies need to make movies more cost-effectively than ever before and/or make them larger, with studio release commitments that expand the potential return globally.

The specialty film market, also known as the art house film market, has changed as well. In the past, specialty divisions of studios, dubbed "independent studios" (such as Fox Searchlight; Sony Classics; Paramount

Vantage; Focus Features), known for producing or acquiring low-budget art house, or specialty films which are marketed to the intelligent and more discerning adult moviegoer have also cut budgets and reduced costs. "In 2004, the average cost of producing a specialty picture was $40.4 million. At the end of 2007, this number had shot up to $74.8 million with P&A spend; a change of 85 percent. This huge change can be attributed to the fact that specialty division films are more directly under the purview of the parent studio. In contrast, since 2004, the average cost for a major studio picture has remained relatively stable, rising only 6 percent between 2004 and 2007, from $100.5 million to $106.6 million. (Source: Pamela McClintock, "H'wood's Niche Reach: Cost to Make, Market Specialty Films Soaring," *Daily Variety*, March 6, 2008). Since then, specialty films have, by necessity, dramatically lowered production costs, and several studio specialty divisions, such as Warner Independent Picture and Paramount Classics have been dissolved.

From 1997 through 2002, I created Franchise Classics, a division of Franchise Pictures, which produced and distributed many specialty films that appeared in such major film festivals as Cannes, Sundance, and Toronto. I think we did it right, by green-lighting the pet projects: *The Big Kahuna*, starring Kevin Spacey and Danny DeVito, which was made for under $2 million; *Things You Can Tell Just by Looking at Her*, starring Cameron Diaz, Holly Hunter, Glenn Close, and Calista Flockhart, for under $2.5 million; and *Green Dragon*, starring Forest Whitaker and Patrick Swayze, also for under $2.5million. The pictures sold well worldwide and made money because, even though they were the "wrong" pictures due to their subject matter, which had limited commercial appeal, they were the "right" pictures at the time because of the star casts and were made for the right price.

During this time I also co-founded a sister company, Phoenician Entertainment, which produced many genre action/adventure films but also such specialty films as *The Third Miracle* (starring Ed Harris and Anne Heche), *Entropy* (starring Stephen Dorff and U2), and *Woman Wanted* (starring Kiefer Sutherland and Holly Hunter). If these three films were made today, their budgets would have to be cut by more than half, as noted earlier, in order not to lose money. Due to the consolidation and changes in the marketplace, today's independent producer must be more skilled than ever before.

Chapter 3

The Global Marketplace

Many people who aren't familiar with the entertainment business don't realize that the majority of films made each year do not have a theatrical release (i.e., they do not appear in movie theaters). An aspiring film producer might wonder what happens to these movies. They are released in what are known as *ancillary* markets, which include DVD, video on demand (VOD), new and emerging streaming and wireless venues, airlines, ships, hotels, satellite, and cable. Most independent films are distributed in these markets, either because they are specifically made for them or because they fail to attract a mainstream buyer who would afford them a theatrical release.

There is another critical point for the independent filmmaker to consider: the general rule of thumb is that 65 percent of the revenue generated by most independent films comes from territories *outside* of North America. By "territory," I mean a particular geographic region, such as a country or a group of countries that has a homogeneous or nearly homogeneous language base. For example, "Germany" is defined as "all German-speaking territories," which include Germany itself, German-speaking Switzerland, Austria, Alto Adige Luxembourg, and Liechtenstein. Buyers may be theatrical distributors in their "territory"; they may be solely home entertainment (DVD/VOD) distributors; buyers for free, pay, cable, terrestrial, or satellite television, or any variety of new media; buyers of ancillary rights, such as airline, ship, and hotel companies; or middlemen who buy film product and resell it in their territory for profit. In most cases, approximately two-thirds of a film's potential revenue will come from Latin America, Germany, France, the United Kingdom, Spain, Eastern Europe, Italy, Benelux (both Flemish- and French-speaking Belgium, the Netherlands, and Luxembourg), Scandinavia, Australia and New Zealand, South Africa, Southeast Asia, Japan, Greece, Turkey, and the Middle East.

This means that only approximately 35 percent of the revenues for most independent films comes from North America, which is defined as the United States, Canada, and their respective territories and possessions. Sometimes the United States and Canada may be sold separately, and sometimes North America may be sold all together. However, pay close attention

to the foreign markets and the trends that are saleable in the major foreign territories because the lion's share of the revenues for your film will come from those places.

The Evolution of the Independent Market

So, how did the independent film market evolve? From the inception of cinema until sometime in the 1940s, motion pictures were only released cinematically, meaning that one would have to go to a movie theater to see a film. But with the advent of television, all of a sudden there was a new ancillary market, another venue where theatrical movies could be seen after their initial theatrical release. When home video arrived in the 1980s, a recordable format evolved, and movies could be recorded off the consumer's television. With this new videocassette format, the domestic home entertainment market was created and soon exploded. Film producers and distributors realized new movies could be made directly for the home video market, and people bought them in droves. Initially a novelty, video-cassettes quickly became a whole new lucrative market. Consumers could go into a video store and buy or rent a film that might have a catchy title or a cool box, but had never appeared in the theaters, and take it home to watch in their living room.

A whole new breed of home video stars emerged within this market, including action stars like Don "The Dragon" Wilson, Michael Dudikoff, Jeff Speakman, and Jeff Fahey, and femme fatale, sexy thriller stars like Shannon Tweed, Shannon Whirry, and Joan Severance. They were all viable commodities and a good attachment for getting the movie made, depending on the genre.

Foreign Sales

How are these independent movies sold? Alluding to what I said earlier about the foreign market comprising the greatest share of the value of an independent film, these movies are sold at trade shows—international sales markets for movies and television product, called film markets—which are much like car or electronics shows. Sellers display their film and television product in sales booths, set up in either hotel suites or convention halls. Buyers from territories all over the world attend, looking to purchase films to meet the specific criteria for their distribution slates in their respective countries or territories. Some buyers purchase all rights, some just television or DVD/home entertainment rights. All are inundated with sellers who are hawking films that are completed and available for screening, films that are in post-production (shot but not yet complete) and may have a trailer or promo for viewing, films that are currently in production and have only a poster or production photos available, and films in pre-production that haven't been made yet and whose producers are seeking pre-sales to

complete their collateral for financing. At most film markets, every imaginable buyer of every imaginable right for filmed entertainment is in attendance. Buyers could be from a network, a theatrical distributor, a DVD distributor, a satellite company, or a cable company; they could be buying any number of ancillary rights; or they might be middlemen looking to purchase film rights before reselling them in their territory for a profit.

Depending on the year, IFTA has up to 170 member companies that participate in many of the film markets worldwide, both as buyers and sellers. The Alliance also puts on what I think is the most important trade show of the year—the American Film Market—which currently takes place at Loews Santa Monica Beach Hotel in Santa Monica, California.

Everyone has heard of the Cannes Film Festival. The concurrent Cannes Film Market (Marche du Film) takes place either in the Palais des Festivals et des Congres or in several of the hotels up and down the Promenade de la Croissette. When I was selling movies, or pre-selling movies as a means to finance them, I would travel to Cannes, Milan, Berlin, Venice, and Toronto, as well as to Sundance (in Park City, Utah) and Santa Monica. I would set up a booth, just like any vendor at any trade show anywhere in the world, and display my motion picture product.

The best sales tool for any movie is a good poster. For a small independent film, I would look at the current posters of the major studios, assess the latest trends, and make my posters reminiscent of a successful studio campaign. Similarly, if a film has completed production, a good trailer is another essential sales tool; again, studio theatrical trailers are good guides for independents to follow. Flyers, synopses, screenplays, and DVD "screeners" of finished films are also crucial. However, completed films are increasingly being uploaded to private Vimeo, or other, accounts, with the links sent to potential buyers. Compression issues affect viewing quality with this method of delivery, but most buyers understand this and overlook it, trusting the film will look far better in its proper resolution.

Flyers are posters that are reduced to 8½ × 11 inches and handed out like trading cards to buyers as they enter the booth, as a means of attracting them to that particular film project. Why are these critically important? Because most buyers of non-theatrical product envision your key art as their DVD box. They generally do not want to spend their own money on new artwork. I have seen buyers literally fold the edges of a flyer to see if it would make a good DVD box and whether it would "jump off the shelf" to attract the consumers in their territory. When creating key art for your film's poster, which will ultimately be reduced to a flyer for foreign markets, keep in mind that buyers do not want something that is too dark. There are quirky, unwritten rules, like "white spells comedy." Also, if the picture you're selling has a secondary level of sell—i.e., some saleable element that will appeal to a foreign market—show that element in the key art. For instance, if there is a Stealth fighter, an aircraft carrier, or even a grizzly bear

in the movie, feature it in the artwork, because it might be an attractive second-level sell for particular territories.

Knowing the criteria for my straight-to-video action label, with a second level of sell element, a veteran independent filmmaker came to me with a lot of stock footage of rattlesnakes. He had some really cool shots of them coming out of toilets, through drain pipes, across hills. Some of the shots were very dynamic, with the snakes' fangs extending towards the camera. The filmmaker wanted me to develop a film for him to direct using the rattlesnake stock footage as my second level of sell. I told him to rent the film *Outbreak*, which stars Dustin Hoffman and Cuba Gooding, Jr., and study the story structure. Then I suggested as a story line that the snakes were genetically engineered in a clandestine military lab to be used as a secret weapon during Desert Storm, and that wherever *Outbreak* had the Ebola virus, he should insert the bio-engineered rattlesnakes.

Buyers also want to see an audiovisual representation of the film that you're selling: your trailer. When you go to the movies, what do you see for twenty minutes before the feature presentation starts? Trailers. In this context, the purpose of these promotional previews is to attract the audience to come to see a movie upon its initial theatrical release. By contrast, when selling a movie at a trade show, a trailer gives buyers an audiovisual representation of good production values, good sound quality, good visual effects (if there are any), and good martial arts or fight scenes (if it's an action film). Naturally, the idea is to persuade buyers that the finished film will look and sound just as good. Unfortunately, this rarely happens.

Definition of Film Sales

When I say that films are "sold," I'm talking about selling the rights to exhibit a film in a defined territory or country for a defined term, or period of years. Territories like Germany and Japan, which may pay the greatest amount of money for the rights to exhibit your picture in their territory, will logically get the longest term (i.e., the most years). These two territories have both expanded their term to between fifteen and twenty-five years before their licensed rights expire. Mid-sized territories, such as the United Kingdom, France, Spain, and Italy, have the second-longest terms, generally between ten and fifteen years, depending on the amount paid. Smaller territories, such as those in Eastern Europe, Latin America, Southeast Asia, Turkey, and Greece, generally have seven-year terms.

Definition of Term

What happens to those film rights after the term expires? They revert to the owner of the film. When film rights revert, they may be sold again and again, for second- and third-cycle terms, or more, into perpetuity. I'm sure

you have all heard about studios, networks, or other big content providers acquiring or buying libraries. What that means is that they are buying the perpetuity rights of a number of movies in a collective film library and can resell those rights repeatedly, for ever.

If one produced and retained rights to a hundred movies and had a one-hundred-picture library, you would have a staggered, or laddered, portfolio (just like a municipal bond portfolio), in which each film's rights would expire at the end of every term in every territory, per picture, times one hundred pictures, and generate revenues in perpetuity.

Foreign Sales Contracts

We have established that independent films are sold at trade shows, which are known as film markets. We have established that rights for those films are sold to countries or territories for a term (i.e., a specific number of years). Those film sales and the rights, terms, and conditions of each sale are commemorated in writing, first in the form of a deal memo, with the template usually provided by IFTA. Subsequently, this deal memo is transposed and expanded into a long-form contract between the seller and the buyer in each individual territory. If they are with a viable distributor, these contracts are negotiable instruments that can be used as collateral with certain banks that have an entertainment lending division. Also, if one is trying to raise money for a film and has sales contracts in territories with viable, bankable distributors, those contracts may be used as collateral with an equity investor.

What is Your Film Worth?

Each year the *Hollywood Reporter*, one of the entertainment industry's most prominent trade papers, publishes "The Going Rate." The following is an example inform published in 2009 for a picture budgeted between $5 million and $15 million:

Country	Percentage
Europe:	
United Kingdom	7–10
Germany	6–8
France	6–7
Italy	3–5
Spain	3–5
Scandinavia	1.5–2.5
Asia:	
Japan	1–10
Australia	2–4
South Korea	1.5–2

Country	Percentage
Latin America:	
All territories	2–3
Eastern Europe:	
Russia	2–3
All other	1
Other territories:	
India, China, Middle East	2
Turkey, South Africa	.05–1

The Fallacy of the Going Rate

Often, "going rates" have little or nothing to do with budget, and numbers can be vastly different, depending on such factors as the film's star cast, genre, or setting. In the foreign markets, films set in urban metropolises are vastly more commercial than those set in rural or desert locations. One film's numbers (e.g., in the $1 million–$3 million range) may be completely different from a comparably budgeted film, depending on several of these factors. Timing is also critical for discerning market value: a genre that was red hot six months ago may be ice cold in six months' time, due to oversaturation or a variety of other changes in the marketplace.

"The Going Rate" is the *Reporter*'s attempt to categorize, per foreign territory, what that territory is worth on a percentage basis, based on the overall budget of a film. But the chart has some serious flaws and can't be trusted as a reliable guide. It attempts to pigeonhole films into budgetary categories, which is not only impossible to do, but false and misleading to the general industry and public. In a few cases, on certain films, the numbers might be valid, but in most they are not. Sometimes they may be vastly high for a specific film then drastically low for another film of the same budget, but with different elements: for example, stars, genre, and setting. Sometimes there may never be a sale in a particular territory or territories. It is critical for a producer to have knowledge of the foreign market and either do his or her own due diligence or find a trusted advisor, generally a sales agent (which we will discuss shortly), to discern the true market value of each individual picture. It takes a skilled and knowledgeable sales agent to stay attuned to the actual current rates per territory. Although I'm sure it is well intended, the *Reporter*'s publishing of "The Going Rate" makes life much more difficult for sales agents because it creates unrealistic expectations for producers and filmmakers, as it takes into consideration none of the factors that actually determine a film's market value.

Why? Because the marketplace fluctuates on a continuum, and genre and cast have tremendous impacts on a film's financial return. If a movie is an

action film, does action work in a particular foreign territory, or is drama a better sell? Is comedy better than horror? The answers vary from territory to territory, and very few films ever sell in every territory worldwide. Also, critically, who are the stars? Are those stars valuable in the majority of the most lucrative territories, or has a particular star who seemed like a good name at the time of production been overexposed in certain territories and, consequently, now *diminishes* the value of the film? When all of these factors are blended together, simple, formulaic percentages cannot be trusted.

There is no *Kelley Blue Book* to predetermine the value of a film the way you can effectively predetermine the value of a used car. Even in the *Kelley Blue Book* there is a private party evaluation, a wholesale evaluation, and a dealer retail evaluation; and the price of the car also depends on wear and tear, mileage, extras, and options. Continuing that analogy, films largely depend on the current state of the marketplace, which stars are in the film, and the genre, as well as the setting of the film. As mentioned above, pictures shot in an urban setting are almost always more valuable than those shot in a desert or another rural setting; that's just the way the market is. Period pieces are a tough sell. Westerns are a tough sell. Ethnic urban pictures are a tough sell in foreign markets.

So, being aware of these preliminary issues, doing proper due diligence, doing a proper analysis of the tastes and trends of the global marketplace can effectively give a producer or filmmaker the knowledge to "design" a film that will effectively tap into the current marketplace. If that film is then produced and delivered for reasonably less than the market value, it should make a profit. However, you need to subtract from the market value all costs for distribution fees and expenses (which we will discuss in a later chapter), as well as interest, a margin for error, and a margin for profit. For example, if the worldwide market value for a film is $500,000 and blended distribution fees and expenses are 20 percent, factoring in a 10 percent margin for error, 10 percent margin for profit, and 5 percent contingency for guild residuals—which must be paid later by the producer—that film should not be made for a penny more than $300,000 (or less, if possible) to insure profit.

Domestic Sales

We have talked a little about foreign markets, but let's now address the domestic market. As we discussed, the domestic market is defined as the United States, Canada, and their respective territories and possessions. Let's say, for instance, you make an independent "genre" picture. By that, I mean an action film, a thriller, an action thriller, but in the exploitation vein. Where might you expect to distribute that picture in North America? By its nature, the picture is probably not going to get a theatrical release unless you pay for the theaters and advertising yourself, and the likelihood is that you will never recover all of that additional expense. So, the available

moneymaking avenues for this non-theatrical film are the DVD and home entertainment markets, which include traditional DVD sales, VOD, and television sales. VOD is currently broken down as follows:

- transactional VOD (TVOD; e.g., Amazon);
- subscription VOD (SVOD; e.g., Netflix);
- advertising supported VOD (AVOD; e.g., ABC, NBC, or CBS websites);
- free VOD (FVOD; e.g., Hulu); and
- hybrids, such as Time Warner, which offers SVOD to its subscribers but also offers TVOD, which allows subscribers to pay extra for other, non-subscription content.

Television currently consists of cable, satellite, pay TV, and free TV. For films of certain genres, there might be the occasional airline sale or sales to a new ancillary market, plus all new and emerging media.

Art House and Specialty Films

If your picture is a quirky, noncommercial, or "off genre" specialty or art house film, you might want to utilize one of a number of specialty distributors. However, it's very difficult for a filmmaker or producer to make money in the art house world. We've all heard stories of bidding wars at Sundance, and how a small art house picture has made lucrative sales because Harvey Weinstein has bought the rights for millions of dollars more than the production budget. However, that is a rare occurence, which is becoming more rare these days.

I had four pictures in three years at Sundance. In 2001, the movie I was offering (one of sixteen films in competition) was *The Green Dragon*, starring Forest Whitaker and Patrick Swayze. I expected a bidding war. It was an audience favorite, and at the end of each screening I anticipated that buyers would make lucrative offers. At that time, divisions of studios like Paramount Classics, Fox Searchlight, and Sony Classics all offered the same deal: $250,000 for all domestic rights, plus a $500,000 commitment for P&A (again, prints, advertising, and media buy) to release the film in a few theaters. Then, if it did well, they would expand or platform into more theaters. This was when I learned that the divisions didn't pay what the studios themselves paid.

At the same time, I received offers from non-theatrical companies—straight-to-DVD companies that weren't prepared to spend money on a theatrical release. They offered anywhere from $1.5 million to $2 million for the same movie; specifically, for not releasing the picture theatrically and incurring P&A expenses.

Which deal do you think I accepted? I took the money and sold to a non-theatrical, home entertainment company for more than six times

what the studio specialty divisions were offering. As part of the deal, the film was released theatrically in L.A. and New York as a gesture to the filmmakers, and everybody was a winner. The filmmakers and actors got to see their movie in a handful of theaters; the home entertainment company made money; and my production company paid back the bank loan and made a profit. *That*, in my opinion, is how small business should work. Everyone should share in the risk and the reward, and if there is a tough decision to make, the priority should be safeguarding the investor or the bank.

After one of those eye-opening Sundance festivals, taking a page out of the studio specialty division playbook, I launched my own "classics" division. I was able to get movie star actors to appear in pet projects of noncommercial, art house pictures for a percentage of any profits. If the picture made money, they were compensated; if it didn't, I didn't lose money.

On the topic of film festivals, most of them are really for the filmmakers to expose their films, see those films in a theatrical venue, and get some audience reaction (which at festivals is generally a love fest). They rarely result in sales. However, some festivals, including Venice, Berlin, Toronto, and certainly Sundance, have evolved into film *markets*, with buyers coming from all over the world to see the premieres and perhaps make preemptive offers to buy the movies, if they feel they are commercial for their respective territories.

P&A

Earlier, we touched on P&A, but these days film prints and trailers have become almost obsolete as theaters have converted to digital screening formats. P&A is very expensive: I have produced some movies for $25 million and the P&A budgets have been $40 million. That's a lot more money spent *promoting* the movie than *the actual production cost*. Also, remember that when you're calculating the overall cost of the film, P&A expense must be factored in on top of the production budget, with the total being the amount of money you need to recoup before the film breaks even and then starts to see a profit.

Television Premieres

A few television channels might be potential buyers for certain genres of movies after a picture is completed. The science fiction channel Syfy, for example, is a possible buyer of films with science fiction, creature, or supernatural elements, but there is never any guarantee. The Lifetime Channel has traditionally acquired movies that deal with women's issues. The Hallmark Channel has traditionally acquired movies that deal mostly with multi-generational family issues. However, it should be noted that the

acquisition price of a completed film will be far less than if you had developed the film specifically for a particular network. These networks pay premium "premiere" prices that are far higher for films they develop with producers rather than films they acquire after they are made.

Domestic Media and the Internet

We talked earlier about the domestic home entertainment market, which evolved from VHS videocassettes to DVDs and now to Blu-ray, which itself will soon become obsolete. That market, however, has eroded greatly, because everyone who has a Blu-ray player has immediate access via the internet to Netflix, Pandora, Voodoo, Amazon, Apple TV, and myriad others. All of these services can deliver movies instantly to a home television screen or wireless device without the user ever having to leave the house, so they render DVDs virtually obsolete (except for the still-convenient transportability that the discs allow, and for collectors who want them for archival purposes). We are living in a very interesting time right now. We are in a major, continual evolution in technology, and every day things change. In years past, in the domestic marketplace, studios were autonomous, networks were autonomous, and there were numerous autonomous buyers out there. Today, they have been consolidated under conglomerate auspices.

The most interesting thing about the internet, for filmmakers, is that it is a global distribution system. Anyone with a digital camera and the ability to upload can give his or her film or video instant worldwide exposure. However, there are two problems: how to market and gain a significant market share amid all the clutter of the internet; and how to monetize the internet in a significant way that might eventually obviate the traditional distribution avenues. While every independent filmmaker has the ability to make a film, upload it, and distribute it without going through conventional channels, we also want to get paid and make films with little or no risk by being able to reasonably calculate revenues before making a movie.

Chapter 4

How to TAP into the Marketplace

In this chapter my goal is to illustrate to aspiring filmmakers the reality and the real-world marketplace of making movies, as opposed to the theory you might learn in a traditional film school. All the movies I have produced have several things in common. First, I established the market desire for that particular picture. Then I established the market value of the picture. Next I made a budget for the picture that was less than the market value, thus establishing a foolproof margin for profit. In order to tap into the marketplace, you must do due diligence, just as you would with any other business deal. I'm using the acronym "TAP" to help you remember the key elements.

- "T" stands for trends. What is the trend in the current global marketplace? Are the majority of the leading territorial distributors buying horror, action, thriller, or comedy? Film trends generally follow the "pendulum theory": a trend gains momentum or desirability on the upswing, becomes oversaturated in the market, and starts a downswing, losing momentum and desirability on the way. It is very important to make sure that the movie you're making will still be part of the current trend before the pendulum swings back the other way. Don't be stuck with the last cheap horror rip-off when the buyers are oversaturated with horror films. As you do your due diligence of the market, establish which trends are on the upswing. Even if you don't have a film to sell, buy a day pass to a film market and walk the halls.
- "A" stands for analysis. Your analysis not only includes a financial analysis of the global market value of that current trend of film in a worst-case scenario, but also your creative analysis. How do I develop a script that will hit all the market trend desires in the world-wide market, so that the territorial sales will support the financial analysis?
- "P" stands for profit. If you do proper due diligence in the foreign and domestic markets, follow the current trends, and then do a proper creative and financial analysis, trend plus analysis equals profit.

As discussed briefly in Chapter 2, the same business paradigms apply to the movie business as to any other business, such as home building. I used the analogy of making a movie to building a house on speculation. As an analogous exercise, let's apply the TAP philosophy to building a spec house. What's the trend? Would you go into a neighborhood where houses are worth approximately $250,000 and build a $5 million house? Why not? You might lose $4,812,500 (i.e., $250,000 less sales agency fees and expenses). Why on earth do people continually make the wrong movies for the wrong prices when there is no market value for them?

As we established earlier, the producer is very much like the builder. The builder establishes the trend in the neighborhood where he or she intends to build. For instance, is the trend three-bedroom, three-bath houses with a detached two-car garage and two living areas? Once you have established the trend, then you have established what type of product to make for the market you've chosen. Next, the builder establishes the market value for the trend of house he or she has established is most desirable, and what the costs will be to build. Finally, the builder assesses whether the house can be built for substantially *less* than the market value, making allowances for a potential drop in the real estate market, financing and carrying costs, a contingency for overruns, realtor commissions and closing costs upon sale, as well as a margin for profit. The builder predetermines whether a profit can be made before he or she buys the land, hires the architect, and commences building. If the analysis determines that it is a high-risk venture, a smart builder will find another project in another neighborhood.

Why would anyone treat a movie project any differently than building any other product for a profit? Establish the trend, establish the market value, subtract sales agency costs, market expenses, a contingency for overruns and a profit margin, then make it for less.

So, using the analogy that the producer is like the builder, he or she first finds the "land"—or the idea, the subject matter, the underlying material, the book, the magazine article. Then he or she hires the "architect"—the writer. The writer, under the producer's tutelage, then develops the script, just as an architect drafts plans and blueprints. Once the blueprint (or the shooting script) is complete, the builder (or producer) hires a construction foreman (or director—admittedly a poor analogy, but one we will use for the sake of this illustration). The construction foreman oversees every facet of construction, and the director oversees every aspect of the filming of a motion picture. Proper due diligence and intelligent business fundamentals should apply to making any motion picture, just as in any other business.

Due Diligence for New Trends

There are also times when one can be a *trendsetter*. I have done this several times during my international sales and film production career. I have done due diligence, refused to take "no" for an answer, and created and

established a market desire of which international buyers were not yet aware. Years ago, as a seller in the international market, I was able to sell in certain territories on a pre-sale basis, meaning that buyers would contract with me to purchase a movie before it was even made, due to the trust they had in me as a filmmaker. But Japan—an extremely lucrative market—was very mercurial, and Japanese buyers often wouldn't buy a film at all. The films that they did buy were very specific and appealed particularly to Japanese consumers.

A turning point occurred in a meeting with a Japanese buyer, a gentleman named Hanada, who worked for a big Japanese corporation. He was a very smart, shrewd businessman but his English was not yet the best. I told him that I would like to pre-sell a movie to him for the Japanese market and explained that such a presell would greatly help with financing the picture.

"Oh, Japanese market very difficult," he said.

I said that I understood that. I had been trying to sell and pre-sell to Japan for many years. I asked him what I could possibly do to entice him to pre-buy my movies.

"Ahhhh, pre-sale impossible! Japanese people very specific," said Hanada.

I asked if Japanese consumers liked family films.

"Family film no good," he retorted.

"Oh, so there are no children in Japan?" I asked.

"Ahhhh, you crazy," said Hanada.

I joked, "Okay, how about donkeys with the laser beams coming out of their eyes? Do the Japanese people like donkeys?"

Once again, he replied, "Ahhhh, crazy, Andrew, you crazy donkey."

As I sat mulling over this conundrum, I picked up a pen someone had left in the office. Lost in thought, I picked it up and began twiddling it between my fingers. Inside the barrel of the pen, in a liquid window, was a little submarine that went up and down as you tilted the pen to and fro. Absently, I said, "How about submarines? Do you like submarines?"

Hanada instantly perked up. "Submarine? You have submarine?"

I hesitated for a nanosecond. "Um, sure, I have submarine. Of course I have a submarine!"

He said, "You have submarine, we buy!"

I had cracked the code. By making "no" the beginning of the conversation, instead of the end, I established that submarines were a trend. So, if I had a submarine, I could pre-sell to the Japanese market. I made a deal with Hanada on the spot for an action submarine movie for $350,000 as a pre-buy, something I had never done before.

I soon came to realize that it wasn't just submarines. The Japanese market, although its buyers didn't know how to articulate it, keyed off of what I call "the second level of sell"—in this case a tangible piece of military hardware that was eye candy for Japanese consumers. I subsequently made seven submarine movies. I made aircraft-carrier movies,

tank movies, movies with Stealth fighters, F-14 Tomcats, Bullet trains—anything that had actual military or technological hardware that I could put on a piece of key art and a poster, I could pre-sell to Japan.

I now had a component of my financing for a new trend of movie, so I went to the next-largest territory, Germany, and asked what they were buying. The answer was action films, but nothing that was gratuitously violent, bloody, or gory, because it wouldn't pass the censors to play on prime-time television in Germany. Now, paradoxically, there are people running around stark naked on prime-time television in Germany, but the censors couldn't care less about nudity. They do care about graphic, gory, or bloody depictions of violence. At the prices I was pre-selling for, the buyers insisted on no gratuitous violence, blood, or gore, because the revenues for late-night television sales are a fraction of what they are for prime time. I pitched to my German buyer that I had a submarine movie in pre-production that was a human drama with lots of action (but no violence, if you can figure that one out), about a man who leaves his young son to do his duty to stop a nuclear threat against the United States. I pre-sold to Germany for $450,000.

I then went to Korea and did my due diligence. The local buyers wanted action films with hand-to-hand martial arts. I pitched them an action film in pre-production about a man who infiltrates a submarine that has been captured by terrorists. Our hero uses hand-to-hand martial arts skills to fight his way from stem to stern to save the submarine and the world from a nuclear disaster. I pre-sold to Korea for $350,000.

Finally, I went to my domestic home video buyer and pitched the movie that I was formulating based on my due diligence with three major foreign territories. The buyer's main interest was in a star who could be featured on the company's video box, and the consensus was that it should be Michael Dudikoff, who had starred in the first two of the *American Ninja* series of films. I immediately called Dudikoff's agent and secured the actor's services. When the agent asked me the title of the film, I came up with *Crash Dive* on the spot.

So, I had pre-sold Michael Dudikoff in *Crash Dive* doing hand-to-hand martial arts in a submarine, without gratuitous violence, blood, or gore and saving the world. I now had to quickly develop a script based on these criteria. The one-liner I pitched to the writer was *"Die Hard* on a submarine."

I made the movie based on the pre-sales to those four territories, so any sales to the rest of the world would be profit. I sold every territory worldwide. *Crash Dive* is a great example of how to do your due diligence, listen to the marketplace, and tap into it by doing a creative and financial analysis of it in order to make a profit. It was a home run for a smaller, independent film, and an example of creating a hybrid film that appealed to all of the key, most lucrative territories. It didn't simply identify and follow a current, saleable trend, but instead created a new trend. And it was produced for far less than the analyzed market value.

I met with my staff and I told them that we had to come up with a great poster for *Crash Dive*. I took a page out of my own philosophical playbook and looked at the poster for *The Hunt for Red October*, then created a distinctly reminiscent image. Instead of Sean Connery's face, we had Michael Dudikoff's face, juxtaposed with a submarine against a red-washed background, with the bold-lettered title, *Crash Dive*. The buyers loved it.

I then had to come up with a great promotional trailer before the film was even shot! I needed a submarine for the promo (not to mention for the movie itself) and I didn't know where I was going to get one. But I had promised the film to my buyers and now I had to deliver. Based on the storyline I had sold, there was no way the U.S. Department of Defense would approve the material and allow us to shoot on a naval base. I contemplated sending a camera crew to Seattle, where they might circle near the naval base in a helicopter to try to get some footage of submarines as they left or entered the port. Maybe we would get lucky and film some shots of a submarine diving and surfacing, but even if so, the shots wouldn't be dynamic or plentiful enough for the entire movie. This was also before CGI was prevalent, so I called a motion control company, built a submarine miniature, and started shooting some motion control shots in a smoke element to replicate water. Finally, though, I had a brainstorm. While watching *Crimson Tide* and studying the multi-tiered set with my set designer, I called the stock footage department at Disney Studios. I asked if they would consider selling any outtakes from the movie, specifically submarine shots. The answer was "yes," so I bought ninety or so amazing submarine shots from Disney's library. They were infinitely better than anything I could have created on my shoestring budget, and I now had the submarine that I had promised to my buyers. I intercut these stock shots with footage of Michael Dudikoff from some of his earlier action movies, added some driving music, a voice-over, and titles to create a powerful promo before our movie had even commenced principal photography. This helped us to pre-sell the film in every territory worldwide. Remember, it's called "show *business*" not "show *art*."

Sales Agents

In years past, in the independent film market, particularly with genre films, the criteria upon which an international buyer might purchase your film were based almost solely on the quality of the key art and the trailer. Unfortunately, though, many buyers got burned because the finished film wasn't nearly as good as the trailer or the key art. Consequently, these days, almost all buyers in all territories want to see the finished picture before they buy it.

We have discussed that films are sold at trade shows, that international buyers attend those trade shows to purchase film rights to meet their distribution slates in their respective territories, and that sellers sell movies to those international buyers. But who are those sellers, and how does an

independent producer or filmmaker get his or her movie into a salesperson's hands, and into one of those booths, in order to TAP into the lucrative foreign market?

The simple answer is that you need a sales agent. Sales agents were once also known as foreign distributors, but they didn't really distribute in foreign territories; instead, they sold films to territorial distributors. They were generally independent companies whose business it was to acquire films from independent filmmakers and producers and sell them in the international marketplace. Sales agents made their money by charging off-market expenses to other people's films that they acquired, as well as by earning a commission for every sale made in every territory world-wide. In later years, many sales agents also became producers—since who better than they knew what the hot trends were in the marketplace?—and they would sell or presell their own product in the foreign marketplace as well as acquire other people's product to cover their overheads and provide cash flow to their companies. The sales agent's game was to use other people's money, earned from acquired films, to cover his or her market expenses and overheads.

What's the right deal to make with the sales agent in today's market? What are the traps and pitfalls to avoid?

In the past, when the market was much stronger than it is today, sales agents might charge a premium sales commission of 25–30 cents for every dollar that they sold and received from all territories in the foreign market. They might charge market expenses of as much as $100,000 for an independent film, which comes off the top before commissions and any disbursement to the producer or filmmaker.

Let's look at that model. For example, say your total foreign projections are $500,000, and you are being charged a 30 percent sales agency fee and $100,000 in market expenses, and at the first film market in which your film is exhibited the sales agent sells it for $200,000. As that money is collected, the first $100,000 goes to the sales agent for their market expenses, then another $60,000 goes to them in sales commission retroactive from first dollar, leaving just $40,000 for the producer. For every $100,000 collected thereafter, the producer gets $70,000 and the sales agent gets $30,000 (their 30 percent commission). So, at $300,000 of collected sales, the sales agent gets $190,000 and the producer gets $110,000, and so on. It is only at $500,000 in monies collected that the producer finally achieves parity with the sales agent.

Furthermore, in this scenario, if the budget of the film was $500,000, and $500,000 was collected from the foreign market, the producer would receive $250,000 from total first cycle foreign sales, and only the domestic market remains for the producer to try to recoup the film's budget. If the 65/35 percentages that we discussed earlier hold, North America would be worth $175,000. If this amount were actually sold and collected, and only $50,000 were incurred in domestic sales fees and expenses, under this model the producer would collect $125,000 domestically, for a

worldwide gross collection of $375,000, thus losing $125,000 of the financiers' investment. Had the film been produced for $300,000 rather than $500,000, the producer and financiers would have made a first cycle *profit* of $75,000, thus implementing foolproof filmmaking.

In today's more discerning market, you should negotiate and stand firm on the following foreign sales deal terms: a 15 percent sales agency fee and a flat $25,000 fee for market expenses. Now, let's do the math under this more favorable scenario. Say you have the same $500,000 in projections and $200,000 is collected after the first market. The sales agent will get $25,000 off the top, plus 15 percent of $200,000 (i.e., another $30,000). So the sales agent gets a total of $55,000, whereas you—the producer—get $145,000. At $500,000 in monies collected from the foreign market, the producer would receive $400,000 while the sales agent would receive $100,000. If you factor in the same hypothetical domestic scenario as above, the producer would receive a worldwide total of $550,000 for the same motion picture. (A basic form sample sales agency agreement can be found in Appendix B. A sample sales agency agreement *with an advance* for a completed picture can be found in Appendix C.)

So, how do you choose or attract a sales agent? First of all, ask questions. Talk to other filmmakers who have done business with the sales agents you are considering. Were they honest? Were they fair? Did they pay on time? What relationships do they have with buyers in the international market? What is a particular sales agent's relationship with key buyers for your particular film in foreign territories? Do they have any output deals? (By this, I mean that a sales agent may have a deal with a particular buyer in a particular territory for a volume of films per year. In an output deal, the buyer has contractually agreed to take every film that meets specific, contractually defined criteria that the sales agent represents on a predetermined price basis.) When there is a guaranteed sale, that's a big value for any producer.

Sales Agency Projections

Next, if there are interested sales agents, ask them to do projections or estimates of what they realistically believe they can sell your film for in every territory worldwide. Projections are made on spreadsheets, listing every territory in the foreign market and the sales agents' estimates of what their best-case scenario ask price is and what their worst-case take price is, per territory. Sales agents are almost uniformly very optimistic about their ask prices, but ask prices are like Bigfoot—often discussed, but rarely (if ever) seen. You should always focus on take prices and the worst-case bottom line that the sales agent is allowed to sell your movie for in each territory worldwide. Eliminate territories that will likely never want your particular genre of film. Add up the numbers and that's the net that you can expect to receive, less the sales agent's commission and your market fees. (Sample sales agency projections can be found in Appendix D.)

Sales Agency Collections

A producer must negotiate a sales agency contract meticulously, paying special attention to accounting practices. Previously, sales agents would account to a producer sixty days after the close of the calendar quarter in which monies for a sale were collected. So, if $100,000 was collected on January 1, the sales agent was not obligated to account to the producer until sixty days after March 31 (i.e., May 30), and then they would have another thirty days to pay. Most likely, the producer would receive an accounting and payment around the first week in July: that is, six to seven months after the initial sale was made. In today's more precarious economy, a sales agent might go out of business prior to payments even being contractually owed to a producer.

In your negotiations, insist on a collection account. This is pretty much what it sounds like—a segregated account set up at a lending institution, such as a bank or a savings and loan, dedicated to the collection of revenues generated by your film. It is governed by what is known as a "collection agreement," a short-form contract signed by all parties who are either owners of or profit participants in the film, the sales agent, and the institution where the collection account has been set up. In your contract with the sales agent, he or she, in turn, contracts with all buyers worldwide to remit their payments for the rights to exhibit your film, not to the sales agent him- or herself, but directly to the collection account. That collection account has irrevocable instruction, pursuant to the collection agreement, to disperse funds under the terms of the collection agreement. Again, all monies from all sales to every territory worldwide whose representatives bought your movie never touch the sales agent's hands but go directly to your collection account. This not only protects you but eliminates the six–seven-month wait for payment and obviates any reliance on the sales agent to account or pay. Money is dispersed to every individual participant in accordance with the collection agreement.

For example, if $100,000 comes into the collection account, and the agreement specifies that the first $25,000 goes to the sales agent for their expenses, then, if you subtract the sales agent's further 15 percent commission from first dollar received, that leaves $60,000 net for the producer, which would be disbursed *immediately*. Also, if a participant—for instance, the director—didn't receive his or her full salary and has a deferment of $10,000 from first monies received, they would be a party to the collection agreement. The $10,000 would go to that participant after remittance to the sales agent; the rest would be remitted to the producer. Most collection accounts cost no more than 1 percent. Trust me, it's money well spent. (A sample collection agreement can be found in Appendix E.)

On the flip side, having been a sales agent myself for two decades, I could have acquired films for international sales and made money on many occasions. However, it's almost a life's-too-short situation, because invariably you

end up with disgruntled producers who have unrealistic expectations, particularly when they realize that the sales agent is getting the majority of the first monies received, and also that many territories (for particular types of films) will never sell. Consequently, even when acting as a sales agent, I always insisted on a collection account, because I did not want the obligation of accounting to or giving audit rights to independent producers who had unrealistic expectations. Again, the collection account was beneficial to me as a sales agent, because it obviated any and all scrutiny from independent producers whose films I acquired, as there was complete transparency with every contract and every dollar that came into and left the collection account.

Sales Agency Pitfalls to Consider

1. Avoid allocations. If your picture is sold along with a group of other pictures, a sales agent could diminish the amount allocated to your film and allocate more favorably to a picture or pictures that he or she either owns outright or has a larger stake in. The foreign buyer pays the same amount of money for the group of pictures and generally has no interest in how a sales agent allocates internally per picture. However, the producer can get a shave and a haircut without even knowing it. Insist on no allocations.

2. Avoid packaging (which is slightly different than allocation). There should be no packaging of your film with another film. As discussed earlier, a very desirable film of a particular genre or featuring a particular star might have a premium value in certain territories. Your film could be the locomotive that drives the sales of an agent's other pictures, which will potentially reduce the price paid for your movie if a buyer is forced to take less desirable films in a package. Insist that your film must be sold autonomously.

3. Limit the term. Earlier, we defined "term" as the number of years. Sales agents may ask to represent your film and have the contractual distribution rights for your film in foreign territories for anywhere from ten years to perpetuity. Do not agree to these terms. Ask for three years, and settle for seven if you must. Go to ten if they are paying you an advance; otherwise don't accept that deal. (An advance is money paid up front by a sales agent to a producer for the rights to sell his or her film.) Advances, and often interest on an advance, are recouped prior to expenses and sales commissions, which would be provided for in the waterfall of disbursement in your collection agreement. *Never* give up perpetuity rights for any film you make.

4. Ask for a "key man" clause. Every sales agent has a lead salesperson who generally has proprietary relationships with buyers worldwide. Name that person as a key man in your agreement, so that if that person gets fired or leaves the company, you have the option to terminate your agreement with the sales agency company. This gives you

the latitude to stay with the original sales agent, go to the departing salesperson's new company, or seek a new sales agent.

5. Consider how to provide for residuals. Most low-budget independent films may not be signatory to multiple unions, but they will almost certainly be signatory to the SAG-AFTRA, the former Screen Actors Guild (SAG). Unless the films are distributed by an arm of a major studio (e.g., Fox, Sony, Universal, Disney, Paramount, or Warner Bros.) no foreign buyer will assume residuals, nor will your sales agent, which leaves residuals reporting compliance and payment as the responsibility of the producer. Non-payment of residuals can result in SAG filing an arbitration against the producer and signatory production company. If SAG then prevails, they may foreclose on your picture under the terms of the collective bargaining agreement to which your production company is signatory. If you establish a collection account, you may provide for the payment of residuals in the disbursement instructions.

6. Insist on no cross-collateralization of your film with other films in any foreign territory. Different than allocation or packaging, cross-collateralization would allow a buyer who purchases multiple films from a sales agent to cross-collateralize the recoupment of minimum guarantee or advance paid for the entire group or package of films, before that buyer is obligated to remit any royalties or overage on any individual title in that territory. Insist that your film is segregated and that all revenues are sacrosanct and not cross-collateralized with any other film(s).

7. Foreign territories either dub or subtitle English-language films into the native language in their territory. Do not allow your sales agent to charge you for dubbing and subtitling costs, since, with only rare exceptions, all foreign territories make their own dubs and subtitling as part of their rights agreements with sales agents. I have seen dishonest sales agents try to charge these additional costs to unsuspecting producers. On the rare occasions when a sales agent has a deal on the table that requires them and/or you, as the producer, to pay for dubbing or subtitling costs, you should negotiate on a case-by-case basis.

8. We have established that almost all buyers now want to see a finished film before they buy it. All sales reps rely on DVD screeners that they send out to the international buyers who will view and hopefully buy your picture. Be aware that piracy is rampant worldwide and is threatening to destroy our business, just as it did through file sharing in the music business. So we must constantly fight to safeguard our films, wherever possible, to prevent piracy. For years, if films were delivered to certain Southeast Asian territories first, they were pirated, and buyers who had previously purchased the film would refuse to take delivery or pay for it, thus rendering your sales in those territories worthless and shooting a large hole in your financial recoupment model. Make sure you have a sales agent who is cognizant and collaborative with you on these efforts.

9. A DVD is a digital master that can be replicated without loss of image quality, so, as a deterrent, make sure that yours has a prominent "burn-in" (a visible watermark) in the lower third of the frame, declaring: "Property of _____ Productions. Do Not Replicate or Distribute!" The same burn-in is essential for any uploaded Vimeo links that are sent to buyers so that they can view your film. Make sure that your sales agent is fully aware of which territories to leave until after other critical territories have taken delivery and you have received payment.

Sales Agent Alternatives

We have discussed sales agents and the preferred terms to negotiate with them. Let's now discuss the alternatives. If you have a finished film or a film that is in post-production, an alternative to hiring a sales agent (which I don't necessarily recommend) is to sell your film yourself. The easiest way to do this is to save the expense of traveling internationally and attend the American Film Market (AFM) in November every year in Santa Monica, California. The costs of attending a film market as a seller may be deceptive, however. For a non-IFTA member, the cost of a hotel room at the Loews Santa Monica Beach Hotel (which will serve as your sales booth) will be greater than it is for IFTA members, who receive discounts. Next, you would have to create your key art and posters, flyers, and trailers, as discussed earlier. Then you must rent panels on which to affix your posters, since you may not tape posters to the walls of the hotel. You might have to rent furniture. You have to make sure you have an audiovisual system that works and is sufficient to display your trailer or screen your finished film. You might incur the expense of traveling to Los Angeles and paying for your meals, lodging, and likely a rental car, as well as entertainment and other expenses. Once you add up all of these real, hard costs, you can accurately determine whether it would be more financially advantageous for you to try to sell the movie yourself or hire a sales agent.

Bear in mind that if you negotiate the right contract with the sales agent, your costs are finite and also cover every other international film market the agent might attend throughout the year, as well as for the term of the contract, as opposed to the single market that you might attend (i.e., the AFM). Factor in, also, that your sales agent likely has existing relationships with buyers, with whom they can make scheduled appointments, and that most sales companies attract traffic into their offices based on their current slates of films. A good sales agent should also have proprietary relationships with key buyers' reps who are going to bring their leading international clients into the sales agent's office.

Another possibility for an independent producer or filmmaker to explore is to hire a producer's representative. A producer's rep's business is to sign producers and their films to a representation agreement to navigate the foreign and domestic marketplaces on behalf of the producer, and try to

place the film with the most appropriate sales agent or distributor for each individual picture. Producer's reps, however, work for a percentage of sales, just as a sales agent does, so the producer or filmmaker, in this scenario, will pay double commissions.

If you, as a filmmaker or producer, are able to attend a film market prior to making your film, visit the booths or hotel offices of sales agents and see what types of films they are currently selling, and which particular sales agent(s) appear to be appropriate for the film you envision making. Collect business cards and try to make connections with lower-level employees at the company, as they might help you arrange an appointment with a decision-maker. Ask what sales agents might consider representing your film once you have secured financing. Ask what type of films sales agents are looking for and what their buyers are requesting from them. Ask questions, listen, and heed their advice.

When determining which way you want to go to sell and distribute your film in the international marketplace, add up the costs of a sales agent, as discussed above, versus the costs of selling your film yourself. It is very expensive to attend any film market on your own, particularly an international one, and there is no guarantee, without established relationships, that you will be able to arrange appointments with international buyers, much less make sales. However, if you do decide to attend the AFM—whether to explore the foreign marketplace and do your due diligence or to try to sell your film yourself—IFTA has published some some tips that may make the experience a little easier (see below).

How to Work the AFM

The AFM is a great place to pitch your project or film—if you have a plan. Use these steps to increase your chances of success.

Prologue

If you have a project or script, the most effective use of your time and money is to purchase an AFM Industry Badge, which allows access to all offices and most screenings beginning Sunday (Day 5), or an Industry Badge Plus, which begins on Saturday (Day 4) and includes four days of conferences. Buy your badge by October 9. After that date, the fees go up.

Step 1: Homework: Create a List of Target Companies

Over 400 production/distribution companies have offices at the AFM but not all are right for your film. Focus your time and effort on the companies best suited for your project.

Starting about one month before the AFM, go to *The Film Catalogue*. Most AFM companies list their projects, profile, and staff contact information. Do further research on the web. Find the companies that are the best candidates for your film.

Once you have created a target list, count the companies on it. If there are less than 10, you're being too picky. ["No distributor is right for *my* film!"] If there are 100 or more, your homework grade is "incomplete." Keep working. A good target list for most projects is 30–50 companies.

Step 2: More Homework: Create a List of Target Executives

For each of your target companies, identify the key executives. Most important are the people in charge of acquisitions, development, and production. Look for their names in the trades and on company websites. If you can't find the right names, call the company's main office and ask.

Finding out who's who is critical. You will never get anywhere by walking into an office unprepared and saying: "Hi, who is your head of acquisitions? I'd like to meet with him . . . or her."

Step 3: Start Scheduling Meetings

Most companies start setting their meeting schedule three or four weeks before the market. The best way to contact them is to send a short, personalized email. After a few days, follow up by phone.

Step 4: Prioritize Your Target List

Separate your list into two groups: companies with an office in the city where you live and those from everywhere else. Focus first on the companies that aren't based where you live. If you are unable to meet with a company from your home city during the AFM, you can always follow up with them after the Market. Use other factors (i.e., the budgets and genres of the company's AFM lineup) to create A and B lists with 20 to 30 companies on each list. This will help prioritize your time near the end of the Market.

Step 5: Work on Your Pitch

A good pitch can get a bad film made and a bad pitch can leave a terrific project languishing on the shelf. Pitching is part art (it's a creative process), part science (pitches need to be organized and follow a tight

scrip), and part salesmanship. There are many resources on pitching, so our only advice is:

- If you are madly, deeply in love with your project, if it's your only child and the AFM is its first day of school, *get someone else to do the pitch*. Pitching it yourself will definitely convince people that YOU love the project but it probably won't do much more.
- In the pitch meeting, remember that YOU are being evaluated along with your project. When a company commits to your project, they are also committing to work with you.
- Your mission during each pitch meeting isn't to sell your project. You won't get a deal in one brief meeting. Your mission is simply: Get the second meeting!
- Consider attending the Pitch Conference Saturday morning.
- Read AFM's *Pitching Essentials*.

Step 6: Make More Appointments

During the first days of the AFM (Wednesday, Thursday, and Friday) call each target company's AFM office that didn't respond to your email or first call. Request a 10-minute meeting with the key executive you identified in Step 2. AFM office phone numbers are listed in the AFM Show Directory (available at the Information desk in the Loews lobby). Ask for a meeting on Saturday (Plus Badge), Sunday, Monday, or Tuesday as most companies will be too busy during the first few days. For companies that won't set a meeting (prepare yourself—there will be many), see Step 9 below.

Step 7: Prepare Materials

Here are some thoughts on what to leave behind after every meeting:

- Your business card. Bring a large supply.
- Your biography and those of all producers attached to the project.
- A synopsis.
- A summary of the film's unique creative and financial attributes. This could include a list of all people attached or committed to the project, a budget abstract (that's less than half a page), any rights that aren't available, investors that are committed, production incentives that you know the film can utilize, etc.

- If the script is done, bring one or two copies with you but don't leave it behind without first consulting with your attorney.

These are just our suggestions—every film and situation is different. Be prepared, but don't bring copies of letters or documents that "prove" anything. It's too soon for that.

Step 8: Work the Show before You Go

Done with your homework? Made your appointments? Confident with your pitch? Materials ready? Great! There's still plenty you can do at the AFM before you get your badge on Sunday:

- Attend the AFM Conference Series. Consider an Industry Badge Plus, as it includes access on Saturday, too!
- If this is your first AFM, attend the AFM Orientation.
- Read the show daily trades to stay on top of trends and deals.

Step 9: It's Showtime!

Here, in order, are your priorities:

- Arrive at every scheduled meeting on time. Be prepared to be "bumped" or delayed. Don't take it personally—selling comes before buying.
- Visit the companies that wouldn't schedule a meeting with you on the phone. Remember: always ask for an appointment with a specific person.
- Visit companies on your B list and those you couldn't easily profile in Step 1. Get a feel for the product they handle and the culture of the company to see if they are the right fit for your film. Consider being a "stealth participant" by picking up brochures and business cards without introducing yourself. Don't ask for a meeting while you are there. (If you've just walked in and asked a bunch of questions, stuffed your bag with their collateral, and grabbed every business card, it isn't likely you'll get a meeting. Instead, wait half an hour and call the company to schedule a meeting . . . with a specific person.)

Additional Steps: Producers with a Finished Film

The steps above are for producers, filmmakers, and writers with projects and scripts. If you have a completed film and are looking for

global distribution, congratulations! Everything above generally applies but you will need to move up the timetable:

- One month before the AFM, prepare 4–6 minutes of selected scenes. Do not create a consumer type trailer. Acquisition executives will want to see complete scenes to get a feel for the film. Put the selected scenes on a website so companies you contact can see them before committing to a meeting.
- When you contact your target companies, include the link to your selected scenes.
- Create DVD screeners so that qualified prospects can quickly view your film in advance of the AFM. If you can arrange for a screening instead, that would be much better.
- Set your initial meetings with each company in the first four days of the Market. Let them know you are arriving on Wednesday and will close a deal before the Market is over.
- Purchase an Executive Badge. (You've invested a lot of time and money—don't get cheap now!)
- Make sure your attorney will be available to you throughout the AFM.

Epilogue

We can't give you personal advice on how to pitch your project or film but we'd like to know how this information worked for you. After the Market, please send your thoughts to AFM@ifta-online.org, Attention: Work the AFM Feedback.

Good Luck!

The Domestic Market, Festivals, and Market Value

The Realities of the Market

As was mentioned in the previous chapter, the majority of independent films are never released commercially into theaters, a fact that rarely occurs to the general public. The majority of independent films are released first into the domestic home entertainment and ancillary markets, and then to all forms of television. At the time of writing, there were still a few cable networks that developed as well as acquired films from independent producers, though specific to their respective network mandates and genres. Other cable networks, on occasion, simply acquired independent films, again if they were of the right genre and/or had the right cast.

In today's market, most of the companies acquiring domestic home entertainment rights from independents for domestic distribution are looking either for specific genre pictures for a price and term that allow them to make a decent profit, or to capitalize on the misfortune of others. By this I mean that they look for producers who have made a "mistake"—generally those who have spent too much money on an off-genre film with a decent cast. A mistake—or a "tweener"—is a picture that falls between the cracks commercially and has not found a theatrical buyer. "Off genre" usually means anything not imminently commercial or genre-specific. Independent films that are "mistakes" also have no theatrical domestic box-office success for television or DVD sales to key off of. The studios and the mainstream have passed on these films and they have perceptually lost value, at which point the acquisition companies swoop in for very little money and pick them up for distribution and usually a very small advance. Uniformly the producers, filmmakers, and financiers for these films did not do their due diligence and follow the TAP parameters.

With rare exceptions in the domestic market, you will likely never see any additional money beyond the initial advance payment, particularly if profit participation is tied to a royalty definition. I have seen $5 million films with good casts sell for as little as a $50,000 domestic advance payment and the filmmakers never seeing another dime, simply because they made the wrong films for the wrong price, possibly with the wrong cast,

and the producers did not do their due diligence and properly assess the marketplace and the market value for their film before making it. There are, however, other instances of independent films generating a "buzz," which in turn generates a competitive bidding climate among a variety of distributors.

As I mentioned earlier, in today's market, television makes its own stars. The movie business seems to be going down the same route. Judd Apatow and producers like him have become trustworthy, branded content providers of certain genres, and Apatow's stable of actors, as they have branched out, have likewise continued to uphold audience expectations. Other new filmmakers have created branded franchises and marketable concepts within their niche markets, such as Tyler Perry with his series of films. Steven Spielberg doesn't need Tom Cruise in his movies to draw an audience. An audience knows exactly what to expect from a Jerry Bruckheimer film. As producers and directors become identifiable brands to moviegoers, the actors or stars in their films become secondary. Average audiences are younger than ever, and they don't care about movie stars in the same way as audiences did in years past. The prevalence of the internet, tabloids, and tabloid television shows has demystified stars and made seeing them a daily occurrence. Although, from a tabloid standpoint, stars seem bigger than ever, *The Assassination of Jesse James*, starring Brad Pitt, earned only $4 million at the box office. When a new franchise such as *Ironman*, with a branded character, can recruit a terrific actor like Robert Downey Jr., who needed major career rehabilitation, and then make close to a billion dollars, it again proves that the right branded content and/or branded character is in itself the star.

Film Festivals

Many independent producers think that film festivals are the key to success, but this is rarely the case. In fact, most film *festivals* are not film *markets*, where films are bought and sold. As mentioned earlier, some exceptions are Toronto, Sundance, Berlin, Venice, and Cannes, but almost all of the other domestic and international festivals are merely vanity screenings for filmmakers and rarely generate sales or revenues, unless a film is highly commercial or in some way unique and creates a buzz within the industry. Festivals may result in a picture receiving favorable reviews that can potentially be used for marketing purposes, but I've seen a multitude of films with slews of good reviews that still can't find buyers if they are non-commercial.

Bear in mind that, while they vary from year to year, top festivals like Sundance may have as many as five thousand submissions, so the competition can be stiff. However, when there's a glut of product in the U.S. market and a domestic theatrical opening, audiences often have difficulty deciding what to see (six or more new movies might open each weekend). In that

case, receiving some sort of festival recognition that you can use in an adver-tisement could be beneficial. Any critical acclaim that can be advertised is something that can set an independent film apart from its rivals. Many buyers at festivals talk to critics or read online critiques in order to avoid picking up a movie that no one else likes.

Putting a smaller independent film into a festival gives it a stamp of approval—of sorts—for the buyers and the distribution community. However, making the right film for a cost-effective price and possessing tremendous production skills have become increasingly vital. Producers and filmmakers first felt this shift as early as 2009 at Sundance. The January 22, 2009, issue of the *Hollywood Reporter* stated, "After the past few years saw at least one film purchase of $8 million or more, reasonableness returned this year. No movie went for more than $4 million, and four films went for $2 million–4 million." That's four films out of approximately one thousand or more submissions.

More than ever, producers and filmmakers need to know their stuff. On January 21, 2009, the *Daily Variety* reported, "After the first screening Sunday, Fox Searchlight tried to grab the film [the $12 million budgeted *An Education*] with a pre-emptive bid, but the offer, in the $1 million–$2 million range, was deemed too low." The picture had cost $12 million to produce! Even with U.K. subsidies and very good international sales ($2 million would have been extraordinarily good), my guess is that the picture lost money.

However, critically acclaimed movies, even if somewhat less commercial, generally seem to find distributors. Good reviews can support and fuel ticket sales and, in some ways, positive reviews from festivals can serve as free marketing. As was mentioned in the previous chapter, I had four pictures in three years at Sundance and realized very quickly that the bidding wars we all hear about are actually few and far between. *Memento* and *The Brothers McMullin* are prime examples of successful festival pictures that also achieved reasonable commercial success. But the majority of festival-type films either remain unsold in the domestic territory or are sold for very little money. In some cases, they are taken on "straight distribution" with no advance paid to the filmmakers.

The naive, vanity-driven filmmaker, desperate to see their movie in a theater, will often sell to a "theatrical distributor" to secure a small—and meaningless—theatrical release and a small advance. When doing this, the filmmaker usually signs away any potential profit. Do not make business decisions based on ego or vanity, or you are very likely to lose money. If you need to assuage an investor, friends, family, cast, crew, or your own ego by seeing your movie in a theater, *rent* one. That will cost you no more than a few hundred dollars, and it will leave you and your investors with the potential to make hundreds of thousands of dollars over the long term.

These days, a small U.S. theatrical release is virtually meaningless in foreign markets. Foreign buyers now primarily look for films that have a

wide release through an arm of a major studio/distributor with tens of millions of dollars of P&A to support them. Secondarily, they look for genre films (as discussed earlier) or movies with recognizable star casts if they do not fit within generally commercial genres.

Listen to the Market

Like the value of any product in any business, the value of a movie finds its own level. Each film has a particular market value based on its cast, genre, budget, release, and marketing commitment in the United States, and the criteria of the respective worldwide territorial markets. With rare exceptions, that's where the bottom line will end up. For example, it doesn't make sense to overpay for a script, director, or actor if none of those elements changes the market value of your film. Agents will try to sell you their clients and convince you that they are worth more money, but if the market tells me I can't make a dollar more for any element that is beyond what I have budgeted for in that category, I will not pay a dollar more, because I know I will never recoup the extra money. Again, most agents do not understand the market and they are commission salespeople.

Using the spec house analogy we discussed in earlier chapters, don't over-build for the neighborhood. You never want the biggest, most overpriced house in a lower-valued neighborhood. You should spend less money in a higher-value neighborhood, even if that means building a smaller house. Don't overpay for the land (the script); don't overpay for subcontractors and building supplies (your crew, goods, and services); don't pay retail for your finish materials (post-production); don't overpay for a realtor (your sales agent). Negotiate everything and never pay retail. A good sales agent, just like a good realtor, will get comps in the "neighborhood" (other films like yours of the same genre with similar levels of cast, in the current year, and the amount they have sold for in both the foreign and domestic market-places), hopefully as part of your due diligence, *before* you make your film. Assess the worst-case value of your house in the neighborhood (your film in the worldwide marketplace), then commence construction (produce your film) for less.

Understand that "talent"—actors, writers, and directors, as well as many producers—for the most part do not have a clue how the business works (and don't care). They just want either a paycheck or the ego boost of making a film and being viewed as an "artiste." They don't have to live with the mess of trying to sell, collect, repay lenders, make interest payments, deal with legal claims that may arise, make residual payments, buy errors-and-omissions insurance, make worldwide deliveries to thirty or more territories, and the myriad other problems and responsibilities that the entrepreneurial producer is stuck with for years, while everyone else gets on with their life and moves on to the next project. The independent entrepre-neurial producer cannot cover up problems and issues relating to his or her

film or pretend they don't exist. They must be dealt with, deftly solved, and eliminated as and when they arise.

Do your due diligence in both the foreign and the domestic marketplaces. Know what to make and what not to make. For example, a venerable Italian distributor once said to me, "Listen to the market: it is telling you no period pieces, no musicals, no urban films, no black-and-white films, so don't try to sell me a movie about a singing African-American basketball team in the 1920s shot in black and white." If the marketplace is oversaturated with horror films, creature films, thrillers, erotic thrillers, martial arts films, or whatever genre is being overdone at the time, the buyers will eventually stop buying them and start looking for different types of movies. Everything is cyclical. Don't be the last person to make a cheap, low-budget creature feature or horror film if the market is telling you horror films are over-saturated and unsellable.

Listen, ask questions of buyers, sales agents, distributors, and other producers, and heed their advice once you determine a consensus. Stay current. Read the newspapers and trade magazines, track trends online, and keep your ear to the ground.

Don't delude yourself into thinking that the world is waiting for your pet project if that project doesn't meet current market demands and can't be produced for less than its ultimate market value. Honest sales agents have an incentive to give you good, solid advice, because the more they sell, the more commission they make. They are inundated with inexperienced, out-of-touch filmmakers who continue to make films that the foreign markets uniformly do not want. Do your homework. I can't stress this enough. Don't think that your film will be the one that proves everyone else wrong and makes the entire world think differently. That is never going to happen!

Enhance Perceptual Value

Look for ways to enhance the perceptual value of your film. Perhaps you can attract an executive producer who has a marquee name from a well-known film, pay them a fee and give them a screen credit, so you can add: "From the maker of . . .", which might lend credibility to your film.

Credits are free, and they are often meaningful barter. Almost every actor in Hollywood claims to have a "production company." This usually means, with the exception of the really big stars, that they have a corporation with the word "Productions" in the name, but nothing else. Stars can attract studios or larger independent companies to pay for their overheads and staff, and they can usually afford to pay for the development of pet projects. Lesser actors, who still may have a name value for your independent film in certain markets, usually do not have the clout for any staff, overhead fees, or development funds, but they often try to branch out professionally, generally without the knowledge of how to do so. Barter a co-production credit with

an actor's company, or possibly an executive producer credit, if that will help attract the actor to your picture or get him or her to work for a reduced fee. As discussed earlier, bifurcating an actor's salary and making a star actor a "producer" is a way to save money in excess pension, health, and welfare contributions.

Think outside the box. Try to conceive a way that you can serve more than one master. In other words, by listening to both the foreign and the domestic markets, try to structure a film that can capitalize on the strengths and desires in the marketplace. An example I cited earlier was the film *Crash Dive*, just one of many movies I made in the 1990s, in which I fused and incorporated the market desires of Japan, Korea, Germany, and the United States into one cohesive genre. Don't think your first film—or your next film—will be the be-all and end-all of movies and will catapult you into instant studio superstar status. Almost every film is merely a stepping stone. Robert Rodriguez and *El Mariachi*, which propelled him into stardom as a filmmaker, come along once a decade, if that.

Market and Currency Fluctuations

Notwithstanding the advice I've given based on all of my years of experience, everything discussed previously could be different tomorrow. The marketplace is mercurial and ever-changing. Companies come and go. Currencies fluctuate and affect buying power from territory to territory. A strong U.S. dollar means weaker sales in foreign markets. Conversely, a weak U.S. dollar means stronger sales in foreign markets, as the euro, yen, and pound have more buying power. However, a weak dollar also means exorbitant prices at foreign film markets when you travel to sell your movies. So it's a double-edged sword. I have often hedged currency fluctuations on territorial pre-sales, when the film might not be delivered for many months, by "buying forward" a particular currency. Of course, this is a gamble, based on your guess as to where the currency market might be at the time you deliver your film. For example, if you bought forward at today's rate on a Japanese contract for 500,000 yen, if the yen moves up against the dollar, you are a genius; but if it moves down from the rate you locked in, you will lose money, as I did on the Japanese contract for a film called *Entropy*. (My Japanese distributor made the same mistake: he also bought forward as a hedge and we both lost money.)

Pre-sell wherever possible. If anyone offers you a remotely reasonable price for a pre-sale in any territory that can offset your risk, take it. In my opinion and experience, if the distributor is solvent, a bird in the hand is a valuable hedge against failure. Your picture could be awful, but at least you've sold it before they've seen it. Conversely, though, if your picture is great and exceeds expectations, don't expect to get more money than the pre-sale deal you made.

Identifying and Developing a Film Based on Trend and Analysis

Once you have assessed the current marketplace and market value for a particular type of film, how do you go about finding or creating an appropriate screenplay to suit the specific needs, desires, and/or requirements of the current market?

Read

Reading a script, taking notes, and writing a synopsis (known in the industry as "coverage") is generally at least a two–four-hour process for someone who is well schooled in doing so. The likelihood of finding a specific screenplay that is uniquely suited to collective global marketplace desires, which also correlates to the market value you've assessed based on the due diligence you've performed, is generally like finding a needle in a haystack. Most agencies, managers, and production companies employ readers to plow through hundreds of screenplays. They write synopses, or coverage, cite strengths and weaknesses, and ultimately *recommend* or *do not recommend* the screenplay for clients or for production based on the criteria that the agent, manager, or production company is looking for. However, as an independent producer, you probably don't have a team of readers on your payroll. Instead, you'll most likely read a large number of screenplays yourself.

A question you might have at this point is where to find the material to start the reading process. Listed below are a few of the numerous screenplay services that offer subscribers access to unsold screenplays.

- InkTip (www.inktip.com): A searchable database of speculative screenplays and books (those written in hopes of attracting a buyer) that connects writers with industry professionals. Writers pay to have their screenplays included and indexed on the website, but production companies, producers, directors, name talent, and agents and managers can search it for free.
- Script Pipeline (www.scriptpipeline.com/home): A community-based research tool used by writers and other industry professionals. Its

organizers have built a writers' database of over one thousand agencies, management and production companies, and any other entities to whom writers might want to pitch their work. Script Pipeline also offers tips on how best to submit a script and what genres and budgets companies are currently interested in.

- Wordplay (www.wordplayer.com): Terry Rossio and Ted Elliott, the writers of *Pirates of the Caribbean*, started Wordplay, and the website has since evolved into one of the best internet resources for screenwriters. It has over three dozen articles on screenwriting, written by two of the hottest writers in the business, along with a discussion board and a forum for posting new articles.

- Done Deal Professional (www.donedealpro.com): This database has up-to-date news on script sales, including who sold what to whom and for how much, as well as daily updates and frequently used message boards.

- IMDb (Internet Movie Database) (www.imdb.com): Not wholly accurate, but more so than most web databases, IMDb lists credits for millions of films, including details of who wrote a particular movie, whether a producer actually has any credits, whether the director was actually the director, and which actors were really in the film. However, due to the hive mentality of the world at large and IMDb's inability to check facts, you need to be constantly vigilant and make sure your profile contains accurate information.

- *Script Magazine* (www.scriptmag.com): Many feel that *Script* (online) is the best screenwriting magazine on the market. Instead of publishing interviews, often the site will offer articles written by the screenwriter of a major studio motion picture.

- IFP (Independent Filmmaker Project) (www.ifp.org): A great organization designed to assist independent filmmakers; it is also responsible for the yearly Independent Spirit Awards.

- Scriptwriters Network (http://scriptwritersnetwork.com): A nonprofit organization designed to help screenwriters. There are three meetings every month: a Speaker Series, with a name industry professional (just about anyone who has ever been nominated for the Best Screenplay Oscar has spoken to the group); a Seminar Series; and a Showbiz Series. The Network also sponsors a contest, two outreach programs, and numerous events.

- Drew's Script-O-Rama (www.script-o-rama.com): If you are looking for a script from a major motion picture, this is the place to find it for free. Drew's is the oldest script download site on the internet and many feel it is still the best.

- The Daily Script (www.dailyscript.com): This site also has free script downloads. Reading scripts that are successfully structured and have been produced is a fruitful learning experience before writing or overseeing the development of your own project.

- Simply Scripts (www.simplyscripts.com): A search engine that searches a database of free scripts of movies, television and radio shows, and stage plays.
- Planet MegaMall (www.planetmegamall.com): If you can't find the script online or would rather have a paper copy from the actual original script, this site sells almost every script imaginable.
- Amazon (www.amazon.com): The internet's largest bookstore has everything from original scripts to books on how to write them. There are books about story structure and books about form. You can even buy the latest edition of Final Draft software, as well as a book on how to use it.

Some sites and services offer reviews and box-office information that may be helpful.

- Rotten Tomatoes (www.rottentomatoes.com): Hundreds of thousands of film reviews, all in one place. This site has capsule reviews from all the major critics, plus thousands of critiques from people you've never heard of. It compiles overall ratings (on a scale from 0–100) and provides links to the full reviews from all of the critics.
- Roger Ebert (www.rogerebert.com): Reviewers explain why they love or hate a movie and what they feel worked or didn't work in films.
- Box Office Mojo (www.boxofficemojo.com): This site has box-office information on almost every film, which is helpful because it's critical for you to know whether the films that are similar to your script connected with the audience or flopped. You might be surprised by the number of films that received great accolades in the press but didn't make much money. You can also see which films didn't make back their production costs.
- *Hollywood Reporter* (www.hollywoodreporter.com): This site offers breaking entertainment news, film reviews, and box-office grosses; film, television, technology, finance, music, and international articles, blogs, columns, and reviews; as well as bloated, self-aggrandizing advertising.
- *Variety* (http://variety.com): This site also offers breaking entertainment news, film reviews, and box-office grosses; film, television, technology, finance, music, and international articles, blogs, columns, and reviews; as well as bloated, self-aggrandizing advertising.

Some sites add a little industry-related comic relief, such as:

- Top5 Movies "Little Fiver" Humor List Archive (www.13idol.com/top5movies): Funny "top ten"-style comedy lists about the film business.
- Scriptshadow (www.scriptshadow.net): Carson Reeves offers a slew of practical advice and reviews of new scripts in Hollywood. On

"Amateur Fridays," he and the Scriptshadow community review a new writer's script.

- Feedback Friday (www.feedbackfriday.blogspot.com): Every Friday screenwriters send in the first ten pages of their scripts to be read and reviewed by Robert Dillon and other writers, who provide interesting feedback and advice.
- Go Into the Story (www.gointothestory.blcklst.com): This blog offers screenwriters updates on the spec market, daily dialogue clips, interviews, and a wealth of useful information.
- Script Frenzy (www.scriptfrenzy.com): Each April, writers band together to write a hundred-page script in thirty days. It's a life-changing event simply because it forces you to write every day. Once you have finished the first draft, you begin rewriting, the point when so many people get bogged down. Writing without worrying about every scene/character/line of dialogue is a great exercise, improving creativity and helping you dig deep to find new ideas.
- IMSDB (www.imsdb.com): Hundreds of thousands of scripts are available on this site. If you want to compete in the world of screenwriting, *reading* scripts is the best way to get used to formatting, and it helps you elevate your own writing to a professional level. Be a better writer by being a voracious reader.

Network to Gain Access to Material

Another way of finding material, particularly if you live on the East or West Coast, or in a major city, is to attend writing seminars, many of which are advertised online. These are designed to introduce writers to directors, producers, and prospective filmmakers. Some operate almost like a speed-dating service, with writers going from table to table, pitching their story and script in five-minute intervals before moving on to the next. One of my assistants used to attend these seminars on behalf of my company, and we actually made a film for Sony based on one of the five-minute pitches and even used the writer a second time.

Try to cultivate a contact at one of the major talent agencies and/or boutique literary agencies and solicit available spec screenplays. Note: it is not easy to be taken seriously by any midsized or larger agency, so you need to find an "in." Establish a relationship with someone at the agency, even at the lowest level. Take an assistant to lunch. Buy drinks for someone who works in the mailroom. As depicted in the HBO series *Entourage*, there is a very strong network of agents' assistants throughout the industry. One of my former assistants knew everything before it became public, because he had personal relationships within the talent agency "assistants' network." Another former assistant worked her way up the ladder in foreign sales companies and she has since held positions as the primary sales agent at several of the top independent production sales and distribution companies.

Make the System Work for You

I once needed a prominent actor to agree to star in a particular film in order to make a deal with a studio. If I didn't get the actor, the deal was off. The following is an example of how I made the system work in my favor:

- The problem: The actor and his agent had already passed on the script.
- The known facts: Most agents, and particularly this agent, rarely read the whole script; they read only coverage of scripts, written by readers in the agency. The actor also rarely bothered to read scripts until he showed up on set; instead, he relied on his agent's recommendations regarding material.
- The assistant: The agent's assistant had made it clear that he was someone who possessed an entrepreneurial spirit and aspired to be a player.
- The solution: I made a deal with the assistant. We changed the date of the draft of the script (as though it were a brand-new, rewritten version). He wrote glowing coverage of the screenplay and put it into the system at the agency, as though it had been covered independently by one of the agency's readers.
- The play: I called the agent and made a lucrative offer to the actor. I told the agent that the script had been completely rewritten and reenvisioned. (It was new to him, of course, since he had never read the original submission himself.) The agent asked his assistant for coverage, then, after reading the now glowing fake coverage on the same old script, called to tell me that the script was much better than the original version so he would now strongly recommend it to his client.
- The deal: Based on his agent's recommendation the actor agreed to do the film, which meant I was able to make the deal with the studio.
- The payoff: The actor made a huge payday. The agency earned a big commission. I made a nice producer's fee. The entrepreneurial assistant got $5000 when the actor signed his contract. Free enterprise was served all around.
- The moral: The system is full of bull. Find any way you can to navigate through it. Think outside the box and beat the system at its own game . . . as long as it's legal.

We discussed earlier that managers, agencies, and production companies (and obviously studios and networks) employ readers to sort through a huge volume of screenplays. However, the independent world is completely different than the studio world. If I am producing a purely independent film with no studio backing or involvement, readers present a problem for me. Unlike the agent in the above illustration, I would never trust anyone else's opinion or knowledge of what works for the independent marketplace. A reader's coverage is meaningless to me, as are a reader's recommendations. I only ever trust my own opinion and knowledge of the independent film marketplace, the importance of genres and their value in the global

market, and, in general, how the business works. If an enthusiastic reader effusively praised and highly recommended a particular script, I would still read the material myself and make my own assessment.

Write

If you feel you have a talent for the written word, writing a screenplay is always an option that affords the independent producer direct control over the material and allows them to realize their vision. Obviously, if you feel that you have no talent or aptitude for writing, this is not an option. But for those who feel they do have the patience, talent, and tenacity to write, it is certainly a viable option. Even if your script ultimately fails, the process of writing it will be highly educational. If you haven't written a screenplay before, I suggest picking up a copy of Syd Field's *Screenplay: The Foundations of Screenwriting*, which offers a simple and concise roadmap to aspiring screenwriters. I have written and co-written many screenplays which have been made into films and Mr. Field's book has proved invaluable to me over the years.

Develop

If you don't have the time or ability to sit down and write a screenplay yourself, the next best thing, if you are a producer, director, or filmmaker, is to oversee the development of your story or idea. That means finding a writer and imparting your ideas to him or her, based on your due diligence in the marketplace and the trend that you've identified. Then it is your responsibility to communicate the creative analysis effectively to your writer and explain how they must hit all the specific criteria you've identified for the key major territories. First you should flesh out your original idea with the writer, then develop it into a story or treatment, and finally into a full-fledged screenplay that is commercially viable in the foreign and domestic markets and meets the criteria you've identified from your key buyers.

Just as there are many "wannabe" producers out there, there are many wannabe writers, too. When searching for a writer, meeting and talking to prospective candidates and hearing their ideas for the type of movie you desire to make is the first step. Years ago, I met with a writer for the development of a TV movie—the meeting was so fantastic, I hired him on the spot. When I received his first draft of the screenplay, however, I was appalled. He had completely missed the boat. This taught me early on never to hire a writer based on a meeting, rather, hire based on reading writing samples of their work. When reading writing samples, ask yourself several questions: How solid are their story structure, act breaks, and character development? Is their dialogue believable? Your search should continue until you find a writer who meets *all* of the specific criteria for your project. There is an old saying, "horses for courses." In this context, it means that a

certain writer might be terrific for an action piece or a thriller but might not be suited to write a romantic comedy or drama. Once you have found a writer who is appropriate for the genre of film you intend to make, the next issue is how to pay him or her.

In this development scenario, you, the producer—having done due diligence and possessing full knowledge of the market desire and market value of the film you are attempting to develop—can leave nothing to chance. You must be hands-on. Don't naively think that you can impart all of the nuances and requirements to a neophyte writer and have them magically create a screenplay that meets every one of your market-specific criteria. Remember, your script must be genre-specific. If you are developing a thriller, it must have a proper thriller structure. Buyers don't want a drama with a final twist passed off as a thriller. When in doubt, use classic films of the genre you are developing as examples of structures that work.

Keep in mind that you also have specific budgetary, and perhaps location specific, parameters within which to work, and the writer needs to understand these limitations. If you are trying to please several territorial buyers with specific elements—such as action without gratuitous violence, blood, or gore; stock footage that may be prevalent in your film (such as a submarine or aircraft carrier); evenly spaced action beats every eight to ten pages; or even a disaster film with a science fiction overlay—you cannot expect any writer to understand everything in detail or deliver such a tall order without your constant guidance and input. Also, remember that you are developing your screenplay based on the market value of the picture, which you have determined through your research. This translates into the production budget, which is something that you, as the producer, must always keep in mind and regularly remind the writer about.

Many young and hungry non-union writers are looking for a break and someone to believe in them. If you are charismatic and able to instill a sense of confidence and collaborative passion, they might be willing to share your vision and work for free until the movie has been made. The problem you then face is that you still need to own or at least control the material so the writer cannot just walk away with your idea if there is a disagreement. Therefore, in every scenario, even among friends, I strongly suggest a written agreement between producer and writer that clearly spells out the terms of your understanding. If you are developing your screenplay with a writer who is working for free and you part ways for any reason, you must own and control the material created by the writer if you ever intend to use any of it. At the very least, you must insist on an option on the material, which gives you exclusive control over it and the right to produce the picture based in whole or in part on any material created by the writer. Even if you have to pay the writer a nominal option fee, applicable against a purchase price if and when the film is made, you must retain exclusive control over the material.

I use one of a number of contracts when dealing with non-union writers. The following are all effective deals for independent producers.

Option Purchase Agreement

Negotiate until you and the writer arrive at an option price, however nominal, which is consistent and realistic based on the proposed budget for the film and on the writer's level of experience and expertise. You, as the producer, will have exclusive control over the material that you are developing during the option period. If the film is made, or if you simply decide to buy out the script, the writer will be paid the entire agreed purchase price. Sometimes, depending on what you are able to negotiate with the writer, the option payment may be applicable to (or deducted from) the purchase price. If the film is never made, or if you do not exercise the purchase option, the material reverts to the writer at the end of the option period. To protect yourself, try to negotiate subsequent option periods, so that you may extend your control over the material without actually purchasing it. This will give you more time to try to set up the production of the film. For example, if the initial option is one year for $1, applicable to a purchase price of $5, try to negotiate two more successive option periods for $1 each, not applicable to the purchase price (an incentive for the writer to make more money if the option is exercised). Under this scenario, if you exercised all three option periods and then purchased the script, the writer would be paid a total of $7. (A sample writer option purchase agreement can be found in Appendix F.)

Work for Hire

A work for hire is a payment—or a series of payments—to a writer as remittance, in full, for work performed. It may encompass a story treatment or outline and one or more drafts of a screenplay. (A sample writer work for hire agreement can be found in Appendix G.) For low-budget, non-union films, I have paid as little as $1500 and at most $10,000 for multiple drafts, which I suggest is the maximum range to be paid for a screenplay at this level of filmmaking. This, without question, would be a vastly unpopular view with the Writers Guild of America (WGA), the union that represents the majority of professional studio and television writers. WGA low-budget minimums *start* in the $35,000 range, plus 14.5 percent pension, health, and welfare contributions, plus residuals if the picture is made. In larger-budgeted films, clearly the better-known writers, who have achieved some success or at least have been hired by WGA signatory companies or sold scripts to majors, are members of the Guild.

Step Deal

I strongly favor the step deal when working with new, non-union writers, because it allows the producer to terminate the deal after any given step if the writer isn't performing satisfactorily and conserves the rest of the money that would have been paid in subsequent steps, allowing the producer to

hire another writer or writers. The step deal dictates how the writer is paid incrementally and is basically a work for hire, with payment increments that may be terminated at the completion of each step. For each step that the writer completes as outlined in the contract, he or she is compensated a predetermined amount. For instance, on a $7000 step deal, a writer might receive $1000 for the outline or treatment, as approved by the producer. The second step might be $2000 for the first draft of the screenplay (as this step demands the most work). Steps three and four, two further drafts, might be $1500 each, while step five might be $1000 for the final draft or polish. Therefore, if all five steps are completed by the same writer, that writer would make $7000. But if the writer is terminated after step three, they would receive only $4500, leaving the producer with $2500 to hire another writer to finish the screenplay. If the initial writer's work at any step is used as the production draft and the film goes into production, the writer may negotiate to be paid the balance of the full $7000 upon commencement of principal photography. It's a negotiation, and the producer may negotiate a lower "floor" to pay the writer if less work is done and there is no other writer on the project.

The step deal is useful if the writer simply isn't getting it, or if you don't like their work, because the money to hire someone else to finish the job to your satisfaction remains in the budget after each step. (A sample writer step deal agreement can be found in Appendix H.)

Non-union Independent Films: The Backbone of the Film Industry

I strongly contend that, similar to Major League Baseball, the independents are the free "farm clubs" for the major studios, networks, and unions, who later all capitalize on the talents of writers, producers, actors, and directors who have developed and honed their skills working in independent films. Without the independents, there would be no training ground for new talent who ultimately make money for the unions, the studios, and the networks, at no risk or expense to them whatsoever. Major League owners pay big money for their farm teams in order to develop talent who later move up to the majors if they are good enough. The studios, networks, and unions get their independent "farm clubs" for free, and yet systematically, in their conglomerate imperialism and greed, try to put the independents out of business. The narrow-minded unions tend to vilify independent producers and filmmakers, rather than embracing them for nurturing the pool of talent that ultimately, as working union members, pays for the unions' many high-salaried administrative staff, attorneys, and accountants and contributes to the vast wealth of pension plans that make all of the unions prosperous. Rather than thanking the independents for their efforts, most guilds smite the independent producer at every turn and are so punitive that independent filmmakers embrace non-union filmmaking all the more.

Tricks to Write for Cost-effective Production

From a production standpoint, while your movie is being developed on paper, you think cost-effectively and communicate specific limitations to the writer. There are several factors that novice producers do not usually take into account when collaborating with writers on scripts. But these factors can add up and drastically increase your production costs. For example, night exteriors are very expensive. Night is predominantly illuminated by moonlight, and to recreate moonlight you need a big, powerful, elevated light source on a Condor, crane, scaffolding, or high stand on top of a truck, or placed on the roof of a building. Aside from the cost of renting and transporting all of that equipment, there is the cost of manpower to transport and operate the Condor, build the scaffolding, hoist the light, transport and fuel a generator to power the light, operate the generator, run cable from the generator to the light, drive the truck to transport the generator, and on and on. Get the picture?

Everything you want to see on film at night has to be lit: the background actors, faces, and everything else all take additional time, additional manpower, additional equipment, and additional money. As a cost-conscious independent producer, you'll need to find creative solutions to problems in order to reduce the overall cost of your project. A trick that I often employed was to use a night exterior stock shot for a transition and then cut to a night interior, which is a controllable set, so all you have to do is block the windows if it's daylight outside and you are shooting day for night. Another possibility is to find a night location that has a great deal of ambient light, such as a brightly lit downtown complex, a train station, or an amusement park. The Las Vegas Strip is a great example, as is the Santa Monica Pier in Los Angeles. Anything that gives you plenty of ambient light sources, and in many cases a lot of colorful light (which looks good on film), is a good way to "cheat" night exteriors in low-budget filmmaking. That way you can capture an image without big lights and equipment and simply add some fill light using small, battery-powered lamps.

Another thing to keep in mind when writing for cost-effective production is to limit the number of speaking roles in your screenplay. Every speaking role costs you union scale plus, at the time of writing, approximately 18.77 percent payroll tax, plus 17.3 percent pension, health, and welfare contributions to the Screen Actors Guild (assuming your picture is a SAG signatory). So every dollar a producer pays to an actor actually costs almost $1.36. And this does not include additional expenses per performer for meals, travel, hotel, and living expenses, if applicable; nor any overtime, forced calls (calls to work sooner than twelve hours after dismissal the previous day), mileage, looping (post-production voice replacement or additional lines), and personal wardrobe rental and cleaning allowance.

Let's look at an example. If a SAG eight-hour day rate is $268, but invariably you will need twelve hours per day with your actor plus lunch, that rate will jump to $469, plus $78.79 for pension, health, and welfare

contributions, $11.50 for wardrobe allowance, an agency fee of 10 percent, your payroll taxes (SUI, FUI, FICA, Medicare), and workers' compensation and payroll fees. So you, as the producer, will pay each actor on a day-player contract almost $800 per day, not counting mileage money, which might also be factored in!

Screenplays for independent films should therefore always limit and consolidate the number of speaking rolls, and particularly SAG speaking roles. Gratuitous one-liners from characters like waiters, bus drivers, and other incidental speaking roles should be consolidated or, preferably, omitted. For example, if there is a scene in a restaurant with a couple sitting at a table, it is unnecessary and costly to have a waiter say "What can I get you?" Instead, the principal actor may just as easily turn to the waiter as he arrives at the table and say, "I'd like the Caesar salad please. Hold the anchovies." The waiter will still appear onscreen, but now you can pay him as a non-speaking extra, thus eliminating the union expenses outlined above (not to mention residuals, which we will discuss later).

Consolidate and limit the number of locations, too. A low-budget film should be structured around a small number of major locations, which saves money, since the number of company moves (when your entire cast, crew, trucks, and equipment pack up and transfer from one location to another) during production will be limited. The most cost-effective production plan is to find a location with a central base camp so that equipment can be dropped off, thus eliminating drivers and fuel costs. For example, if your script calls for a church, a private home, a retail store, and a restaurant, it's wise to look for a neighborhood that has all of these buildings in close proximity to one another. You might then negotiate with the church or the restaurant to use their parking lot as the base camp for your trucks and equipment, or obtain a permit for adjacent street parking. Then there will be no need to move all of your production vehicles. A normal pickup or stake-bed truck may be used to transport smaller amounts of grip, camera, and lighting equipment to the retail store, restaurant, and/or private home without having to move your entire caravan of vehicles, thus eliminating the time, drivers, and manpower it takes to pack, move, unpack, and set up in a series of new locations. Depending on proximity, it might even be possible to *walk* to the various locations in the above example, using small pushcarts to transport the equipment. Your film will benefit from multiple locations without incurring any of the costs of drivers and fuel, or having to spend time on multiple company moves.

In 2007 I made a film for Sony called *Missionary Man*, which employed exactly the limited-location scenario I've just described. We filmed in Waxahachie, Texas, setting up our base camp behind the old jail. We shot for eighteen days in numerous downtown locations without ever making a company move. Instead, we used a combination of hand-carts, stake-bed truck, pickup truck, and small passenger van to move cameras, grip and sound equipment, and lights. Throughout the filming we made just two

company moves: to Lake Waxahachie, a few miles away, for two nights; and to Lake Whitney at the very end of the shoot. We filmed twenty-six days with only two company moves.

We will discuss many more possibilities for cost-effective production in a later chapter, but all of the cost-saving measures described above should be considered during the development of your screenplay. In low-budget film-making, a rule of thumb I have always employed is to focus the story and script around one major location, with no more than three additional company moves, and limit the number of speaking roles to a maximum of twenty.

Screenplay Titles and Perception

The system and way of doing business in the current mainstream entertainment business is like "the emperor's new clothes." Everything is perception, and (figuratively at least) thousands of people are walking around naked in Hollywood while sycophants and yes-men tell them they look great. I realized early on that actors and agents respond to perception more than anything else. If I needed an actor of reasonable note to star in *Blood Chase Psychos*, for example, I would not put that title on the script; nor would I feature the obviously cheesy nature of the film in submission to Breakdown Services, a company that synopsizes scripts and character breakdowns for casting purposes for all talent agents and managers. Instead, I would substitute a pompous title, such as *Inheritance of Valor*, to disguise any inference that the project was a low-budget exploitation movie. Similarly, the synopsis for actors and agents might read: "After a heartbreaking personal loss, Dirk Stone has taken a leave of absence from the Los Angeles Police Department. A series of events force him to confront his inner demons and transcend his fears in order to rescue a small child who is being held hostage by a ruthless serial killer." Meanwhile, potential buyers in foreign markets would receive a very different synopsis for *Blood Chase Psychos* (the same movie, of course): "Deranged psychotic killers escape from a prison mental ward and go on a bloodthirsty rampage. Only one man, ex-L.A. cop Dirk Stone, can stop them."

Perception is everything. I have used the (fake) title *Inheritance of Valor* numerous times during pre-production and casting to secure the services of some pretty good actors who likely wouldn't have responded to a cheesy foreign-market action title. Also, many films are shot under "working titles" which may change once the film is completed.

Assuming you have the final draft of your screenplay, based on the trend that you identified and your creative and financial analysis of the global market-place, what do you with it? Chapter 7 will take you through the next steps. First, though, you should register your screenplay with the United States Copyright Office to acquire copyright protection for the material you have developed. Also register both the story treatment and the screenplay with the WGA to protect yourself and your material against potential plagiarism.

Chapter 7

Now That I Have My Script, What Do I Do?

Pitch to a Studio or Network

As an independent producer, you may personally try to cultivate contacts or ally yourself with a partner who has existing contacts or industry relationships in order to get you in the door at a network or a studio to pitch your project. Assuming you are lucky enough to arrange a pitch meeting with a studio or network creative executive, the process will go something like this. After honing your pitch, sometimes with a writer, you attend the meeting and verbally present your project to the development executive. Most often, you leave a written outline of your project. If you are successful in generating enthusiasm and creative support from the development executive, this may lead to a long list of story revisions. Should you be fortunate enough to get through this stage of the process, the creative executive might then recommend the project to his bosses. If you are exceedingly lucky, a writer may be hired and sometimes a director will come on board. If a screenplay is commissioned and you are unknown as a producer to the network or studio executives, they may assign a studio- or network-approved creative producer or writer-producer to your project, all of which obviously reduces your overall control. Your producer's fee and credit, which will be dictated by studio and network precedents, will have to be negotiated at this time. Generally, a network or studio production executive will be assigned to the picture.

On occasion, I have reached this stage of the process only to learn that a new studio or network department head has been hired; the old department head, who has shepherded my project for months, has been fired; and all of the previous regime's projects have been jettisoned and put into what is known as "turnaround," (where the rights to a project developed by one studio are sold to another studio for an amount equal to development costs and overhead. The term is often used as a euphemism for the death of a project.)

I recently developed a sequel to a successful film with a studio, but the intended star was sentenced to prison for tax evasion. Obviously, the picture was never made, and I never saw a dime for my year of development efforts.

Only the writer was paid, and the studio now owns my script! In another studio deal, I spent three years negotiating and developing a remake of one of its library titles. After I had written multiple drafts of the screenplay and spent $25,000 on legal fees to make the deal, the studio went bankrupt and ceased operations, and I did not receive a dime of compensation and again only the writers were paid. As an independent filmmaker, I could easily have made a dozen movies during those three years. (From the mid-1990s through 2001, I produced and acquired approximately twenty films each year.) It's never a good idea just to sit around and wait for the whims of a corporate studio executive to dictate your livelihood. Be the master of your own destiny, not a victim of someone else's failings.

Should you finally achieve a studio- or network-approved script with a director attached, the final green light for your project might hinge on recruiting a network/studio-acceptable cast (i.e., star actors) and creating a network/studio-approved budget. At this point a completion bond company with a bond representative might be assigned to the picture, and the production will have to operate within a very tight and concise box. The film will then be produced within an agreed budget and schedule, with the bond company standing behind the studio or network with takeover rights to complete the picture if any excessive scheduling or budgetary overruns should occur. The picture then becomes the property of the studio/network, at the very least for long-term distribution, with the producer, director, and everyone else all working for the studio/network or the entity set up specifically to produce the film.

If you survive all of the above steps and ultimately get a green light for your film, the studio/network will finance the picture and you will earn a fee.

In the past, I made deals with studios in which they purchased domestic distribution rights for a particular film while I retained, sold, and owned foreign rights in a co-production, co-financing scenario. Today, however, the studios are owned by conglomerates and their mandate is to retain worldwide rights; finance it 100 percent; pay the producer a fee and a royalty percentage on the back end, so that by studio accounting and "royalty" definitions he or she will never see another dime; and have the producer deliver the film and move on.

Recently, on a few occasions, I have retained the rights to a desired project, or I have created a desirable package and made a deal in which the studio financed the entire picture yet I was able to carve out and retain a couple of foreign territories in addition to my producer's fee and, in some cases, my overhead expenses. I was able to do this in 2005 and 2006 with sequels to *The Foreigner*, starring Steven Seagal, and *Half Past Dead*, starring Bill Goldberg and the rapper Kurupt, since I owned the underlying rights to both pictures.

However, in all of the above scenarios, the final cut of the picture and the marketing and distribution plans are at the discretion of the studio/network executives. Basically, under their employ, the producer is responsible for

seeing that the picture is completed on time, on budget, and in substantial conformity with the approved screenplay; and for delivering it to the studio/network in accordance with the delivery and post-production schedules. (See Appendix I for a sample post-production schedule, and Appendix J for a sample delivery schedule.)

As an independent producer or filmmaker, imagine that you have done your due diligence and have developed a script that meets all the demands of your market analysis. How will you finance the picture? This has always been the principal conundrum for every filmmaker.

Equity Investor

An equity investor could be any individual, company, friend, family member, or stranger who believes or who has a vested interest in your picture and is willing to fund either all or a percentage of the overall budget. Let's say you've analyzed a trend in the marketplace and assessed the global market value for your independent low-budget feature film to be $400,000. Imagine that the budget of the film is $200,000 and how that would look on paper, in terms of what a deal structure might look like for an equity investor. We've discussed what the appropriate sales agency deal would be for an average independent low-budget picture. For simplicity, imagine that the sales agent is representing worldwide rights. Market expenses should be capped at $25,000; the sales agency's fee should be capped at 15 percent. So, in this exercise, $25,000 would come off the top from gross collections. Assuming $400,000 of gross collections (now a net of $375,000), the equity investor would receive 85 percent and the sales agent would receive their 15 percent sales fee. After repaying the equity investor his or her initial investment of $200,000, plus 10 percent interest, that leaves $95,000. For the sake of this exercise, we will calculate SAG residuals at an estimated $15,000, which leaves a net of $80,000, which in most cases would be split 50/50 between the equity investor and the producer or filmmaker.

In most independent productions, an equity investor should receive his or her money back in first position from all worldwide sources, with pre-agreed distribution fees and usually reasonable distribution expenses allowed "off the top." If and when the equity investor has received all of his or her money, which usually includes a pre-agreed interest percentage, there is commonly a split thereafter of between 25 and 50 percent to the investor, depending on what you have been able to negotiate, with the remaining percentage paid to the producer.

Again, a 50/50 split after the investor has recouped his or her money is pretty standard. Distribution fees remain an ongoing off-the-top expense borne by both parties. There might be a deferment pool for potential talent, writer, director, producers, and anyone who has not earned a fee or took a substantially reduced fee to get the picture made. Generally, these

deferments are borne as off-the-top expenses after recoupment. Actors, directors, and writers often have a profit participation as well, and these generally kick in at this point, sometimes solely from the producer's share. Always try to negotiate deferments and other talent participations as off-the-top expenses, so that the investors bear their proportionate share of such costs after they have recouped their money plus a reasonable amount of interest. If the distributor has reduced its fees to help get the movie made, there may be a retroactive adjustment to that entity until it receives its full distribution fee, generally after the investor has recovered their full investment.

One sure-fire way for you to get your movie made is finance the picture yourself. I have often done this when I have assessed the market value of a particular film and have created a budget that guarantees a profit, or if there is a pre-sale in a major territory or territories to offset my risk. This means that I have personally written the check for the entire production cost of the film; personally created employment for the cast, crew, and post-production staffs; and personally assumed the financial risk. I have always made money—on over two dozen films that I have financed out of my own pocket—whenever I have applied my own philosophy and my empirical knowledge of the marketplace.

By contrast, I very rarely invest my money in other people's projects. I produce movies as a business, with a clear and consistent business plan. Occasionally art happens along the way, but in my world it always happens in the context of that business plan. I never throw caution to the wind and spend more on the production of a film than the market value I've established. Nor do I ever make a film that the market has told me not to make out of some misguided artistic passion. Many business-savvy equity investors don't care how artistic a picture is, as long as it generates a profit. Such people are generally easy to work with, but very hard to find. Protect your equity investor at all costs. Cherish them, and treat their money as if it were your own. If you are given the privilege of making your movie and your investor at least gets their money back or even better makes a profit, the chances are that they will roll with you again and again in the future. By doing this, in addition to demonstrating your knowledge, business acumen, and integrity, you save yourself from continually having to reinvent the wheel. Even reasonably successful filmmakers and producers often spend about 90 percent of their time trying to raise financing for their projects, which leaves them about 10 percent of the time actually making films.

Limited Partnership

A limited partnership is similar to a general partnership, except that, in addition to one or more general partners (GPs), there are one or more limited partners (LPs). The GPs are, in all major respects, the same as in a conventional partnership: they have management control, share the right to use partnership property, share any profits, and have joint and several

liability for any partnership debts. A limited partnership might be formed specifically for the financing and production of a motion picture.

As in a general partnership, the GPs have actual authority, as agents of the firm, to bind all the other partners in contracts with third parties that are in the ordinary course of the partnership's business. Like shareholders in a corporation, the LPs have limited liability, meaning, for instance, that they are liable only for debts incurred by the firm to the extent of their registered investment. Furthermore, unlike a GP, they have no management authority. In effect, the GPs pay the LPs the equivalent of a dividend on their investment.

Limited partnerships are distinct from limited liability partnerships (LLPs), in which *all* partners have limited liability. In some states, an LP can elect to become an LLP. In this arrangement, the GPs are liable only for the business debts of the company, not for acts of malpractice or other wrongdoing done by the other partners in the course of the partnership's business.

In the United States, LPs are quite common in the film industry, real estate investment projects, and businesses that focus on single or limited-term projects. The LP is also attractive to firms that wish to provide shares to many individuals without incurring the additional tax liabilities of a corporation. Well-known limited partnerships include Carnegie Steel Company, Bloomberg, and CNN.

Another example of a limited partnership was the Time Warner Entertainment Company, in which Time Warner Cable was the GP and Media One and AOL Time Warner, Inc. were the LPs. In this limited partnership, as in any other, the LPs were not allowed to "participate in the management or control of the business of the Partnership, or have any rights or powers with respect thereto, except those rights or powers expressly granted to them by the terms of this Agreement or those conferred on them by law. The Limited Partners shall not have the authority to bind the Partnership." Furthermore, the LPs' liability was minimized, meaning they enjoyed more protection than the GPs, but at the expense of a loss of control.

I have personally never made a film under the auspices of a limited partnership, but many other producers have, with some success. Most of the LPs that have crossed my desk were almost invariably formed to promote over-budgeted films with the wrong casts in the wrong genres. I knew, based on my understanding of the marketplace, that they would never be commercially successful. Ultimately, the uneducated partners will end up unhappy and out of pocket, while those promoting such deals generally don't care, so I avoid them.

Self-finance

As mentioned earlier, I have financed a number of my own films and have been successful doing so. Many other producers, producer/directors, and

writer/producers have invested their own money, or friends' or family money, to produce their own films. Generally, all the familiar rules of recoupment of investment as outlined above should still apply. Obviously, if you are risking your own livelihood, you have a vested interest in ensuring that the project is as cost effective as possible, while creatively trying to make the best and most commercial picture possible. Many people think that movies are not very good investments, but if you know what you are doing, and if you've done due diligence and trust both your financial analysis of the marketplace and your ability to make a film for less, they can be quite lucrative. I've made more money through financing my own movies than I've ever made in fees when working for a studio or network. Bear in mind that if friends and family money is borrowed, there is the added pressure of potential strain on personal relationships if their investment is not recouped.

There is a great story about my old friend, the actor/writer/director Robert Townsend. Back in the mid-1980s, Robert pooled all of his personal assets to produce *Hollywood Shuffle*, which he co-wrote with Keenen Ivory Wayans. The film became a huge success and launched Robert's career. As the story (which featured in the film's trailer) goes, Robert got multiple credit cards, maxed out all of them to pay for the film, and had crew members wear shirts with college logos on them so he could avoid permit and location fees and get lower equipment rates. He made his movie in an ingenious, entrepreneurial way and reaped the benefits of a long and diverse career as a director, writer, producer, and actor.

Grants

Film grants are blocks of money that governments or private organizations offer for the purpose of funding film projects that meet certain criteria, often relating to raising social awareness. (Details can be researched easily on the internet.) Funds are almost always released prior to the development of the project based on a specific proposal. For example, a friend of mine in Los Angeles obtained a grant from the federal government to produce a series of half-hour webisodes on safety and bullying in school. Obviously films made under grants do not apply to the TAP paradigm.

Government agencies are also a major source of funding for documentary films. In fact, these grants are among the most generous. The top three U.S. government funders for documentaries—the National Science Foundation (NSF), National Endowment for the Humanities (NEH), and National Endowment for the Arts (NEA)—award millions of dollars to filmmakers every year. A large portion of the Public Broadcasting Service (PBS) schedule is underwritten by this troika, and they are funding ever more programs on other outlets, such as the Smithsonian and National Geographic channels.

The NEA was established by Congress in 1965 as an independent agency of the federal government. To date, it has awarded more than $4 billion to support artistic excellence, creativity, and innovation for the benefit of

individuals and communities. It extends its work through partnerships with state arts agencies, local leaders, other federal agencies, and the philanthropic sector.

Filmmakers may also secure funding by providing services for the federal government. To be considered for a government contract, you must "bid" for the job. A multitude of service companies lists opportunities that come up daily, but you need to subscribe to their services, and that can be costly. I'd recommend taking a free trial offer with one of them, which will give you some idea as to which agencies are looking for video/film productions, the extent of the work involved, and the fees that are paid. You might also obtain a copy of a recent government video/film, ask a qualified production manager to break it down and estimate how much it cost to make, then compare that cost to the fee that was paid, which will give you a good idea of what profit margins may exist. A friend of mine investigates these opportunities on FedBizAccess (www.fedbizaccess.com). Alternatively, at no cost, any U.S. citizen can ask a government agency to inform them of any contracting opportunities when they arise or information on where to search for them.

Another way to obtain federal funding is through the competitive grant process. A number of federal agencies announce grant opportunities to the general public through the U.S. Department of Health and Human Services. Generally these grants are meant to solve or address critical issues. So, in the case of filmmakers, an innovative idea like producing an educational film could qualify, unless the grant announcement specifies otherwise. Obtaining competitive grants involves far more than just writing a synopsis, however. It's a very technical process and the agencies usually demand a plethora of information. The website www.grants.gov carries links to competitive grant announcements and explains exactly what's involved. Be very careful when completing your grant application, as you will be disqualified immediately if you don't follow the instructions to the letter— even to the extent of using the designated point size and margin width.

Subsidies

Many subsidies are offered in the United States. They vary from state to state and exist to try to attract filmmaking to a given state by offering financial incentives. They are generally provided by states or countries and offer a variety of cash incentives, rebates, tax incentives, or tax credits, which often can be sold or factored for cash, and often constitute a component of the financing for a movie. I've personally accessed subsidies and tax credits all over the world, in states such as New Mexico, Louisiana, Rhode Island, Connecticut, Texas, New York, as well as Canada, the United Kingdom, South Africa, and India. Some states offer nothing; others, such as Texas, offer as little as 5 percent for a minimum spend on state goods and services of $1 million; while the likes of Michigan offer up to 42 percent.

Louisiana has offered subsidies in the form of tax credits, which has created an industry for middlemen brokers who are in the business of maximizing the "state spend," and thus the tax credit. They then sell the tax credit to large corporations, receiving a fee, usually from both sides, for doing so.

Canada offers an array of subsidies for films that are produced under the Canadian Audio-Visual Certification Office (CAVCO), with stringent Canadian content requirements. Generally, either the writer or the director must be Canadian (i.e., a citizen, landed immigrant, or permanent resident). The highest-paid actor may be non-Canadian, but the second highest paid and all but those in limited cameo roles must be Canadian. All other performers and all other goods and service providers (e.g., vendors, equipment, labs, and post-production services) must be Canadian. Non-Canadian executive producer credits are allowed, but they must be commensurate with the number of Canadian executive producer credits. The production company and everyone and everything else must be Canadian, and the producer of record must be Canadian. However, there is one allowable non-Canadian production company credit.

I have made many films in Canada over the years. Some have had Canadian content and some have not. An additional incentive to shoot in the country was that the Canadian dollar was traditionally far weaker than the U.S. dollar, so a great deal of money could be saved simply through the exchange rates.

In 1999, my company financed and produced *Art of War*, starring Wesley Snipes, which was released theatrically through Warner Bros. The picture was made in Quebec, under that province's lucrative, but very restrictive, French-Canadian content requirements. Although there may be clear financial benefits to filming in Canada, there are severe restrictions in terms of cast, crew, vendors, services, and location versatility, and creative compromises always have to be made when shooting films that are indigenously American.

Many foreign subsidies emerge and then disappear over time, from German tax funds (many of which ended in fraud, indictments, lawsuits, and prison terms for their principals) to U.K., Luxembourg, and South African funds. From 2004 to 2006, I made twelve films under a U.K. co-production treaty coupled with a sale and leaseback deal. All of these were shot in Romania, which had a co-production treaty with the United Kingdom.

The Great Subsidy Myth

Beware of state subsidies that seem to be too good to be true, because they probably are. As mentioned above, Michigan has advertised almost 50 percent in state-funded subsidies, while Tennessee at one point touted up to 32 percent. But let's review how these really work. The Tennessee subsidy was only available and applicable as follows: 15 percent of a qualified state expenditure was available as a cash rebate at the end of production

from the state film commission for a minimum spend of $200,000. So, if the qualified state expenditure was less than $200,000, you did not get any money. If you had a picture with a larger budget, the state also offered an additional 15 percent of a qualified state spend of $1 million or more from the Tennessee state revenue side, but only to a company that had bona fide Tennessee headquarters. (Moreover, this additional subsidy was based on a pre-approved, qualified state spend, which had to meet the state's criteria, and an audit of your budget.) If your qualified state spend was less than $1 million, you did not get the subsidy.

Your crew, equipment, hotel locations, vendors, travel and living expenses, production offices, staff and local actors, fringe (pension, health, and welfare contributions) and payroll tax (if using a Tennessee payroll company), and all other items had to total at least $1 million. Almost certainly, your stars, director, writer, producers, director of photography, as well as post-production, special effects, and film and video lab work would all be done outside of Tennessee so would not qualify for subsidies. Assuming all of these post-production and above-the-line costs were in line with the rest of your budget, the film would have to cost close to $2 million. If you received the 15 percent on a $1 million state spend from the revenue side in addition to the 15 percent from the film commission side, plus 2 percent for indigenous music, the state subsidies would total 32 percent of $1 million—$320,000. That would leave you with a cash budget of approximately $1.7 million.

Consider that if you shot the exact same film on the exact same schedule in a right-to-work, non-union state, your below-the-line costs might be less than half, so if you decided to shoot in Tennessee you would spend more than double to get back just 32 percent in subsidies. Consider also that the higher budget would mean you incurred union fringes and higher SAG rates just by increasing your spend to qualify for the subsidies. In short, for example, a low-budget, non-union film that might be shot for $500,000 (and would likely have a worldwide market value of $600,000) would cost almost *four times* as much in order to recoup 32 percent from Tennessee. At a $2 million budget level, the net cost to produce the film, after maximum subsidies and rebates, would be $1,360,000. How would you finance that? With a market value of just $600,000, you would have an ingoing loss of $760,000, not including sales agency fees and expenses.

The unions don't care if producers lose money or go out of business. They care about the employment of their members and the resulting contributions to their pension, health, and welfare plans, which generate huge wealth for the unions and pay their executives' salaries.

Let's take this a step further. We now recognize that it is completely impractical and financially irresponsible for you to spend $1 million in qualified state spend simply to qualify for the maximum subsidy for what should be a low-budget film, so instead you settle for the 15 percent offered by the state film commission. Imagine your total film budget is $500,000, and you qualify for the film commission subsidy because you will be

spending over $200,000—let's say a total of $250,000—on Tennessee goods, services, and personnel. You would then qualify for $37,500 (15 percent of $250,000) rebated from the Tennessee state film commission at the end of production.

However, consider what it might cost to travel to Tennessee to shoot your film there. Imagine you are an L.A.-based company, and your writer, director, producer, director of photography, two principal stars, and line producer all have to travel from California to Tennessee for your production. Under this scenario, you'd likely send six people on a one-week preliminary scouting trip, then there would be an additional trip back to Tennessee for pre-production with all of your out-of-state personnel, which generally could not be completed in less than four weeks. Add to that a four-week shooting period and a one-week wrap. All of that totals at least ten weeks of travel, living expenses, rental cars, ground transportation, meals, hotels, airfares, and more for each person. Add shipping costs to the film and video lab, which will add up to several thousand dollars going either to Tennessee's state-approved lab (which historically has been in Chicago and funneled through Nashville for qualification) or directly to your usual lab in Los Angeles. Then factor in the costs of your two stars' first-class travel and living expenses for four weeks of production, plus a couple of pre-production days for hair, makeup, and wardrobe. You will far exceed $37,500 in travel, living, and shipping costs alone.

Does this start to make sense? Subsidies and the promise of free money are like anything else that's allegedly free. If it's too good to be true, it probably is. They can make financial sense, but generally only for high-budget pictures or TV shows produced by studios or networks, which are signatories to union collective bargaining agreements and must therefore shoot under strict union contracts. Obviously, for them, it is benefical to get some of their outlay mitigated or refunded and lower their hugely inflated production costs. Studios work with OPM (Other People's Money), and their personnel are employees of massive conglomerates who receive generous salaries regardless of outcome.

Perhaps my biggest disappointment with a subsidy, although minuscule financially, was for a faith-based movie called *Breaking the Press*, which I shot in Texas. It was a basketball-themed film, with hundreds of extras (all Texas residents) in the stands during multiple games. Many of the extras were recruited through casting agencies, and many were volunteers and students. The most notable aspect of the film was that, aside from two crew members, everyone who worked on it was a state resident. The budget was very small, and the state subsidy was a paltry 7.5 percent of the qualified Texas spend. The application for it demanded a voluminous amount of paperwork, necessitating the hiring of additional personnel specifically to comply with all of the documentation. When the film was in post-production, the Texas state film commissioner was relieved of his duties (the film commission is a division of the governor's office) and the department fell into disarray.

His replacement rejected our film's submission unilaterally, without allowing us to appeal, and refused to pay the subsidy.

I had been courted by the state and city film commissions to shoot my films (and to persuade others to shoot theirs) in Texas. Since I was the writer, producer, and director and lived in Dallas at the time, it was initially appealing to stay close to home for the shoot. The fledgling Texas film industry had long been trying, in vain, to compete with neighboring states like New Mexico and Louisiana, which offered 25–35 percent subsidies or tax credits—much more than the pittance offered in Texas. Having been a board member of the Independent Film and Television Alliance (IFTA) for almost a decade, I was often questioned by our constituency as to why any knowledgeable out-of-state producer would ever choose to shoot in Texas when substantially more "soft monies" were offered by other states. The lessons learned were twofold: if I should ever elect to shoot another film in Texas, it would not be worth the bother and additional expense to try to procure the tiny state subsidy; and even so, I would never trust the state film commission again.

Had I ventured two and a half hours from my house to Shreveport, Louisiana, I could have obtained tax credits amounting to more than four times what Texas had offered, and I am confident I would have received them, as Louisiana has a long history of delivering on its promises to filmmakers.

The Hidden Costs

There are many more myths about subsidies. Many U.S. state subsidies are offered by non-right-to-work states, which means that any production in those states must be full union. As an example, imagine a state subsidy gives you a rebate of 25 percent of your qualified state spend. Let's say that you schedule a five-week full-union shoot, but most local crew is either unavailable or unqualified, so you have to incur additional costs to import your crew from elsewhere and then provide for their housing and meals throughout pre-production and production. Often the equipment you need for your film will not be available locally either, so you'll have to hire union drivers and incur fuel costs to drive to the nearest city that has substantial film equipment rentals, rent the equipment, then drive back to your location. Of course, the equipment must be returned at the end of the shoot, too. Similarly, local department heads are usually unavailable or unqualified, so you will have to bring in your own from out of state.

A full-union, tier-three, weekly below-the-line cost (based on a five-day week) is generally about $350,000, minus the out-of-state crew and equipment rentals, which might result in a state qualified spend (on which the subsidy or rebate would be based) of something like $250,000 per week. A 25 percent subsidy, based on that $250,000, would equal $62,500. Subtract that from your gross spend of $350,000, and the net weekly

below-the-line cost would be $287,500 for a five-day week. Factoring in a sixth day would result in an additional net $57,500, so that would be $345,000 for one six-day week.

The *most* I have ever spent below the line for a six-day week on a *non-union*, low-budget shoot is about $125,000! So a low-budget, six-day, non-union shoot costs less than half of a full-union, five-day shoot, *even after the deduction of subsidies*. The benefits of saving $220,000 each week on a low-budget independent film that is independently financed is the difference between financial success and failure. (In a later chapter, I will present a case study of an actual non-union film I made a few years ago and then contrast that with what the film would have cost if it had been shot full union.)

So, even after a 25 percent subsidy or rebate, the production would spend (and lose) more than two and a half times the weekly production budget by going down the full-union, subsidy/rebate route. The bottom line is that, for small films, the costs of qualifying for state subsidies, rebates, and tax credits are almost always higher than the benefits they pay. *Capisce?*

Remember that most of the states offering the greatest subsidies and tax incentives are union states, which require shooting with union crews in order to qualify for the subsidies and incentives. The smart independent producer must not be misled by some of the large percentages that are offered by the likes of Michigan. Get out your calculator, factor in *all* the costs and benefits, and work out whether it would be cheaper to shoot in an alternative, non-union state with lower or even zero incentives, rebates, subsidies, and tax credits. In most cases, you will find that it is.

Foreign Pre-sales

As discussed earlier, all territories outside of the United States and Canada (and their territories and possessions) comprise what is known as the foreign market. Depending on your project, you—or your designated sales agent—might be able to pre-sell your film in certain foreign territories. For example, as I recounted earlier, I have financed several movies entirely through either foreign pre-sales or a combination of foreign and domestic pre-sales. I did this by securing a loan from the entertainment lending division of a domestic bank, such as Imperial Capital Bank, Comerica Bank, City National Bank (all based in Los Angeles), or a foreign bank, such as Royal Bank of Canada or Royal Bank of Scotland, using the pre-sale contracts as collateral. If your film has commercial appeal in certain foreign territories, you may be able to pre-sell to them and obtain a contract or contracts that could be used as collateral with a lending bank or even an equity investor.

Bank Financing

Bank financing is another way to finance your film, but *every loan requires collateral*, and entertainment loans are no exception. Collateral could be in

the form of a foreign pre-sale or multiple foreign pre-sales, a domestic pre-sale, a combination of foreign and domestic pre-sales, or a subsidy, and, if there is still a gap or shortfall, an equity component (i.e., equity investment, as discussed earlier). However, banks require completion bonds, and both banks and bond companies require that collateral for the funding of the entire budget and associated costs of financing the picture (the *strike price*) must be in place prior to closing of the prospective loan. Also, loan and security agreements are meticulously contracted with the bank, which factors in loan fees, interest reserve, bank legal fees, a legal reserve, plus a fully executed contract with a completion guarantor (who generally charges 3 percent of the film's budget as a bond fee), in order for the bank to close financing and make funds available for production.

A bank requires what is known as a "notice and acknowledgement of assignment" (NOA) to be executed with each foreign distributor. This is essentially a direction to pay, which obviates the sales agent and legally requires the distributor to pay the bank directly upon delivery of the film. Note that the NOA procedure and bank and bond documents can take 90–120 days to negotiate and complete.

Domestic Pre-sales

As we touched on earlier, the surest domestic distribution possibilities for low-budget independent films are all forms of home entertainment, television, new media, and ancillary markets. The television possibilities are mostly cable networks, and any pre-sale for a guaranteed sum to a bona fide home entertainment distributor and/or cable network will generally be bankable collateral.

Combination Financing

I use this term to mean the combination of any of the above forms of financing, cobbled together to meet the total budgetary requirements for a film project. By way of example, in the early–mid-2000s I produced a film called *Pursued*, starring Christian Slater, Estella Warren, and Michael Clarke Duncan, through a Canadian company under CAVCO regulations (see above). In line with the CAVCO guidelines, the writer was Canadian, while the director was a Canadian landed immigrant. Slater was the single allowable (highest-paid) non-Canadian actor. Warren, the second-highest-paid star, is Canadian, as are her co-stars Gil Bellows and Saul Rubinek. Clarke Duncan is not Canadian, but I was able to hire him because he appeared only in a minor, three-day cameo role and I had met all other CAVCO criteria.

I pre-sold the U.S. rights to Artisan Entertainment just prior to its acquisition by Lionsgate, and the Canadian rights separately to Lionsgate in Canada, which obtained a Canadian television broadcast sale—a prerequisite for a Canadian content CAVCO picture. I deposited the Lionsgate

contract in a Canadian bank, along with the Canadian tax credits and subsidies. I also pre-sold to several foreign territories, then deposited the funds, along with the Artisan contract, in a U.S. bank. Finally, along with another investor, I put my own personal cash into the project to meet the total strike price. The picture was produced and delivered in accordance with all foreign, U.S., and Canadian delivery requirements (three different versions to meet the various territories' running-time criteria). Ultimately, the picture was released straight to DVD through a division of Sony Pictures Home Entertainment, as well as through Lionsgate in Canada, and was subsequently sold to U.S. television (as mentioned earlier, Canadian television was pre-sold). The foreign contracts, Canadian contracts, and subsidies eventually paid off the two banks, and the remainder of the foreign sales reimbursed my personal investment and that of the other equity partner. It was a good little movie and everyone made money out of it.

Crowdfunding

Several crowdfunding (social media) websites serve as platforms for creative enterprises, including film projects, which are brought to life through the direct support of others. Among the leading sites are Kickstarter, Indiegogo, gofundme, teespring, Patreon, YouCaring.com, crowdrise, DonorsChoose.org, Kiva, and GiveForward.

Each project is independently created and its presentation crafted by filmmakers who have complete control and responsibility over it and how it is presented on the website. Presentations usually include a video that explains the nature of the project and the potential rewards for backers. Every project has a funding goal and deadline. If people like the project, they can pledge money to make it happen—anything from a dollar to tens of thousands of dollars. On most funding sites, if the project reaches its funding goal, all of the backers' credit cards are charged simultaneously when the deadline set by the creator of the project is reached. On most sites, it's all-or-nothing, meaning that if the funding goal is not reached, no one is charged and the prospective filmmakers must start again from scratch.

With social media funding, the contributors do not receive equity in the projects to which they donate money, so the practice is not yet regulated. Instead, most contributors are offered "incentives," ranging from a copy of the script, a download of a song, or a DVD of the completed film to cast memorabilia, a set visit, or even an invitation to the premiere, all of which will depend on the level of contribution. There has been recent legal conjecture that if producers have not accurately stated the facts regarding their project and do not meet their promises, they might find themselves subject to state and federal laws prohibiting wire fraud, unfair competition, and false advertising. Complete and accurate disclosure of all material facts will benefit anyone trying to raise money on a social media site. Also, certain

state labor laws prohibit charging anyone a fee to apply for or accept employment, should any such incentive be offered.

Do Whatever it Takes to Make the Deal

Some students have asked me how to approach an equity investor, which is clearly a critical component in the financing in many movies. Some film schools teach students that they need to learn to draft a voluminous business plan, but I have never done that for any of my 175 movies. There is no way to create a profit and loss (P&L) statement for a film in pre-production. One could show a P&L for a historical film's performance, but, as discussed earlier, sales agents can give projections of how they think a film will perform only on the basis of their current due diligence in the marketplace and the film's market value based on their research, but these numbers are not binding. Also, as discussed earlier, numerous variables can affect a film's value, either positively or negatively, by the time it is delivered.

If you are trying to sell to an equity investor or a foreign buyer, you must instill that person with confidence in the movie you are about to make, so it is critical to tell a good story. That means you must have passion and charisma, and you must be able to convey that passion to the potential investor. Second, by sharing the due diligence that you (and possibly your sales agent) have done to identify a desirable trend, along with your creative and financial analysis, you can have confidence in what the market will bear for your picture. Letting a potential investor know that you intend to make your film for substantially less than its market value will present you as fiscally aware and responsible and generate considerable confidence in your ability.

Sometimes there will be roadblocks that have nothing to do with your analysis of the marketplace. Most individuals are more concerned with their own welfare than the welfare of your picture, so you may need to play by street rules and do whatever it takes to get the project off the ground. If you watched *Entourage*, think Ari Gold at his finest. As recounted in a previous chapter, I paid a negligent agent's assistant to create excellent coverage for a screenplay in order to persuade an actor to commit to the project, and numerous people in Hollywood always have their hands out for "incentives" to make a deal work. I know several agents and managers who will, for the right price (under the table), deliver their clients for a film, even if that film is not in the client's best interests. And I know others who have cheated their own companies out of commissions in exchange for cash, artwork, cars, hookers, down payments on houses, drugs, vacations, and home renovations. I have known theatrical, video, and television buyers—and even entertainment company executives—from territories all over the world who can be persuaded to buy or advocate the purchase of a film in exchange for a little personal "incentive."

Chapter 8

Investors, Actors, Attorneys, Agents, Managers, Business Managers

It is an important fact to realize that most people in the entertainment business *do not understand the how the business really works*. They usually know, care about, and understand solely their own compartmentalized function within the industry, like an auto worker on an assembly line who knows how to tighten a screw on the rearview mirror or how to bolt in the center console but has no clue how to make the whole car, much less how that model was greenlit for production, where it's going when it leaves the assembly line, what port it is being delivered to, who the dealer will be and in which country, and who the end user will be. The entire process in its filmmaking equivalent is vital knowledge for any successful independent producer to possess.

But, as we discussed earlier, most people in the movie business are employees of major conglomerates, and are skilled solely in one job description. There are thousands of people associated with the film industry have strictly compartmentalized jobs, from creative development, finance, legal, accounting, production, post-production, delivery, foreign sales, marketing, distribution, publicity, exhibition, and collections to the various tasks that are linked to the ancillary afterlife of a motion picture. By contrast, very few people understand—or need to understand—the full scope of what goes into making a single film, much less the entire range of the entertainment business.

In most instances, each employee serves an individual function as a component of the assembly line when producing films for the conglomerates. Producers at this level, if they are any good, understand the studio/ network's bureaucracy and politics and how to navigate within those parameters. They might, indeed, even participate in the creation, packaging, production, and delivery of a film project to the studio, but they rarely participate in the financing, global distribution, marketing, publicity, worldwide territorial sales, worldwide physical delivery, tracking of rights and availabilities, or collection of revenues. Although they may have a profit participation in the picture, they rarely have ownership of either the copyright or the distribution rights.

Conversely, an independent producer entrepreneur should learn all, understand all, and be capable of overseeing all.

Entertainment Attorneys

Almost all of the major entertainment attorneys understand only the studio and network worlds. The normal scenario goes like this: someone makes his or her client an offer, usually to the client's agent, and the attorney participates in negotiating a contract. When it comes to the world of independent films, very few mainstream entertainment attorneys possess the knowledge or understanding of what the market values are for these films, much less the market value of actors, writers, directors, and producers—nor do they generally care. Attorneys are high-paid *employees* of their clients (although many of them act as though their clients work for *them*), and their standard orientation, expertise, and understanding center on how to negotiate employment contracts with the majors, who are the employers, and on how to secure the most lucrative terms possible, particularly if they are working on a commission basis. Consequently, if attorneys try to impose studio terms onto small, independent films, they generally become impediments to the successful progress of a small production.

Agents

Most agents don't understand or care about the independent movie business. They are commission salespeople who, like studio producers, understand the bureaucracies and politics of the studios and networks—where they make the bulk of their money. The independent business is somewhat of an afterthought for most of them, although they are prepared to participate in it to some extent, since independent films, particularly in recent years, have generated considerable prestige and critical acclaim for talent, which is good for the agents and agencies. They also participate in the independent sector because many of their clients have cherished pet projects that have been turned down by all of the major studios. Turning to the independent market is a way for them to get such noncommercial films with name talent made outside of the studio system and helps them to mollify their star clients. The independents also provide jobs for unemployed agency clients while they wait for the next big studio or network gig.

Independent producers must realize that, once a script or film project has filtered down to them from a major talent agency, it has probably been passed on by all the major studios and mini-majors, as well as everyone else in Hollywood. Only then do agents go fishing in the pool of independents to see if they can entice someone to bite. As a rule, they have no regard for the ongoing success or wellbeing of independent production companies or producers. In general, they are interested only in the here and now—the Janet Jacksons of the film industry ("What have you done for me lately?").

I have personally witnessed agencies cajole, muscle, and blackmail naive independent producers or deep-pocketed investors who have just arrived in Hollywood into making thoroughly noncommercial films, just to get "in" with the agencies. These movies are often made at the expense of producers, financiers, or independent companies that are trying to establish a relationship with one of the larger agencies, but by the time the aspiring producers have gained their much-desired "in," they are so broke or disenchanted with the business that they flee, having lost all of their money and most of their faith in humanity.

I have seen corruption, threats, favoritism, drugs, sexual favors, extortion, nepotism, bribes, kickbacks, payola, cooked books, forgeries, and anything else you might imagine perpetrated by agents. There is an old adage in the film business: "How do you know if an agent is lying?" Answer: "His lips are moving." On the other hand, over the years, I have also met some wonderful, nurturing, and caring agents with a true eye for talent and career guidance. What little innocence there is within the entertainment business exists in the hearts and minds of the creative talent and those few creative, visionary agents who nurture that talent.

Protect Your Investor

I've already stated several times that if you are ever lucky enough to find an independent financier who is willing to invest in your film, protect him or her at all costs. Make the *right* film for the *right* price. Make sure that your investor gets a return on his or her money. Be cost effective at every turn and keep the investor interested in future projects. This is not only the ethical thing to do, but a wise, ongoing business plan for an independent producer who may enjoy a mutually beneficial relationship with a financial partner for years to come. Protecting your investor can provide you with a source of finance for your films and years of gainful employment for you and others. So, rather than trying to hustle a potential backer for a one-off fee on a noncommercial money-loser, be smart and think long term. And if you have your heart set on making a black-and-white docudrama about a sociopath who runs over small animals with his car (a film student at Southern Methodist University actually pitched me this concept!), make a few successful films with your investor first, then *use your own money* to indulge your whim if you still need to get the idea out of your system.

Producers and Filmmakers Need to Understand Actors

The business of entertainment is even more of a mystery to most actors. They tend to be financially naive and sheltered from the business side of things, with their main lifeline and connection to the industry being through their agent, manager, or, in some cases, attorney. Most actors,

except for some major film and television stars, have very little, if any, understanding of how the business works, how and why certain projects are given a green light while others are not, where the financing comes from, or how distribution works.

People think that there are huge dollars to be made from acting. In reality, only about one in every hundred professional actors makes over $100,000 a year. Most of the rest earn below the poverty level from acting gigs and are forced to supplement their meager income by taking a variety of other jobs while waiting for their "big break." The myth of every waiter in Hollywood being an out-of-work actor is not really a myth at all.

Actors' Quotes

In 2004, I made a film with an actor who had once been a significant star, but his career had faded somewhat and he was now doing independent films. His "quote"—or "rate"—was $1 million per movie, based on a four-week shooting schedule. When talking to the actor's agent, I offered his client the co-lead in my movie and agreed to pay his weekly rate of $250,000 based on a four-week schedule, but with the caveat that I needed him for only two weeks so would pay him only $500,000. I was able to convince the agent that we were maintaining the actor's quote of $1 million for four weeks. He was merely working half of that time. The plan was to shoot six-day weeks, and the completion bond company required two free days, if needed and used, as part of the deal. The entire picture had a twenty-day shoot, based on three six-day weeks, plus two days in a partial fourth week. I got my star-name actor for fourteen of the twenty days for 50 percent of his standard rate by negotiating shrewdly.

Sometimes you have to use psychology during negotiations—you should always look for ways to allow agents and talent to save face, especially when you have secured an actor's services for less than their quote. Every actor and agent is afraid of word getting out that an actor's price has dropped, for fear of never achieving their established quote again.

Actors' Language

We have discussed that producers, directors, and filmmakers need to learn the various idioms and terminology of the movie industry. Likewise, it is important to realize that actors speak many different languages, depending on the training they have received and the techniques they have studied. A great illustration of this is from the 1976 film *Marathon Man*, starring Sir Laurence Olivier and Dustin Hoffman. Olivier trained at the Central School of Speech Training and Dramatic Arts in London, whereas Hoffman studied at the Actors Studio in New York, where he was trained in "the method." These are two diametrically opposed schools of acting: the former is very external in approach and technique, while the latter is very internal

and relies on evoking "organic" emotions through imagery, sense memories, and personalization. Imagery could be something as simple as imagining a half-full hot-water bottle and mimicking its behavior to give the appearance of drunkenness, rather than *playing* drunk. A sense memory could be recalling a childhood incident to generate the feeling one had in that moment, and then carrying that emotion into the scene. Personalization involves transposing someone from your own life, such as a lover, a family member, or an enemy onto a fictional character.

In one famous scene from *Marathon Man*, Olivier's character, a Nazi war criminal, tortures Hoffman's unwitting history student by drilling into his teeth and hitting exposed nerves with no anesthetic. As the story goes, Olivier saw Hoffman sitting on his own, putting himself through apparent emotional angst prior to shooting the harrowing scene. Olivier asked his young co-star: "What on earth are you doing, my boy?" Hoffman answered, "I'm doing a sense memory, Larry, preparing for the scene." Olivier observed Hoffman's preparatory machinations a moment longer and then retorted, "Why don't you try acting, my boy?"

It's a great story, but imagine the director, John Schlesinger, dealing with and directing these two great actors who were trained in two completely different disciplines and spoke vastly different languages regarding their craft. He also had to learn how each actor worked in order to achieve his desired results. Schlesinger had to learn the language and understand the essence of "the method" in order to communicate effectively with Hoffman in a way that the actor respected, understood, and responded to, based on his training. And he had to communicate with Olivier, who spoke a completely different language, in a totally different way.

Casting

Actors naively think that a successful audition is always about their performance. They would be shocked if they could sit in on a casting session and see how truly random some producers' and directors' choices are. Casting often has more to do with mixing and matching physical types, meeting the ethnicity requirements spelled out in certain SAG contracts, and many other factors, than it does with pure talent. When SAG financially incentivizes a low-budget production to hire a specific gender, age, or ethnicity of actor, rather than the most talented performer or the actor who is most suited for the role, it disserves to the talent of the actor but it certainly helps the independent producer (more on this later).

Sometimes a producer and/or director may look for the strongest actor for a role regardless of physical type, whereas at other times a certain physical look could be the key criterion for casting. In the former case, performance and audition are critical; in the latter, appearance is critical. However, in most cases, particularly as the casting process drags on and supporting roles and day players have to be cast, the process becomes

far more arbitrary, with most filmmakers just wanting to get it over with as soon as possible. However, there are wonderful instances when an actor walks into an audition and knocks your socks off, and you hire him or her immediately. This is a mutually fabulous event whenever it happens. The actor is cast based on ability and the producer and director are delighted to end the tedium of casting.

Choosing a Representative and the Rates You Pay

The industry standard for creative talent—including writers, directors, actors, and some producers—is to pay an attorney 5 percent of earnings for standard transactional legal services. A 5 percent fee to an attorney amounts to a lot of money, unless the client is a famous writer, director, or movie star and does not have an agent or manager. I advise always paying your attorney an hourly rate. As a person trying to "make it" in the entertainment industry, you need to find an agent or manager who truly believes in you and your talent and establish a personal relationship and bond with him or her. Talent needs someone who genuinely believes in their ability and cares for their wellbeing.

Business Managers

Business managers exist to "manage" the assets and income of their clients. They generally charge 5 percent, and I myself paid that amount to a business manager for a number of years. Had I opened my own envelopes, written my own checks, and paid a few hundred dollars for an accountant to file a tax return, I would have saved enough to buy a new car *every year*. A better way of saying it is that I started making and saving money when I stopped handing it over to other people and became the master of my own fate by taking charge of my own affairs. *Take charge from the beginning.* Trust yourself. Learn your business well, whatever aspect of the entertainment industry you choose to pursue.

Managers

You must understand the concept of agents and managers. Although, under federal law, talent managers cannot procure employment for actors, they can certainly set up meetings, get feedback, and turn negotiations over to an attorney or agent to make a deal. (Management contracts distinctly state that managers are paid to give advice and counsel to their clients, but may not procure employment.) My opinion is, if creative talent has a manager who truly cares and believes in him or her, the manager should receive 10 percent, while an hourly fee should be paid to an attorney to negotiate and close deals. There is no need to pay an additional 10 percent to an agent. On the other hand, if one is lucky enough to find an agent who has a similar personal interest, that agent can set up meetings or auditions, negotiate,

and close deals without any need to pay for a manager or an attorney. Most of the larger agencies also have in-house attorneys who can provide legal comment on clients' contracts.

Insecurities and Common Sense

Creatively talented people are notoriously insecure, and many in Hollywood prey on those insecurities; hence the rise of the duplicative services of talent agents, attorneys, and managers. Consider this: if an actor is lucky enough to be in the approximate 1 percent who makes $100,000 a year and pays his agent 10 percent, an attorney 5 percent, a business manager 5 percent, and a manager 15 percent, that is $35,000 off the top *every year*. The actor, left with $65,000, will still be in a top-tier tax bracket, which will entail paying approximately 41 percent in federal and state taxes (assuming they live in California). Not factoring in any business deductions after the actor's reps and taxes, that $100,000 in gross earnings has now been reduced to less than $40,000. That breaks down to about $3333 per month for living expenses. A one-bedroom apartment in a modest part of Los Angeles will cost $1500 per month. That leaves $1833 per month for food, car, clothes, insurance, gas, travel, phone, and much more. That's pretty paltry for someone who ostensibly earns six figures per year. Look at it another way: paying an agent 10 percent, not employing a manager or a business manager at all, and paying an attorney an hourly rate only if and when needed, the same actor would net approximately $53,100 per year ($4425 per month)—27 percent more.

Save Yourself

I strongly advise directors, writers, and producers not to overextend themselves financially. Freelance talent cannot afford to spend money in the same way as those who have the job security of permanent employment. Freelance talent cannot rely on regular paychecks and may remain unemployed for many months, if not a year or more. So my rule of thumb has always been to save money. Save at least one year's living expenses, set the savings aside as a sacrosanct emergency fund, and do not touch it unless to live on between jobs. Consider yourself broke if you have less than that in the bank. Do not leverage. Do not finance. If you cannot pay cash for it, do not buy it. If you are hired for the pilot for a new television series, don't run down to the showroom and buy a new car or put a down payment on a house. The majority of pilots are never sold as series, and you may lose your new house or car.

At the end of every fiscal year, scores of guild-member directors, producers, actors, and writers scramble, scheme, scam, and beg for any employment that might bring their earnings and pension, health, and welfare contributions up to the bare minimum to qualify for their respective

union medical plans. Those who can't meet the requirements are probably barely earning minimum wage, without even factoring in the deductions of costs for agents, managers, entertainment attorneys, and/or business managers.

Directors, writers, and writer/producers, unless they are working as show runners on hit television series, are usually freelance workers. Directors tend to focus on trying to get the next job, while writers concentrate on trying to sell a finished script or getting a new assignment. There are times when both writers and directors will create and/or identify a project that they will try to package and pitch to producers, studios, networks, and distributors in order to create employment for themselves, but the pitfalls are many, the success rate low, and, as we have already discussed, you are left at the mercy of others.

Many people have felt victimized by the entertainment business, but that can only happen if you allow it to happen. *Do not be a victim.* Take your life and your livelihood into your own hands. Be proactive. Be tenacious and resilient. Conceive an idea, breathe life into it, will it into existence, then see it through to completion.

Film Production Basics

Budget

As we have discussed in previous chapters, every picture has a market value. Assuming you have done your due diligence in the marketplace and have been able to raise money for your picture, the next step is to create a realistic budget. Using the spec house analogy from previous chapters, a budget for a film is not unlike a budget for the construction of a house. In a spec house budget, there are line items for labor, fringes, and payroll tax where applicable, permits, goods and services, various vendors, materials, equipment, subcontractors, appliances, finish materials, landscaping and lighting, builders' fees, and more. In a movie budget, there are similar categories and line items for labor (both cast and crew), fringes and payroll tax, permits, goods and services, various vendors, materials, equipment, subcontractors, post-production and delivery elements, producers' fees, and more. Just like the budget for a house, the budget for a movie comprises every cost associated with it, from blueprint/script through to final delivery.

Film budgets are broken down into two basic categories: above the line (ATL) and below the line (BTL). Above the line is largely the creative and administrative talent, including script, director, producers, actors, and their travel, living, and other costs associated with their services. Below the line represents all crew, purchases, goods, services, and vendors throughout the production and post-production phases, including delivery items, a contingency (usually 10 percent), as well as any related financing charges, bank fees, legal fees, and completion bond fees (usually 3 percent).

Union versus Non-union

As an example, we will use figures from a low-budget independent film that I actually produced and directed. Prior to committing to the production and financing the film, I assessed the market and the market values of several current film trends in the foreign market. One of these trends was multi-generational family films featuring talking animals. I contacted a domestic home entertainment company and pitched the idea of a family film about a boy and his talking donkey. The domestic buyer felt that a

family film with a unique character—like a talking donkey—which could be featured on a DVD box, that was also multi-generational and hit multiple demographics was a saleable concept. Historically, talking-animal films had always seemed to work reasonably well for his company, and no one had ever used a donkey before. (During the early stages of pre-production, I learned why: donkeys are extremely difficult to train, so we quickly replaced the concept of a donkey with a much more amenable mule.)

I was able to pre-sell the domestic rights for a $250,000 advance, payable on delivery of the finished film. Having identified a trend that worked both internationally and domestically, and having analyzed the creative elements that worked best worldwide, I next set out to analyze and assess the foreign value of the film.

I commissioned a foreign sales agent and negotiated my sales agency agreement. As discussed in a previous chapter, I kept this down to a flat $25,000 in expenses (which included trailer and artwork) plus 15 percent commission on all foreign sales revenues, to be paid into a collection account. Through our collective due diligence, we estimated the high foreign ultimate (the best-case cumulative total of money that we might expect to receive from sales) as $600,000, and the low foreign ultimate (the worst-case cumulative total of money that we might expect to receive from sales) as approximately $315,000.

Having predetermined the domestic value and actual pre-sold domestic rights, and having assessed the market desirability and market value in foreign territories, I set out to budget and produce the film for no more than $350,000. (As mentioned, I had a firm $250,000 from the domestic pre-sale, so if my foreign sales hit the low ultimate of only $315,000, less $85,000 to the sales agent for expenses and commissions, in a worst-case scenario I would still make a $130,000 profit.)

My domestic deal called for a "fully loaded, industry-standard budget of $500,000." This definition included fees for such things as producer (my producer's fee was allowed to be $50,000), director, writer, financing, completion bond, contingency, and post-production supervisor. I determined that to make a profit from the film, I needed to perform all of the major functions myself and defer my fees. So, first, I wrote the story and co-wrote the screenplay. I paid my non-union co-writer, through a very cost-effective step deal, to transpose my story and rewrite my original draft while I scouted locations and began pre-production, then I wrote all of the subsequent drafts myself. This meant I saved and deferred about $8000 that would otherwise have been paid to a writer. I then decided to direct the film, saving a further $30,000. And, of course, I produced the film, saving my allowable $50,000 fee.

Next I decided to finance and cash-flow the movie myself, saving a gross 15 percent (when factoring in a loan origination fee, interest, interest reserve, legal fees, and legal reserve, totaling $75,000) that would otherwise have been paid to a bank. Financing through a bank would also have

required a completion bond—3 percent of the total budget is the standard rate, so I saved a further $15,000. An industry-standard budget always includes a 10 percent contingency ($50,000) for any unforeseen over-budget costs. Legal fees incurred during production of a small film might run to $15,000, but I performed all of the legal services myself, without consulting an attorney. An industry-standard overhead charge would be 5 percent, or $25,000 in this instance. I used my own cars as picture cars and had my staff drive them instead of hiring drivers; and I used friends and family as some of the actors and as almost all of the extras. SAG residuals should always be calculated and factored into any independent film budget. I always include these within the costs of production, since I am firmly obligated to pay them. Fortunately, in this case, the domestic company assumed the payment obligation of SAG residuals in North America. My estimate for foreign residuals was approximately $13,500.

In the outside world, my allowable industry-standard budget would have been $631,500. But by performing so many duties and functions myself I deferred those budgetary items: the money for them would ultimately come from the worldwide sales of the film. By cash-flowing the film, I basically provided a bridge loan for the domestic pre-sale amount ($250,000) and really invested only $100,000 of my own money against a projected net return of $230,000 from the foreign market. An ingoing return on my investment of 130 percent was not a bad deal. Another way of looking at it is that I created a writing, producing, and directing gig for myself and ultimately received a little more than the total cost of hiring people to perform those duties. I also stepped into the shoes of a bank by investing my own money in my own film, then made what the bank would have made when the film turned a profit. However, all of the steps described in previous chapters had to be followed, using my hands-on production experience, in order to achieve the guaranteed profit margin.

The picture was shot in fourteen days, and it was completely non-union (except for the SAG). The picture was signatory to the SAG Modified Low Budget Agreement, which at the time was applicable for all movie budgets under $625,000. For the edification of the reader, an ethnicity casting incentive increased the budget level at the time to $937,500 for the same Modified Low Budget salary rates for actors if the criteria for ethnicity in casting were met. In order to qualify for this incentive, 50 percent of the employment days had to include a combination of minorities under SAG's definition of minorities,which includes women (of any ethnicity), persons over the age of sixty (of any ethnicity or gender), African Americans, Asians, Pacific Islanders, or Hispanics. At the time, the day-scale rate for the SAG Modified Low Budget Agreement was $268 for eight hours, plus SAG pension, health, and welfare contributions of 14.8 percent (it is much higher now). The weekly scale was $933 dollars per five-day week, assuming ten-hour days, plus the same 14.8 percent. Actors were also allowed to fly coach, rather than first class (which is required under normal SAG agreements).

Producers and filmmakers must be aware that payroll taxes and fees, as well as any applicable union fringe (which we will cover in a later chapter), must be paid for every salaried actor and crew member who goes through payroll, plus a 10 percent agency fee that is payable to all scale actors' agents.

To illustrate union versus non-union costs, I produced a non-union picture, which we'll call *Picture X*, which at the time cost $678,000. For the sake of comparison, I have created top sheets for both a non-union budget and a full-union budget, using the same equipment and identical shooting schedules, with full rates and expenses at that time. (The non-union top sheet can be found in Appendix L and the sample full-union comparison top sheet in Appendix M.) As you can see in the appendices, the union budget (for the exact same picture) is three times greater. Moreover, union rates, as well as pension, health, and welfare contributions, have risen since then, meaning payroll taxes would be higher—so a full-union budget would be even higher today.

The union rates in Appendix M for International Alliance of Theatrical and Stage Employees (IATSE) and Teamster workers were the television movie contract rates that were in effect when *Picture X* was produced (they are higher now). These were the applicable contracts for this film since the union rates put the budget over $1 million. SAG TV contract rates always apply for such budgets, as well as the applicable DGA and WGA rates (which are higher now, too). On reviewing the top sheet, or first page, for each budget (containing a line-by-line summary of the main budget categories and the total amounts budgeted for each; hence a top sheet gives a quick view of how a film budget is structured), the non-union top sheet shows the actual cost of *Picture X*, while the full-union top sheet shows how the cost of the same movie would increase in almost every category when produced under union contracts. Remember that there are also payroll taxes, which increase dramatically, and a 10 percent fee payable to the talent agents of every actor who works for SAG minimum scale, and all must go through payroll. And there are further cost increases just for the extras, stunt players, looping, pension, health, and welfare contributions, and more.

Clearly, then, the increase in budget caused by becoming signatory to the IATSE and the Teamsters is astronomical. IATSE and its locals represent all below-the-line crew (grips, electricians, camera operators and assistants, the director of photography, editors, and editorial assistants), many lab and post-production houses and their personnel, plus increased payroll taxes and, in some cases, depending on your contract, residuals.

The film also featured many horses, mules, and a dog, all of which were central to the story. A Teamsters contract would require not only that all drivers of all vehicles be union members, but that all animal wranglers would be as well. Since there were no drivers in the non-union show (as everyone drove themselves; animal wranglers handled all of their own transportation; and crew personnel drove the camera truck and the grip and

electric truck, without dedicated drivers), the increase in personnel would be huge. There were half a dozen picture cars plus grip, electric, and camera trucks, a vehicle to tow the generator, six motor homes for the actors, several trucks and trailers for the equine animals, a full-time dog wrangler, two full-time horse wranglers, and eight days of shooting featuring multiple horses, which would have required multiple wranglers on set each day. The increase in cost just for drivers and wranglers would have been enormous. Man-days went from zero in the non-union scenario to approximately 370 at union scale for eight hours, plus additional compensation thereafter for twelve hours, over the course of the fourteen-day shoot, plus prep, shoot, and wrap days that would be union requirements. At union rates, plus payroll taxes, plus pension and welfare contributions, plus overtime, plus breakfast and lunch, craft services, and additional fuel, becoming signatory to the Teamsters would have cost the production a fortune.

The increase in budget caused by becoming signatory to the DGA and WGA would be as significant, too. As mentioned, I paid my co-writer $2000. The WGA would have required a union scale contract. Meanwhile, the DGA's involvement doesn't end with the director. It requires that a unit production manager, first assistant director, second assistant director, and trainee all must be hired under the applicable DGA scale rates, including prep and wrap. So the increased costs of becoming signatory to the DGA and WGA would have been vast. Also remember that there would be residuals due to the writer, director, and staff, as well as to the actors, which could top more than $100,000 out of any future earnings, *even if the budget is not recouped*, for the exact same picture with the exact same stars with the exact same market value! Except in the case of "big name" star talent, *spending more money does not increase the market value of a film*, assuming the filmmaking expertise and production values remain the same.

My assessment of the market value of the film prior to production proved to be quite accurate. So the enormous increase in cost had the film been shot as a union picture would have resulted in a loss of hundreds of thousands of dollars for an unsuspecting investor. Faced with that scenario, I simply would not have made the film and would not have created employment for the many people who worked on it, both in production, post-production, delivery and servicing, and foreign sales. No educated entrepreneurial producer or filmmaker on earth would ever enter into a film that he or she knew was a losing venture off the bat. However, uneducated people do it all the time. It is your job to know better!

Non-union: Smaller Crews

A general truism in non-union, independent filmmaking is that you catch people either on the way up or on the way down. Sometimes you catch people between jobs who just want to keep busy. Those on the way up are

generally younger technicians who want the experience and are willing to work for lower rates (as well as credits for their résumés). Those on the way down are generally older individuals who have usually worked on bigger films but are finding it more difficult to get work, so they have made themselves available to the lower-end, independent films.

In almost all cases, seek to hire people who can multitask. Look for crew members who have substantial previous experience working in secondary capacities, those who are capable and eager to step up and perform in a primary capacity. A frequent example of this occurs in the art department. Unless I'm building a specific set that requires original design and construction for a one-of-a-kind location, sci-fi, period, or fantasy film, I look for an art director to step up to production designer, and a set decorator to step up as art director. Most low-budget films are shot on practical locations, so they don't require extensive builds but some set dressing. Why hire a production designer at higher rates when an art director or set decorator, at lower rates, can do the job as effectively? In all cases, I look to reduce the amount of manpower, eliminate duplicative positions, and bring in day players on only an as-needed basis.

I personally abhor large crews that are overstaffed and invariably leave people unoccupied for large portions of the day. Nothing is more wasteful, for a producer and/or director, than a crowd standing idly around the craft service table, or drivers sitting around on a multiday location with no vehicles moving, costing the production money in meals, while the core crew is working. I prefer the European style of filmmaking, which consists of smaller crews with overlapping tasks who are not governed by union-delineated restrictions. Every crew member you hire is not only an extra mouth to feed breakfast, lunch, and snacks to throughout the day but an additional opinion and possibly a dissenting distraction, if given idle time. Disseminating information is also always critical in filmmaking, and the larger the crew, the more difficult it is to communicate your ideas effectively.

As discussed in a previous chapter, whenever equipment can be dropped off and picked up by the equipment vendor, do it. This eliminates the need for a driver sitting idly on set, drawing salary while the equipment is stationary. This is common sense, and adhering to such practices is money in the bank for the independent producer. Unsurprisingly, my views and opinions are not popular with unions, whose mandate is to try to monopolize and recruit every production in this country to be union signatory. However, that is clearly not practical for independent and low-budget filmmaking, as the earlier budget comparison clearly illustrates.

Don't get me wrong: there certainly is a time and a place for union production, such as on big-budgeted films funded by major studios. When making a studio or big-budget picture, unions are essential, as all studios are signatories to all union collective bargaining agreements, particularly when high-profile talent is involved.

Payroll Companies

Everyone who is hired to work on a film needs to be paid for his or her work, but paying these employees is much more complicated than simply writing a stack of checks at the end of every week. Time sheets, at the most basic level, record hours worked and must be filed and you must keep track of them. Federal and state taxes must be calculated and withheld from each individual employee's check. A risk manager must be hired to monitor and maintain workers' compensation files. If there are background actors (extras) involved in the production (and there almost always are), their pay must also be handled. Extras can number from a handful to several thousand.

Furthermore, if your movie is a union film, in addition to all of the preceding factors, there are myriad extra regulations and requirements for each specific union that must be considered and complied with. Fringes specific to each union must be calculated and paid, as well as payroll taxes and withholdings. Minimum salaries for each union must be considered based on the tier level of your collective bargaining agreement. With SAG alone, you must calculate whether any given actor is on a daily or weekly contract and when any applicable overages kick in, not to mention reporting obligations of payment information back to each specific union and the tracking of residuals.

This volume of work is obviously much more than one or two people can handle, but hiring an entire payroll staff for the run of a show is not cost effective and places unnecessary liability and burden on a production company. So, to keep track of everything involved with paying employees, specialized firms, called payroll companies, are hired. These subcontractors are retained by a production company in order to keep track of hours, pay employees as required by their respective contracts and unions, and remain in compliance with state and federal laws. Some of the payroll companies that currently offer their services to the entertainment industry are Entertainment Partners, PES Payroll, the Jacobson Group, Cast and Crew Entertainment Services, Media Services, PayReel, ABS Payroll, and the Maslow Media Group.

The payroll company becomes the "employer of record" for the production personnel, cast, and crew and their staff are well versed in every aspect of union regulations, as well as labor laws, in all states. Should the payroll company make a mistake and violate any of these laws or regulations, it is contractually liable, thus absolving the production company itself from any liability. Additionally, such companies have the capability and staff to handle movies with casts and crew that number in the thousands. They should be able to calculate, cut, and mail checks for an entire crew, as well as the cast, in twenty-four to seventy-two hours.

Depending on the scope of your movie, these companies will competitively quote you a rate for their services based on the size of your cast and crew, any special needs you may have, and your budget level. This quote

comprises the following: the standard state and federal taxes and fringes; workers' compensation insurance fringe; and the "handling fee," which is basically what the company charges for doing its job. This fee may be either a percentage of each check, usually capped around seven dollars per check, or a flat rate per check. If checks are mailed, postage will also be charged.

For an independent producer, the most important thing a payroll company provides is workers' compensation insurance. If there is an accident or injury on set or related to the film, while the person is (or persons are) employed by the payroll company on behalf of the production, the liability for any claim rests with that company, which is the employer of record.

Beware of Making Large Prepayments

Many payroll companies ask for huge advances and prepayments, sometimes your entire below-the-line salaries, prior to commencing principal photography. Negotiate! Do not accept the company's alleged "standard terms." In these difficult economic times, every rule can—and sometimes should—be changed.

In January 2008, Axium, formerly one of the leaders in providing payroll and related services for the entertainment industry, went belly up in a debacle that was likened to the demise of Enron. The company filed for Chapter 7 bankruptcy, then sent employees an email instructing them not to report for work the next day because the bank had frozen all of its accounts and it was no longer in business. Basically, Axium was broke. This disruption of payroll created a ripple that affected the entire entertainment industry. Not only were several production companies and studios unable to pay their employees and crews, as Axium had been their employer of record, but they lost all the money that Axium had received upfront to cover below-the-line salaries.

The documents Axium filed for Chapter 7 bankruptcy shed little light on the reason for its apparent sudden insolvency, but noted that it "lacks sufficient liquidity or other resources" to meet its obligations. (There has been speculation that the bankruptcy was due to a combination of bad investments and Axium executives dipping their hands into the company cookie jar.) In a bid to alleviate the problems created by the insolvency, Entertainment Partners (one of the Axium's former competitors and one of the largest entertainment payroll companies) assumed most of Axium's debt and helped productions get back on their feet.

If there is a lesson to be learned from this fiasco, it is this: don't let your production's money rest in anyone else's hands, lest it is squandered and you are left unable to pay your employees, or, worse, unable to finish your film. If a payroll company won't let you pay your payroll expenses each week as they are incurred (as it should be), and instead demands a huge advance, walk away and give the business to one of their competitors.

Places Never to Cut Corners

In the mid-1990s, an actor showed up on the set of a low-budget film that my company was financing. Within six hours, he announced that he was feeling ill and asked to leave the set and go home. During the night, he went to the emergency room, was diagnosed with necrotizing fasciitis (the flesh-eating bacteria), underwent emergency surgery, and fortunately survived. However, he then hired an attorney and sued everyone: the distribution company and its executives; the director and his company; the payroll company; and numerous other parties. (Irrespective of the facts that he worked for only six hours; that the flesh-eating bacteria is essentially a staph infection, which could have been contracted anywhere and clearly was contracted before the actor's short stint on set; and that such bacteria need an "entry point" and the actor was a bodybuilder, shaved his chest, and allegedly injected steroids.) In the United States, with its horribly flawed judicial system, anyone can sue anyone for anything, and a losing party does *not* have to pay the legal fees of a falsely accused defendant. So you may win a case but still have to pay hundreds of thousands of dollars in legal fees, as I did in the above example, just to defend yourself, your company, your investor, and any associates from a variety of nuisance claims. As a footnote, during the three-year litigation discovery process, the actor was under surveillance by a private investigator. While pretending still to be incapacitated, he was videotaped at his home in great shape with his shirt off, and at an airport easily lifting and carrying large pieces of luggage and escorting his girlfriend from a limousine. Finally, after three years of legal proceedings, the actor's attorney settled with the payroll company. Thank God for payroll and workers' compensation insurance. Although it is expensive, it is more than worth it when you need it.

Insurance and Murphy's Law

On a production, if something can go wrong, it probably will at some point. Since there is no way to budget for every possible variable or disaster, no production should ever be without insurance. There are four main types of insurance: production insurance, cast insurance (also known as "producer's indemnity insurance"), negative insurance, and errors and omissions (E&O) insurance; and a fifth type, essential element insurance.

Production Insurance

Production insurance is the standard insurance necessary for all legitimate film productions. This includes coverage such as backup workers' compensation (in case an employee's injuries are not fully covered by the workers' compensation provided by your payroll company), general liability, and commercial auto insurance. It also covers costs for delays and reshooting

due to inclement weather, equipment failure, set damage, fire, flood, damage to locations, and more.

I shot a movie in Shreveport, Louisiana, that was a Syfy Channel world premiere. Using the vegetation around the bayou to replicate the Amazonian jungle, we created an entire village, including sacrificial altars, but then torrential rains hit. The rain continued to fall until the river, which was adjacent to our sets, rose and everything started to flood. We moved to higher ground but the flood followed us. Finally, after a weekend of rain, we took longboats out to where our sets had been and rescued them before they floated down the river. Our production insurance claims helped us cover the losses and enabled us to finish the picture.

Cast Insurance

Cast insurance, or producers' indemnity insurance, covers your production in the event the project must be aborted or put on hold due to issues involving key talent. This could happen if actors or other key personnel, such as the director, cannot start, continue, or finish filming due to death, injury, or illness. However, this coverage is available only once the insured actor (or actors) has passed a medical examination, as required by the insurance company. Until that point, the actor is covered only for accidents.

David Hemmings, the great English actor, director, and producer, worked on a film I produced called *Blessed*, which was shot under the working title of *Samantha's Child*. But after shooting several scenes in Bucharest, Romania, he died. With proper cast insurance and the help of an insurance claim, we were able to complete the film with a combination of CGI, reshoots, and new scenes with a photo double. Without proper insurance, the picture might have been abandoned, or would have cost the producers an enormous amount of money, which would have meant the difference between a profit and a loss.

In the case of the film *The Imaginarium of Doctor Parnassus*, which starred Heath Ledger, after the actor's unfortunate demise the producers, financial backers, and other interested parties all had to decide whether to abandon the film. Ultimately they came up with various devices to allow the movie to be finished, with other actors playing Ledger's character in several sequences.

Essential Element Insurance

Essential element insurance is specific insurance on a key element of the film, such as a star or a director. This is generally a necessity if a motion picture is financed by a bank and has a completion bond. If an actor and/or director is a "named element" in any distribution contract in the world that is being used as collateral for part of the production loan for financing the film, then essential element insurance is required. In this event, the actor

or director must submit their medical records and agree to a more comprehensive physical examination, including an electrocardiogram, blood tests, and urine analysis, in order to demonstrate his or her health and insurability. If all is in order, the insurance company becomes responsible for loss or abandonment in the event of disability or death of the essential-element-insured person.

There have been times on my films that insurance companies have refused to cover an actor in specific circumstances, such as when undertaking certain physical activities, or when exposure to allergens is possible. For instance, Gary Busey, who worked for me on *Steel Sharks*, had an insurance exclusion for exposure to horse saliva. Fortunately, the movie was set on a submarine, so there was little likelihood of that. Having a known history of recreational drug use also can affect an actor's insurability, as can any history of missing work days that have resulted in an insurance claim.

Negative Insurance

Negative insurance covers all physical loss or damage to film, videotape, memory cards, or hard drives. It protects the production company from having to pay to reshoot the lost or damaged materials, or for the costs associated with abandoning a project due to a catastrophic event. However, it excludes claims resulting from faulty materials, equipment, or lab damages. All of these can be covered with additional insurance.

Errors and Omissions (E&O) Insurance

All of the above types of insurance are usually applicable during pre-production and production. However, once a film is finished, a completely different type of insurance is necessary: errors and omissions. An E&O policy protects producers and subsequent owners or distributors from a variety of risks, including (but not limited to) violation of third-party trademarks or copyright; failure to obtain permission or licenses for a variety of things, including music; libel or slander; unauthorized use of names; invasion of privacy (failure to secure the consent of somebody who inadvertently appears on camera and decides to make a claim); according credit incorrectly in the end crawl or main titles that was contractually agreed upon; or claims based on allegations of plagiarism, unfair competition, piracy, or infringement of copyright.

The importance of E&O insurance cannot be overstated. Without it, your project might never be sold or even seen. For example, seven weeks before Steven Spielberg's *Amistad* was supposed to make its 1997 debut, Barbara Chase-Riboud, author of the novel *Echo of Lions*, filed a lawsuit. She alleged that DreamWorks, Inc., had copied "scenes, characters, and plot devices" from her novel and used them in the movie. The lawsuit demanded $10 million in damages, as well as an injunction against the film's opening.

Luckily, a judge ruled in DreamWorks' favor and *Amistad* was allowed to open as scheduled, but the studio quickly settled with Chase-Riboud for an undisclosed amount.

Countless large and small films have suffered similar threats. DreamWorks has deep pockets, so they may not have felt the need for E&O insurance. However, small production companies are not so lucky; hence the immense importance of E&O insurance in the independent sector, especially given today's increasingly litigious world. Many vultures are prepared to take advantage of our flawed legal system and prey on any company if they think it will net them a tidy profit. In 2007, I produced a film for Sony Home Entertainment called *Flight of Fury*. A man whose sole livelihood seemed to come from filing lawsuits asserting ridiculous claims in order to make money on nuisance settlements (he was labeled a "vexatious litigant" by the California state civil court) filed a demand for damages against Sony. He claimed that our film was based on one of his scripts, which he said that Steven Seagal had read in the early 2000s, and now he wanted a substantial monetary settlement. When I was contacted by Sony's attorneys, I informed them that *Flight of Fury* was actually a remake of a film that I had produced in 1997 called *Black Thunder*. I sent them the original screenplay of the earlier film, which was virtually identical to *Flight of Fury*, and the vexatious litigant's claim was blown out of the water. But in slightly different circumstances we might have been forced to make an E&O claim.

Also in 1997, I produced and directed an HBO world premiere in Warsaw, Poland, called *The White Raven*, based on a novel. I used to play basketball with a group of guys in Los Angeles, and one of them, who claimed to represent musical talent, supplied me with a couple of songs that I used as source score over a sequence in the picture. Once the movie was delivered, an attorney who represented one of the bands that had recorded one of the songs asserted a claim that we didn't have proper clearance or permission from the band and the songwriter, and that my friend had misrepresented his clients. This was very distressing for me, as we had all the appropriate documentation from my basketball buddy, whom, the attorney claimed, had no right to execute any documents on behalf of his client. However, he stated that it would cost me $10,000 just to defend myself, and said, "Just pay me the ten grand and we'll go away." This kind of extortion happens on a regular basis in the film business. People assert a claim and settle for the likely cost of defense, put some money in their pocket to go away, and the company ultimately avoids potentially more expense in legal fees to defend itself in court.

As you can see, E&O insurance is very important.

Production Legal Counsel

It's always a luxury on a low-budget independent film to have production legal counsel. Generally, on a small picture, I would pay no more than

$10,000 to a small to mid-sized legal firm to perform production legal services. These services would include negotiating and drafting deals for the star actors, director, sometimes director of photography, and yourself, as producer (and any other producers); the writer's agreement; all chain of title; any distribution or sales agency agreements; as well as advice and assistance in all negotiations.

In the case of an ultra-low-budget film, if you have no money for legal expenses, usually a simple agreement in the form of a crew deal memo, with an attachment of "standard terms," will suffice. (A sample standard terms attachment can be found in Appendix N. However, I make no representations or warranties regarding the use, in whole or part, of any of the document samples found in the appendices of this book. They are included solely for illustration purposes.)

How to Manage Production Costs

Learn Smaller to Get Bigger

There is an old adage, "Good small-boat sailors almost always make good big-boat sailors, but very rarely do people who start out sailing big boats turn into good small-boat sailors." The same is true of filmmaking. If you have been given huge budgets and resources from the beginning of a film career, it is much harder to learn the skill, discipline, and fiscal creativity that are needed to make a small film.

There are so many things to beware of when budgeting and scheduling an independent low-budget film. Some of the higher-ticket items that can undermine a low-budget film—and the solutions—are listed below.

Unions and Guilds

For a low-budget independent film, reducing the number of unions and guilds is critical in order to save costs on: increased salaries; pension, health, and welfare contributions; increased payroll taxes; increased minimums due to raising the level of the budget; prohibition from multitasking (unless you are qualified in each specific union category); restrictions of hours; overtime; forced-call payments; and residuals. All of the aforementioned items do not enhance the production value of anything an audience will see onscreen; they just cost vast amounts of money and have a dramatic, negative impact on your potential profit, or at least return of investment to your financier. This is not a popular sentiment with the guilds and unions, but union crews, rates, and restrictions are really appropriate only on large, studio-level films and television shows. This is the stark, harsh reality in today's global economic crunch, as we illustrated earlier when contrasting union and non-union budgets for a small film.

"Non-union" generally means non-IATSE and non-Teamster. It is also vastly more cost effective if the production is non-WGA and the director and his or her staff are non-DGA. Bear in mind that residuals are applicable with SAG, DGA, WGA, and sometimes IA, and that *the producer (i.e. you), or the person or company who is signatory to the collective bargaining agreements, is*

responsible for paying them, unless you have sold the film and the buyer has executed a buyer's assumption agreement that has been countersigned by all of the guilds and unions. And remember, even if the rates paid to a union director, writer, or crew member were identical to non-union rates, they would still cost you the additional union pension, health, and welfare contributions, which are significant.

As discussed earlier, if you want a name actor to appear in your film, it is essential to be signatory to SAG, since almost all name actors are members of that guild. Fortunately, several low-budget SAG contracts are now available for smaller independent films, and each has its merits. However, each has potential pitfalls, too.

If your picture has to be union, producing it under the lowest possible budgetary tier or union contract level is the way to go. The unions have different rates for different levels of production, and the lower the tier of your contract, the lower the global savings will be across the board, thus lowering your overall production budget.

Texas is a right-to-work state that supports people who work both union and non-union. However, when I was shooting an independent film there a few years ago, a non-union crew member called the major craft union in an effort to get the film converted to a union contract, thinking he would make more money. The union sent representatives to Dallas, and they met surreptitiously with the dissenting crew member. In situations like this, when unions are trying to "organize" a production, they tend to work in the shadows. They attempt to infiltrate the film crew without the producers' knowledge, looking to gain the support of crew member after crew member, until they reach a quorum of signatures from 50 percent of the crew in order to force a vote to convert to a union contract, which they did on this particular film.

I subsequently received a threatening call from a union "organizer" who insulted me personally, was completely ignorant of the financing of the picture, and said he would shut the picture down if I did not meet with him and his two colleagues, who had all flown in from out of state, and agree to their terms. Two major lending banks and a completion bond company were the actual financiers and guarantors of the film, which had a finite budget and schedule based on the total existing collateral, so there truly was no extra money beyond the existing budget, and it was the banks and bond company who were the real victims of this extortion. I was simply a producer for hire and a figurehead on their behalf.

I hired a labor attorney on behalf of the production company and we met with the three union executives. The lead organizer insulted me again, irrespective of the tens of thousands of union jobs that I had created over the years, and they collectively threatened to shut the picture down if I did not agree to convert it retroactively to a union contract. I informed them that they weren't blackmailing me, since I was only a producer for hire, but two major financial institutions. They didn't seem to care.

Since the film was ten days from completion of principal photography and the lead actor had a limited window of availability, I couldn't, at that juncture, afford to shut the production down and hire a new crew, which I would have done if it had been my film alone. So I negotiated a deal. Knowing the union's true agenda, I simply agreed to make a flat contribution to their pension plan.

In the organizers' minds, they had wielded a big stick and organized a non-union movie. In actuality, I paid their pension plan contribution out of the film budget's contingency, kept our schedule on track, and didn't pay a penny more to any crew members than I would have paid them as a non-union crew. I finished the film on time with an unanticipated invasion of the contingency, for which I needed pre-approval from the bond company. The sole beneficiary was the union's pension plan, not the crew or even the dissenting crew member who had called the union in the first place.

The organizers called their union bosses after we had agreed the deal, and they offered their congratulations for a job well done. In reality, the pittance that the union received—under $20,000—would barely have covered the organizers' expenses for the weeks the three union organizers spent in Texas, including airfares, hotels, meals, and rental cars. The net contribution to the plan must have been minuscule, if anything at all. The crew hadn't realized that any additional money would go straight into the coffers of the union's pension plan, not to the workers themselves, and they weren't happy after the fact.

After that experience, I never shot another film in Texas. So, all of those disgruntled crew members who thought they might get a bonus by converting the movie to a union contract not only didn't receive another penny but stigmatized the Dallas/Fort Worth area for me and other producers to whom I spread the word. They ensured that all of us—who produce multiple films per year—wouldn't shoot another motion picture in the area. Since then, I have chosen locations in other states and countries.

IATSE and Teamsters: Negotiate

Teamsters are the drivers, transportation coordinators, and captains who traditionally drive all trucks and any equipment that has wheels, such as motor homes, trailers, and honey wagons. (This last is a long trailer that has toilets for crew and multiple dressing rooms with private toilets for actors. It is traditionally pulled by an eighteen-wheel rig.) The wranglers who handle horses and other livestock, wagons, and carriages are also Teamsters.

For lower-budget, independent films, depending on the state or region in which you are shooting, Teamster locals may be willing to negotiate with independent producers. For instance, I've often bargained with the Teamsters to carry two or three drivers for the run of the show. Sometimes,

depending on your budget, it is easier to negotiate with them than to try to avoid dealing with them. Generally, if your budget is under $1 million and you approach the Teamster locals and show them your budget and your rates, they will leave you alone. This type of preemptive approach eliminates animosity between the production company and the Teamsters local. We've all heard and read about the threats of strikes or disruption on set by disgruntled unions. This and the high cost of union labor are major reasons why so much film production and other industries have left the United States for other countries.

When negotiating with the Teamsters, try to negotiate an eight-hour—not a twelve-hour—minimum day, as well as discontinuous employment of drivers when you are at a specific location for an extended period of time and equipment is stationary. I once took over the production of a small Sony picture. The producer who preceded me hadn't negotiated any concessions with the Teamsters. The company was at a particular location for two weeks without a company move, during which time every single driver sat, on the clock, every day, and collected a full paycheck, while the equipment never moved. Had the preceding producer negotiated properly, a number of drivers could have been "dropped" until the company moved again. Think ahead. Don't be intimidated. If you don't ask, you certainly won't receive. Also ask for an eight-hour minimum day when negotiating with the IA. This means you can dismiss people after an eight-hour day if they are not needed, and not get stuck paying everyone a twelve-hour day irrespective of there being any work for them to do. Finally, when hiring union crew, don't just interview the individual; ask other people for their opinions on whoever you are considering. You may learn that some film crew individuals are always disgruntled and have reputations for stirring up dissent on the set.

One camera assistant on the union film in Texas mentioned above was called Mike. He was a perpetually disgruntled troublemaker who would walk around the set and create problems among the rest of the crew, and not only in his own department. He encouraged others to join him in filing grievances against the company for such things as working in Roscoe smoke (a nontoxic, water-based smoke used by cinematographers), with his claim being that he was forced to operate in hazardous conditions. (Roscoe smoke creates a hazy, atmospheric, diffused look. You see it in haunted house scenes, on stage during rock concerts, even in churches, and it is used on almost every movie set.) The guild, in turn, demanded $46,000 in "damages" for just the camera local, which is only a faction of the crew members the union represents. In one phone call, I settled for $10,000, because it was cheaper than the legal fees if we had gone to arbitration; but it still felt like extortion, and took $10,000 from the studio's pocket. Of the settlement amount, only $2600 went to the members directly; the rest was contributed to the union's pension plan.

The lesson: do your due diligence on every person you hire.

Reduce the Number of Locations

We've seen that company moves cost money, that multiple locations (unless strategically contiguous, as previously discussed) cost money, and that staying in one location for as long as possible allows a producer to negotiate a better rate than would be possible if the shooting schedule called for short periods in multiple locations. Remember that these considerations need to be factored into the screenplay as you develop it.

Reduce or Eliminate Distant Locations and Save Money

It costs money every time an actor or crew member works in a distant location (which SAG defines as any place that cannot be reached from the producer's studio within twenty-four hours of travel by ordinary means) or outside the Studio Zone. Often called the Thirty Mile Zone—or TMZ—the Studio Zone differs in size from city to city and is defined as the territory within a set radius from an established central point. (A sample Studio Zone map can be found in Appendix O.) This central point also varies from city to city. In Los Angeles, for example, the central point is the intersection of Beverly and La Cienega boulevards. Actors, depending on their SAG contract, usually travel in the best airline class available or receive mileage payments if the location can be driven to. They also require hotel accommodation and per diem (cash for meals) for every day they are on location. Crew members require virtually the same expenses, although crew on low-budget films will certainly travel coach and stay at more reasonably priced hotels than most actors will. Meals—or money for meals—still need to be provided for everyone, and actors' meals or per diem rates are prescribed by SAG. A star actor will receive much more lavish per diem, hotel, transportation, and perks. Travel and living expenses are determined by a simple calculation of meals, hotel rates and taxes, air and transportation, and other related travel expenses for the number of people traveling multiplied by the number of days spent on location.

Reduce the Number of Speaking Roles

I spent a number of years as vice chairman, then chairman, of the Independent Producers Association (IPA), which shared common membership with the Independent Film and Television Alliance (IFTA). The IPA was responsible for collective bargaining on behalf of a number of independent companies. Time and time again, I tried to explain to several of the guilds that revenues for independent films were shrinking while the floors and fringe rates were continually increasing for all guild members. (Unfortunately, except for the DGA, my words fell on deaf ears.)

When meeting with the SAG and hearing its representatives argue that they were "serving their members" by increasing the daily and weekly rates,

my response was to tell them that they were simply depriving several actors of work for every independent film produced. I explained that worldwide revenues were lower than ever for independent films, so every time the pension and welfare contributions and the daily and weekly rates for actors increased, independents would be forced to cut more speaking roles to compensate for the increased costs and fewer actors would be hired per film. It's an unfortunate aspect of the independent business in these financially challenging times. Most actors just want to work, and I'm not sure that it serves the SAG's membership as a whole to decrease the number of roles that are available to them.

Reduce Night Exteriors

As was discussed earlier, night exteriors are very expensive. They require big lights, electrical cables, manpower, scaffolding or Condor lifts, generators, fuel, and operators. So look for alternatives to external shooting at night as you develop your screenplay.

Reduce Company Moves

As was also discussed earlier, company moves cost significant time and money. Again, consolidate and limit the number of locations, thereby limiting the number of company moves during production.

Reduce Days or Weeks of Equipment Rental

As we have seen, equipment is usually rented on what is termed a "one-day week." This means that the rental "day rate" is essentially the same for the entire week. One of the reasons for shooting a six-day week in a low-budget production is to capitalize on limiting week rentals. Picking up equipment on a Friday afternoon (theoretically for a Monday morning shoot) would allow you to use it on Friday night, as well as on Saturday and Sunday. On a fourteen-day schedule, your six-day week could go from Saturday to Thursday, with Friday as your off day, for two consecutive weeks, then you could shoot on Saturday and Sunday and return your equipment first thing Monday morning. Hence, you would be able to shoot for fourteen days for the price of two one-week rental fees. Under a standard Monday through Friday shooting schedule, you would incur three weeks' rental fees on equipment for those same fourteen shooting days.

Similarly, with a location rental, if you are able to characterize the rental as a weekly—rather than a daily—and squeeze more shooting days into the calendar week, you will incur fewer costs.

Reduce the Number of Shooting Days

If your director is well prepared and conscientious, and your director of photography is flexible and fast, you should try to limit shooting days to

those that are absolutely necessary. For every day of shooting, you pay your entire cast and crew, as well as locations, equipment, and all other daily production costs a prorated daily amount of money. Also, during development and preparation of your film, determine exactly which scenes and shots will be required editorially to tell your story. The biggest cost savings for your film are achieved when it is still on paper and you can cut or simplify extraneous scenes.

Rethink Expensive Sequences

Cost is always a factor and concern in independent filmmaking. If your writer has dreamed up an intricate and expensive car chase, smashing into other vehicles and careering in and out of traffic, this is clearly a logistical challenge for any film. On a low-budget film, it would be a prohibitively costly venture to purchase, rent, repair, and/or demolish multiple vehicles; hire drivers to transport vehicles, as well as stunt drivers to execute the precision driving and crashes safely; and pay a large premium on your insurance policy for potential personal injury and property damage. A car chase also requires the local police to close off and keep the public away from the streets where the filming takes place, paramedics to stand by in case of injury, firemen in case of fire, and multiple stunt drivers and photo doubles for actors in order to pull off the sequence professionally.

The same intensity, excitement, and emotional impact might be achieved by transposing a car chase to a foot chase through alleyways, fire escapes, and a multi-tiered warehouse with interesting shapes and design, and actors who, for the most part, can do their own running and perhaps other non-life-threatening stunts without the need for stuntmen or photo doubles. If you remember the terrific foot chase that director Joe Carnahan staged in the film *Narc*, then you get the idea. Again, it is much easier to reenvision and creatively construct exciting sequences when your movie is still in the script stage. You should attempt to reenvision and creatively construct exciting sequences and maintain the integrity of the picture and its dramatic beats, while reducing extraneous production costs.

Reduce Vehicles, Drivers, Fuels, and Transportation

The case study/cost comparison in Chapter 9 perfectly illustrates the potential increase in manpower and cost of adding drivers and vehicles under a union scenario. Obviously the fuel costs to run all of the added vehicles, equipment, and generators can be significant. Fuel certainly became more significant for everyone, including me, in the summer of 2008, when the price of gas rose to over four dollars per gallon and I was shooting a film that required a twenty-nine-mile drive to the location every day.

Lay Low and Publicize Later

When producing a low-budget independent film, particularly if it's non-union, keep your mouth shut about it and put a lid on your cast, crew, and staff until it has wrapped. If you announce your film in the press and publicize it before you shoot, the chances are it will come to the attention of the unions. Similarly, the local unions are more likely to hear about a movie if crew members and actors are on the street talking about it before shooting begins. Once the unions catch wind of your production, they will call and request a meeting. They will ask to see your budget and try to convert the film to a union contract. If you ignore them, they are likely to show up at your office or on your set, and they have various means to make your life miserable and force you to sign a union contract, or make you jump through hoops to prove that it's not worth their while for such a small film.

There's an old cliché that there's no such thing as bad press. I believe, to the contrary, that there's no such thing as good press for a low-budget film in pre-production. As far as I'm concerned, in our tabloid society, the press is the enemy. I've seen even the most well-intentioned press releases backfire. For instance, agents or managers might not want to see their actors mentioned or listed in the press or film-market advertisement for a low-budget film. (Conversely, actors may be upset if they are inadvertently omitted from a press article.)

Problems always arise when a film's budget is mentioned in the press, irrespective of whether the quoted figure is accurate. If the cited budget is low, public perception of your film will suffer. If it is high, the film is immediately on the radar of the unions, and no matter what you tell them, they won't believe you. As described above, it is always best to avoid union attention in a low-budget film.

Publicity may also alert the permit office to a location you might be trying to shoot guerrilla style, without a permit, or create other types of scrutiny that could otherwise be avoided. Many low-budget films do pull permits for filming where required, but my recommendation is to choose a company or corporation name that does not have the word "Production(s)" in it. This is because permit offices are notorious for alerting unions to film projects and production companies that have just pulled permits for filming. For example, if the company name you are contemplating is "Jack Bell Productions," I would suggest throwing interested parties off the scent by calling it "Jack's Garden Company," "Bell Supply Company," or "Jack Bell's Maintenance Corporation" instead. I started doing this years ago because an individual in the Los Angeles permit office regularly alerted the unions every time a permit application was filed in the name of a production company. Again, my motto is "Film first, publicize later." Finish shooting your film, *then* sound the trumpets. Issue a press release, place an ad in a trade publication, or whatever floats your boat. But get your movie in the can first. Doing the opposite can cost you a lot of money.

Budgeting Software

The industry standard for budgeting motion pictures is Entertainment Partners' Movie Magic Budgeting 7 computer software (available at: www. entertainment partners.com/budgeting/), while the best book on motion picture budgeting is Ralph Singleton's *Film Budgeting: Or, How Much Will It Cost to Shoot Your Movie?* (Lone Eagle Publishing, 1996). All aspiring independent producers and filmmakers should read Mr. Singleton's book and acquire Entertainment Partners' software. It is enormously valuable to gain a working knowledge of how to budget a motion picture based on the actual, real-world costs of actors, extras, stunt performers, directors, writers, crew, camera equipment, locations and permits, film and digital post-production, composers, editorial, special effects, and post-production sound, as well as payroll, administration, delivery, and fringes, all of which constitute a complete film budget. Becoming familiar with both union and non-union rates and fringes, and understanding how to use the budgeting software—which calculates costs based on the fringe formulas that the user inputs—are an eye-opener and will give you an insight into what the true total costs are of producing a movie.

Properly constructing a film budget based on a specific screenplay is a tremendous skill, built on vast, current knowledge of production that goes hand in hand with the schedule you create.

Creating a Schedule for the Picture

When scheduling a low-budget independent film, it is essential that the producer understand the exigencies of production and the impact that the schedule has on the budget and ultimate cost of a film. As was discussed earlier, costs can be cut by consolidating and/or cheating locations to elimi-nate company moves wherever possible, and by limiting night exteriors, which are time-consuming and expensive.

Scheduling Software

The most common software used for motion picture scheduling is Entertainment Partners' Movie Magic Scheduling 5 (available at: www. entertainment partners.com/scheduling/). I recommend buying this along with the same company's Movie Magic Budgeting 7 as a bundle to save money. The scheduling software will allow you to create actual shooting schedules based on budget, number of shooting days, locations, company moves, day interiors, day exteriors, night interiors, night exteriors, actors' schedules, and stunt requirements. You will also learn how to create a "day out of days" for on-camera talent, which delineates precisely how many and which days each actor will work on a given picture.

If you digest and apply the knowledge contained in this book and master the software, you, as a trained and knowledgeable producer, will be able to construct a practical film schedule based on the criteria of any screenplay and budget.

Low-budget Shooting Schedules

Our case study in Chapter 9 had a fourteen-day production schedule. As discussed, under the SAG Low Budget Theatrical and Modified Low Budget and Ultra Low Budget Theatrical Agreements, there is an allowance for shooting six-day weeks. When shooting with higher budgets and/or under standard union and SAG contracts, six-day weeks are not a viable or cost-effective option.

Once again, some of the advantages of shooting six-day weeks are: fewer total production weeks; reduced costs for equipment rental (as most equipment rental houses rent on a one-day week); and reduced lodging costs (by reducing the overall length of schedule and not paying lodging and per diem for two "off" days per week).

Scheduling is an art form based on knowledge, experience, and creative ideas, as well as an ongoing dialogue between the producer, director, director of photography, and first assistant director during pre-production about how to schedule the picture most effectively. Usually, many versions of a schedule will be discussed before agreement is reached. Further, often the days of availability of a critical location or limitations of a star actor's schedule might undermine even the best production schedule, and compromises will have to be made. (A sample shooting schedule can be found in Appendix P.)

Stagger Actors' Call Times

A call sheet is a two-sided sheet of usually legal-sized paper, which is issued on a daily basis by the production and AD (assistant director) staff. It lists the call time for the crew to report to location, availability of breakfast, when work commences, when the crew breaks for lunch, a projected wrap time, precise times of sunrise and sunset, and actors' call times for makeup, hair, and set calls. Call sheets also list all crew and equipment, locations, special effects, special props, stunts or vehicles, and every key element in the day's work, as well as an advance schedule for the following day. (A sample call sheet can be found in Appendix Q and a sample production report can be found in Appendix R.)

A good, cost-conscious producer must constantly keep in mind the actors' contracts: whether they're daily, weekly, or run of show. It is critical to try to avoid the impact of overtime, both in scheduling your low-budget feature and on a daily basis when creating your call sheets. SAG day player contracts stipulate eight hours before overtime. Weekly player contracts

specify ten hours before overtime. And if you have overscale actors, their contracts usually call for twelve hours before overtime. Clearly you would like to create your call sheet each day so as to incur no overtime, or at least as little as possible. Each day, you must creatively strategize with your director and AD before finalizing the call sheet for the following day. You must figure out a logical order of shooting, when specific actors will be needed for specific scenes, in what order they should be shot, and which shots without actors can be held until the end of the day, in order to reduce the amount of set time for actors who may go into overtime. Daily, weekly, and overscale players may be called each day in a staggered order in order to reduce or, ideally, eliminate overtime payments.

Mounting a Production

Tricks of the Trade

When producing a low-budget independent film, there are many simple tricks that I've learned and used in an ongoing effort to maximize production value for the lowest possible cost. I've seen low-budget producers have shirts made with recognizable network news logos on them, which usually get them and a small camera and sound crew into certain areas without scrutiny. I've also seen producers print up business cards that gain them access under certain "perceived" auspices as well.

In "Fast, Cheap and in Control" (*Daily Variety*, February 6, 2008), David Frankel wrote:

> Shooting outside the studio gates offers independent filmmakers much more freedom. Unencumbered by upper-echelon studio execs, independent directors are free to make their own choices and are free to "helm" their project with much more creative leeway. These directors are faced with smaller budgets than indies shot under a studio's supervision but, ironically, the budgetary constraints often encourage and foster more creativity and innovation. This is because independent filmmakers can't just throw more money at a problem to make it go away, like the studios can. Instead of getting lost in the literally thousands of decisions studio directors must make (because they have enough money to do almost anything they could imagine), independent filmmakers are challenged and charged with getting it done for less, and are subsequently afforded the luxury of being able to focus. This may be the reason that all five of the 2007 Oscar nominees for Best Director helmed pictures outside the studio system.

That was a pretty astute obsveration for a journalist back then, and it is even more applicable today.

Production Staff and Pre-production

Pre-production is one of the most important facets of the production of any picture. It is the planning stage, where decisions are critical, and

you'll be forced to live with those decisions throughout the course of the production.

Pre-production is when crew, actors, and hair and makeup personnel are hired; locations are scouted and chosen; extras recruited; production legal work is performed; union signatory agreements (where applicable) are executed; and camera, grip, lighting, electric, sound equipment, dollies, cranes, Steadicam, trucks, wardrobe and cast trailers, picture cars or other specialty vehicles, and all other equipment are rented. All of these items are based on you, the constraints of your production budget, and your schedule. It is during pre-production when you negotiate your post-production editorial and lab deals, as well as your total post-production sound package, all in accordance with your delivery schedule, which must meet both foreign and domestic distributors' requirements. (As mentioned earlier, Appendix J provides a sample delivery schedule that should generally serve both foreign and domestic delivery requirements for a non-theatrical independent feature film.)

Protect Yourself from Personal Liability

In the earliest stage of pre-production, you will set up the production entity, which will comprise not only the company namesake for the picture, but the entity that will enter into agreements with vendors, cast, crew, and union collective bargaining. Make sure that you do not have personal liability in the production entity. Do not use a DBA, which stands for "doing business as." This is only a name and it leaves you personally liable, without the layer of protection afforded by a corporation or limited liability corporation (LLC). In other words, a DBA is no more than a fictitious business name acting on behalf of the individual, and you should never assume personal liability on a motion picture. Always protect yourself.

Hire Motivated Multitaskers

When crewing up for an independent film, you generally get people on the way up or on the way down in the film business who are willing to work for lesser rates than they would receive on a higher budget union production. Find and hire people who can multitask, such as a combination line producer/unit production manager who can work with you to create and hone the budget, and stick to it. The producer and line producer will work with a first assistant director to create and hone a schedule, and together they will oversee and administrate the entire below-the-line of the production. Find a solid production coordinator who can be the fulcrum of communications from the office to the set, and who is also skilled and efficient with paperwork. This person should be able to create wrap files in accordance with your delivery schedules, which will be essential for your ultimate delivery of the picture, which in turn triggers payments. They will

also be responsible for interfacing with SAG or any other guilds in terms of providing the required paperwork and compliances, as well as with accounting and payroll. I heard the CEO of the Container Store speak recently, and I concur completely with his philosophy regarding employees:

- One average person = three lousy people
- One good person = three average people
- One great person = three good people

If your budget can afford it, find a good production accountant who can work alone on a small show. If it is a very complicated production, he or she should have an assistant who has accounting knowledge. I've produced some very low-budget movies without an accountant, using one of my personal assistants or one of the production personnel to do basic accounting runs on Quicken or Quick Books and pay all vendors by interfacing directly with the payroll company. The payroll company calculates cast and crew salaries based on time cards and union pension, health, and welfare rates, where applicable; it also pays all other independent contractors.

Payroll

Find a payroll company in your area that will not only process payroll for employees which becomes the employer of record and provide workers' compensation insurance for those employees. If someone is an independent contractor or has a loan-out corporation (one that is owned by one or more artists and provides services to a third-party production company, often for tax reasons or to avoid personal liability), run that person's checks through payroll as well, so that he or she is covered by workers' compensation insurance. If you are shooting in a state that offers subsidies and your film qualifies, many payroll companies will have offices that meet the local requirements.

Production Office

On most low-budget features, the production office serves as the communication and information hub, from pre-production, through the duration of production, and up to at least a week or two after wrap. As discussed earlier, production offices are generally cheap, no frills, temporary workspaces. Some producers and filmmakers on very small films use their homes as their production offices. On very low-budget productions, I have often closed the production office at the start of shooting (saving at least a month's rent) and set up a room in a trailer or honey wagon as a mobile production office for the duration of the shoot. In that event, I have allowed the production accountant, if there is one, to work from home. They interface by phone and email and make the occasional payroll run in person to the set for the payment of invoices and cast and crew payroll.

When searching for a space to set up a production office for a single film, look for short-term, temporary space and negotiate. Do not just accept terms that a landlord or realtor may try to dictate. Insist on a month-to-month rental and make sure that there is ample parking for crew and staff. Also, try to find an office space that has reasonable nearby parking for production vehicles or trailers if you need a place to park them during prep, production, or wrap-out. If a production office offers additional services, such as telephones, internet, or reception, weigh those costs against what it may cost you to put in similar services yourself for three to four months.

SAG, the Thirty Mile Zone (TMZ), and Locations

The Studio Zone, as we saw in Chapter 10, is the territory within a set radius from an established central point which differs from city to city. In Los Angeles, SAG principal performers may be required to report anywhere within the Studio Zone, provided that, when the place of reporting is somewhere other than the producer's studio, they are paid mileage (thirty cents per mile, based on the distance from the studio to the place of reporting and back, except for certain types of television shows). However, mileage is waived if the place of reporting is within a ten-mile radius of a point designated by the producer, as long as that point is within the Thirty Mile Zone (TMZ).

If the place of reporting is outside of the TMZ and not at the producer's studio, SAG performers are deemed to be "on location." If they are required to stay on location overnight or must travel overnight to reach the location, this is considered an "overnight location." On overnight locations, the producer is required to provide transportation from the hotel to the shooting location and back, and they must pay the actors for the travel time.

Alternatively, the producer may have performers report to a location within the Studio Zone and then shuttle them to a location outside of the zone. In this case, mileage is not paid, but the performers' workday commences as soon as they board the shuttle bus and ends only when they are dropped back at the "report to" location.

Negotiate with SAG as to the physical designation of your production office. SAG has been known to designate a location as a production office hub arbitrarily, and producers should always contest such a designation if it imposes an unfair radius on the production. For instance, in Dallas, Texas, SAG has designated the Las Colinas Studios in Irving as the hub of the radius for the TMZ. I've shot numerous films in Dallas, and my production offices have always been in downtown Dallas, about fifteen miles from Las Colinas, which would limit my radius in moving further away from Las Colinas to only fifteen miles. I have regularly contested this with SAG and the guild has always allowed my downtown production office to be recognized as the hub of the TMZ. Waxahachie, Texas (which I often use for rural

and small-town locations), is just within the TMZ from downtown Dallas. Had I naively accepted SAG's arbitrary designation of Las Colinas as my production office, Waxahachie would be a distant location requiring travel and living expenses for the entire cast and crew, rather than having them simply report to the location each morning and go home each night. In general, never accept what people dictate to you without negotiating, questioning, asking, and thinking outside the box to bend rules, which have usually been made arbitrarily.

Overtime

As we covered briefly earlier, the general acceptable crew deal for low-budget productions is twelve hours plus lunch, with an occasional, but not unreasonable, amount of overtime. If overtime is occasional and not excessive, generally a low-budget, non-union crew will let it slide. However, if it becomes excessive, recurring, or abusive, you should be prepared to pay. A fair formula is to prorate the daily rate into an hourly rate for the crew members and pay them overtime accordingly, with a reasonable increase for the extra hour(s). For example, if a crew member's day rate is $250 for twelve hours, which breaks down to $20.83 per hour, I might pay $30 for an overtime hour.

Local Rules

Learn the local rules, which vary from state to state and sometimes even from city to city. It's always prudent to do research before deciding to shoot in a particular city or state. Below are a few examples, for illustration.

Tennessee is a right-to-work state and offers subsidies. However, Memphis is a quite strong union city, while other areas of the state generally welcome non-union productions. Another example is New York City, where no permits are required as long as a camera platform does not touch the ground or pavement. So, theoretically, one could shoot freely without ever securing a permit by using nothing but a Steadicam or a handheld camera.

Always do your due diligence in the region, city, or state where you intend to shoot, and you might come across other local quirks or nuances that could help (or hinder) your production.

Buy and Return

Another common cost-cutting practice for the independent filmmaker is to buy and return merchandise, if it is in pristine condition. Many indie producers buy props and wardrobe items, use them gently, carefully repackage them, and return them after filming. As an example, on a recent production, we shot a sequence in a large conference room, which had overhead fluorescent lighting. To give the scene a moodier, more somber look,

the director of photography and I went with classic bankers' lamps with tinted glass shades. We needed fourteen to cover the expanse of both sides of a massive, U-shaped conference table, and they were prohibitively expensive, given the film's very small production budget. So we bought them, carefully unpacked them, shot the scene, carefully repacked them, and returned them for a full refund.

Hair and Makeup

Hair and makeup can be critical to any production, particularly if there are wild hairstyles, if it's a period piece, or if there is any sort of special effects makeup. When I was shooting a world premiere movie for the Syfy Channel in Louisiana (mentioned in Chapter 9), we had to create a look for an indigenous Amazonian tribe, very much in the vein of the tribe in Mel Gibson's film *Apocalypto*. So makeup was a critical element in the design of the film. On a contemporary-era film, where nothing extraordinary with hair and makeup is required, actors' hairstyles just need to maintain continuity from scene to scene, and makeup is often used simply to balance the skin tones and assist the director of photography with lighting. Of course, hair can grow over the course of a production, so keeping length consistent is a key job for the hairdresser. Female actors also frequently change their hairstyles—up, down, bangs, no bangs—so keeping the styles consistent while also keeping the actresses happy is critical, particularly when shooting scenes out of sequence.

Almost all films are shot out of sequence. Imagine you're shooting an action film. For a fight scene, a bruise or scar might be logical or scripted for one of your key actors. When the scar appears, it's critical to keep it consistent thereafter. Or, if there is a time progression, you must consider what the scar would look like as time goes on. Finally, if you shoot scenes prior to the appearance of the scar, it better not show up before it is supposed to. As you can see, when shooting out of sequence, makeup artists must keep a close eye on continuity.

Grip and Electric

Grip and electric equipment are indispensable components of any feature film. On a movie set, there is a hierarchy within the crew that goes from the producer to the director, who delegates his or her cinematic vision to the director of photography, who delegates to the gaffer, who delegates to the key grip. It's almost like the chain of command in the military.

The grip department's main function is to use the tools at its disposal efficiently to control the light in such a way that it enhances what the gaffer (the head electrician) is trying to accomplish when creating the "look" that the director and director of photography desire. When we talk about the "look" of a film, we're basically describing the visual tones. A director and

director of photography may decide that they want a high contrast look, desaturated, a warm or cool visual look and style. The various tools grips use to accomplish these effects include flags, scrims (nets on wire frames of different densities that, when positioned in front of a light, reduce the exposure according to the density of the net), diffusions, and gels. For example, if the director of photography wants to drop the F-stop, or the exposure level, a single scrim reduces the exposure level by one stop, a double scrim by two stops, and so on. You can even have half-scrims that cut the light off one part of the set but not elsewhere. Meanwhile, solid flags completely cut the source light, and diffusions and gels soften and change the texture and the look of the light. All forms of equipment that serve as platforms for lights, whether they are hanging lights or lights on stands or scaffolding, are the responsibility of the grip department.

Almost any time the camera is moving, it's on some type of dolly. The camera dolly is a very complicated piece of equipment, a moving platform that fluidly transports the camera without bumps and allows the lens height to raise and lower, often simultaneous with movement. The key grip has responsibility for moving the camera dolly through the shot. Today a Steadicam—essentially a mechanical harness worn by a camera operator, with an arm that holds the camera on a gyro mount and allows it to move fluidly—is common on almost every film, although the movement is not as elegant as with the stable fluidity of a dolly shot. Assisting and securing the Steadicam operator during a shot is another responsibility of the grip department, as are cranes and jib arms, which serve as long, counterweighted extension arms for the camera. Today's jib arms have "hot heads," which allow the camera operator to control the camera and operate focus, zoom, and iris remotely.

As we have seen, the look of a film is determined largely by the lighting, and movie lights usually require far more power than a normal household circuit can accommodate, so film productions almost always carry generators. On a low-budget film, these may range from 250 to 1500 amps. The gaffer generally determines the size of the generator(s) that the production will need, based on the size and power requirements of his lighting package. The general mathematical equation for amperage calculation is 8.3 amps to every 100 watts.

As mentioned above, the gaffer is the head electrician, so they are in charge of realizing the director of photography's lighting plan from scene to scene and shot to shot. The grip and electric departments work together closely, and other crew electricians maintain the generator, run cables from the generator to the lights, and follow the gaffer's instructions to the letter.

The gaffer will always try to have the generator as close to the set as possible without disrupting production sound, because distance in electricity is critical. As the length of cable from generator to lights increases, more power is needed. For example, if you are shooting in the desert and it's an environmentally sensitive area that requires the generator to be placed a mile

from the set, substantially more power will be needed, because voltage drops with distance, hence the need for a bigger generator. A larger power plant is more expensive and uses more fuel, and long cable runs demand more than the average cable rental as well as extra time and manpower.

You should always try to get the "Neiman Marcus look at a Target price." If there is cognitive collaboration between the director, the director of photography, and the gaffer, they can always find ways to make the most of limited funds and resources by using available light, light-emitting diodes (LEDs), smaller tungsten lights, and smaller lighting packages in general, as well as limiting or eliminating shots that require large power consumption. In low-budget filmmaking, look for a director of photography and a gaffer with reputations for working within the parameters that the production can afford.

The director of photography, gaffer, and electric department can use many different types of lights—from tungsten or incandescent to hydrargyrum medium-arc iodides (HMIs), fluorescents, and LEDs. When discussing the spectrum of light, we are actually referring to different color *temperatures*. Tungsten lights project a warm temperature. HMIs, which are more powerful and costly, were developed from the old-school arc lights that were used in the golden years of Hollywood. The latter were huge lights with two deep-carbon probes that were moved in and out by an operator to control an enormously bright arc of light, almost like a welding arc. This spectrum of light was close to that of sunlight. Today, HMIs are used to recreate both daylight and moonlight, but they are a more expensive option.

For a typical low-budget film, you might use a three-ton or five-ton grip and electric package on one truck. (There are ten-ton packages, big forty-footers, and on bigger-budget movies there may be a forty-foot semi-rig just for grip equipment and another just for electric!) A three-ton grip and electric package is common on a low-budget movie. The smaller truck will contain an efficient amount of tungsten and HMI lights and stands, as well as a fairly standard grip package. Good rental houses have everything arranged so that each item has a place, and the equipment is very easily loaded and unloaded from the truck.

Shooting with Multiple Cameras

When shooting with two cameras, it is important to choose angles that are dynamic, distinctly different, and will cut together editorially. If you are shooting with two cameras facing each other on a 180-degree axis, when those are intercut editorially, the eye line of one or the other angle will not be correct. I shot a film once with a Chinese director of photography who claimed that, in China, there was no line. (Here, "line"—also known as "axis of action," "continuity line," or "180-degree line"—refers to an invisible line that runs through a scene, often between two key actors. The camera can shoot from any position within one side of that line, but it must

never cross it. This convention ensures that the shot will have consistent spatial relations and screen directions. If the camera "jumps the line," the 180-degree rule will be violated and continuity will be impacted.) He uniformly placed two cameras in positions where the eye lines were consistently incorrect on one angle or the other.

Often directors who are accustomed to working with two cameras will set one camera for a master shot and another for a close-up, one camera from a high, wide angle and the other from a low angle with a tighter, longer lens, or vice versa. When shooting multiple actors, two cameras can be quite beneficial: for instance, when shooting either a wide shot and a close-up simultaneously, or two close-ups at the same time. There are instances, however, when two cameras can become cumbersome, so it is important to know when to retire one of them for a particular shot or sequence. Your director of photography will generally let you know if the lighting, space, or angle is feasible to get usable and well-lit shots with two cameras.

Print and Pickup

Often, due to a variety of factors—including time constraints, actors' performances (or lack thereof), actors "going up" on (misspeaking or forgetting) their lines, or if a camera move is particularly complex or time-consuming— a good producer and/or director will print and pick up. By this, I mean that the shot, camera move, or performance is good up to a certain point, and the director (either instinctively or as instructed by the producer) will print the take and then pick up the scene from that point onwards, knowing editorially that there will be intercuts to bridge the two takes. Printing and picking up long or complex scenes obviates repeating difficult camera moves, saves time as the scene does not have to be shot again from the beginning, and saves film stock, developing, and processing costs (if you happen to be one of the remaining few who shoots on film). For a long or complicated scene, or one that has a large amount of dialogue that the director may want to stage in different areas, he or she may divide the scene into segments, cutting after each segment and picking it up from the next camera position, camera move, or actor's change in action. (An example of a change in action is when an actor falls out of frame from a punch. The director may then cut and pick up from a new angle, with the actor falling *into* frame.)

If, as producer or director, you have unlimited time, funds, and resources, shoot as much as you want. But in the independent world and in television, where time is money and resources are limited, print and pickup is a valuable tool.

Loss and Damage

Loss and damage insurance, referred to in the industry as L&D, is prevalent on almost every film. HMIs can be very expensive: for example, a broken

lens for a 12k HMI costs about $3000 for the lens and $2000 for the globe if it breaks or blows. We talked about the importance of production insurance in Chapter 9, but even with insurance there may be a deductible of between $2500 and $10,000 per incident. On one of my low-budget productions, the driver lost control of the grip and electric truck on an icy mountain road and crashed. The truck was totaled, as was all of the grip and electric equipment contained within it. That's why insurance is critical.

Every filmmaker should cultivate a good relationship with a solid equipment rental house and the people who run its day-to-day operations. They are your lifeline during production if equipment malfunctions, if there are broken or blown-out globes in lights that are imminently needed, or if any number of other issues arise. Remember that good relationships with filmmakers are also important to the rental houses. They are hoping that the filmmaker will continue to make movies, and that the relationship will be mutually beneficial over the long term, with the filmmaker remaining loyal to the rental house because the rental house continues to provide exemplary service with a smile.

Your department heads must manage their crews with a responsible eye on taking care of and returning all production property in good condition. Crews are notorious for being less than careful or attentive with grip and electrical gear, walkie-talkies, props, and wardrobe, to name a few categories. By contrast, camera crews have such respect for cameras, lenses, and related equipment that they tend to care for their gear meticulously—they are generally much more responsible than any other department.

Vehicles and Transportation

Often, on low-budget pictures, there is neither money nor line item for picture vehicles (cars that actors drive as their characters' vehicles). If the vehicles are not involved in stunts, a great money-saving device is to borrow actors' or crew members' personal cars.

As far as equipment goes, as we have seen, low-budget films generally combine grip and electrical equipment on one truck, and the generator can often be towed behind it. There is almost always a camera truck, too. I have frequently rented a small cube van for this purpose, which can also accommodate the sound cart. And I often use another cube van for the art department and set dressing. If budget allows, there is usually a hair and makeup trailer as well, sometimes referred to as a "combo," which is towed by one of the other vehicles. On non-union, low-budget pictures, key crew members generally drive their own department vehicles; on a larger union show that is signatory to the Teamsters, dedicated drivers would be hired. On some low-budget films, I have been able to negotiate just two Teamster drivers—usually for the honey wagon and the camera truck—and the union

has allowed crew members to drive the other vehicles. Such deals have to be negotiated from picture to picture.

Whether union or non-union, the transportation department determines where best to park the vehicles so that they are close by but out of frame for any planned exterior shots. The transportation department also works with the key grip and the gaffer to determine the best position for the generator in terms of accessibility and shortest run of electrical cable and whenever possible shielded behind hard surfaces, such as a wall or a building, so that generator noise is not heard on the soundtrack.

Fuel Costs

Fuel costs can be a significant factor on a low-budget picture. If you are driving to a location that is more than thirty miles from your production office, the production must pay mileage money, as indicated earlier, to both actors and crew. On a normal shoot, the main generator, as well as the smaller generators for the actors' trailers, the honey wagon, the hair and makeup trailer, and all the production vehicles need to be continually refilled. Therefore, transportation and fuel costs must be carefully calculated and factored into the production budget.

Security

At the end of each shooting day and on intervening off-days, if the crew and equipment are not returning to a secure studio location, hundreds of thousands of dollars of equipment and vehicles might be left unattended. So productions must invest in a nightwatchman or a security guard to safeguard that there is no vandalism, loss, damage, or theft.

Shooting out of Sequence

Almost every film I've ever made has been shot out of sequence (the exception was *The Boys in Company C*). For instance, you might shoot the beginning of the movie and the end of the movie on the same day, because they both take place in the same location. We discussed earlier that consolidating or being creative with scheduling is one of the most cost-effective ways a producer can make a movie. We also mentioned that shooting out of sequence creates continuity issues for almost every department—from wardrobe, props, and set dressing to hair and makeup. The script supervisor oversees continuity for the entire film, but actors have specific responsibility for continuity of their characters and performances: they should remember the physical moves or gestures they have used throughout the printed master shot and then match those moves or gestures in each subsequent shot, such as a close-up. A loosely used term, "matching" is critical for editorial continuity, and synergy among cast, camera, and script supervisor

is vital. The director of photography and the gaffer are responsible for lighting continuity from scene to scene. Even the transportation department has a responsibility for continuity involving picture vehicles.

Meals

Food is always an issue. An old adage in film production is that "a crew works on its stomach," meaning that money is well spent on providing ample and good-quality food for your crew. During production, food is divided into two general categories: on-set meals and craft service.

On-set Meals

These generally include breakfast and lunch. Almost all productions provide the crew with a walking breakfast. If they choose to eat it on set, they need to do so half an hour prior to shooting call. Lunch is always provided six hours after crew call and usually lasts half an hour, commencing from when the last person has gone through the lunch line. Lunch for a standard, reasonably low-budget production is provided by a caterer who has expertise in serving film production crews. Numerous caterers are usually available to feed your cast and crew for $12–15 a head for breakfast and lunch, but such companies tend to have relatively limited menus. Generally, the crew then works six hours from the end of lunch to wrap.

It is essential that accurate information is communicated to your caterer on a daily basis. Be sure that you have the correct headcount of crew, cast, and extras for each day in advance. Sometimes you may want to provide boxed meals for extras, which can be more cost effective than a fully catered meal and is generally perfectly acceptable. Any adjustments in crew call that might change at the end of the shooting day if overtime is incurred must be communicated to your caterer. Remember that caterers leave right after lunch to shop and prepare for the next day, so it is vital to keep an open line of communication with them.

An alternative to catering is to order from local restaurants or healthy fast-food establishments that are acceptable to the majority of the crew. On a Syfy Channel premiere movie I produced in 2008, I took great pains to ensure that the crew was provided with a home-cooked lunch, with a choice of meat and a variety of vegetables. I then discovered that most of the crew members were not eating the catered food, but were instead ordering fast food every day. On low-budget films, consider discussing meals with your department heads to arrive at a consensus before deciding how to spend money on food. You might be surprised to find that the crew's preference is more cost effective than your catered option. Actors are usually a different story, though.

When going down the non-caterer route, I have made deals with some restaurants for either free food or discounted rates in exchange for a credit

in the end titles of the picture or featuring a shot of their restaurant on screen. Freebies are unlikely these days, but discounts can usually be negotiated. Be sure to provide alternatives to fried, high-fat meals. When providing meals without a caterer, you will need a completely trustworthy production assistant (PA) to ensure that plenty of hot food is delivered to the set on time and presented in such a way that the crew can get through the line expeditiously and eat. Also make sure that the crew has a dry, warm place to sit and eat if the weather is inclement, or a place that is shaded from hot sun.

Craft Service

This generally consists of a couple of folding tables laden with refreshments, such as fresh coffee, tea, bottled water, soft drinks, snacks, and fruit, usually bought in bulk from a discount store like Sam's Club or Costco. A dedicated craft service person, usually hired at more than a PA's pay rate, keeps the tables stocked at all times. Good craft service people also often make snacks or sandwiches and offer them to crew members on set in the late morning and late afternoon (of a conventional day) as an energy boost. In the old days, producers used to provide beer at wrap, but we can no longer afford the liability, given today's litigious society.

Second meals are sometimes necessary if a production incurs overtime. As discussed above, a normal low-budget production day is twelve hours plus lunch. However, if there is a wrap-out from a particular location—that is, equipment needs to be packed into the trucks for a move to another location—you need to factor in a second meal for any crew members who are involved in the move, as they will be working more than six hours after lunchtime. Likewise, if you are shooting beyond the six-hours-past-lunchtime stipulation, a second meal must be provided for cast, crew, and anyone else who is still working.

The beauty of staying in one location for multiple days is that if your production day is a "walk away" (meaning that the equipment can stay where it is overnight and production will continue on the same set the next day, without having to wrap-out), you can shoot right up to your six-hours-after-lunch deadline without having to pay for a second meal.

Seek Local Hires

Whenever possible, hire locally. To reiterate, every time you hire someone outside of your city, zone, or region, you incur additional expenses of mileage, airfare, rental cars, drivers, hotels, and per diem (meals expenses). Generally, $50–65 a day for most cast members' per diem is acceptable, but stars may get $100 or more, even on a low-budget feature. The latter also usually get rental cars, paid for by production, as well as ground transportation to and from airports and to and from the set. These costs can add

hundreds of dollars per day, per person for the full duration of a production. Multiply this by the number of non-locally hired actors and/or key crew members and thousands of dollars might be added to your production costs. So choose local cast and crew whenever they can be found.

The Editor and the Director

The editor is the creative technician who pieces together the raw footage each day during production, and constructs every scene in the motion picture in accordance with the desire of and the design created by the director and the director of photography. He or she assembles the dailies (every shot from every scene filmed on a given day), including master shots, close-ups, over-the-shoulder shots, inserts, and various other angles, into edited scenes. Likewise, scenes are ultimately cut together in linear fashion to create a full assembly of the picture. An editor's assembly is usually an intentionally long cut of the picture, which includes almost everything shot during the production period. This gives the director the maximum amount of options when he or she comes into the editing room to work alongside the editor to accomplish the director's cut.

During this latter stage, the director will work collaboratively with the editor to fine-tune the cut of the picture, hopefully to the running time required by the producers and/or distributors. If the picture is non-DGA signatory, the director can be dismissed at this point, if the producer so desires. However, if it's a DGA-signatory picture, the director has creative rights that the guild has negotiated and established over several decades. Those rights ensure that the guild-signatory director is allowed to be present throughout the post-production process.

So, your contract and whether your director is union or non-union will determine how much flexibility and control you, as the producer, will have during the post-production period. If the director is non-union, you may wish to keep them on board and provide editorial notes for the type of picture that you know you have to deliver to the marketplace. If they prove resistant to your guidelines, you can always exercise your right to dismiss them and recut the picture to deliver the film that has been sold to the distributors.

I can't tell you how many times I've hired a director to do a specific genre picture only to find that they are trying to make an "arty" film which they believe will gain them a reputation as a "serious director." If they are non-union, I always dismiss them after shooting and recut the picture so that it satisfies what the studio or other distributors expect and require. In another instance, on a DGA picture, an abusive, disgruntled director of some note attempted to subvert my post-production process. I called the DGA and asked a representative to visit the editing room during the sound mix to keep the director in check. (Under DGA creative rights, I was allowed to do my cut and sound mix and make other final decisions, but the director was allowed to be present at each step of the post-production process and

opine in his angry and volatile way.) Of course, the whole situation was vastly uncomfortable, and although I was a member of the DGA for many more years, thereafter I would never hire a union director who might subvert or impede the post-production process. If I, as the producer, am the employer or financier, or if I am responsible to the financier, I prefer not to put myself into a position where I can't completely control the completion and delivery of the picture: A dictatorship—not a democracy!

Music and the Composer

The composer creates the musical score for a motion picture. Music is one of the most important components of any film. Inappropriate or bad music over any scene can ruin otherwise great work; conversely, exceptional music can substantially enhance mediocre work. Music can evoke great emotion and change the entire experience of the audience. Composers create the composed score, meaning the non-vocal underscore of the film, and often also supply songs that may be used as source music (such as when a song is playing on the radio in the background of a scene) or as source score (when a song is played as though it's part of the score, not in the background).

A film score is usually original music written to accompany a specific film, and as the director and composer "spot" through the movie, they decide which scenes or sequences would benefit from a musical underscore, and which can play "dry" (without music). The score comprises a number of compositions, usually orchestral, instrumental, or electronic, which can range from something as simple as a low, sustained note or chord or percussion rhythms, to a fully orchestrated piece, which are collectively called *cues*. These are timed to begin and end at specific points during the film and are designed to enhance the dramatic or emotional impact of a scene or sequence. Scores can be electronic or orchestral, and performed by an ensemble of musicians, a full orchestra, a band, soloists, a choir, or even a single vocalist. They are recorded by a *sound engineer*.

One film comes to mind—*The Firm*, starring Tom Cruise, in which the entire score, as I recall, was composed and played on a single piano, although there were source cues from popular music groups as well. Source music is preexisting music that can be heard in the scene, as opposed to the score or the underscore. Source cues may range from music emanating from a radio or in an elevator to performers (like a band) actually playing one of their songs on screen. These songs are usually not considered elements in the film's score, although they do form part of the soundtrack.

On one of my movies, there was insufficient time for the composer to gather or create and record any source cues. So, over a weekend, my music supervisor and I went into his recording studio, where we wrote and recorded several original songs that we then placed in the picture for free. However, we have received royalties on them ever since.

Scores encompass an enormous variety of styles of music, depending on the genre of the film and the director's creative vision. Some now feature both live instruments and electronic sounds, whereas others use digital samples to imitate live instruments. Advances in composition software have enabled some composers to create *and perform* entire scores on their own, without the need to hire any other musicians. There are also many royalty-free and zero-fee online music sources. However, as an independent producer, if you can afford to pay even a small amount to an aspiring composer for an original score, and you are able to negotiate and retain the publisher's share of the royalties, you will have an additional worldwide revenue stream as soon as the film starts to play on television. The American Society of Composers, Authors and Publishers (ASCAP) and Broadcast Music, Inc. (BMI) are the two leading U.S. performing rights organizations for song-writers, composers, music publishers, and music rights management. They both collect license fees from businesses that use music and distribute royalties to songwriters, composers, and music publishers. (A sample composer agreement can be found in Appendix S.)

Extras

Extras, also known as background players or background actors, are generally nonspeaking persons who appear on camera. In films or television shows, you might see them in restaurants, walking on streets, in crowd scenes, in office buildings, or in any other on-camera, nonspeaking situation in which people should appear. Also known as "atmosphere," they give real-life credibility to scenes in every movie.

In a low-budget theatrical contract, the Screen Actors Guild requires that the first thirty extras each day must be SAG extras. SAG extra rates in a Studio Zone such as Los Angeles are for eight hours, plus fringe, payroll tax and payroll fee, and overtime (time and a half), calculated for all hours worked beyond eight. So, for a twelve-hour day, every SAG extra will cost you over $300. Once you have reached the stipulated thirty SAG extras, you may hire non-union extras. However, under the SAG Ultra Low Budget Agreement, you may hire *all* non-union extras. Extras casting services provide both SAG and non-SAG extras and are easily found locally. Almost all city or state film commissions will have local listings, and many will offer a creative directory for local extras casting agencies.

I filmed the movie *Half Past Dead 2* in Los Angeles completely non-union except for the SAG, but I still paid an exorbitant premium as a result of that guild's union extra rules. We shot various sequences of a prison riot over a four-week stretch, which required numerous extras and background stunt performers on a daily basis—a huge expense for a low-budget film. However, this was a calculated decision, since I had found a women's prison in eastern Los Angeles that provided everything I needed in one location for the entire film. Basically, I paid for the union extras in

order to eliminate the greater costs associated with drivers, fuel, and several company moves.

In a right-to-work state such as Texas, non-union extras cost around forty dollars per day, depending on how they are hired, hours worked, and where you are shooting. To be clear, in a right-to-work state, although you may be SAG signatory for actors, you can still hire non-union extras without violating your collective bargaining agreement. As noted above, thirty SAG extras might cost you over $9000 per day, while thirty non-union extras might cost as little as $1200 per day. So, when budgeting a production that requires a large number of extras, you must consider the financial impact of union versus non-union.

Producers Set the Tone

A producer should be a charismatic leader who possesses the ability to rally cast and crew, but should also be clear and decisive and not victimized by anyone. (A good director should also possess these characteristics.) If there is a troublemaker on set or in the office, the producer should dismiss him or her and find a replacement at the earliest opportunity. Everyone is enamored with the idea of working in production, but most people don't realize what hard and unglamorous work it is. Only when this reality hits home do some people discover that they simply do not have the aptitude, work ethic, or desire to make it in the film industry. If one of your employees has reached this realization, it is in everyone's best interests to let them go.

It is always preferable to have a good working relationship with your director. However, many directors view the producer as the enemy, the cop, the warden, the monitor, or the person who stops them exercising the full breadth of their creative vision. Do not buy into this. *They* work for *you*. Hone your skills as a producer/filmmaker and be prepared to step in and take over, if necessary. Dictate to the director what needs to be done to complete a day's shooting or even the entire film. You are not trying to win a popularity contest. If a director consistently subverts you or undermines the type of film you are meant to deliver, make a directorial change. If your production is signatory to the DGA, make sure you comply with the guild's succinct guidelines regarding how to do this.

Make sure you deliver the film that the marketplace expects and desires, and that your buyers want. It is your job to protect and serve your investors, your distributors, and your audience. As I mentioned above, directors will often attempt to subvert the genre film that you hired them to make and will try to shoot an artsy film instead. If the buyers and the marketplace happen to want an art film, your script is perfect for an art film, and your investors have agreed to finance an art film, then let them get on with it.

However, if the buyers, distributors, and/or investors are expecting an action film or thriller, don't allow your director to manipulate and undermine what you've been charged with delivering. Watch the dailies

religiously! For each scene, make sure the director is getting proper "coverage" (sufficient wide shots, close-ups, master shots, and other angles, so that when all are edited together, the result is a visually pleasing scene that tells the whole scripted story and includes all of the scripted action), that the key events are highlighted cinematically, that the performances are appropriate, and that the genre is served.

Be assertive from the beginning. Most directors do not understand the business or the marketplace. Don't wait until two weeks into production before putting your foot down. Do it on day two, if necessary, as soon as you've seen the first day of dailies. If the director is not serving the project in a way that you believe it should be served, give him or her specific instructions. Dictate shots and coverage, if necessary. Wherever you feel they are needed, insist on pickup shots. (These are usually shot after the main action. Often filmmakers will look at a cut of the fully edited film and then list any pickup—or insert—shots they feel are necessary to complete the movie or heighten a specific moment cinematically. Inserts shots are usually close-ups that draw attention to a specific action or detail that has already appeared in a wider shot. Examples in a car chase sequence might be close-ups of hands on the steering wheel, a foot on the accelerator, a tight shot of the speedometer, the car's spinning tires, or a hand on the gear shift.) If the director resists, don't hesitate to replace them.

Real Producers Are Filmmakers

Low-budget films that make money are the producer's medium. Low-budget art films that lose money are usually the director's medium. Occasionally the two mesh and work synergistically towards the same goal, but all too often they come into conflict, with covert agendas that ultimately subvert the film and its commercial viability. In general industry vernacular, the term "filmmaker" refers to the director or the writer/director. But I believe that the multiskilled producer is also a filmmaker. Just as some directors—such as Steven Spielberg and James Cameron—have become brands, talented men from whom the audience knows what to expect, there are equivalent branded producers, such as Jerry Bruckheimer, Scott Rudin, Brian Grazer, and George Lucas. When an audience sees one of their names on the credits of a film, they expect high quality or a certain engaging genre. Be a producer/filmmaker. Know every aspect of filmmaking and trust your creative instincts.

After Wrap

The final paychecks for all crew and cast should have been issued within one week of completion of principal photography. SAG will issue a penalty if any actor has to wait longer than this to be paid. On most low-budget pictures, the production office should be closed by the end of the second

week of wrap (the second week following the completion of principal photography). All items to be returned to stores or vendors should have been delivered, final paychecks for vendors issued, and an entire wrap binder—in duplicate, containing everything necessary for the delivery of the picture in accordance with the delivery schedules—delivered to the producer by the production coordinator.

There will always be nuisance items—things that have been overlooked, neglected, lost, or stolen; checks that may need to be reissued; and myriad other problems that will fall into your lap after everyone else has left. Be prepared to handle these, and keep a contact list of all crew, cast, vendors, and personnel to follow up and ask any questions that might shed light on a problematic situation. If there are any loss or damage claims during the wrap period, they should be settled by this time as well.

When the general public hears the words "film company," it immediately puts out its hand, in the assumption that movie productions are always awash with cash. *Cry poor.* In the independent world, there are no deep pockets. Rarely, if ever, is there any studio or network involvement during production. Tell everyone, "There is no money." Negotiate every claim to secure the best deal you possibly can.

Chapter 12

Navigating the Actors' Union

SAG–AFTRA

As we've covered earlier, if you want or need a "name" actor in your movie, or simply professional actors, your production company must become signatory to the Screen Actors Guild (SAG), which merged with the American Federation of Television and Radio Artists (AFTRA) and now functions under the official title SAG–AFTRA, which I've referred to throughout as SAG. The guild represents almost every professional film and television name actor in the United States. Some disgruntled producers have referred to it as "the Mafia," but, having been a guild member myself for over forty years, I prefer to think of it as a necessary monopoly.

I do, however, have strong opinions about what is beneficial for actors and firmly believe that some perceived guild "wins" have actually been very detrimental to non-star working actors. I also feel that, for decades, the fat-salaried staff and legal and accounting representatives at SAG went to great lengths to keep a lid on the Pandora's box of great wealth the guild amassed by keeping the members away from certain knowledge and facts. They treated the actors like sheep and that they were incapable of running their own affairs, while hired hands and legal and accounting firms made millions of dollars at the expense of guild members. Then a funny thing happened: some actors woke up and decided to get involved in the administration of their own union. Unfortunately, this resulted in bitter feuds between rival factions, in-fighting, discord, and turmoil within the ranks of SAG. Mud-slinging and propaganda now abound between individual actors and their alliances, but still, for the most part, SAG and its members don't understand the independent business, and they continue to hurt themselves with many of their naive decisions.

One such example is "Global Rule One." Melissa Gilbert, when she was president of SAG, along with Bob Pisano, made a political platform of the enforcement of Global Rule One. It states that any actor who is U.S. domiciled *must* work under a SAG contract, even when rendering services outside of North America. In years past, before the enforcement of Global

Rule One, studios, as well as independent producers, shot hundreds of films outside of the United States, attracted by cheap production costs and/or lucrative subsidy deals. I've personally shot more than two dozen films in countries such as Bulgaria, Romania, Poland, Berlin, the United Kingdom, and India, and easily two dozen more in Canada. Prior to Global Rule One, most producers would hire an average of six to eight SAG actors per picture to work on these films. Now, because of the rule, most independent producers hire only one U.S. star to work on a foreign production, casting the other English-speaking roles from the United Kingdom or locally, even if they have to replace (loop) their voices with U.S. accents in post-production. So just *one* star actor gets an opportunity to work, flies first class, receives his or her five-star hotel room and per diem, and earns his or her pension and welfare contributions on top of salary, while *five to seven* other actors, per picture, remain unemployed or continue to wait tables to make a living. The elected and well-salaried geniuses at SAG claim that Global Rule One is good for their members, when in fact it puts large numbers of them out of work.

Additionally, for years, SAG has bemoaned what it terms "salary compression." The guild's own definition of salary compression is paying most of the money to one star while every other actor receives scale. Under Global Rule One, they have not only *exacerbated* salary compression, but have effectively killed the possibility of journeyman actors earning even scale.

Prior to Global Rule One, even for small films that I produced outside the United States (such as *Inferno*, shot in India, *The White Raven* and *The Foreigner*, both shot in Poland, or *Half Past Dead*, shot in Berlin), I hired at least seven U.S. actors, in addition to the main star. But then, from 2004 to 2007, after the enforcement of Global Rule One, I produced and/or financed twelve films in Bucharest, Romania. In each case, I hired just one U.S. star (e.g., Wesley Snipes, Steven Seagal, or Heather Graham) and recruited all of the other actors from the United Kingdom or Bucharest. The Romanian actors worked non-union for very little money, they did not cost the production any travel or living expenses, and there were no payroll or pension, health, and welfare fringes or agency fees to pay. Many of their accents were passable as Russian or another East European dialect, and it was an easy task to adapt the script to make the characters fit the voices, if necessary. Others were looped with U.S. accents in post-production. Hiring locals instead of Americans saved these productions tens of thousands of dollars per picture. Also, most U.K. actors can deliver flawless U.S. accents, which they learn as part of their training. Hiring U.K. actors for key roles saved the productions money in a variety of ways: their rates were lower than those of their U.S. counterparts; airfares from the United Kingdom were substantially cheaper than flights from the United States; and all the actors worked non-union, which saved the productions payroll taxes, pension, health, and welfare contributions, and agency fees.

In short, over the course of just three years, SAG's Global Rule One denied employment to almost a hundred of its members on my films alone!

Residuals

I spent many years and countless collective bargaining sessions as vice chairman and then chairman of the Independent Producers Association (IPA), trying to negotiate a residual structure with SAG that made sense for both the actors and the independent producers, but to no avail. Entertainment unions all bargain with the Alliance of Motion Picture and Television Producers (AMPTP), which negotiates on behalf of all the major studios. Prior to the formation of the IPA, independent companies did not have a recognized collective bargaining body or enough critical mass to be able to negotiate agreements, separate from the studios, which addressed the very different problems inherent to independent production. For decades, independents have been bound to the same terms and conditions that the studios have accepted, with no consideration or understanding of independent issues or our limited resources compared to the majors. This has always been a ridiculously unfair situation for independent companies, but SAG's executive management has turned a blind eye to the concerns of independent producers, and after years of failing to reach an agreement with SAG, the IPA has become dormant, to the detriment of its members.

SAG calculates residuals on worldwide revenues, and there are formulas for residuals for various media, depending on the collective bargaining agreement to which you are signatory. Many years ago, when there was only theatrical and television exhibition, residuals were meant to compensate actors for *reuse*. If, for example, a theatrical film were sold to television (the main supplemental market for a theatrical film at the time) and reused, there was a residual-use formula. The definition of residuals has changed over the years: SAG now calculates them based on exhibition in supplemental markets. However, the definition and reality of supplemental markets has changed dramatically, even for studios, and in many cases (and most cases for independent films) what are termed "supplemental" markets are actually the *primary* markets.

Very few independent pictures get a theatrical release. Video on demand, all forms of television and cable, all forms of internet (now or hereafter devised), all forms of video, DVD, or any successor format in all media in all territories around the world are collectively the *primary market* for every independent film, but SAG fails to acknowledge this. Further, if your production is signatory to a theatrical contract, the residuals formulas have been: 3.6 percent for free television and basic cable; 3.6 percent for pay television; and 4.5 percent of the first million dollars of gross video receipts and 5.4 percent thereafter. When a sales agent sells all of the rights to a particular film in a foreign territory for a blanket price (as is usually the case

in today's market), rarely, if ever, does the sales agent or foreign distributor delineate which portions of that sale might be attributed to theatrical, video, television, and other ancillary revenues, such as internet, new media, airline, ship, and hotel rights.

The independent producer who is signatory to SAG is still responsible for discerning and then trying to calculate residuals based on the guild's obsolete formula, and then accounting to SAG *on a quarterly basis*, without ever receiving any detailed information from the sales agent or any further information from the territorial distributor. Again, in today's market, almost all foreign distributors consider *all rights globally* as their *primary* (not ancillary or supplemental) *market*, to recoup the amount they have paid for the film's rights in their territories. It has always been almost impossible for an independent signatory company to comply with SAG's requirements, and it is even more difficult in today's market and economy. They also cause almost all non-studio producers to be technically noncompliant with guild requirements before a film is even delivered, particularly if bank financing is involved.

I have tried to explain to SAG and other unions that most independent signatory companies cannot be compared to studios and networks: they are either one-off production companies or very small companies that do not have accounting departments or residual compliance personnel. Consequently, it is virtually impossible for the vast majority of independents to comply with quarterly residuals accountings and reporting. Something else that all independent producers should be aware of is that under the current SAG contractual language, a picture might owe residuals (based on supplemental market language) long before the production costs have been recouped. A production may be contractually required to pay SAG actors' residuals before the cost of the film has been recovered or its investors have been repaid. In fact, actors might be paid twice before you've been paid once.

As every independent producer/entrepreneur in the world will attest, there is no longer any such thing in the independent world as a "supplemental market." *Every market in every territory in every medium around the globe is the primary market for an independent motion picture.*

Furthermore, SAG does not realize why its current residual structure is a problem for independents. I have fought long and hard over the years with various guild representatives (aside from those in the DGA, who tend to be insightful, helpful, and malleable) to try to explain the realities of the marketplace. For instance, the IPA negotiated with SAG for years to try to implement a flat 2 percent residual structure for the independents, so that for the various worldwide media there would be no logarithm to calculate and report (which for the most part doesn't occur anyway). Simply 2 percent across the board for any sales and in any and all media would be paid to SAG off the top, thus eliminating compliance issues, which most independent filmmakers can never adhere to anyway.

While SAG continually raised the floor in its collective bargaining agreements with the majors, the independents have had no recourse except to pay scale to every actor except for the star, while also reducing the number of speaking roles, resulting in fewer jobs for actors and exacerbating SAG's "salary compression."

SAG has been somewhat innovative in addressing some lower-tiered contracts that are of great benefit to the independent producer. However, in a couple of these lower-budget collective bargaining agreements, SAG still retains the archaic condition that the picture must have a meaningless "theatrical" release somewhere in the world to meet the criteria of the "theatrical" contract. If there is no such release under the SAG criteria, there are punitive reprisals, all of which are outlined in the collective bargaining agreement. Furthermore, under a standard SAG theatrical or television contract, most independent films could not be made because the rates are too high. Every producer and filmmaker would love to have their film released theatrically, but very few movies are picked up by a theatrical company after completion. By contrast, in its lower-budget contracts, the DGA, the most flexible of all of the entertainment-related unions and guilds, simply insists that there should be *intent* and genuine effort to procure a theatrical release. And there is no penalty if the picture fails to sell to a theatrical distributor.

Today, the theatrical market for smaller pictures continues to shrink. Hence, the chance of a small independent picture getting a domestic, or even foreign, theatrical release has become quite slim. Most producers and sales agents get around this by finding a small foreign territory that has access to a theater with digital projection and then virtually giving away the film for free, simply in order to comply with SAG's archaic condition. The whole process is a waste of time and money.

Production Bonds

Some years ago, SAG started insisting on what it calls "financial assurance bonds." To comply, the signatory production company must put up a cash deposit (so be prepared for this before you start shooting, and include it in the cash flow of your budget) to "make sure that actors get paid." The bond is based on SAG's calculation of your total SAG salaries, which in turn is based on your "day out of days" schedule, including actors, stunt people, and SAG extras, if applicable.

Prepayment of Star Salaries

On any independent film, I always prepay the overscale stars and actors. This brings down the total calculation of SAG salaries and fringes, and lowers the financial assurance bond. Once the picture is completed, it might be six months to a year of persistence before SAG finally returns your bond.

For example, if your bond is $15,000, $20,000, or $30,000, prepare to be without that money until you can get the guild to focus on paying your refund, which it will do only once it has determined that all of your actors have been paid. This determination is evidenced by turning in a final cast list after looping is complete. SAG invariably drags its feet interminably before refunding money to producers.

Be Persistent

SAG is inundated with paperwork and bureaucracy. Your picture will be one of dozens waiting for its bond to be refunded. So be the squeaky wheel. Call your SAG rep personally on a regular basis. Email them. Ask what the holdup is. Ask if there is anything else the rep needs. If you are given forms to complete and submit, do so right away and follow up the next day. Make copies of everything, as SAG is notorious for "losing forms" or claiming it never received them, so be prepared to send them time and again.

Residuals Bonds

SAG also sometimes insists upon "residuals bonds," which it demands punitively, at its sole discretion, seemingly with no rhyme, reason, or consistency. A residuals bond relates to the prepayment of residuals on a picture. SAG may demand one from a particular producer working on a particular film from whom it has never required one previously, and from whom it never requires one again. Meanwhile, a producer of very similar pictures may never have to pay a residuals bond, or may have to find the money for every film they make. Such capriciousness has no place in any business, but SAG gets away with it because it has, since the merger with AFTRA, become a monopoly of almost all of the professional actors in the United States.

SAG Unintentionally Accelerated the Digital Revolution

People have speculated about the demise of film and the advent and rise of the Digital Age for years, but one event prior to the SAG-AFTRA merger precipitated and accelerated the digital revolution in our industry more than anything else. Some years ago, the SAG contract was up for renewal and negotiation with the producers and the Academy of Motion Picture Arts and Sciences (AMPAS). Although there was no strike, there was a perception that one might occur. So, to protect themselves prior to the imminent television pilot season, producers hired actors under an AFTRA contract, as opposed to going under a SAG contract with actors who might go on strike and shut down production. SAG's jurisdiction covered productions shot on film (as opposed to videotape) or intended theatrical productions, while AFTRA's was for television productions shot on tape or

film productions shot on tape and intended for non-theatrical distribution. It was a match made in heaven for television production to switch from the old SAG contract to an AFTRA contract for digital production of television series. Because of the definitions of jurisdictions of these two actors' guilds, and to protect themselves against a SAG strike, producers were *forced* to switch from film to digital. The switch occurred not because of any technological advance, but because of a change in the labor agreement. After a full season of production with these digital tools, a whole new crew base trained in digital production emerged and then went on to other television productions and into motion pictures.

AFTRA had always been the lesser guild, with less power, and then all of a sudden it gained tremendous power because SAG had overplayed its hand when trying to negotiate the new collective bargaining agreement with producers. Realizing it had to do something to halt its demise, SAG, which had pushed for a merger with AFTRA several times previously, now voraciously pursued a merger to create a single union for all professional film, television, and radio actors in the United States, and it finally succeeded in 2012.

Financial Core

Financial core—or "Fi-core"—is, under federal law, a choice that any member of any union may make. It gives him or her technical membership in the guild or union but only limited rights. Fi-core members pay limited dues but they are covered by health and pension plans. Once a person elects to go Fi-core, the decision is irreversible. Fi-core members cannot vote in guild elections or hold office within the guild or union. However, they may work both union and non-union, and when working under a union contract they continue to receive the standard union rates, as well as pension, health, and welfare contributions, and operate under the same rules and protection as full voting members. George Clooney recently became a Fi-core member of the Writers Guild of America after he was snubbed by the guild's arbitration process and refused a writer credit on the film *Leather Heads*, which he co-wrote and directed.

Fi-core has always been a viable option for union members who wish to work both union and non-union. However, SAG, DGA, WGA, and all other guilds consider it their "dirty little secret." The guilds and unions vilify members who choose Fi-core status, because it dissipates their monopolistic power when members realize that they have another option. After the WGA strike at the end of 2007, twenty-eight writers opted for Fi-core status. The guild maligned them publicly in an attempt to frighten and discourage others from following suit. In response, the AMPTP defended the writers and took the guild to task, going so far as to file a claim against the WGA with the National Labor Relations Board. It claimed that the guild had violated federal labor laws by trying to blacklist the Fi-core

writers and deny them employment by ridiculing them as "strikebreakers" and "the puny few."

I resigned from the DGA several years ago because I objected to its insistence on a financial assurance bond for a picture I had written and was directing and financing. It was a ludicrous demand, since I was the only DGA personnel and I was paying myself. I had close personal relationships with two key, amenable guild executives in Los Angeles, but their hands were tied since I was shooting in Texas, which was governed by the New York office, whose staff proved immovable. I floated the idea of becoming Fi-core with my friends at the DGA, but they implored me not to, saying it "would be a dark day" if I chose that option because I would join a list that they would "hate to see me on." Instead, they urged me to resign. Go figure.

Chapter 13

Respect for the Dollar

I've produced movies for as little as $60,000 to as much as $70 million, and the one thing I've learned from producing smaller independent films that seems to go out the window in larger studio films is *respect the dollar*. Studios, due to their ongoing collective bargaining agreements with all applicable unions and guilds, are union shops, across the board, for the production of their films. (Although some studios, from time to time, do acquire films in negative pickup arrangements, and those films might have been shot non-union.) Studios are owned by enormous conglomerates that are publicly traded and have colossal corporate wealth.

In the independent world, my motto is: "Treat every dollar as though it's your own." Whether your film is funded by bank financing, private equity, limited partnership funds, friends' and family money, or out of your own pocket, treat every dollar as though it were your life savings. Production financing is often so difficult to come by that to treat it frivolously, or to squander money unnecessarily for vanity, ego, or simple carelessness because it's not your own, is a shortsighted philosophy for any filmmaker who wants to keep making movies. The most time-consuming, and usually least successful, chore within moviemaking is trying to raise financing. If you are lucky enough to put together a source of funding and your investors get their money back, they will probably roll the dice with you again. So, protect your investors' money at all costs. Use all of the resources at your disposal to ensure that the market value of the film you produce exceeds the investment budget, and likely you will have a source of funding for your next project. Verify everything personally; don't rely on other people's opinions. Do your own due diligence and never take "no" for an answer. As crises arise, and they always do, think outside the box, and you will usually find a solution to almost any production-related problem.

Profit Participations

Even a small, noncommercial film, if produced under studio auspices, is subject to the applicable union rates in every category; and when multiple unions, not just SAG, are involved, salary rates, fringes, and residuals

dramatically increase budgets. Consequently, a film that might cost $1 million or less in the low-budget, independent, non-union world, might cost $3 million in the studio world. Studios also often build overhead fees, financing costs, residuals, certain publicity costs, and sometimes completion bonds into their budgets. Added to that are the studios' distribution and marketing costs, P&A expenses that are often as much or even more than the film's production budget, plus interest on their investment across the board, which push any deferments or potential profit participants so far back that people rarely see any money on the "back end." I'm sure everyone at some point has heard or read about a studio's "creative accounting" and films that have made hundreds of millions of dollars yet still show no profit under the net profit or royalty definition given to a profit participant.

Studio definitions of royalties, net profits, and defined proceeds have been honed over the past century, generally to ensure that movies which make tens, if not hundreds, of millions of dollars show no profit for participants under well-crafted participation definitions. As I mentioned earlier, I liken studio royalties to sightings of Bigfoot: he's often discussed but rarely, if ever, seen.

Any studio movie that does not depend on special effects could be produced for substantially less in the independent world. And lower production costs give an investor or profit participant a realistic chance of receiving a deferment, royalty, or profit.

Residuals Assumption Agreements

In the independent world, once a movie has been completed and everyone else has moved on to their next project, the unions will usually turn their attention to the producer, who is frequently the person who has executed the union signatory paperwork, and start to demand residuals. If you do not own the film, make sure that the owner—or an authorized signatory of the company that owns the film—either signs the union agreements initially or signs a buyer's or distributor's assumption agreement before the picture is distributed, so that he or she is the party responsible to the guilds for residuals. Alternatively, if you have signed the guild agreements yourself and are therefore on the hook for residuals, always calculate a realistic projected amount for applicable residuals and provide a line item for the payment of residuals in the budget of the film.

Bear in mind that if you are the signatory with SAG for a film that fails to pay residuals, the guild will stigmatize you from that point onwards, which will hinder your ability to produce films in the future. It will also file arbitration against the signatory party and, if residuals still remain unpaid, foreclose on the film, meaning the producer or rights holder loses all rights.

Philosophical Differences

In the big-budget studio world, as issues arise, the philosophy is to throw money at a problem. The only question is: how much? The independent philosophy is to figure out a way to get a version of what is wanted or to solve the problem in a creative way, without increasing costs. Anyone can solve a problem with cash (especially when it is not your own money), but that is neither a creative nor a pragmatic solution in the independent film world; nor is it a way for any independent film to make a profit.

During production, any number of events that pose a threat to completing a shot, scene, or sequence in the way it was originally written (erratic weather conditions, locations that fall through, dates that change, an actor who doesn't show up on time, a wardrobe or costume malfunction, a broken prop, a crashed vehicle, equipment problems) must be dealt with creatively, on a daily basis, by the producer, director, and crew. Thinking outside the box, coming up with creative solutions and compromises, is therefore an essential skill in film production.

In one of my movies, the script called for a convoy of military vehicles arriving to quarantine a small town. The local union would not allow picture car vendors even to rent vehicles to the production, since it was not union signatory. (Another example of unions exerting pressure on independents.) I wanted at least five vehicles in the convoy. The rental fee for a single Humvee or military Jeep was $1500, plus $265 a day for just eight hours with a driver (we were shooting twelve hours plus lunch every day, which would have added hundreds of dollars per day solely for the driver), plus $500 each way for delivery and return of the vehicle, plus fuel (which at the time was over three dollars per gallon). Factoring in all fees, expenses, and fringes on a six-day week, a single vehicle for one week would have cost the production more than $6000, not to mention the huge added expense of the union contract, which would have called for union drivers for several of the production vehicles for the entire run of the show.

Ultimately, we found a military Jeep to rent for $1000, *including* fuel, transport to and from the location, and driver—a saving of $5000. Next I purchased a camouflaged SUV for $900 and stenciled "U.S. Army" on the doors. Then I found a camouflaged water truck owned by a local resident who let us use it for free, just for the chance to drive it in the movie. The local volunteer fire department let us use two of their fluorescent-yellow water trucks for free, too. I made "HazMat Unit" stickers and "Biohazard" decals for $250, then applied them to the trucks. Finally, I dressed more than thirty townspeople (who worked for free) in military uniforms and hazmat suits and placed them in and on the vehicles, with others running frantically to secure the town square as the trucks arrived.

In other words, I created a terrific convoy sequence for less than $2500. After production I sold the SUV for $1000, so my net cost for a great sequence was under $1500. Had I acquiesced and gone down the union

route, the same sequence, as originally envisioned, would have cost more than $30,000.

Runaway Production

"Runaway production" is generally used to mean the exodus of film production from California and, ultimately, from the United States. This process began in the 1990s, when union labor costs, and therefore overall production costs, escalated to the point that it was inequitable to film in Hollywood, Los Angeles, or most other U.S. locations. The industry was seemingly mystified by this and started launching research studies to determine what was causing productions to flee.

Warren Beatty and I once spoke to a SAG committee of actors to try to explain why so many production companies were shooting elsewhere. I cited the following reasons:

1. In many cases, the escalated costs of production in the United States exceed the market value of the picture; hence, everyone (including the studios) needs to find a way to reduce their production costs.
2. Much to the surprise of many of the actors on the committee, I explained that SAG was a large factor. The actors' union and its legal counsel continued to make it more difficult, and often prohibitive, to shoot in the United States, because of the increased union, residual, and pension, health, and welfare rates; demands for financial assurance and residuals bonds; voluminous paperwork; lab pledge-holder agreements, which force the producer to get written approval from the guild(s) before moving or transferring any film or video element; guild liens; a variety of other union demands; and, last but not least, threats that actors would not be allowed to go to work unless producers acquiesced to the guild's demands.
3. The willingness of English-speaking actors in Canada and the United Kingdom to work under more realistic terms on independent films made it increasingly attractive for independent producers to avoid SAG whenever possible.
4. Abuses that union employees perpetrated on studios and networks, and the resulting escalation of costs in Hollywood and the United States, exacerbated the problem. For example, in 1981, I was working on a television series on the Warner Bros. lot. Daily production would generally wrap between six and seven o'clock, and for the rest of the evening I would often sit with the Teamster drivers in one of the actors' motor homes, drinking beer and playing cards. I was "off the clock"; but the drivers were not. Finally, at nine-thirty or ten o'clock, they would say, "Well, boys, it's time to punch out and go home," having milked the clock for two or three hours of overtime. The next morning, many of them would put in for forced calls, causing the

studio additional exorbitant and unnecessary increases in production costs. I also met a driver in New York who, with his union buddies' assistance, was working under the name of a dead man, further highlighting the corruption within the industry. The union employees were helping funnel money to someone who shouldn't have had the job, much less be entrusted with driving talent to and from airports, hotels, and the set.

5. A strong U.S. dollar sends producers scurrying to Canada to take advantage of a favorable exchange rate, as well as provincial rebates and massive Canadian content subsidies.

6. The lack of meaningful subsidies in California and most other states also helped Canada lure numerous U.S. productions over the border. (Finally, many U.S. states caught on and, in an attempt to recapture some of the lost production and its revenues, developed their own subsidy, rebate, and tax credit structures. But by then they were competing with dozens of countries that offered even better packages.)

Chapter 14

The Internet and New Media

Loss of Privacy

As great a tool as the internet is for learning, research, and mass communication, it is also one of the most insidious devices ever created. With today's tabloid mentality and a society that embraces invasions of privacy and the pervasive spreading of inaccuracies, rumor, innuendo, lies, and gossip, in my opinion the damaging and slanderous aspects of the internet should be regulated, just as laws govern these infractions in the real world. Fringe online spies and bloggers have become parts of mainstream society, and now even studios kowtow to them. Tabloids have jumped into our living rooms with network and cable television shows that harass and exploit celebrities, causing considerable distress to real human beings, not movie characters. The paparazzi stalk, bully, invade, and endanger those in the public eye, yet the government does little to limit this plague that has infested our society under the guise of news or entertainment.

Lewis Lapham, best known as the longtime editor of *Harper's Magazine*, has been quoted as saying that what gets lost in the Digital Age is context; and, often, it's history that provides context. He suggests, "Without context, you have no cause and effect. The Renaissance, for example, comes out of the rediscovery of classical antiquity. You can't know or appreciate where you're going if you don't understand and appreciate where you've been. We change our tools and our tools change us." We suffer when we lose historical context, even in filmmaking.

Wikipedia

In the ever-expanding internet world, the "hive mind" (also called collective consciousness) is becoming ever more pervasive. With wiki sites (collaborative websites whose content can be edited by anyone who has access to it) like Wikipedia and user-fueled databases like the Internet Movie Database (IMDb), history (and the information that constitutes it) is becoming more about what the collective world *thinks* and less about *facts*.

Sites such as Wikipedia do not allow the sources of real and valid information about the individual subjects they list to correct misinformation,

since facts from the actual sources seem contrary to their philosophy. I once lost a deal because an "unnamed source" had posted untrue information about me on *my* Wikipedia biography. I rectified the errors when I discovered this, but soon my corrections were removed and replaced with more inaccuracies by another "unnamed source". I learned, to my horror, that anyone at any time can make changes and "contributions" to the information in any profile which the world assumes are facts. However, when my assistant tried to correct my biography again, he was banned from contributing to Wikipedia.

Sometimes what is posted is not only inaccurate but subversive or defamatory. Victims are forced to monitor dozens of sites on a continual basis in order to keep their reputations intact, as people naively still tend to believe most of what they read online. However, I was recently buoyed somewhat by a fourth-grade girl who was doing research for a school project. "Don't use Wikipedia," she said. "It's a lie."

Clearly, there are good and bad sides to the "anyone can contribute" philosophy. Since multiple people contribute to wiki entries and articles, they are constantly updated. The more popular a topic is, the more people contribute to it, and the more often it is updated. But this is no guarantee that what appears is accurate. Since anybody can edit wiki information, people who know little or nothing about a topic can spread inaccuracies or untruths. Supporters of the wiki sites claim that such misinformation is corrected quickly by other users, but that is an absurd argument, since it would take tremendous vigilance and manpower to monitor and correct every entry constantly. Consequently, incorrect or incomplete information is especially prevalent in wiki entries about topics that aren't very popular or mainstream.

IMDb

The problems that plague wikis also affect other databases that rely mainly on user input, such as IMDb. IMDb users submit information for inclusion on the database; "moderators" then supposedly verify the new material before allowing it to appear on the website. However, users contribute so much information (a surprising amount of which is grossly inaccurate) that the moderators are frequently overloaded. Consequently, it seems that they either don't have the time to verify new entries at all or they are insufficiently thorough in their research. Entries for popular and current titles tend to be much more accurate than those for older, obscure, or non-mainstream films (i.e., the bulk of independent movies).

I have personally submitted corrections and an accurate filmography to IMDb countless times, and my attorney has written several letters, yet the administrators have consistently refused to make any changes or correct my information. At the time of writing, my profile was missing forty-three of my producer credits while crediting me with several projects with which

I had no involvement. I have resorted to publishing the correct information on my own website (www.andrewstevens.info) and illuminating the fallacies that appear on so much of the internet. Yet most people around the world rely on online databases like IMDb for their information, so we must all continue the fight to correct the egregious inaccuracies that ignorant or malicious contributors post on them.

Google Maintenance

Factions of the internet operate like digital tabloids, hence the rise of "reputation managers"—tech-savvy and skilled people who scour the internet to correct and guard against negative, slanderous, defamatory, and inaccurate postings, or at least push them from the first few Google search pages. It is a sad aspect of modern life that individuals are so vulnerable to online attack that they have to employ reputation managers just to set the record straight.

New Media

When people talk about new media, they are generally referring to the internet, which offers global distribution of audiovisual product, virtually instantly, and allows almost limitless streaming and downloading opportunities for viewers. It's still very much a media "Wild West," although studios and networks are desperately trying to find more effective ways to monetize it. In other words, maximizing profits from distributing filmed entertainment product online.

The internet has already changed conventional distribution and marketing models for ever. Hopefully, our government won't allow the majors and conglomerates to monopolize the internet and new and emerging media, as they have all other forms of distribution. If that happens, it will be a tragic day for free trade and free enterprise. By contrast, if the internet remains free, independent filmmakers will still have access to a global self-distribution mechanism.

Piracy in Music and Film

The internet has been a major source of piracy that has robbed film and music distributors of billions of dollars' worth of revenues, to such an extent that it has virtually destroyed the music business. People still and always will listen to music and desire new sounds, new artists, new songs, but with the exception of major artists, when your favorite tracks can be downloaded for as little as ninety-nine cents or streamed for free, why would the majority of consumers pay an inflated price for an entire album?

In the old days of analog tape, every copy made from a copy was a generation removed from the master, suffered from reduced resolution and

quality, and was, by its very nature, a deterrent to piracy. By the fifth or sixth generation, picture and sound quality were so poor that the copy was worthless, so the copying would stop there. However, with the advent of digital technology, limitless copies could be made from a digital master with no loss of quality. Then, along came the internet, so all of those illegal copies could be "shared." Studios and independents alike are now in a perpetual fight to curtail piracy and preserve the industry. Once a movie or a song is encoded digitally and uploaded to the internet, chances are it will stay there for ever. It is nearly impossible to stop the spread of a movie or an album, especially if it is in high demand. Presumably, the average music or film pirate's mentality is: "Why pay a large amount of money for something when it can be obtained free, with little or no chance of being caught and penalized?"

Meanwhile, the FBI and the Recording Industry Association of America (RIAA)—the trade group that claims to represent the U.S. recording industry—have proved almost powerless to stop the raging epidemic of online piracy. The sheer number of pirate downloads is simply too great to curtail, and the technologies have become so advanced that it is all but impossible to track who is downloading what, and where they are located. These two organizations have focused on busting large pirate rings and illegal distributors. Meanwhile, copyright holders and artists have been hit hard, as their work floats along the information superhighway, out of their control and generating zero revenue.

On many occasions I have made lucrative sales in foreign territories, only for the distributor to cancel, renegotiate, or simply refuse to pay for the film due to piracy. An Italian distributor shared with me that every time he released a theatrical film into the cinemas, people on the streets would be selling pirated DVDs that were cheaper than the price of admission to the cinema in which his movie was playing. He combated this in a unique way, by "pirating" his own movie! He hired street vendors to sell "bootleg" DVDs and collected the "illicit" revenues.

Imagine that you invested your unique creativity, hard work, and money into a film that was then stolen by online pirates. The internet could—and should—be the most profitable distribution medium the entertainment industries have ever known, so fighting piracy and enforcing copyrights online are vital for the security of our business in the future.

Chapter 15

Marketing and Publicity

Studio Campaigns

We discussed key art earlier in relation to independent film sales. In layman's terms, key art is the photographic (or, in the early days of cinema and drive-in movies, the non-photographic drawings, sketches, or paintings) that were depicted on the poster and/or flyer (also known as a sales sheet or one sheet). Over the years, new key art is often produced for highly successful films. For instance, *Star Wars'* first piece of key art featured an artist's rendering of Mark Hamill and Carrie Fisher, with Darth Vader in the background, whereas subsequent designs included more of the cast members, such as Harrison Ford, as they became better known to audiences.

For an independent film without the luxury of studio dollars, you should aim to create the most saleable key art and flyer as cost-effectively as possible. In the old days, before computers and Photoshop, it was a lot easier to composite multiple images through drawings, sketches, or paintings. For example, the key art for *Gone with the Wind*—which features a foreground embrace with Clark Gable as Rhett Butler and Vivien Leigh as Scarlett O'Hara, while Atlanta burns in the background—is an artist's rendering. At the time, without artists' representations, there was no way to composite multiple images with real photographic likenesses. A standard clause in almost every star actor's contract that has survived over the decades is the "non-photographic likeness" clause, which states that the actor will have just three opportunities (usually) to reject an artist's rendition of his or her non-photographic likeness.

Styles of posters and key art for movies have evolved over the years, as have the tastes of generations of moviegoers and audiences. Graphic designers are always trying to be innovative and cutting edge. William Shakespeare said that there are only seven basic stories—everything else is a variation on them. Similarly with key art, almost everything is basically a variation on something that has already been seen in some form or another. With the advent of personal computers, color printers, and Photoshop and other design software, coupled with today's ever-changing technologies, almost anyone with nominal expertise can create quite sophisticated artwork on a

home computer. There are also many cost-effective graphic design companies whose prices have declined considerably due to all of the foregoing reasons, as well as consolidation and competition. Printing digitally, which is more cost effective than traditional four-color printing, a thousand two-sided color flyers might cost as little as $800. Key art also needs to be available electronically in high-resolution files, with English text for North America and other English-speaking markets, and textless for the foreign territories, so that each territory may overlay the local language onto the artwork. However, the time is fast approaching when physical flyers will be obsolete; instead, the image will simply be transmitted from the seller's wireless device to the prospective buyer's wireless device.

Studios still spend huge amounts on multiple compilations (comps) of key art, posters, flyers, and advertising materials—primarily because they have traditionally publicized their movies in this way and can afford it. But I have seen wonderful, virtually free campaigns by innovative independent producers and filmmakers, and conversely have seen lavish studio campaigns costing hundreds of thousands of dollars that were unadulterated garbage. The key to a successful campaign is not what you spend, but good taste, understanding your product in the context of the market you are catering to, and knowing your core demographic. Bad taste is always bad taste, regardless of what it costs.

A case in point is a Warner Bros. picture I produced in 2001 called *3000 Miles to Graceland*, starring Kevin Costner and Kurt Russell. It was an edgy heist/road movie with an impressive ensemble cast, including Courteney Cox (from *Friends*), David Arquette, Christian Slater, Howie Long, Ice-T, Kevin Pollak, Thomas Haden Church, and Bokeem Woodbine. The diverse cast appealed to a very wide demographic, including African Americans, hip young television viewers, and football fans.

An early artwork comp featured a suitably edgy black-and-white group shot of this terrific cast which perfectly conveyed what the movie was about and would have appealed to the core demographic. But this image was never used. The dilemma for the studio and the production company was that, in addition to Russell having certain likeness approvals, Costner had approval over the key art itself! Obviously, the easiest option for the studio's venerable art director was to cater to Costner's ego to get the star to sign off on the key art, which would then be used as the movie's poster. So the shot he submitted to Costner featured him in the foreground (in a more prominent position than Russell, even though Russell was the main lead), dressed in an Elvis costume, with Russell in a secondary position, also dressed as Elvis. (The movie contains a ten-minute sequence in which Russell, Costner, and their crew infiltrate a Las Vegas casino disguised as Elvis impersonators.) Both actors were enamored of Elvis and Costner approved the key art concept and both actors approved their likenesses.

However, Russell had played Elvis years before in a TV miniseries that was well known among his fans, and in hindsight the image of him playing

an Elvis impersonator probably caused considerable confusion among the movie's potential audience. The public had no idea what the movie was about based on the misguided and misdirected artwork. Yet the studio executives had been wary of using the far better black-and-white group shot because of Costner's contractual approval and he could have held up the whole process. So once they got his approval for the "two Elvises" key art, they just went with it, despite my objections in numerous creative meetings. The movie should have targeted a young male audience, which at the time was the largest movie-going demographic, but with two quinquagenarians dressed as Elvis on the poster, the studio's "line of least resistance" resulted in young boys and men staying away from the theaters in droves.

To make matters worse, the trailer also focused almost entirely on the film's casino heist sequence, in which *everyone* was dressed as Elvis impersonator, while an incessant loop of "Viva Las Vegas" played in the background. This further branded the film to the public as the "Elvis movie," which was completely misleading. Audiences had no idea what the movie was about. Fifteen–thirty-year-old males could not have cared less about Elvis Presley, much less Elvis impersonators, and the theatrical release of the picture flopped, due almost entirely to the poor marketing and publicity.

Warner Bros. and the venerable art director probably cost the studio, and my former company, tens of millions of dollars in box-office receipts due to their poor, "easy out" marketing decisions and negligence. Even crazier is that my company was charged hundreds of thousands of dollars for the awful marketing campaign that killed the movie. A junior high school kid on his or her laptop could have created a better campaign for nothing.

Since then, the picture has appeared on DVD and television, and numerous people have told me how good it is. They never saw it during its theatrical release, though, because the publicity campaign convinced them that it was "just some Elvis film," rather than the edgy, darkly humorous, heist picture that it actually is.

Key Art in the Independent Film World

For the independent producer or filmmaker, the trick is to come up with one piece of key art that can serve all markets. On an independent budget, you usually don't want to pay for more than one piece of key art for flyers to hand out to prospective buyers at film markets. The exception to this rule is when you try to pre-sell a movie before locking in a star cast. In such cases it is a good idea to make temporary artwork for the pre-sale process. This can then be replaced with final key art featuring the stars' names and likenesses after the film completed.

In late 2012, I was in pre-production on a family movie with the American Film Market drawing near. I didn't have a star cast in place as yet, so I created some cute temporary artwork for pre-sale purposes. The

film was going to feature an English sheepdog, so I composited a stock photo of a dog, along with some other images that supported the story line of the film. Later, after shooting, I simply composited shots of the film's stars onto the original dog photo and background image and layout. Since I salvaged much of the original artwork, the "redo" cost only $600 in total, not including the printing of the second set of flyers.

As I mentioned in an earlier chapter, having key art and a good flyer has always been critical to international sales. Very few buyers ever want to do any additional creative work, other than overlaying text in their own language (over the textless key art). I have seen buyers purchase rights to a film on the basis of nothing more than the marketing materials, if the film concept was saleable for their territory. I have also seen buyers reject a film on the basis of bad key art, since they do not have the time, manpower, desire, or budget to create new publicity material. Never underestimate the importance of good key art and marketing materials which are critical for sales.

Study Current Film Campaigns

As important as it is for the independent producer to understand the market-place, the market desire for a product, and the market value of a product before the film is made, it is equally important for a producer to understand the marketplace from a marketing standpoint and to be able to guide the marketing materials creatively for successful sales globally. Look at current campaigns for films that are playing in theaters, on VOD or DVD, and on Direct TV or Netflix, and you can educate yourself on the type of key art concepts, including tones and brightness, that are currently successful.

Often a novice producer or sales company will create artwork that is too dark. This is because it is a lot easier for a designer compositing key art to blur lines and add shadows and blackness than it is to do lighter, finer work. Perception is everything when positioning a film in the marketplace, and if the artwork is cheesy, buyers will assume that the film is cheesy.

Still Photography

Production stills are a requirement for any delivery to any territory anywhere in the world. The still photography requirements are spelled out in distribution contracts and sales agency contracts, and they include a minimum number of shots of actors in scenes from the film, portraits of the stars, group shots of stars or key actors who interact in the film, and often shots of key elements in the film, such as a submarine or a dog if they are central to the story line. If a key element is created in post-production, such as a CGI monster or a space ship, still photos must be extracted from still frames of the film or rendered in still frame by the effects house.

In addition to being used in the promotion of the picture, production stills and star portraits are critical in the creation of key art for the film.

If there are insufficient photos to create decent key art, or if a unique concept is desired, often a photo shoot will be arranged to photograph actors or a "set piece" concept specifically for the key art.

Log Lines

Almost all key art for movie posters and flyers have "log lines" (sometimes known as sell lines). These are usually concise, catchy lines (one, two, or three is standard) that assist the visual image in "selling" the film. From a sales perspective, the log line lets the buyers know what the film is— thriller, comedy, horror, or action—as well as a sense of what it is about. Look at log lines of recent films to see what styles are currently trending.

Stars

A general rule is to marquee your stars if they are well known and popular. However, as we covered earlier, be aware that some name actors may have oversaturated themselves in both the foreign market and the home entertainment market, so they may actually be a negative factor for buyers in certain territories. If some buyers react negatively to an actor in your movie, they have probably lost money on previous films in which that actor starred. In such cases, it is probably better to feature the actor only in the credit block, not prominently on the key art (unless you are contractually obligated to do so). Your preliminary due diligence should have clarified which actors might be valuable assets to your film's sales, as well as those who might be detrimental.

Second Level of Sell

In publicity and marketing, another thing that I've embraced over many years is the "second level of sell." A television network executive back in the late 1970s defined this as: "One is the movie you make, and one is the movie you sell." I illustrated this earlier, when discussing the movie *Crash Dive*. In Germany, the film was marketed as a single father trying to find his young son while fighting to save the world against a nuclear threat. The second level of sell was the human drama. In Japan, the second level of sell was the submarine, torpedoes, missiles, gadgetry, and technology. In Korea, the second level of sell was the hand-to-hand martial arts.

Trailers

As discussed earlier, the purpose of the trailer is to attract either an audience to a film or a buyer for a film, for instance in a foreign territory. It is the ultimate sales tool for any film.

Trailers generally consist of a series selected shots from the film, edited to give the audience or buyer a sense of the movie, its genre, cast, and production value in two and a half minutes or less. For the foreign market, less is more—around ninety seconds, and certainly no more than two minutes, works best. Rarely is a film as good as its trailer, since the excerpts are invariably from the most exciting, funny, or otherwise noteworthy parts of the film (depending on genre). Trailers are generally nonlinear: shots and sequences are not necessarily in the order in which they appear in the film.

There is a fine line between "selling" and giving a misleading representation of a film. Often, in independent films, a name star is hired in a smaller, "cameo" role, as fewer days worked equals less money paid to the star. But a trailer may give the impression that such an actor is one of leading players. Trailers can also attempt to skew films that are shot to appeal to a specific demographic in order to attract another demographic. For example, the trailer for a "chick flick" which appeals largely to women may prominently feature an action sequence (which is most likely a minuscule part of the full movie) in order to try to appeal to a male audience as well.

Many "trailer houses," particularly in Los Angeles, specialize in cutting effective trailers that tell, or at least allude to, the story of a film in a highly condensed fashion and generate maximum audience or buyer appeal. As with a picture editor, trailer houses rely on comments from filmmakers and sales agents to hone the creative presentation, best shots, and running time. Film marketing has become a large industry and trailers have become highly polished pieces of advertising, able to present even poor movies in an attractive light. This is one reason why almost all buyers today want to see the finished film, rather than committing to it after seeing only the trailer.

Trailers often begin with a structure similar to the film itself, even if in a nonlinear way, and lay out the premise of the story. Today, they feature numerous editorial devices and effects to enhance the visual montage of the most powerful, funny, or emotional moments of the film, and they usually build to a dramatic climax. Voiceover narration may be used to set up the premise of the film or provide an explanation to enhance the audience's understanding of the plot. Often title cards are used to help delineate a time or place, and sometimes title cards with key words such as "Gripping," "Bold," or "Powerful" may be used to accentuate what the distributor would like the audience to perceive about the film.

Since a trailer is a highly condensed format, music helps set the tone and mood, accentuate key moments, and build to a climax, as in a full feature film. Music used in the trailer may be from the film itself or it could come from a music library, if the score has not been completed by the time the trailer is needed, or if other music supports the montage style of the trailer better than the composed score. In the latter case, you must secure full clearance for worldwide usage in all media for every musical composition contained in the trailer.

As mentioned above, trailers often feature marquee stars or name creators, directors, or producers who may help sell or brand the movie; they also usually feature the contractual credit block for the picture at the end. Finally, for all studio films and many independents, the Motion Picture Association of America (MPAA) rating will appear, unless the film is not yet rated, in which case this is usually stated in a voiceover.

MPAA Rating

In order for a movie to receive distribution in almost every territory worldwide, films are required to have a rating by the MPAA which views movies and assigns a rating. Many distributors will have a ratings restriction in their distribution contract, generally "No more restrictive than R" if it is an action or exploitation film, or "No more restrictive than PG-13" if it is a television movie. However, the MPAA has a double standard with respect to studio films and independent films. It has historically been much more consistently punitive towards independent films, assigning much harsher ratings to them than it does to studio films, and displaying much more leniency to bigger-budgeted studio pictures that contain equal or even more violent or risqué content. As an example, Steven Spielberg's *War of the Worlds*, a very violent film, was rated PG-13. If the movie had been made by an independent company the film would undoubtedly have been assessed an R rating. The MPAA has historically been more punitive with ratings on independent films.

I have had numerous fights with the MPAA over seemingly arbitrarily assigned ratings. After trims and negotiations with the "censors" there, I have usually been able to procure a less punitive rating. A harsh MPAA rating can negatively affect box-office and/or ancillary sales, since the more restrictive the rating, the more restrictions there are for exhibition. An R rating restricts young males under eighteen, a huge part of the movie-going audience, from seeing a theatrical film without a parent. Many R-rated films create television versions that eliminate violent or explicit content.

The paradox is that cable network series and miniseries, particularly on Starz, HBO, Showtime, and Cinemax, have pushed the boundaries of explicit sexual and violent content, even during prime time. This would have been unthinkable ten years ago; and, if rated by the MPAA, most of these series would be classified NC-17. Television has its own rating system; however, unless one sets parental restrictions on the TV istelf, anyone can view the programs.

As an example, on *The Pledge*, starring Jack Nicholson, a film that my company financed and I executive produced, Sean Penn, the director, got into a heated battle with the MPAA over one shot. The movie, which otherwise was a melancholy and lyrical picture, without any nudity or, in my opinion, gratuitous violence, contained a sequence where Benicio del

Toro's character takes a pistol from a policeman's holster, puts the gun in his mouth, and pulls the trigger. The sequence happens abruptly and unexpectedly, but the MPAA decided that that one shot was too graphic. To avoid the NC-17 rating that the MPAA threatened, one of its representatives negotiated over *individual frames* with Penn to secure an R rating.

On *The Whole Nine Yards*, starring Bruce Willis and Matthew Perry, another film that my company and I financed and I executive produced, a choice was made to retain shots in which Amanda Peet exposes her breasts. That decision probably cost the movie $10 million at the box office, since it garnered an R rating rather than the PG-13 that would have been granted if those shots had been cut.

Likewise, on *Angel Eyes*, starring Jennifer Lopez and Jim Caviezel, yet another film that my company financed and I executive produced, the film received an R rating rather than PG-13 because of the massive amount of gratuitous profanity. We had allowed the director a loose rein, and in post-production we found it impossible to cut the unnecessary expletives without reshoots, which we couldn't afford. Lopez's audience at the time was primarily young boys and girls, who couldn't see the film due to the rating (and shouldn't have seen it due to the vulgar language).

The fallacy of the MPAA is that films are assessed by staff members who are paid to view them and assign ratings. Their opinions and evaluations are subjective and vary from person to person, under criteria suggested by the MPAA. These individuals impose their judgments on filmmakers with little consistency, except that they are consistently more strict towards independents. I contend that they are censors in every sense of the word, although the MPAA vehemently denies this. But consider this: if the MPAA gives your film a harsh rating, which can completely undermine its success, its representatives will make suggestions and negotiate with producers on cuts that will satisfy and assuage their utterly subjective opinion. Since there is no rival ratings board, the MPAA operates as a monopoly with total autonomy.

Title Search

Prior to finalizing your delivery elements, you should have a title search done on the title under which you plan to distribute your picture. Organizations such as the Law Offices of Dennis Angel (Scarsdale, New York) and Thompson Reuters Corporation (New York City) research your title in every database worldwide to make sure that there are no other competing pictures of the same title. If they determine that no film title specifically conflicts with yours, a title search will suffice for your errors and omissions policy. However, if another picture has the same title, or even a similar title, it may require a legal opinion in order for you to include that title in your E&O policy.

EPK

An electronic press kit (EPK) generally comprises behind-the-scenes footage as you are filming; interviews with key talent, producers, writers, director, and others; and stunts or effects sequences as they are set up and filmed. It is used and often required by distributors as "added value" material for the DVD. Generally, an EPK is a line item in a film budget. On a low-budget film, one person is usually hired to shoot it, if not for the entire production schedule, at least for a number of key days on most locations. Sometimes I get the movie's still photographer to shoot the EPK as well. And I have hired people to shoot *and edit* the EPK. Otherwise, I make deals with the picture's editors to cut the EPK after the final cut of the picture is locked.

Chapter 16

Recap

I hope the contents of this book have been informative. My purpose in writing it was to demystify the entertainment business and how things work in the real world, behind the scenes. I have attempted to dispel the myths about filmmaking and to empower the aspiring filmmaker with the knowledge of how to make the right film for the current marketplace for the right price and how to make no mistakes.

Anytime someone asks me what I do and I say that I produce films, almost invariably the person's response is: "I bet that's weird and you have to deal with a lot of wacky people." Then they scoff at what fool's gold they perceive the business to be. But when I explain how the business really works—creating a product on a margin—whether they are in real estate, the gas and oil industry, or any sort of manufacturing business, most people say, "That's *exactly* what I do! You just use different terminology." They recognize the same due diligence and universal deal structures. Film is a product, and American films are exported all over the world. Film can be art, it can be entertaining, it can be socially enlightening or emotionally affecting, but it is *always* commerce.

In my experience, it is equally difficult to try to explain how the business really works to people who actually participate in it. The bottom line is that even if you, your friends, your family, or your colleagues think that something is a great idea, there is no point pursuing it if no one else wants to buy it, exhibit it, or see it. Likewise, if you euphemistically "overpay for the neighborhood" and overspend on a film that has a low market value, you will lose money.

Listen to the experts. Listen to the market. Listen to the buyers. Listen to the exhibitors. Filmmaking is no different from any other business in which you listen to knowledgeable people to gauge the current state of the market.

The entertainment business needs a constant influx of new, fresh talent and ideas, particularly in the independent film world. Be flexible and creative when collaborating and fashioning the germ of an idea into something that is at least commercially viable enough to recoup your financiers' investment. Filmmaking is a privilege, and if you are lucky enough to make it your profession, protect your downside so it continues to be in the future.

Major Entertainment Conglomerates and their Holdings as of 2013

The Big 6 Conglomerates

The Walt Disney Company

2012 revenues: $44.3 billion. The Walt Disney Company operates worldwide. Its Media Networks segment owns the ABC Television Network and eight owned TV stations; ESPN Radio Network, Radio Disney Network, and thirty-five owned and operated radio stations; and operates ABC-, ESPN-, ABC Family-, and SOAPnet-branded internet businesses. Its additional segments are Parks and Resorts (including Walt Disney World Resort in Florida and Disneyland Resort in California), Studio Entertainment, Consumer Products, and Interactive. Its Studio Entertainment segment produces and acquires live-action and animated motion pictures, direct-to-video content, musical recordings, and live stage plays.

Film-related holdings

Production: Walt Disney Pictures, which includes Walt Disney Animation Studios and Pixar Animation Studios; Walt Disney Studios Motion Pictures (live action); Marvel Studios; Touchstone Pictures; and Disneynature.

Sources: http://finance.yahoo.com/q/pr?s=DIS+Profile; www.waltdisney studios.com/corp/about

21st Century Fox/News Corp

2012 revenues: $8.8 billion. News Corporation comprises two separate publishing and entertainment entities. The publishing company is made up of publishing businesses, an education unit, and integrated marketing services business; the entertainment company includes cable and television assets, filmed entertainment, and direct satellite broadcasting businesses. Its media holdings include the Fox Broadcasting Company; television and cable networks such as Fox News Channel, Fox Business Network, National

Geographic Channel United States (71 percent), and FX; print publications such as the *Wall Street Journal* and *New York Post*; book publisher HarperCollins; film production companies including 20th Century Fox, Fox Searchlight Pictures, and Blue Sky Studios; and numerous online properties, such as MarketWatch, *American Idol*, and AskMen.

Film-related holdings

Production and distribution: Fox Filmed Entertainment, the film and television production and home entertainment arm of Twenty-First Century Fox (formerly News Corporation), includes Twentieth Century Fox, Twentieth Century Fox Espanol, Twentieth Century Fox Home Entertainment, Twentieth Century Fox International, 20th Century Fox Television, Fox 2000 Pictures, Fox Music, Fox Searchlight Pictures, Fox Studios Australia, Fox Studios LA, Fox Television Studios, Blue Sky Studios, Shine Group, Twentieth Television, Fox Consumer Products, and Premium Movie Partnership (Australia and New Zealand, 50 percent). Fox Home Entertainment distributes more than 1000 titles annually to the home video market and has distribution agreements with MGM and Lions Gate; Fox Filmed Entertainment licenses content to third parties for use on pay TV and pay-per-view systems.

Sources: www.cjr.org/resources/?c=newscorp; www.cjr.org/resources/?c=newscorp; http://finance.yahoo.com/q/ks?s=NWSA+Key+Statistics

Time Warner

2012 revenues: $29.4 billion. Time Warner operates in the United States and internationally in three segments: Networks, Film and TV Entertainment, and Publishing. Its holdings include Turner Broadcasting System, Home Box Office, businesses managed by Warner Bros. Entertainment, and Time Inc.; its brands include TNT, TBS, CNN, HBO, Cinemax, Warner Bros., New Line Cinema, *People*, *Sports Illustrated*, and *Time*.

Film-related holdings

Production: Subsidiary Warner Bros. Entertainment owns the Warner Bros. Pictures Group, Warner Bros. Pictures, Warner Bros. Pictures Domestic Distribution, Warner Bros. Pictures International, and New Line Cinema.

Source: http://finance.yahoo.com/q/pr?s=TWX+Profile

Viacom

2012 revenues: $13.5 billion. Viacom operates in the United States and internationally through two segments: Media Networks and Filmed

Entertainment. Its leading brands include MTV, VH1, CMT, Logo, BET, Centric, Nickelodeon, NICK JR., TeenNick, Nicktoons, Nick at Nite, Comedy Central, TV Land, Spike, Tr3s, Paramount Channel, and Viva; as well as Paramount Pictures.

Film-related holdings

Paramount Pictures and Paramount Vantage.

Sources: http://finance.yahoo.com/q/ks?s=VIA; www.cjr.org/resources/?c= viacom

CBS Corporation

2012 revenues: $14.7 billion. CBS operates in the United States and internationally via five segments: Entertainment, Cable Networks, Publishing, Local Broadcasting, and Outdoor Americas. The Entertainment segment produces and distributes television programming and theatrical motion pictures and operates online information and entertainment networks. Cable Networks owns and operates multiplexed channels offering subscription services (Showtime, The Movie Channel, Flix, Smithsonian Networks), as well as the CBS College Sports Network; the segment also owns Smithsonian Networks. The Publishing segment comprises four Simon and Schuster units: Simon and Schuster Adult Publishing Group, Simon and Schuster Children's Publishing, Simon and Schuster Audio, and Simon and Schuster International. The Local Broadcasting segments owns 30 TV stations and 127 radio stations and related online properties. Outdoor Americas provides advertising space on billboards, benches, kiosks, and similar places.

Film-related holdings

Showtime Networks (Showtime, Showtime 2, Showtime Showcase, Showtime Extreme, Showtime Beyond, Showtime Next, Showtime on Demand, Showtime Women, Showtime Family Zone), The Movie Channel, The Movie Channel on Demand, The Movie Channel Xtra, Flix, Flix on Demand, and Smithsonian Networks.

Sources: http://finance.yahoo.com/q/pr?s=CBS+Profile; www.cjr.org/ resources/?c=cbs

Sony Corporation of America

2012 revenues: $72 billion. Sony Corporation of America operates six business segments: Electronics & Mobile, Music, Digital Services, Film & Television, Games, and Other Businesses. Its holdings include Sony

Electronics, Sony Mobile Communications, and Sony Creative Software; Sony Pictures Entertainment; Sony Music Entertainment, Sony/ATV Music Publishing; Sony Computer Entertainment America, Sony Online Entertainment; Sony Network Entertainment, Sony DADC, Gracenote; and Sony Biotechnology, Micronics, and Sony Card/Sony Rewards.

Film- and television-related holdings

Sony Pictures Entertainment (SPE), which includes Columbia TriStar Motion Picture Group (Columbia Pictures, TriStar Pictures, Sony Pictures Classics, and Screen Gems, and releasing groups Sony Pictures Releasing and Sony Pictures Releasing International), Sony Pictures Digital Productions (Sony Pictures Animation, Sony Pictures Imageworks, and Sony Pictures Interactive), Sony Pictures Home Entertainment, Sony Pictures Studios, Sony Pictures Technologies, and Sony Pictures Television (including Crackle.com, a premium video website). Services include Sony Pictures Imageworks, Sony Pictures Interactive, Sony Pictures Studios, and Sony Pictures Stock Footage.

Source: www.sony.com/en_us/SCA/company-news/press-releases/all.html# film-television

IFTA Model Sales Agency Agreement Completed Picture: Basic Form

User's Note: Areas in gray indicate alternative or sample provisions and may need to be completed and adjusted for each particular deal. Unused alternatives should be deleted. Areas in dark gray indicate options for alternative provisions and should be deleted.

[Sales Agent Letterhead]

As of []
("Effective Date")

[Producer Executive Name]

[Producer Company Name]

[Producer Company Address]
[Producer Tel] [Producer Fax] [Producer E-mail]

Re: [Picture]
Sales Agency Agreement (Completed Picture – No Advance)

Dear []:

When executed by both Parties, this letter will confirm the terms of the sales agency agreement ("Agreement") between [] ("Producer") and [] ("Sales Agent") for the Picture (as described in Paragraph 3) as follows:

A. REPRESENTATION PROVISIONS

1. **DEFINED TERMS**: Terms with initial capitals are Defined Terms. If not defined where they first appear, Defined Terms are defined in the IFTA® International Schedule of Definitions and the IFTA® International Schedule of Territories current as of the Effective Date, or otherwise by industry standard custom and practice.

2. **APPOINTMENT**: On the terms of this Agreement, Producer appoints Sales Agent to act, and Sales Agent agrees to act, as Producer's exclusive agent during the Agency Period with sole authority to negotiate and conclude license agreements on behalf of Producer with third parties ("Distributors") for exploitation of the Distribution Rights and Allied Rights in the Picture throughout the Territory in the Authorized Languages during the Distribution Term ("Distribution Agreements") and otherwise to represent the Picture as authorized in this Agreement. During the Agency Period, Producer will not negotiate or conclude any Distribution Agreement, but will refer all inquiries regarding any Distribution Agreement to Sales Agent. Producer acknowledges the Initial Delivery Date for the Picture (per Paragraph 19.1) is [_____].

3. **PICTURE**: The Picture means the motion picture currently titled [___], a [feature length] [theatrical / made-for-video / made-for-television motion picture], whose country of origin is [___], produced by [___], directed by [___], starring [principal star(s) in the role(s) of ___] and based on an original screenplay [dated _____] written by [_____] [from underlying material written by _____], shot in [color / B&W] on [16 mm film / 35 mm film / digital cinema], primarily in the [English] language, formatted for a [theatrical / television] running time of not less than [90 / 96 / ___] minutes [or more than 120 minutes], entirely shot, finished and assembled, with fully synchronized sound, music and effects, with no more than incidental stock footage, [telling a complete story / as screened on _____], [capable of receiving an MPAA/CARA rating no more restrictive than "R"], and ready in all respects upon its Delivery for immediate exploitation of all Distribution Rights throughout the Territory. The Picture includes all available versions, such as a director's cut, airline version, and all available bonus materials and outtakes.

4. **TERRITORY AND LANGUAGE**:

4.1. **Territory**: The Territory means all of the following: [_____] [*excluding* _____].

[4.2. [**Major Territories**: For purposes of this Agreement, the following are Major Territories: _____.]

[4.3. **Domestic and International Territory**: For purposes of this Agreement the Domestic Territory is: _____. The International Territory is the Territory excluding the Domestic Territory.]

4.4. **Changes in Territory**: Each country in the Territory means the country as its political borders exist on the Effective Date along with its then existing territories, possessions and protectorates. If during the Agency Period an area separates from a country in the

Territory, then the Territory will still include the entire area which formed one political entity as of the Effective Date of this Agreement. If during the Agency Period an area is annexed to a country in the Territory, then Producer grants Sales Agent a right of First Negotiation to become the exclusive sales agent for the Distribution Rights in the Picture through the end of the Agency Period in the newly annexed area to the extent such rights become available. Sales Agent may include comparable provisions in all Distribution Agreements.

4.5. **Non-Contiguous Areas**: Non-Contiguous Areas mean embassies, military and government installations, oil rigs and marine drilling sites, airlines-in-flight and ships-at-sea flying the flag of a country but not located within its contiguous geographic borders. The Territory does not include the Non-Contiguous Areas of other countries located within the Territory, but does include Non-Contiguous Areas of each country in the Territory as necessary for exploiting any particular Distribution Rights.

4.6. **Authorized Languages**: The Authorized Languages are all Local Languages in each country in the Territory [*except* _____ _____]. Where a Territory is designated as a specific language territory (*e.g.,* French Speaking) then the Authorized Languages for such Territory are only the designated languages.

5. **AGENCY PERIOD AND DISTRIBUTION TERM**:

5.1. **Agency Period**: The Agency Period means the period starting on the Effective Date and continuing until [_____ (___)] years after the earlier of Delivery of the Picture to Sales Agent in accordance with Paragraph 16, the first public release of the Picture in the Territory by authority of Sales Agent, or the Outside Delivery Date in Paragraph 19.2.

5.2. **Distribution Term**: The Distribution Term means the license period for any Distribution Agreement duly concluded by Sales Agent under this Agreement. During the Agency Period, Sales Agent may negotiate Distribution Agreements having a Distribution Term that starts during the Agency Period and extends [for up to [_____ (___)] years from Delivery of the Picture under the relevant Distribution Agreement / for customary periods as decided by Sales Agent in good faith based on market conditions, but not exceeding [_____ (___)] years without Producer's Approval per Paragraph 9.2 / for no more than [_____ (___)] years after the end of the Agency Period without Producer's Approval per Paragraph 9.2]. Producer will honor all grants of exclusivity throughout the Distribution Term of any Distribution Agreement.

6. **Distribution Rights and Allied Rights:**

6.1. **Distribution Rights:** The Distribution Rights means all exclusive rights in the Picture [in all distribution media now known or later arising / for each of the following exclusive rights: Cinematic, Ancillary, Pay Per View, Video, Pay TV, Free TV, Internet and ClosedNet (including customary uses such as Simulcasting, Catch-Up TV, IPTV, Covermount, Kiosk, Pack Sales and Partwork Sales)] [and Souvenir Booklets in Japan].

6.2. **Allied Rights:** The Allied Rights means all customary rights as necessary or convenient to exploit the Distribution Rights, including: (i) creating and using advertising and marketing materials for the Picture, including trailers and clips (but only to the extent they do not generate residual or reuse fees without Producer's Approval); (ii) using the name, voice and likeness of Persons rendering materials or services on the Picture for advertising and marketing the Picture, subject to customary contractual restrictions and obligations provided to Sales Agent by Delivery; (iii) creating and using dubbed, subtitled, voice-over, multi-track and other versions of the Picture in the Authorized Languages; (iv) editing, re-titling or reformatting the Picture for censorship or release requirements [provided that there will be no creative editing of the Picture without prior meaningful consultation with Producer]; (v) authorizing use of customary advertisements and commercial announcements in the Picture; [(vi) authorizing sponsorships of the Picture subject to contractual restrictions and obligations advised to Sales Agent by Delivery]; (vii) including the Picture in screenings to the trade in order to interest Distributors; and (viii) adapting and reformatting the Picture in all sizes, gauges, formats, processes and copy protection technologies necessary or convenient for exploitation of any Distribution Rights. Sales Agent will comply with all contractual restrictions and obligations to third parties rendering services or materials to the Picture with respect to the exercise of all Allied Rights after having been provided Notice of such restrictions and obligations by Producer. In addition, Sales Agent will provide to all Distributors such contractual restrictions and obligations. No inadvertent failure by Sales Agent or any Distributor to comply with any obligation owed to Producer or a third party in exercising any Allied Rights will be a material breach of this Agreement, but Sales Agent will take reasonable steps to cure prospectively any such failure promptly after Sales Agent receives Notice of such failure.

6.3. **Reserved Rights:** The Reserved Rights means [all rights in the Picture other than the Distribution Rights and Allied Rights /

the following rights in the Picture: Merchandising (excluding Souvenir Booklets in Japan), Live Performance, Publishing, Remake, Sequel, and publishing or administration rights for any music in the soundtrack album for the Picture]. Producer may only exercise or authorize exercise of any Reserved Rights in accordance with this Agreement.

[6.4. **[First Negotiation Right] [First Negotiation / Last Refusal Right]**: Producer also grants Sales Agent an exclusive [First Negotiation Right] [First Negotiation / Last Refusal Right] throughout the Agency Period: (i) to become the exclusive sales agent [for all Reserved Rights / the following Reserved Rights: _____]; and (ii) to continue representing the Picture as the exclusive sales agent after the end of the Agency Period.]

6.5. **Royalty Income:** To the extent that Producer controls such rights, Producer also authorizes and grants to Sales Agent, by itself or through an appropriate collecting organization, to collect on behalf of Producer all amounts collected by any collecting society, authors' rights organization, performing rights society or governmental agency, arising from all royalties, levies and remuneration imposed by Law or collectively managed including, but not limited to audio-visual royalties for secondary or simultaneous retransmission by means of any cable, satellite, microwave, Internet, Closed Network or other system, any Simulcasting or Catch-Up TV, tax rebates, exhibition surcharges, or levies on blank Videograms, if the actions generating such income occur within the Territory during the Agency Period or any applicable Distribution Term, no matter when such sums are paid. Royalty Income means all such sums paid or payable directly from the applicable collecting organization(s) to Producer or Sales Agent which will be included in Gross Receipts.

7. **HOLDBACKS:**

7.1. **Sales Agent:** Sales Agent agrees to negotiate to include the following Holdbacks in relevant Distribution Agreements to the full extent allowed by Law: (i) if the Territory does not include the Picture's country of origin, not to authorize a general public release of the Picture in the Territory until the *earlier of* its First Release in its country of origin or [six (6) months / _____] from its Delivery or [one (1) year / _____] from the Effective Date; (ii) if the Distribution Rights include Video, not to authorize the export of Videos from inside the Territory to areas outside the Territory; (iii) if the Distribution Rights include Pay Per View or Pay TV, not to authorize sale outside the Territory of decoders for any encrypted broadcast of the Picture originating

inside the Territory; (iv) if the Distribution Rights include PayPerView, Pay TV or Free TV, not to authorize any Broadcast of the Picture from inside the Territory intended for primary reception outside the Territory, but incidental overspill will not be a breach of this provision; and (v) if the Distribution Rights include Internet or ClosedNet Rights, not to authorize making the Picture available on the Internet or a Closed Network except with customary provisions regarding technological measures to prevent access outside the Territory.

7.2. **Producer**: Producer agrees to abide by the following Holdbacks and to include them in any distribution agreement outside the Territory to the full extent allowed by Law: (i) if the Territory includes [the Picture's country of origin / North America] but is not worldwide, not to authorize [any / Theatrical] release of the Picture outside the Territory until the *earlier of* its first such release in [the Picture's country of origin / North America] or [six (6) months / _____] from its Delivery or [one (1) year / _____] from the Effective Date; (ii) if the Distribution Rights include Video, not to authorize the export of Videos from outside the Territory to areas inside the Territory; (iii) if the Distribution Rights include PayPerView or Pay TV, not to authorize sale inside the Territory of decoders for any encrypted broadcast of the Picture originating inside the Territory; (iv) if the Distribution Rights include PayPerView, Pay TV or Free TV, not to authorize any Broadcast of the Picture from outside the Territory intended for primary reception inside the Territory; (v) if the Distribution Rights include Internet or ClosedNet Rights, not to authorize making the Picture available on the Internet or a Closed Network except with customary provisions regarding technological measures to control access within the Territory; and [(vi) Producer will not authorize any exploitation, until ___ months / ___ years after the Outside Delivery Date, of the following Reserved Rights: _____ _____].

B. PERFORMANCE PROVISIONS

8. SALES AGENT SERVICES:

8.1. **Standards**: Sales Agent will undertake the customary services of a professional sales agent in the motion picture industry in representing the Picture under this Agreement. Producer understands that Sales Agent may represent other motion pictures in addition to the Picture which other motion pictures may compete with the Picture. Sales Agent will devote such time and resources to the Picture as Sales Agent believes in good faith are appropriate, but

need not render services exclusively for the Picture. Sales Agent will have no less rights than any member of the general public with regard to the intellectual property rights in and to the Picture.

8.2. **Services Rendered – Agency Period**: During the Agency Period, Sales Agent will: (i) represent, market and promote the Picture at film markets and festivals and by other customary means; (ii) solicit, negotiate and conclude Distribution Agreements; and (iii) meaningfully consult with Producer regarding Sales Agent's activities for the Picture upon reasonable request or as otherwise required under this Agreement.

8.3. **Services Rendered – Distribution Term**: During the Distribution Term for each Distribution Agreement, Sales Agent will: (i) organize Delivery of the Picture to Distributors, including providing appropriate notices of availability of delivery elements or materials, coordinating with laboratories, and arranging shipping; (ii) coordinate with Distributors to obtain necessary censorship approvals, tax certificates, import licenses, currency transmission certificates or like documents; (iii) provide required consultations and approvals such as for release dates or making other versions of the Picture; (iv) send notices of payments due and use commercially reasonable efforts to obtain reports and collect amounts due; (v) monitor Distributor compliance with Distribution Agreements; (vi) timely provide Producer with information that Sales Agent learns about unauthorized exploitation or piracy of the Picture; and (vii) render Statements and payments of Producer's Share as required under this Agreement.

8.4. **Services Excluded**: Sales Agent's services do not include undertaking any audit or arbitration for any Distribution Agreement or pursuing any anti-piracy action. However, if after mutual consultation either Party desires to conduct an audit or arbitration, then the other Party will meaningfully cooperate with the conducting Party in providing information and assistance needed to do so. The Party conducting the audit or arbitration will be responsible for advancing all necessary costs and attorney's fees, but may recoup them from any recovery in the audit or arbitration, with any remaining amount of such recovery being included in Gross Receipts.

8.5. **Distribution Deal Terms**: Subject to other terms in this Agreement, Sales Agent is authorized to negotiate and conclude all Distribution Agreements within commercially reasonable parameters. However, without Producer's Approval, Sales Agent will not conclude any Distribution Agreement for the Picture: (i) to an Affiliate of Sales Agent [except on an arm's-length basis]; [(ii) on a "straight distribution" basis where payments are based solely on

performance and there is no license fee or Minimum Guarantee]; or (iii) in conjunction with other motion pictures *unless* each motion picture in such Distribution Agreement has a separate Minimum Guarantee allocated on a fair and reasonable basis and no cross-collateralization is allowed among the licensed motion pictures.

8.6. **Distribution Deal Documentation**: For documenting Distribution Agreements, Sales Agent will use commercially reasonable efforts to utilize a form of agreement subject to Producer's Approval, with the IFTA® Model International Licensing Agreements (including the IFTA® International Multiple Rights Deal Memo) being pre-approved. However, Producer understands that Distributors may negotiate the terms of an approved form, may require use of their own form, or may require use of a form pre-negotiated with Sales Agent. As such, Sales Agent is authorized to conclude Distribution Agreements using any agreement form as may be commercially practicable under the circumstances. Producer authorizes Sales Agent to execute all Distribution Agreements (including deal memos) "as agent for" Producer. However, if requested by Sales Agent, Producer will timely execute any Distribution Agreement. Producer upon reasonable request may access, review and copy all Distribution Agreements concluded by Sales Agent.

8.7. **No Performance Guarantee**: The Parties acknowledge that exploiting motion pictures is a speculative business. As such, neither Party makes any representation or warranty, express or implied, regarding the ability to conclude any Distribution Agreement, to exploit the Picture or to earn or collect any Gross Receipts or Producer's Share. Any estimates or projections about possible Distribution Agreements or performance of the Picture are statements of opinion *only*. Producer acknowledges that Producer's Share is merely an accounting entry and Sales Agent does not guarantee that Gross Receipts will be earned or Producer's Share will be payable in any amount. Sales Agent does not guarantee the performance of any Distributor under any Distribution Agreement.

9. PRODUCER INVOLVEMENT:

9.1. **Producer's Cooperation**: Producer will fully and timely cooperate with Sales Agent as necessary for Sales Agent to render all services, including meaningfully and timely providing all required information, Producer's Approvals, consultations and decisions. Producer agrees that any failure by Producer to render any such cooperation as and when required will excuse Sales Agent from performing any service dependent on such cooperation.

9.2. **Producer's Approval**: Producer's Approval means Notice to Sales Agent that Producer affirmatively approves or disapproves a

matter for which approval is required or requested, which will not be unreasonably withheld or delayed. Approval will be deemed given if Sales Agent does not receive such Notice within twenty-four (24) hours during a film market or film festival, or five (5) days otherwise, of Producer's receipt of the request for approval. An ambiguous or incomplete Notice will be deemed approval of any item not affirmatively disapproved. If Producer disapproves any matter, then upon reasonable request Producer will timely identify to Sales Agent any steps needed to obtain approval.

{Select applicable provisions}
{Approval of Deal Terms}

9.3. **Designated Deal Terms**: Designated Deal Terms means the proposed [distributor, rights granted, territory, minimum guarantee, key elements, distribution term, holdbacks and delivery dates]. Producer's Approval will apply to the Designated Deal Terms of all Distribution Agreements concluded by Sales Agent during the [first year of / entire] Agency Period [in the Major Territories / in the following Territories: _____].

{Ask/Take Schedule}

9.4. **Ask/Take Schedule**: [Upon reasonable request, after execution / after viewing a rough cut of the Picture], Sales Agent will prepare one "Ask/Take Schedule" of target asking and taking amounts for Minimum Guarantees for Distribution Rights in the [Major Territories / in the following Territories: _____]. Any Ask/Take Schedule so prepared is conditioned upon the Picture conforming to the description provided in Paragraph 3 and will become part of this Agreement. After Complete Delivery and during the [first year of / two (2) years of / entire] Agency Period, Sales Agent will not conclude any Distribution Agreement whether for all or some of the Distribution Rights in a Territory with a Minimum Guarantee less than the applicable take price on the Ask/Take Schedule without Producer's Approval. Notwithstanding any Ask/Take Schedule, Producer understands that Sales Agent does not guarantee that any particular right or territory can be licensed or that any particular ask or take price can be obtained.

9.5. **Use of Ask/Take Schedule**: Producer acknowledges that any Ask/Take Schedule provided by Sales Agent may contain proprietary, trade secret information of Sales Agent regarding territory pricing or customer contacts. As such, Producer will maintain any Ask/Take Schedule provided by Sales Agent under this Agreement in strict confidence and not disclose it to any third party without prior Notice of Sales Agent's consent in each instance. In no case may Producer include any Ask/Take Schedule

in any private placement memorandum, securities offering or financing proposal without specific prior Notice of Sales Agent's consent in its sole discretion, along with all disclaimers required by Sales Agent. This provision does not apply to any information that becomes publicly available other than through a breach of any confidentiality requirement or pursuant to a governmental order or subpoena.

C. PAYMENT PROVISIONS

10. PRODUCER'S SHARE:

10.1. **Defined**: Producer's Share means the amount of Gross Receipts, if any, remaining after deducting and recouping on a continuous basis in the following order of priority: (i) Sales Agent's Commission; and (ii) Sales Agent's Recoupable Expenses.

10.2. **Recoupment and Payment**: Sales Agent will recoup its Commission and Recoupable Expenses and calculate Producer's Share on a continuous basis for as long as Gross Receipts are earned. [Except for payments made by a collection agent established under Paragraph 14.3,] with each Statement rendered by Sales Agent under Paragraph 15.2, Sales Agent will then pay Producer's Share then due, if any, to Producer or its designee at the place where Producer receives Notice or such other place as Producer may designate by Notice to Sales Agent.

10.3. **Returnable Payments**: Producer acknowledges that returnable payments, such as deposits, are not includable in Gross Receipts or used to calculate Producer's Share until earned per Paragraph 11.2. However, Sales Agent, in its sole discretion, may elect to calculate and pre-pay Producer's Share on any returnable payments received as if they had been earned. In such case, if the payments later become returnable, then Producer agrees upon demand to make a full refund of all pre-paid amounts received by Producer to the Distributor entitled to the refund, or, if Sales Agent in its discretion has elected to make the refund to Distributor, then Producer will reimburse Sales Agent such amount or Sales Agent may deduct the amount of the refund from other amounts due to Producer for the Picture. As a condition to making any such pre-payment, Sales Agent may require that Producer provide appropriate assurances of full and timely repayment.

10.4. **Producer's Tax ID**: Producer will timely provide Sales Agent with its current and accurate tax identification number and related information as needed to make any payment of Producer's Share. Sales Agent in its discretion may withhold any payment of Producer's Share until such information is received.

10.5. **Base Currency**: The Base Currency is [US Dollars / Euros / _____].

10.6. **Currency Conversion**: To the greatest extent possible, Sales Agent will make all calculations of Producer's Share and its components in the Base Currency. If any Gross Receipts are earned or Recoupable Expenses are incurred in another currency, Sales Agent will endeavor to convert them to the Base Currency using the exchange rate at the bank where the account for the Picture is maintained as utilized on the Statement on which the items are reported. If Sales Agent finds it impracticable to convert any monies earned or incurred in another currency to the Base Currency, then to the extent permitted by Law, Sales Agent will deposit in Producer's name in a depository reasonably designated by Producer that portion of Producer's Share, in the other currency, to which Producer would be entitled if such monies were convertible to the Base Currency. Such deposit will constitute payment in full to Producer of the amount so deposited.

11. **GROSS RECEIPTS**:

11.1. **Defined**: Gross Receipts means all gross monies and other consideration paid or payable without any deduction as "earned" with respect to any Distribution Agreement that is substantially negotiated or concluded by Sales Agent under this Agreement including Advances, Minimum Guarantees, Overages, Royalty Income and the like.

11.2. **Earned**: Gross Receipts will be deemed earned when unconditionally received by, forfeited to or credited to Producer or used for Producer's benefit or account, including amounts paid to third parties at Producer's direction, at any time during the Agency Period, any applicable Distribution Term and thereafter for so long as Gross Receipts are paid or payable. Deposits and other conditional payments will be deemed earned on the earlier of the date when they become non-refundable or are forfeited due to an uncured breach by the Distributor.

[11.3. **Producer's Failure of Performance**: If any Distributor cancels its Distribution Agreement, refuses to make payment when due, or demands a refund of any payment solely because of a claimed default by Producer, such as a breach of warranty or Failure of Delivery, then, solely for purposes of calculating Sales Agent's Commission and Recoupable Expenses and not Producer's Share, Gross Receipts will be deemed earned with respect to amounts paid or payable under such Distribution Agreement to the same extent as if the Distributor had unconditionally made all such payments when due. Sales Agent

will calculate Sales Agent's Commission and Recoupable Expenses that it would have recouped from such deemed Gross Receipts, and [Sales Agent may set-off and deduct such amounts from any other payment of Producer's Share / Producer agrees to repay Sales Agent such amounts upon demand.]

12. **SALES AGENT'S COMMISSION**:

12.1. **Calculation**: Subject to Paragraph 12.2, Sales Agent will be entitled to a Commission based on all Gross Receipts earned under this Agreement calculated as follows:

{Select applicable Alternative}
{Alternative – One Fee}

____ % of Gross Receipts earned from any source

{Alternative – Variable Fee by Major Territory}

____ % of Gross Receipts earned from any Distribution Agreement that contains any of the Major Territories; and
____ % of Gross Receipts earned from any from any Distribution Agreement that does not contain any of the Major Territories.

{Alternative – Variable Fee by Domestic/International Territory}

____ % of Gross Receipts earned from the Domestic Territory; and
____ % of Gross Receipts earned from the International Territory.

{Alternative – Variable Fee by Distribution Right}

The following percentages of Gross Receipts earned for the indicated Distribution Right:

Distribution Right	Percentage Fee
Cinematic	____
Ancillary	____
PayPerView	____
Video	____
Pay TV	____
Free TV	____
Internet	____
ClosedNet	____

Where multiple Distribution Rights are included in a Distribution Agreement, Sales Agent's Commission will be based on the allocations in the Distribution Agreement; if there are none, it will be based on the allocation determined by Sales Agent in good faith.

{Alternative – Variable Fee by Payment Type}

____ % of Gross Receipts earned from Guarantees and
____ % of Gross Receipts earned from Overages

For these purposes: (i) "Guarantees" means fixed payments due under Distribution Agreements, including Advances, Minimum Guarantees, and License Fees; and (ii) "Overages" means contingent amounts based on performance payable after recoupment of Guarantees, if any, including royalties, contingent compensation, and net receipts.

[Alternative – Tiered Fee]

____ % of Gross Receipts earned from first dollar to US$_____

____ % of Gross Receipts earned from US$_____ to US$_____

____ % of Gross Receipts earned in excess of US$_____.

12.2. **Use of Subagent(s)**: A subagent is an agent appointed by Sales Agent to represent the Picture in accordance with this Agreement and is not a Distributor. Sales Agent's Commission will be inclusive of the commission of any subagent(s) used by Sales Agent except for customary subagent(s) used to conclude Distribution Agreements for television rights [in the Major Territories / in _____] whose commission will be deducted ["off the top"] from Gross Receipts derived from such Distribution Agreements [and capped at ___% of such Gross Receipts].

13. **RECOUPABLE EXPENSES**:

13.1. **Defined**: Recoupable Expenses means all direct, documented, reasonable and customary costs and expenses paid or incurred by Sales Agent in representing the Picture under this Agreement.

13.2. **Marketing Expenses**: Marketing Expenses means all Recoupable Expenses for: (i) advertising, marketing and promoting the Picture; (ii) creating and manufacturing trailers, one-sheets, promos, advertising, marketing and publicity materials; (iii) attending film markets and festivals where the Picture is actually introduced or made available to potential Distributors, including participation fees, travel expenses, office charges and customary entertainment costs with potential Distributors all as allocated to the Picture ; [(iv) retaining public relations or marketing firms for representing the Picture subject to Producer's Approval per Paragraph 9.2]; (v) undertaking promotional or trade screenings for the Picture; (vi) arranging promotional tours for talent associated with the Picture [subject to Producer's Approval per Paragraph 9.2]; and (vii) other reasonable and customary marketing expenses.

13.3. **Servicing Expenses**: Servicing Expenses means all Recoupable Expenses for: [(i) withholding, sales, use, VAT or like taxes charged on any Gross Receipts or Delivery Materials, but not including any franchise or income tax of Sales Agent; (ii) verifying, quality checking, handling and storing all Delivery Materials; (iii) obtaining necessary licenses and clearances and undertaking searches and obtaining corrective documents for any items in the Chain of Title not duly delivered by Producer, including reasonable [outside] attorneys' fees and required payments to third parties, provided Sales Agent will consult with Producer in advance before incurring such fees or payments; (iv) accepting Delivery and creating and manufacturing Delivery Materials not duly delivered as provided in Paragraph 20; (v) servicing Distribution Agreements including charges for creating, manufacturing, packaging, duplicating, shipping, handling and storing servicing materials required under Distribution Agreements and charges for servicing agents; (vi) international telephone, fax, postage, messenger and copying fees; (vii) notarial and consularization certificates, import licenses, governmental permits and the like; (viii) undertaking billings and collections under any Distribution Agreement, including currency conversion fees, escrow fees, and bank charges including for separate bank accounts; (ix) actual [outside] attorneys' fees for negotiating and concluding any Interparty Agreement, Notices of Assignment and Acknowledgement with Distributors, and related documents required for obtaining financing for the Picture, if any; (x) actual costs of outside professionals, including servicing agents, attorneys, auditors and accountants, to assist in negotiating, servicing or enforcing any Distribution Agreement, provided Sales Agent will consult with Producer in advance before retaining any such outside professionals; and (xi) other reasonable and customary servicing expenses].

13.4. **Distributor Payment**: Sales Agent will use commercially reasonable efforts to require payment of all applicable Servicing Expenses by the Distributor under the affected Distribution Agreement but does not guarantee the ability to do so. Any Servicing Expenses paid by the Distributor will be deducted from the Servicing Expenses recoupable by Sales Agent.

13.5. **Allocation**: Where Sales Agent incurs any Recoupable Expenses for the Picture and other motion pictures, Sales Agent will allocate such expenses among all affected motion pictures on a fair and reasonable basis.

{Select applicable Alternative}
{Alternative — Recoupment Only}

13.6. **Recoupment**: Sales Agent will advance all Recoupable Expenses, which Sales Agent may recoup from Gross Receipts in accordance with Paragraph 10. Producer will have no liability to any third parties for any Recoupable Expenses not so recouped from Gross Receipts.

{Alternative — Marketing Budget}

13.7. **Marketing Budget**: Sales Agent will timely prepare for Producer's Approval a proposed budget of anticipated Marketing Expenses. [Producer will then pay Sales Agent the approved budgeted amount and Sales Agent will then incur and pay Marketing Expenses in substantial conformity with the approved budget. Sales Agent will then incur and pay Marketing Expenses in substantial conformity with the approved budget, recouping such amounts as Marketing Expenses in accordance with Paragraph 10.2.] Sales Agent need not incur Marketing Expenses in excess of the approved budget, but may do so in its discretion. However, Sales Agent will be solely responsible for paying such excess and may not recoup the excess from Gross Receipts without Producer's Approval.

{Alternative — Overall Expense Cap}

13.8. **Overall Cap**: Without Producer's Approval, Sales Agent will not recoup Recoupable Expenses in excess of [US$ _____] [*excluding* _____ and amounts under Paragraph 20]. Sales Agent may incur Recoupable Expenses in excess of this cap but Sales Agent will be solely responsible for paying such excess and may not recoup the excess from Gross Receipts without Producer's Approval.

{Alternative — Expense Category Cap}

13.9. **Marketing Expense Caps**: Without Producer's Approval, Sales Agent will not recoup Marketing Expenses in excess of [a Marketing Budget to be established with Producer's Approval / US$ _____ *excluding* _____]. Sales Agent may incur Marketing Expenses in excess of this cap, but Sales Agent will be solely responsible for paying such excess and may not recoup the excess from Gross Receipts without Producer's Approval.

13.10. **Servicing Expense Cap**: Without Producer's Approval, Sales Agent will not recoup Servicing Expenses in excess of

[US$ _____] *[excluding* _____ and amounts under Paragraph 20]. Sales Agent may incur Servicing Expenses in excess of the above cap, but Sales Agent will be solely responsible for paying such excess and may not recoup the excess from Gross Receipts without Producer's Approval.

{Alternative — Market Attendance Caps}

13.11. **Market Attendance Caps**: Without Producer's Approval, Sales Agent will not recoup those Marketing Expenses per Paragraph 13.2 (iii) for attending the following film markets or festivals in excess of the following amounts: [_____

_____].

Sales Agent may incur such Marketing Expenses in excess of the above caps, but Sales Agent will be solely responsible for paying such excess and may not recoup the excess from Gross Receipts without Producer's Approval.

14. COLLECTIONS AND PAYMENTS:

{Select applicable Alternative}
{Alternative — General Account}

14.1. **General Account**: Sales Agent will deposit all collections of Gross Receipts in its general company accounts and make all disbursements from Gross Receipts for the Picture from such accounts. Producer will have no claim to any Gross Receipts, Producer's only right being a claim to payment of Producer's Share if and when due. Sales Agent will pay Producer or its designee the amount of Producer's Share as shown due on each Statement rendered by Sales Agent under Paragraph 15.2.

{Alternative — Separate Account}

14.2. **Separate Account**: Sales Agent will establish a Separate Account at [Bank] in the name of the Picture and direct all payments of Gross Receipts to be made into such account. Sales Agent will calculate and pay any Producer's Share, if any, from such account [with each Statement rendered by Sales Agent under Paragraph 15.2 / within fifteen (15) days after Gross Receipts are earned and received in the Separate Account, in which case Sales Agent will reconcile such payments to amounts shown due on later Statements rendered by Sales Agent under Paragraph 15.2, paying Producer any underpayment or recouping any overpayment from later payments.].

{Alternative — Collection Account}

14.3. **Collection Account**: Sales Agent and Producer will negotiate in good faith and timely conclude an agreement with a [mutually

approved] third party Collection Agent for making all collections and disbursements of Gross Receipts. [The Parties pre-approve [____] as Collection Agent.] Sales Agent will direct all payments of Gross Receipts into the Collection Account established by the Collection Agent for the Picture. From all Gross Receipts deposited in the Collection Account which have become earned as indicated by Notice from Sales Agent, Collection Agent will make disbursements in the following order: (i) first the Collection Agent will deduct its administration fees and charges; (ii) then the Collection Agent will pay Sales Agent its Commission and Recoupable Expenses in accordance with [an invoice / _____] presented by Sales Agent to the Collection Agent / or as otherwise set forth in the collection agreement]; and (iii) then the Collection Agent will remit the balance remaining, if any, to Producer or its designee. In rendering Statements, Sales Agent will reconcile amounts paid from the Collection Agent to amounts shown due on the Statement. In case of an overpayment to any Party, the Party will promptly return the overpayment to the Collection Account.

15. STATEMENTS AND AUDITS:

15.1. **Standards**: Sales Agent will maintain full and accurate books and records for the Picture [at Sales Agent's principal place of business] using generally accepted accounting principles on a consistent, uniform and non-discriminatory basis consistent with this Agreement.

15.2. **Statements**: [Unless otherwise provided by any collection agency established under 14.3,] Sales Agent will render to Producer periodic Statements due from Sales Agent showing all Gross Receipts earned and Recoupable Expenses paid or incurred in calculating Producer's Share on a cumulative and current basis. Such statements will be rendered no less frequently than sixty (60) days after each calendar quarter during the first [three (3) years] of the Agency Period and thereafter [semi-annually / annually], throughout the Agency Period and any applicable Distribution Term.

[15.3. **Incontestability**: All items shown on any Statement will be deemed incontestable twenty-four (24) months after the Statement is rendered unless Producer during such period gives Sales Agent Notice specifying each contested item in reasonable detail. Sales Agent may correct any item shown on any Statement, in which case the incontestability period will re-commence solely with respect to the corrected item. Sales Agent need not maintain any books or records for any item for more than two (2) years after the item is deemed incontestable.]

15.4. **Audits**: Producer may audit the books and records of Sales Agent regarding the Picture for any item not deemed incontestable using [qualified / licensed / professional] accountants upon at least one (1) month's prior Notice once annually during the Agency Period and until one (1) year after the applicable Distribution Term. If the audit falls during a film market or festival, Sales Agent may delay the audit until two (2) weeks after its conclusion. The audit will be at Producer's expense unless the audit demonstrates an underpayment, accepted by Sales Agent or later proven to be correct, of more than [US$_____ / ten percent (10%) of the amount shown due Producer on any Statement], in which case Sales Agent will pay on demand the underpayment and the reasonable audit costs of uncovering the underpayment [up to the amount of the underpayment / not to exceed _____].

D. DELIVERY PROVISIONS

16. **DELIVERY**: Delivery of the Picture means actual, physical delivery to and acceptance by Sales Agent, at Producer's obligation and expense, of all Delivery Materials in the attached and incorporated IFTA® Delivery Schedule in accordance with this Agreement. Initial Delivery means Delivery of all Delivery Materials marked as Initial Materials, and Complete Delivery means Delivery of all Delivery Materials.

17. **INSPECTION**: All Delivery Materials must conform to the Picture as specified in Paragraph 3. Sales Agent will have a period of [twenty-one (21)] days after receipt of *all* Delivery Materials to inspect them for technical quality and conformity to specifications ("Inspection Period"). If Sales Agent determines any Delivery Materials are not acceptable, Sales Agent will give Producer a Notice to such effect within the Inspection Period specifying the defect(s) in reasonable detail, with any defect not specified being waived. Producer will then timely deliver substitute Delivery Materials to Sales Agent who will have another Inspection Period. This process will continue with successive periods until either Sales Agent has accepted, or waived acceptance, of *all* Delivery Materials, or the Outside Delivery Date occurs, and nothing in this process will waive Producer's obligation to make Complete Delivery by the Outside Delivery Date. Sales Agent may in its discretion waive Delivery of any particular Delivery Materials and in so doing agrees that Delivery has deemed to occur without them, but this will not waive Sales Agent's right to require Producer upon reasonable Notice to make later Delivery of any waived Delivery Materials.

18. **CHAIN OF TITLE**: Delivery includes providing Sales Agent with *all* documents in the Chain of Title, as identified in the IFTA® Delivery

Schedule, demonstrating Producer's ownership or control of all Distribution Rights and Allied Rights in the Picture throughout the Territory for the Agency Period and any anticipated Distribution Term. Sales Agent will have a period of [twenty-one (21)] days after receipt of *all* documents in the Chain of Title to inspect them for legal sufficiency ("Review Period"). If Sales Agent reasonably disapproves any document, Sales Agent will give Producer Notice within the Review Period specifying the defect(s) in reasonable detail, with any defect not specified being waived. In accordance with Paragraph 33.7, Producer will then timely obtain at Producer's expense necessary corrective documents. If Producer fails to do so, then Sales Agent may do so, charging the cost of so doing as a Servicing Expense. Sales Agent's failure to request or Producer's failure to provide any documents in the Chain of Title will not limit or excuse any of Producer's representations, warranties or indemnities under this Agreement. Sales Agent will have the right in its discretion to waive any defect in any document contained in the Chain of Title for purposes of making any payment to Producer, but such waiver will not waive Sales Agent's right to require delivery of satisfactory Chain of Title documents at a later time.

19. **DELIVERY DATES**:

 19.1. **Initial Delivery Date**: [_____]. Producer must initiate the Delivery process of the Picture within a reasonable time after execution of this Agreement. Producer will undertake all reasonable efforts to complete Initial Delivery of the Picture by no later than the above Initial Delivery Date.

 19.2. **Outside Delivery Date**: [_____]. In any case, Producer must make Complete Delivery of the Picture by *no later than* the date specified above or, if no date is specified, [six (6) months] after the Effective Date ("Outside Delivery Date"). Since the Delivery process includes time periods for inspection and correction, Producer must initiate the process in sufficient time to assure its completion by the Outside Delivery Date.

20. **FAILURE OF DELIVERY**: Producer's failure to make Complete Delivery by the Outside Delivery Date will be a material breach of this Agreement. In such case, Sales Agent, in addition to any other right or remedy, may deem all outstanding Commissions and Recoupable Expenses under any concluded Distribution Agreements to be earned and payable as of such Outside Delivery Date. Sales Agent will also have the right, but not the obligation, to create and manufacture any required Delivery Materials and to use them to service applicable Distribution Agreements as Sales Agent deems appropriate. Sales

Agent may charge and recoup [one hundred and ten percent (110%)] of the creation, manufacturing, shipping and handling costs of so doing as a servicing cost [(*i.e.*, actual cost plus an overhead charge)], which amount will be outside of any cap on Recoupable Expenses. This charge will be in addition to and not a waiver of any right or remedy Sales Agent may have for a Failure of Delivery.

21. **OWNERSHIP OF MATERIALS**:

21.1. **Delivery Materials**: Producer will retain legal ownership of and title to all Delivery Materials and no granting of access to or possession of any Delivery Materials by Producer will constitute a "first sale." Instead, Sales Agent will only hold all Delivery Materials on loan for servicing Distribution Agreements. Upon reasonable request, Sales Agent will provide Producer with Notice of the location of all Delivery Materials. Sales Agent will exercise due care in safe-guarding all Delivery Materials during [the Agency Period and any applicable Distribution Term].

21.2. **Created Materials**: Sales Agent will own title to all materials created or manufactured under its authority from the Delivery Materials, including those under Paragraph 20, subject to an exclusive license to use all such created materials for purposes of this Agreement, while Producer will retain the copyright in all such materials. If such an exclusive license is not allowed under Law in the Territory, then Producer grants to Sales Agent a non-exclusive free license to use all such materials in the Territory during the Agency Period and all Distribution Terms. Upon reasonable request, Sales Agent will provide Producer or its designees with access to any alternate language tracks, subtitled tracks and dubbed versions, masters, advertising and promotional materials including trailers, artwork and other materials created or authorized by Sales Agent from the Delivery Materials. Producer will pay Sales Agent promptly on receipt of invoice for any [third party] costs of providing such materials.

21.3. **Return of Materials**: Upon the later of the expiry of the Agency Period or of the final Distribution Term, Sales Agent will promptly at Producer's direction: (i) return all Delivery Materials to Producer at Producer's expense or provide Producer with a customary certificate of their destruction; and (ii) either sell all then available materials created by Sales Agent to Producer for their unrecouped actual costs of manufacturing, shipping and storage, or provide Producer with a customary certificate of their destruction.

22. **ACCESS TO OTHER MATERIALS**: If Producer has or will conclude a distribution agreement for the Picture with any distributor in the

[U.S. / any other country outside the Territory], Producer will use good faith efforts to obtain for Sales Agent free access to all delivery, publicity and advertising materials for all versions of the Picture created by or for any such distributor, but any failure to do so will not be a breach of this Agreement. Producer will give Sales Agent timely Notice whether Producer has obtained such access, free or otherwise, and the particulars for its exercise, *provided* if Producer has free access to any such materials Sales Agent will also have free access to those materials. Any fee for such access, or clearance or use costs for such materials advanced by Sales Agent, will be treated as a Recoupable Expense [outside any applicable cap].

E. THIRD PARTY PROVISIONS

23. **THIRD PARTY PAYMENTS**: Producer will be solely responsible for making timely payments to all parties rendering services or materials to the Picture, including all profit participations, guild and union residuals, royalties and reuse fees, and music clearance fees in accordance with Paragraph 24 and Sales Agent will not be responsible for such payments. Producer agrees to execute on demand any side-letter required by any applicable guild or union necessary to allow any collecting organization to collect or pay Royalty Income for the Picture.

24. **MUSIC**:

 24.1. **Cue Sheets**: As part of Delivery, Producer will supply Sales Agent with one (1) electronic file of a customary music cue sheet detailing the particulars of all music contained in the final version of the Picture and trailer, including the title of each composition, the composer(s), lyricist(s) and publisher(s) (including percentage of ownership if more than one publisher), copyright owner(s), performer(s), arranger(s), usage(s) (whether background instrument, background vocal, *etc.*), the number of such uses, the place of each composition showing the location and duration of each cue by the film footage or HD time code and running time of each cue and the performing rights society involved for each composer and publisher. Sales Agent will undertake to provide such cue sheets to Distributors for filing with the appropriate governmental agency or music rights society in the Territory.

 24.2. **Synchronization and Other Licenses**: Producer will obtain by [Initial] Delivery, and maintain in effect for the Agency Period and any applicable Distribution Term throughout the Territory, all rights needed to synchronize the underlying musical composition(s), to use the sound recording and to use any other musical composition to any music commissioned for the Picture

for all music embodied in the Picture on all its Copies or promotional materials without cancellation or charge to Sales Agent or any Distributor for all applicable Distribution Terms. Producer will be solely responsible for paying all sums needed to obtain and maintain such rights.

24.3. **Mechanical**: Producer will obtain by [Initial] Delivery, and maintain in effect for the Agency Period and any applicable Distribution Term throughout the Territory, all rights needed to make mechanical reproductions of all music embodied in the Picture sufficient to exploit the Picture consistent with this Agreement on all its Copies or promotional materials, without cancellation or charge to Sales Agent or any Distributor for all applicable Distribution Terms. Producer will be solely responsible for paying all sums needed to obtain and maintain such mechanical rights, *provided* if a mechanical or authors' rights society in a country in the Territory refuses to honor in that country a valid authorization obtained by Producer, then Producer will not be responsible for such sums charged by such mechanical or authors' rights society. [Sales Agent is not responsible for obtaining mechanical rights to the music in the Picture; however, any costs for mechanical rights that may be advanced by Sales Agent in its sole discretion will be recouped by Sales Agent as a Servicing Expense outside of any cap.]

24.4. **Performance**: Producer will obtain by [Initial] Delivery, and maintain in effect for all relevant times throughout the Territory, all clearances needed to establish that the non-dramatic ("small") performing rights in each musical composition embodied in the Picture are either: (i) in the public domain in the Territory; or (ii) owned or controlled by Producer sufficient to allow Sales Agent and any Distributor to exploit the Licensed Rights without additional payment for such rights; or (iii) available by blanket license from a performing rights society in the Territory affiliated with the International Confederation of Authors and Composers Societies (CISAC).

25. **PRODUCER REPRESENTATIONS AND WARRANTIES**: Producer represents and warrants to Sales Agent that all of the following are true and correct and will remain so throughout the Agency Period and any applicable Distribution Term: (i) Producer is duly organized and in good standing in [_____ with Entity No. ____] and has full authority to enter into and perform this Agreement; (ii) the Picture is fully original other than incidental stock footage or public domain material; (iii) Producer exclusively owns or controls all Distribution Rights and Allied Rights in the Picture throughout the Territory for the Agency Period and any relevant Distribution Term; (iv) Producer

has not and will not appoint any other sales agent to represent any Distribution Rights in the Picture anywhere in the Territory throughout the Agency Period, and Producer will honor all grants of exclusivity in all Distribution Agreements for their entire Distribution Term; (v) Sales Agent will not be responsible for any claim of residuals under 28 U.S.C. § 4001 or any other Law or provision of any collective bargaining agreement; (vi) except as provided in Paragraph 24 for embodied music, by Delivery, Producer will have satisfied all obligations to and obtained all necessary authorizations from writers, producers, directors, composers, performers and all other Persons rendering materials or services for the Picture, to use their contribution to the Picture without cancellation, impairment or further payment; (vii) for embodied music, by Delivery, Producer will have obtained all necessary authorizations from authors, composers, lyricists and performers to use all synchronization, mechanical and performance rights as provided in Paragraph 24; (viii) nothing in the Picture or any Delivery Materials, including its title or embodied music, infringes any intellectual property right (copyright, author's right, neighboring right, patent, trademark, *etc.*) or personal right (defamation, libel, slander, performer's right, right of publicity, moral right, *etc.*) of any Person nor will any exploitation of the Picture violate any Law; (ix) there are no pending or threatened claims, arbitration or litigation, nor any liens, security rights, charges or encumbrances [other than customary guild security interests], affecting the Picture or any Delivery Materials that might impair Sales Agent's free and unencumbered representation of any Distribution Rights or Allied Rights anywhere in the Territory for the Agency Period and any applicable Distribution Term; (x) the Picture (including any available coverage material) will be capable of obtaining an MPAA/CARA rating no more restrictive than "R" or its equivalent in major countries in the Territory; (xi) all documents in the Chain of Title are true and complete copies of the original, valid and enforceable according to their terms; and (xii) Producer has undertaken reasonable efforts to ensure that all suppliers of essential special effects and other digital information embodied in any Delivery Materials have not included any electronic self-help instructions that will cause such digital information to cease operation of its own accord in a manner that materially impairs any use of such Delivery Materials, but this does not apply to electronic Rights Management Information that prevents unauthorized use of the Delivery Materials.

26. **SALES AGENT REPRESENTATIONS AND WARRANTIES**: Sales Agent represents and warrants to Producer that all of the following are true and correct and will remain so throughout the Agency Period: (i) Sales Agent has full authority to enter into and perform this Agreement; (ii) no advertising or marketing materials created by Sales Agent will

infringe any intellectual property right (copyright, author's right, neighboring right, patent, trademark, *etc.*) or personal right (defamation, libel, slander, performer's right, right of publicity, moral right, *etc.*) of any Person, subject to any failure of Producer's representations and warranties applicable to such materials; and (iii) Sales Agent will not conclude any Distribution Agreement subject to Producer's Approval without first obtaining such approval.

27. **INDEMNITIES**: Each Party will indemnify, defend and hold harmless the other Party from any third party claim or resulting loss, liability or damage, including reasonable [outside] attorneys' and professional fees, arising from any failure of any of the Party's representations or warranties [or undertakings] contained in this Agreement. Producer will include Sales Agent as an additional insured under Producer's policy of errors and omissions insurance for the Picture and provide Sales Agent with a customary certificate of such coverage as part of Delivery of the Picture.

F. DEFAULT PROVISIONS

28. **DEFAULT AND REMEDIES**:

 28.1. **Notice and Cure**: Each Party will give the other Party Notice of any claimed default under this Agreement. If the defaulting Party fails to cure the default within fourteen (14) days for a monetary default or twenty-one (21) days for a non-monetary default after receipt of Notice, the aggrieved Party may pursue any available right or remedy for such uncured default.

 28.2. **Recoverable Damages**: Each Party may only seek to recover incidental or direct damages occasioned by any default. Each Party waives any right to seek special, consequential or punitive damages, including "lost profits" from any default. This waiver is an independent covenant that survives the failure of essential purpose of any other remedy, even if limited.

 28.3. **Cancellation**: At any time after an uncured material default, an aggrieved Party will have the right to give Notice of its intent to cancel this Agreement to the defaulting Party. A "cancellation" means a termination of this Agreement for cause, *i.e.*, for an uncured material default.

 28.4. **Effect of Cancellation**: In case of cancellation, each Party will retain all its rights and remedies due for any performance rendered up to the time of cancellation including all claims for Recoverable Damages, Commissions, and Recoupable Expenses. [In addition, with respect to any existing Distribution Agreements, either: (i) Sales Agent will continue to service all Distribution Agreements substantially negotiated or

concluded by Sales Agent up to the time of cancellation, including collecting all Gross Receipts and making recoupments under Paragraph 10.2 attributable to such Distribution Agreements, but Sales Agent may not negotiate any new Distribution Agreements; or (ii) alternatively, if the Parties mutually agree, Producer will assume all Distribution Agreements substantially negotiated or concluded by Sales Agent up to the time of cancellation and make all payments of Sales Agent's Commission and Recoupable Expenses from Gross Receipts as earned under such Distribution Agreements.] Sales Agent may include in any Distribution Agreement a provision that Producer will have no right to terminate, cancel or rescind such Distribution Agreement, or to seek any equitable relief to enjoin or restrain the Distributor's exploitation of the Picture, Producer's sole remedy for any breach of the Distribution Agreement being limited to monetary damages.

28.5. **Equitable Relief**: Producer agrees that the Distribution Rights are of a unique artistic or intellectual value, the loss of representation of which cannot be fully compensated by monetary damages, so that Sales Agent will have the right to seek equitable relief, including an injunction, for a default by Producer. Nothing in this Agreement prevents Producer from seeking equitable relief for any attempted exploitation of any Distribution Rights or Allied Rights in the Picture outside the scope of this Agreement or any applicable Distribution Agreement.

28.6. **Set-Off**: Sales Agent may set-off and recoup from Producer's Share whenever due any overpayment of Producer's Share [or any other amount due Producer from Sales Agent under this Agreement].

29. **ARBITRATION**: Any dispute arising under this Agreement, including with respect to any right or obligation that survives termination or cancellation of this Agreement, will be administered and resolved by final and binding arbitration under the IFTA® Rules for International Arbitration in effect as of the Effective Date of this Agreement ("IFTA® Rules"). The IFTA® Rules are available online at the following address: www.ifta-online.org. Each Party waives any right to adjudicate any dispute in any other court or forum *except* that a Party may seek interim relief as allowed by the IFTA® Rules. The arbitration will be held in the Forum and under the Governing Law designated in this Agreement, or, if none is designated, as determined by the IFTA® Rules. The arbitration will be decided in accordance with the Governing Law. The Parties will abide by any decision in the arbitration and any court having jurisdiction may enforce it. The Parties submit to the jurisdiction of the courts in the Forum for interim relief, to compel arbitration or to confirm an

arbitration award. The Parties agree to accept service of process in accordance with the IFTA® Rules and agree that such service satisfies all requirements to establish personal jurisdiction over the Parties. The Parties waive application of the Hague Convention for Service Abroad of Judicial and Extrajudicial Documents in Civil or Commercial Matters with respect to the procedures for service of process.

G. GENERAL PROVISIONS

30. CREDIT: Sales Agent will be entitled to add [, at its unrecoupable expense,] its logo before the main credits of the Picture and in any related advertising, marketing and publicity material released in the Territory [and an additional credit in the form of " _____ " / in the main credits / end credits / as may be mutually agreed by the Parties.]

31. NOTICES:

 31.1. **Notice**: A Notice means any communication required or allowed under this Agreement. All Notices must be in a record authenticated by the sender. Notice sent by personal delivery or mail will be effective when received. Notice sent by fax or e-mail will be effective when the sender receives an acknowledgement showing receipt by the recipient. A Notice of Termination or of Cancellation sent by fax or e-mail must be accompanied by Notice sent by non-electronic means to be effective.

 31.2. **Place to Send Notice**: All Notices must be sent to a Party at its address on the Cover Page, except a Party may change its place for notice by Notice duly given. If a Party is no longer located at its place for Notice, the sender may give Notice by sending Notice to the receiving Party's last known address and providing a copy to a public official, if any, in the jurisdiction where such address is located designated to receive notice for absent parties, such as a Secretary of State, Company Commissioner or other appropriate authority.

 31.3. **Notice Time Periods**: All time periods in this Agreement based on Notice run from the date the recipient receives, or is deemed to have received, such Notice.

32. ASSIGNMENT AND DELEGATION:

 32.1. **Producer**: Except as provided in this Paragraph, Producer may not assign this Agreement, or rights under it, or delegate any duties, in whole or in part, voluntarily or involuntarily, whether outright or for security, without prior Notice of Sales Agent's consent, and any attempt to do so without such prior Notice will be void and of no effect. For these purposes, an assignment includes an outright transfer, the granting of any lien or security

interest, and a sale of substantially all of the assets of Producer or a conveyance of a majority of the membership interests or voting equity securities of Producer. As a condition to giving any consent, Sales Agent may require the assignee or delegate to assume in an authenticated record all obligations of Producer under this Agreement. However, once Producer has made Complete Delivery, Producer may assign, outright or for security, without the need for Sales Agent's prior consent, any portion of Producer's Share by giving Sales Agent Notice of the assignee and place for payment. Any assignment or delegation allowed under this Paragraph will be binding on and inure to the benefit of the assignee or delegate but will not release Producer from its obligations under this Agreement.

32.2. **Sales Agent**: Except as provided in this Paragraph, Sales Agent may not assign this Agreement, or rights under it, or delegate any duties, in whole or in part, voluntarily or involuntarily, whether outright or for security, without prior Notice of Producer's consent, and any attempt to do so without such prior Notice will be void and of no effect. For these purposes an assignment includes an outright transfer, the granting of any lien or security interest, and a sale of substantially all of the assets of Sales Agent or a conveyance of a majority of the membership interests or voting equity securities of Sales Agent. As a condition to giving any consent, Producer may require the assignee or delegate to assume in an authenticated record all obligations of Sales Agent under this Agreement. However, Sales Agent may without prior Notice of Producer's consent: (i) make an assignment or delegation to any affiliated, parent or subsidiary company of Sales Agent; (ii) [provided that Sales Agent is not then in default,] make an assignment to an entity which acquires substantially all of Sales Agent's assets and which assumes in an authenticated record all of Sales Agent's obligations under this Agreement; (iii) assign or grant a security right in any portion of Sales Agent's Commission or Recoupable Expenses; or (iv) authorize or appoint subagents for any Territories or Distribution Rights in accordance with Paragraph 12.2, provided the subagent agrees to be bound by this Agreement. Any assignment or delegation allowed under this Paragraph will be binding on and inure to the benefit of the assignee or delegate but will not release Sales Agent from its obligations under this Agreement.

33. MISCELLANEOUS:

33.1. **Entire Agreement**: This Agreement represents the entire understanding of the Parties regarding its subject matter,

superseding all prior written or oral negotiations, understandings, representations or agreements between them, if any. Each Party expressly waives any right to rely on such prior negotiations, understandings, representations or agreements, if any.

33.2. **Modification**: No modification of this Agreement is effective unless evidenced by a record authenticated by both Parties.

33.3. **No Waiver**: No waiver of any right or remedy under this Agreement will be effective unless contained in a record authenticated by the Party making the waiver. The exercise of any right or remedy will not waive any other right or remedy. No waiver of any default will be a waiver of any right or remedy for any other default.

33.4. **Remedies Cumulative**: All remedies are cumulative; resorting to one remedy will not preclude resorting to any other remedy at any time.

33.5. **Attorneys' Fees**: The Prevailing Party in any dispute or arbitration under this Agreement [will / will not] be entitled to recover reasonable [outside] attorney's fees incurred in prosecuting or defending the case. This provision supersedes any contrary provision in the IFTA® Rules.

33.6. **Terminology**: In this Agreement "and" means all possibilities, "or" means any or all possibilities in any combination, and "either . . . or" means only one possibility. "Including" means "including without limitation"; "must" or "will" means a Party is obligated to act or refrain from acting; "may" means a Party has the right, but is not obligated, to act or refrain from acting.

33.7. **Additional Documents**: Upon reasonable request each Party will execute and deliver any additional documents as are necessary to evidence, secure or perfect the other Party's interest under this Agreement or to carry out its terms, and each Party authorizes the filing of such documents with appropriate public authorities.

33.8. **E-Commerce**: No record relating to this Agreement, including this Agreement itself or any Notice, may be denied legal effect, validity, or enforceability solely because an electronic signature or electronic record was used in its formation or transmission.

33.9. **Governing Law**: This Agreement will be governed by and interpreted under the laws of [California]. The predominant purpose of this Agreement is providing services with respect to intellectual property and not a sale of goods.

33.10. **Forum**: The exclusive Forum for conducting any arbitration under this Agreement will be [the County of Los Angeles, California] and for any other disputes under this Agreement the forum will be [the courts located within the County of Los

Angeles, California]. The effectiveness of this exclusive forum selection clause will be determined by the Governing Law of this Agreement.

33.11. **Severability**: If any provision of this Agreement is determined to be invalid or illegal under any applicable Law, the remaining provisions of this Agreement will nonetheless remain in full force and effect, unless the invalid or illegal provision was a material part of the consideration for a Party to enter into this Agreement. In such case, upon reasonable request by either Party, both Parties will negotiate in good faith in an attempt to modify this Agreement to comply with the applicable Law and to effectuate the original intent of the Parties as closely as possible, failing which either Party may seek to rescind this Agreement for a material failure of consideration to the extent allowed by applicable Law.

33.12. **Counterparts**: This Agreement may be executed in counterparts, each of which will be an original but all of which together will form one instrument.

If the above provisions correspond to your understanding, please sign this letter below where indicated.

[Sales Agent]

By: _____

Its:

Accepted and agreed:

[Producer Company Name]

By: _____

Its:

Dated:

IFTA Model Sales Agency Agreement Completed Picture: With Advance

User's Note: Areas in gray indicate alternative or sample provisions and may need to be completed and adjusted for each particular deal. Unused alternatives should be deleted. Areas in dark gray indicate options for alternative provisions and should be deleted.

[Sales Agent Letterhead]

As of [＿＿]
("Effective Date")

[Producer Executive Name]
[Producer Company Name]
[Producer Company Address]
[Producer Tel] [Producer Fax] [Producer E-mail]

Re: [*Picture*]

Dear [＿＿＿＿＿＿＿＿＿]:

When executed by both Parties, this letter will confirm the terms of the sales agency agreement ("Agreement") between [＿＿＿＿＿＿] ("Producer") and [＿＿＿＿＿＿] ("Sales Agent") for the Picture (as described in Paragraph 3) as follows:

A. REPRESENTATION PROVISIONS

1. DEFINED TERMS: Terms with initial capitals are Defined Terms. If not defined where they first appear, Defined Terms are defined in the IFTA® International Schedule of Definitions and the IFTA® International Schedule of Territories current as of the Effective Date, or otherwise by industry standard custom and practice.

2. **APPOINTMENT**: On the terms of this Agreement, Producer appoints Sales Agent to act, and Sales Agent agrees to act, as Producer's exclusive agent during the Agency Period with sole authority to negotiate and conclude license agreements on behalf of Producer with third parties ("Distributors") for exploitation of the Distribution Rights and Allied Rights in the Picture throughout the Territory in the Authorized Languages during the Distribution Term ("Distribution Agreements") and otherwise to represent the Picture as authorized in this Agreement. During the Agency Period, Producer will not negotiate or conclude any Distribution Agreement, but will refer all inquiries regarding any Distribution Agreement to Sales Agent. Producer acknowledges the Initial Delivery Date for the Picture (per Paragraph 20.1) is [_____].

3. **PICTURE**: The Picture means the motion picture currently titled [___], a [feature length] [theatrical / made-for-video / made-for-television motion picture], whose country of origin is [___], produced by [___], directed by [___], starring [principal star(s) in the role(s)_____] and based on an original screenplay [dated _____] written by [_____] [from underlying material written by _____], shot in [color / B&W] on [16 mm film / 35 mm film / digital cinema], primarily in the [English] language, formatted for a [theatrical / television] running time of not less than [90 / 96 / ___] minutes [or more than 120 minutes], entirely shot, finished and assembled, with fully synchronized sound, music and effects, with no more than incidental stock footage, [telling a complete story / as screened on _____], [capable of receiving an MPAA/CARA rating no more restrictive than "R"], and ready in all respects upon its Delivery for immediate exploitation of all Distribution Rights throughout the Territory. The Picture includes all available versions, such as a director's cut, airline version, and all available bonus materials and outtakes.

4. **TERRITORY AND LANGUAGE**:

 4.1. **Territory**: The Territory means all of the following: [_____] [excluding _____].

 [4.2. **Major Territories**: For purposes of this Agreement, the following are Major Territories: _____.]

 [4.3. **Domestic and International Territory**: For purposes of this Agreement the Domestic Territory is: _____. The International Territory is the Territory excluding the Domestic Territory.]

 4.4. **Changes in Territory**: Each country in the Territory means the country as its political borders exist on the Effective Date along with its then existing territories, possessions and protectorates. If during the Agency Period an area separates from a country in the Territory, then the Territory will still include the entire area

which formed one political entity as of the Effective Date of this Agreement. If during the Agency Period an area is annexed to a country in the Territory, then Producer grants Sales Agent a right of First Negotiation to become the exclusive sales agent for the Distribution Rights in the Picture through the end of the Agency Period in the newly annexed area to the extent such rights become available. Sales Agent may include comparable provisions in all Distribution Agreements.

4.5. **Non-Contiguous Areas**: Non-Contiguous Areas mean embassies, military and government installations, oil rigs and marine drilling sites, airlines-in-flight and ships-at-sea flying the flag of a country but not located within its contiguous geographic borders. The Territory does not include the Non-Contiguous Areas of other countries located within the Territory, but does include Non-Contiguous Areas of each country in the Territory as necessary for exploiting any particular Distribution Rights.

4.6. **Authorized Languages**: The Authorized Languages are all Local Languages in each country in the Territory [*except* _____ _____]. Where a Territory is designated as a specific language territory (*e.g.,* French Speaking) then the Authorized Languages for such Territory are only the designated languages.

5. **AGENCY PERIOD AND DISTRIBUTION TERM**:

5.1. **Agency Period**: The Agency Period means the period starting on the Effective Date and continuing until [_____ (___)] years after the earlier of Delivery of the Picture to Sales Agent in accordance with Paragraph 17, the first public release of the Picture in the Territory by authority of Sales Agent, or the Outside Delivery Date in Paragraph 20.2. [If by the end of the Agency Period, Sales Agent has not recouped the Advance paid under Paragraph 10, then the Agency Period will be extended for _____ additional years.]

5.2. **Distribution Term**: The Distribution Term means the license period for any Distribution Agreement duly concluded by Sales Agent under this Agreement. During the Agency Period, Sales Agent may negotiate Distribution Agreements having a Distribution Term that starts during the Agency Period and extends [for up to [_____ (___)] years from Delivery of the Picture under the relevant Distribution Agreement / for customary periods as decided by Sales Agent in good faith based on market conditions, but not exceeding [_____ (___)] years without Producer's Approval / for no more than [_____ (___)] years after the end of the Agency Period without Producer's Approval per Paragraph 9.2. Producer will honor all grants of exclusivity throughout the Distribution Term of any Distribution Agreement.

6. **DISTRIBUTION RIGHTS AND ALLIED RIGHTS**:

6.1. **Distribution Rights**: The Distribution Rights means all exclusive rights in the Picture [in all distribution media now known or later arising / for each of the following exclusive rights: Cinematic, Ancillary, PayPerView, Video, Pay TV, Free TV, Internet and ClosedNet (including customary uses such as Simulcasting, Catch-Up TV, IPTV, Covermount, Kiosk, Pack Sales and Partwork Sales)] [Souvenir Booklets in Japan].

6.2. **Allied Rights**: The Allied Rights means all customary rights as necessary or convenient to exploit the Distribution Rights, including: (i) creating and using advertising and marketing materials for the Picture, including trailers and clips (but only to the extent they do not generate residual or reuse fees without Producer's Approval); (ii) using the name, voice and likeness of Persons rendering materials or services on the Picture for advertising and marketing the Picture, subject to customary contractual restrictions and obligations provided to Sales Agent by Delivery; (iii) creating and using dubbed, subtitled, voice-over, multi-track and other versions of the Picture in the Authorized Languages; (iv) editing, re-titling or reformatting the Picture for censorship or release requirements [provided that there will be no creative editing of the Picture without prior meaningful consultation with Producer]; (v) authorizing use of customary advertisements and commercial announcements in the Picture; [(vi) authorizing sponsorships of the Picture subject to contractual restrictions and obligations provided to Sales Agent by Delivery]; (vii) including the Picture in screenings to the trade in order to interest Distributors; (viii) adapting and reformatting the Picture in all sizes, gauges, formats, processes and copy protection technologies necessary or convenient for exploitation of any Distribution Rights. Sales Agent will comply with all contractual restrictions and obligations to third parties rendering services or materials to the Picture with respect to the exercise of all Allied Rights after having been provided Notice of such restrictions and obligations by Producer. In addition, Sales Agent will advise all Distributors of such contractual restrictions and obligations. No inadvertent failure by Sales Agent or any Distributor to comply with any obligation owed to Producer or a third party in exercising any Allied Rights will be a material breach of this Agreement, but Sales Agent will take reasonable steps to cure prospectively any such failure promptly after Sales Agent receives Notice of such failure.

6.3. **Reserved Rights**: The Reserved Rights means [all rights in the Picture other than the Distribution Rights and Allied Rights / the following rights in the Picture: Merchandising (excluding

Souvenir Booklets in Japan), Live Performance, Publishing, Remake, Sequel and publishing or administration rights for any music in the soundtrack album for the Picture]. Producer may only exercise or authorize exercise of any Reserved Rights in accordance with this Agreement.

[6.4. **[First Negotiation Right] [First Negotiation / Last Refusal Right]**: Producer also grants Sales Agent an exclusive [First Negotiation Right][First Negotiation / Last Refusal Right] throughout the Agency Period: (i) to become the exclusive sales agent [for all Reserved Rights / the following Reserved Rights:_ _____]; and (ii) to continue representing the Picture as the exclusive sales agent after the end of the Agency Period.]

6.5. **Royalty Income:** To the extent that Producer controls such rights, Producer also authorizes and grants to Sales Agent, by itself or through an appropriate collecting organization, to collect on behalf of Producer all amounts collected by any collecting society, authors' rights organization, performing rights society or governmental agency, arising from all royalties, levies and remuneration imposed by Law or collectively managed including, but not limited to: audio-visual royalties for secondary or simultaneous retransmission by means of any cable, satellite, microwave, Internet, Closed Network or other system, any Simulcasting or Catch-Up TV, tax rebates, exhibition surcharges, or levies on blank Videograms if the actions generating such income occur within the Territory during the Agency Period or any applicable Distribution Term, no matter when such sums are paid. Royalty Income means all such sums paid or payable directly from the applicable collecting organization(s) to Producer or Sales Agent which will be included in Gross Receipts.

7. **HOLDBACKS:**

7.1. **Sales Agent**: Sales Agent agrees to negotiate to include the following Holdbacks in relevant Distribution Agreements to the full extent allowed by Law: (i) if the Territory does not include the Picture's country of origin, not to authorize a general public release of the Picture in the Territory until the *earlier of* its First Release in its country of origin or [six (6) months / _____] from its Delivery or [one (1) year / _____] from the Effective Date; (ii) if the Distribution Rights include Video, not to authorize the export of Videos from inside the Territory to areas outside the Territory; (iii) if the Distribution Rights include PayPerView or Pay TV, not to authorize sale outside the Territory of decoders for any encrypted broadcast of the Picture originating inside the Territory; (iv) if the Distribution Rights include PayPerView, Pay

TV or Free TV, not to authorize any Broadcast of the Picture from inside the Territory intended for primary reception outside the Territory, but incidental overspill will not be a breach of this provision; and (v) if the Distribution Rights include Internet or ClosedNet Rights, not to authorize making the Picture available on the Internet or a Closed Network except with customary provisions regarding technological measures to prevent access outside the Territory.

7.2. **Producer**: Producer agrees to abide by the following Holdbacks and to include them in any distribution agreement outside the Territory to the full extent allowed by Law: (i) if the Territory includes [the Picture's country of origin / North America] but is not worldwide, not to authorize [any / Theatrical] release of the Picture outside the Territory until the *earlier of* its first such release in [the Picture's country of origin / North America] or [six (6) months / _____] from its Delivery or [one (1) year / _____] from the Effective Date; (ii) if the Distribution Rights include Video, not to authorize the export of Videos from outside the Territory to areas inside the Territory; (iii) if the Distribution Rights include PayPerView or Pay TV, not to authorize sale outside the Territory of decoders for any encrypted broadcast of the Picture originating inside the Territory; (iv) if the Distribution Rights include PayPerView, Pay TV or Free TV, not to authorize any Broadcast of the Picture from outside the Territory intended for primary reception inside the Territory; (v) if the Distribution Rights include Internet or ClosedNet Rights, not to authorize making the Picture available on the Internet or a Closed Network except with customary provisions regarding technological measures to control access within the Territory; and [(vi) Producer will not authorize any exploitation, until ___ months / ___ years after the Outside Delivery Date, of the following Reserved Rights:_____ _____].

B. PERFORMANCE PROVISIONS

8. SALES AGENT SERVICES:

8.1. **Standards**: Sales Agent will undertake the customary services of a professional sales agent in the motion picture industry in representing the Picture under this Agreement. Producer understands that Sales Agent may represent other motion pictures in addition to the Picture which other motion pictures may compete with the Picture. Sales Agent will devote such time and resources to the Picture as Sales Agent believes in good faith are

appropriate, but need not render services exclusively for the Picture. Sales Agent will have no less rights than any member of the general public with regard to the intellectual property rights in and to the Picture.

8.2. **Services Rendered – Agency Period**: During the Agency Period, Sales Agent will: (i) represent, market and promote the Picture at film markets and festivals and by other customary means; (ii) solicit, negotiate and conclude Distribution Agreements; and (iii) meaningfully consult with Producer regarding Sales Agent's activities for the Picture upon reasonable request or as otherwise required under this Agreement.

8.3. **Services Rendered – Distribution Term**: During the Distribution Term for each Distribution Agreement, Sales Agent will: (i) organize Delivery of the Picture to Distributors, including providing appropriate notices of availability of delivery elements or materials, coordinating with laboratories, and arranging shipping; (ii) coordinate with Distributors to obtain necessary censorship approvals, tax certificates, import licenses, currency transmission certificates or like documents; (iii) provide required consultations and approvals such as for release dates or making other versions of the Picture; (iv) send notices of payments due and use commercially reasonable efforts to obtain reports and collect amounts due; (v) monitor Distributor compliance with Distribution Agreements; (vi) timely provide Producer with information that Sales Agent learns about unauthorized exploitation or piracy of the Picture; and (vii) render Statements and payments of Producer's Share as required under this Agreement.

8.4. **Services Excluded**: Sales Agent's services do not include undertaking any audit or arbitration for any Distribution Agreement or pursuing any anti-piracy action. However, if after mutual consultation either Party desires to conduct an audit or arbitration, then the other Party will meaningfully cooperate with the conducting Party in providing information and assistance needed to do so. The Party conducting the audit or arbitration will be responsible for advancing all necessary costs and attorney's fees, but may recoup them from any recovery in the audit or arbitration, with any remaining amount of such recovery being included in Gross Receipts.

8.5. **Distribution Deal Terms**: Subject to other terms in this Agreement, Sales Agent is authorized to negotiate and conclude all Distribution Agreements within commercially reasonable parameters. However, without Producer's Approval, Sales Agent will not conclude any Distribution Agreement for the Picture: (i) to an Affiliate of Sales Agent [except on an arm's-length basis];

[(ii) on a "straight distribution" basis where payments are based solely on performance and there is no license fee or Minimum Guarantee]; or (iii) in conjunction with other motion pictures *unless* each motion picture in such Distribution Agreement has a separate Minimum Guarantee allocated on a fair and reasonable basis and no cross-collateralization is allowed among the licensed motion pictures.

8.6. **Distribution Deal Documentation**: For documenting Distribution Agreements, Sales Agent will use commercially reasonable efforts to utilize a form of agreement subject to Producer's Approval, with the IFTA® Model International Licensing Agreements (including the IFTA® International Multiple Rights Deal Memo) being pre-approved. However, Producer understands that Distributors may negotiate the terms of an approved form, may require use of their own form, or may require use of a form pre-negotiated with Sales Agent. As such, Sales Agent is authorized to conclude Distribution Agreements using any agreement form as may be commercially practicable under the circumstances. Producer authorizes Sales Agent to execute all Distribution Agreements (including deal memos) "as agent for" Producer. However, if requested by Sales Agent, Producer will timely execute any Distribution Agreement. Producer upon reasonable request may access, review and copy all Distribution Agreements concluded by Sales Agent.

8.7. **No Performance Guarantee**: The Parties acknowledge that exploiting motion pictures is a speculative business. As such, neither Party makes any representation or warranty, express or implied, regarding the ability to conclude any Distribution Agreement, to exploit the Picture, or to earn or collect any Gross Receipts or Producer's Share. Any estimates or projections about possible Distribution Agreements or performance of the Picture are statements of opinion *only*. Producer acknowledges that Producer's Share is merely an accounting entry and Sales Agent does not guarantee that Gross Receipts will be earned or Producer's Share will be payable in any amount. Sales Agent does not guarantee the performance of any Distributor under any Distribution Agreement.

9. **PRODUCER INVOLVEMENT**:

9.1. **Producer's Cooperation**: Producer will fully and timely co-operate with Sales Agent as necessary for Sales Agent to render all services, including meaningfully and timely providing all required information, Producer's Approvals, consultations and decisions. Producer agrees that any failure by Producer to render any such cooperation as and when required will excuse

Sales Agent from performing any service dependent on such cooperation.

9.2. **Producer's Approval**: Producer's Approval means Notice to Sales Agent that Producer affirmatively approves or disapproves a matter for which approval is required or requested, which will not be unreasonably withheld or delayed. Approval will be deemed given if Sales Agent does not receive such Notice within twenty-four (24) hours during a film market or film festival, or five (5) days otherwise, of Producer's receipt of the request for approval. An ambiguous or incomplete Notice will be deemed approval of any item not affirmatively disapproved. If Producer disapproves any matter, then upon reasonable request Producer will timely identify to Sales Agent any steps needed to obtain approval.

{Select applicable provisions}
{Approval of Deal Terms}

9.3. **Designated Deal Terms**: Designated Deal Terms means the proposed [distributor, rights granted, territory, minimum guarantee, key elements, distribution term, holdbacks and delivery dates]. Producer's Approval will apply to the Designated Deal Terms of all Distribution Agreements concluded by Sales Agent during the [first year of / entire] Agency Period [in the Major Territories / in the following Territories: _____].

{Ask/Take Schedule}

9.4. **Ask/Take Schedule**: [Upon reasonable request, after execution / after viewing a rough cut of the Picture,] Sales Agent will prepare one "Ask/Take Schedule" of target asking and taking amounts for Minimum Guarantees for Distribution Rights in the [Major Territories / in the following Territories: _____]. Any Ask/Take Schedule so prepared is conditioned upon the Picture fully conforming to the description in Paragraph 3 and will become part of this Agreement. After Complete Delivery and during the [first year of / two (2) years of / entire] Agency Period, Sales Agent will not conclude any Distribution Agreement whether for all or some of the Distribution Rights in a Territory with a Minimum Guarantee less than the applicable take price on the Ask/Take Schedule without Producer's Approval. Notwithstanding any Ask/Take Schedule, Producer understands that Sales Agent does not guarantee that any particular right or territory can be licensed or that any particular ask or take price can be obtained.

9.5. **Use of Ask/Take Schedule**: Producer acknowledges that any Ask/Take Schedule provided by Sales Agent may contain proprietary, trade secret information of Sales Agent regarding

territory pricing or customer contacts. As such, Producer will maintain any Ask/Take Schedule provided by Sales Agent under this Agreement in strict confidence and not disclose it to any third party without prior Notice of Sales Agent's consent in each instance. In no case may Producer include any Ask/Take Schedule in any private placement memorandum, securities offering or financing proposal without specific prior Notice of Sales Agent's consent in its sole discretion, along with all disclaimers required by Sales Agent. This provision does not apply to any information that becomes publicly available other than through a breach of any confidentiality requirement or pursuant to a governmental order or subpoena.

C. PAYMENT PROVISIONS

10. **ADVANCE:**

 10.1. **Amount:** [US Dollars/Euros/etc.]_____. Sales Agent will pay Producer a non-returnable but fully recoupable Advance against Producer's Share (as defined in Paragraph 11) in the Base Currency and amount specified above in the following installments:

 a. ____ % (_____) on execution of this Agreement;
 b. ____ % (_____) on approval of the Chain of Title;
 c. ____ % (_____) on Initial Delivery;
 d. ____ % (_____) on Complete Delivery;
 e. ____ % (_____) on First Release;
 f. ____ % (_____) on _____

 Producer must provide Sales Agent with an invoice for each installment showing the amount due and the date the applicable event triggering payment occurred. Sales Agent will not be required to pay any installment until [____] days after receipt of each such invoice.

 10.2. **Base Currency:** The Base Currency is the currency in which the Advance is denominated.

 [10.3. **Interest:** Producer will be entitled to Interest at the rate specified in Paragraph 11.6 on any installment of the Advance not paid on the due date determined in the invoice provided in Paragraph 10.1 until it is paid in full.]

 10.4. **Consideration:** Producer agrees that Sales Agent's payment of the Advance is in itself full and fair consideration for entering into this Agreement regardless whether or not any Producer's Share becomes payable to Producer.

11. PRODUCER'S SHARE:

11.1. **Defined**: Producer's Share means the amount of Gross Receipts, if any, remaining after deducting and recouping on a continuous basis in the following order of priority: (i) Sales Agent's Commission; and (ii) Sales Agent's Recoupable Expenses, [(iii) Interest] and (iv) the Advance.

11.2. **Recoupment and Payment**: Sales Agent will recoup its Commission, Recoupable Expenses, [Interest] and the Advance and calculate Producer's Share on a continuous basis for as long as Gross Receipts are earned. [Except for payments made by a Collection Agent established under Paragraph 15.3,] with each Statement rendered by Sales Agent under Paragraph 16.2, Sales Agent will then pay Producer's Share then due, if any, to Producer or its designee at the place where Producer receives Notice or such other place as Producer may designate by Notice to Sales Agent.

11.3. **Returnable Payments**: Producer acknowledges that returnable payments, such as deposits, are not includable in Gross Receipts or used to calculate Producer's Share until earned per Paragraph 12.2. However, Sales Agent, in its sole discretion, may elect to calculate and pre-pay Producer's Share on any returnable payments received as if they had been earned. In such case, if the payments later become returnable, then Producer agrees upon demand to make a full refund of all pre-paid amounts received by Producer to the Distributor entitled to the refund, or, if Sales Agent in its discretion has elected to make the refund to Distributor, then Producer will reimburse Sales Agent such amount or Sales Agent may deduct the amount of the refund from other amounts due to Producer for the Picture. As a condition to making any such pre-payment, Sales Agent may require that Producer provide appropriate assurances of full and timely repayment.

11.4. **Producer's Tax ID**: Producer will timely provide Sales Agent with its current and accurate tax identification number and related information as needed to make any payment of Producer's Share. Sales Agent in its discretion may withhold any payment of Producer's Share until such information is received.

11.5. **Currency Conversion**: To the greatest extent possible, Sales Agent will make all calculations of Producer's Share and its components in the Base Currency. If any Gross Receipts are earned or Recoupable Expenses are incurred in another currency, Sales Agent will endeavor to convert them to the Base Currency using the exchange rate at the bank where the account for the Picture is maintained as utilized on the Statement on which the

items are reported. If Sales Agent finds it impracticable to convert any monies earned or incurred in another currency to the Base Currency, then to the extent permitted by Law, Sales Agent will deposit in Producer's name in a depository reasonably designated by Producer that portion of Producer's Share, in the other currency, to which Producer would be entitled if such monies were convertible to the Base Currency. Such deposit will constitute payment in full to Producer of the amount so deposited.

[11.6. **Interest**: The Interest Rate will be: [___ %; ___ basis points over [Prime/1- month LIBOR/ 3-month LIBOR], Sales Agent will be entitled to recoup Interest on [Recoupable Expenses /the Advance.] Interest will be computed and adjusted monthly from the time the interest-bearing payment is made until it is recouped. "Prime" means the advertised base rate on major corporate loans charged by the bank where the account for the Picture is maintained. "LIBOR" means the applicable London Inter-Bank Overseas Rate.]

12. GROSS RECEIPTS:

12.1. **Defined**: Gross Receipts means all gross monies and other consideration paid or payable without any deduction as "earned" with respect to any Distribution Agreement that is substantially negotiated or concluded by Sales Agent under this Agreement, including Advances, Minimum Guarantees, Overages, Royalty Income and the like.

12.2. **Earned**: Gross Receipts will be deemed earned when unconditionally received by, forfeited to or credited to Producer or used for Producer's benefit or account, including amounts paid to third parties at Producer's direction, at any time during the Agency Period, any applicable Distribution Term and thereafter for so long as Gross Receipts are paid or payable. Deposits and other conditional payments will be deemed earned on the earlier of the date when they become non-refundable or are forfeited due to an uncured breach by the Distributor.

[12.3. **Producer's Failure of Performance**: If any Distributor cancels its Distribution Agreement, refuses to make payment when due, or demands a refund of any payment solely because of a claimed default by Producer, such as a breach of warranty or failure of Delivery, then, solely for purposes of calculating Sales Agent's Commission and Recoupable Expenses and not Producer's Share, Gross Receipts will be deemed earned with respect to amounts paid or payable under such Distribution Agreement to the same extent as if the Distributor had

unconditionally made all such payments when due. Sales Agent will calculate Sales Agent's Commission and Recoupable Expenses that it would have recouped from such deemed Gross Receipts, and [Sales Agent may set-off and deduct such amounts from any other payment of Producer's Share / Producer agrees to repay Sales Agent such amounts upon demand.]

13. **SALES AGENT'S COMMISSION**:

13.1. **Calculation**: Subject to Paragraph 13.2, Sales Agent will be entitled to a Commission based on all Gross Receipts earned under this Agreement calculated as follows:

[Select applicable Alternative]

[Alternative – One Fee]

____ % of Gross Receipts earned from any source

[Alternative – Variable Fee by Major Territory]

____ % of Gross Receipts earned from any Distribution Agreement that contains any of the Major Territories; and

____ % of Gross Receipts earned from any from any Distribution Agreement that does not contain any of the Major Territories.

[Alternative – Variable Fee by Domestic/International Territory]

____ % of Gross Receipts earned from the Domestic Territory; and

____ % of Gross Receipts earned from the International Territory.

[Alternative – Variable Fee by Distribution Right]

The following percentages of Gross Receipts earned for the indicated Distribution Right:

Distribution Right	Percentage Fee
Cinematic	____
Ancillary	____
PayPerView	____
Video	____
Pay TV	____
Free TV	____
Internet	____
ClosedNet	____

Where multiple Distribution Rights are included in a Distribution Agreement, Sales Agent's Commission will be based on the allocations in the Distribution Agreement; if there are none, it will be based on the allocation determined by Sales Agent in good faith.

[Alternative – Variable Fee by Payment Type]

_____ % of Gross Receipts earned from Guarantees and
_____ % of Gross Receipts earned from Overages

For these purposes: (i) "Guarantees" means fixed payments due under Distribution Agreements, including Advances, Minimum Guarantees, and License Fees; and (ii) "Overages" means contingent amounts based on performance payable after recoupment of Guarantees, if any, including royalties, contingent compensation, and net receipts.

[Alternative – Tiered Fee]

_____ % of Gross Receipts earned from first dollar to US$_____
_____ % of Gross Receipts earned from US$_____ to US$_____
_____ % of Gross Receipts earned in excess of US$_____.

13.2. **Use of Subagent(s)**: A subagent is an agent appointed by Sales Agent to represent the Picture in accordance with this Agreement and is not a Distributor. Sales Agent's Commission will be inclusive of the commission of any subagent(s) used by Sales Agent except for customary subagent(s) used to conclude Distribution Agreements for television rights [in the Major Territories / in _____] whose commission will be deducted ["off the top"] from Gross Receipts derived from such Distribution Agreements [and capped at ___% of such Gross Receipts].

14. **RECOUPABLE EXPENSES**:

14.1. **Defined**: Recoupable Expenses means all direct, documented, reasonable and customary costs and expenses paid or incurred by Sales Agent in representing the Picture under this Agreement.

14.2. **Marketing Expenses**: Marketing Expenses means all Recoupable Expenses for: (i) advertising, marketing and promoting the Picture; (ii) creating and manufacturing trailers, one-sheets, promos, advertising, marketing and publicity materials; (iii) attending film markets and festivals where the Picture is actually introduced or made available to potential Distributors, including participation fees, travel expenses, office charges and customary entertainment costs with potential Distributors all as allocated to the Picture; [(iv) retaining public relations or marketing firms for representing the Picture subject to Producer's Approval]; (v) undertaking promotional or trade screenings for the Picture; (vi) arranging promotional tours for talent associated with the Picture [subject to Producer's Approval]; and (vii) other reasonable and customary marketing expenses.

14.3. **Servicing Expenses**: Servicing Expenses means all Recoupable Expenses for: [(i) withholding, sales, use, VAT or like taxes charged on any Gross Receipts or Delivery Materials, but not including any franchise or income tax of Sales Agent; (ii) verifying, quality checking, handling and storing all Delivery Materials; (iii) obtaining necessary licenses and clearances and undertaking searches and obtaining corrective documents for any items in the Chain of Title not duly delivered by Producer, including reasonable [outside] attorneys' fees and required payments to third parties, provided Sales Agent will consult with Producer in advance before incurring such fees or payments; (iv) accepting Delivery and creating and manufacturing Delivery Materials not duly delivered as provided in Paragraph 21; (v) servicing Distribution Agreements including charges for creating, manufacturing, packaging, duplicating, shipping, handling and storing servicing materials required under Distribution Agreements and charges for servicing agents; (vi) international telephone, fax, postage, messenger and copying fees; (vii) notarial and consularization certificates, import licenses, governmental permits and the like; (viii) undertaking billings and collections under any Distribution Agreement, including currency conversion fees, escrow fees, and bank charges including for separate bank accounts; (ix) if the Parties mutually agree, the actual [outside] attorneys' fees for negotiating and concluding any Interparty Agreement, Notices of Assignment and Acknowledgement with Distributors, and related documents required for obtaining financing for the Picture, if any; (x) actual costs of outside professionals, including servicing agents, attorneys, auditors and accountants, to assist in negotiating, servicing or enforcing any Distribution Agreement, provided Sales Agent will consult with Producer in advance before retaining any such outside professionals; and (xi) other reasonable and customary servicing expenses].

14.4. **Distributor Payment**: Sales Agent will use commercially reasonable efforts to require payment of all applicable Servicing Expenses by the Distributor under the affected Distribution Agreement but does not guarantee the ability to do so. Any Servicing Expenses paid by the Distributor will be deducted from the Servicing Expenses recoupable by Sales Agent.

14.5. **Allocation**: Where Sales Agent incurs any Recoupable Expenses for the Picture and other motion pictures, Sales Agent will allocate such expenses among all affected motion pictures on a fair and reasonable basis.

14.6. **Recoupment**: Sales Agent will advance all Recoupable Expenses, which Sales Agent may recoup from Gross Receipts in accordance with Paragraph 11.2. Producer will have no liability to any third parties for any Recoupable Expenses not so recouped from Gross Receipts.

14.7. **Marketing Budget**: Sales Agent will timely prepare for Producer's Approval a proposed budget of anticipated Marketing Expenses. [Producer will then pay Sales Agent the approved budgeted amount and Sales Agent will then incur and pay Marketing Expenses in substantial conformity with the approved budget. Sales Agent will then incur and pay Marketing Expenses in substantial conformity with the approved budget, recouping such amounts as Marketing Expenses in accordance with Paragraph 11.2.] Sales Agent need not incur Marketing Expenses in excess of the approved budget, but may do so in its discretion. However, Sales Agent will be solely responsible for paying such excess and may not recoup the excess from Gross Receipts without Producer's Approval.

14.8. **Overall Cap**: Without Producer's Approval, Sales Agent will not recoup Recoupable Expenses in excess of [US$ _____] [*excluding* _____ and amounts under Paragraph 21]. Sales Agent may incur Recoupable Expenses in excess of this cap but Sales Agent will be solely responsible for paying such excess and may not recoup the excess from Gross Receipts without Producer's Approval.

14.9. **Marketing Expense Caps**: Without Producer's Approval, Sales Agent will not recoup Marketing Expenses in excess of [a Marketing Budget to be established with Producer's Approval / US$ _____ *excluding* _____]. Sales Agent may incur Marketing Expenses in excess of this cap, but Sales Agent will be solely responsible for paying such excess and may not recoup the excess from Gross Receipts without Producer's Approval.

14.10. **Servicing Expense Cap**: Without Producer's Approval, Sales Agent will not recoup Servicing Expenses in excess of [US$

_____] [*excluding* _____ and amounts
under Paragraph 21]. Sales Agent may incur Servicing Expenses
in excess of the above cap, but Sales Agent will be solely
responsible for paying such excess and may not recoup the
excess from Gross Receipts Producer's Approval.

14.11. **Market Attendance Caps**: Without Producer's Approval,
Sales Agent will not recoup those Marketing Expenses per Par-
agraph 14.2 (iii) for attending the following film markets or
festivals in excess of the following amounts: [_____
_____]. Sales Agent may incur such Market-
ing Expenses in excess of the above caps, but Sales Agent will
be solely responsible for paying such excess and may not recoup
the excess from Gross Receipts without Producer's Approval.

15. **COLLECTIONS AND PAYMENTS**:

15.1. **General Account**: Sales Agent will deposit all collections of
Gross Receipts in its general company accounts and make all
disbursements from Gross Receipts for the Picture from such
accounts. Producer will have no claim to any Gross Receipts,
Producer's only right being a claim to payment of Producer's
Share if and when due. Sales Agent will pay Producer or its
designee the amount of Producer's Share as shown due on each
Statement rendered by Sales Agent under Paragraph 16.2.

15.2. **Separate Account**: Sales Agent will establish a Separate
Account at [Bank] in the name of the Picture and direct all
payments of Gross Receipts to be made into such account. Sales
Agent will calculate and pay any Producer's Share, if any, from
such account [with each Statement rendered by Sales Agent
under Paragraph 16.2 / within fifteen (15) days after Gross
Receipts are earned and received in the Separate Account, in
which case Sales Agent will reconcile such payments to amounts
shown due on later Statements rendered by Sales Agent under
Paragraph 16.2, paying Producer any underpayment or re-
couping any overpayment from later payments.].

15.3. **Collection Account**: Sales Agent and Producer will negotiate
in good faith and timely conclude an agreement with a [mutually

approved] third party Collection Agent for making all collections and disbursements of Gross Receipts. [The Parties pre-approve [___] as Collection Agent.] Sales Agent will direct all payments of Gross Receipts into the Collection Account established by the Collection Agent for the Picture. From all Gross Receipts deposited in the Collection Account which have become earned as indicated by Notice from Sales Agent, Collection Agent will make disbursements in the following order: (i) first the Collection Agent will deduct its administration fees and charges; (ii) then the Collection Agent will pay Sales Agent its Commission, Recoupable Expenses, [Interest] and unrecouped Advance in accordance with [an invoice / _____] presented by Sales Agent to the Collection Agent / or as otherwise set forth in the collection agreement]; and (iii) then the Collection Agent will remit the balance remaining, if any, to Producer or its designee. In rendering Statements, Sales Agent will reconcile amounts paid from the Collection Agent to amounts shown due on the Statement. In case of an overpayment to any Party, the Party will promptly return the overpayment to the Collection Account.

16. **STATEMENTS AND AUDITS**:

16.1. **Standards**: Sales Agent will maintain full and accurate books and records for the Picture [at Sales Agent's principal place of business] using generally accepted accounting principles on a consistent, uniform and non-discriminatory basis consistent with this Agreement.

16.2. **Statements**: [Unless otherwise provided by any Collection Agent established under Paragraph 15.3,] Sales Agent will render to Producer periodic Statements showing all Gross Receipts earned and Recoupable Expenses paid or incurred in calculating Producer's Share on a cumulative and current basis. Such statements will be rendered no less frequently than sixty (60) days after each calendar quarter during the first [three (3) years] of the Agency Period and thereafter [semi-annually / annually], throughout the Agency Period and any applicable Distribution Term.

[16.3. **Incontestability**: All items shown on any Statement will be deemed incontestable twenty-four (24) months after the Statement is rendered unless Producer during such period gives Sales Agent Notice specifying each contested item in reasonable detail. Sales Agent may correct any item shown on any Statement, in which case the incontestability period will recommence solely with respect to the corrected item. Sales Agent need not maintain any books or records for any item for more than two (2) years after the item is deemed incontestable.]

16.4. **Audits**: Producer may audit the books and records of Sales Agent regarding the Picture for any item not deemed incontestable using [qualified / licensed / professional] accountants upon at least one (1) month's prior Notice once annually during the Agency Period and until one (1) year after the applicable Distribution Term. If the audit falls during a film market or festival, Sales Agent may delay the audit until two (2) weeks after its conclusion. The audit will be at Producer's expense unless the audit demonstrates an underpayment, accepted by Sales Agent or later proven to be correct, of more than [US$_____ / ten percent (10%) of the amount shown due Producer on any Statement] in which case Sales Agent will pay on demand the underpayment and the reasonable audit costs of uncovering the underpayment [up to the amount of the underpayment / not to exceed _____].

D. DELIVERY PROVISIONS

17. **DELIVERY**: Delivery of the Picture means actual, physical delivery to and acceptance by Sales Agent, at Producer's obligation and expense, of all Delivery Materials in the attached and incorporated IFTA® Delivery Schedule in accordance with this Agreement. Initial Delivery means Delivery of all Delivery Materials marked as Initial Materials, and Complete Delivery means Delivery of all Delivery Materials.

18. **INSPECTION**: All Delivery Materials must conform to the Picture as specified in Paragraph 3. Sales Agent will have a period of [twenty-one (21)] days after receipt of *all* Delivery Materials to inspect them for technical quality and conformity to specifications ("Inspection Period"). If Sales Agent determines any Delivery Materials are not acceptable, Sales Agent will give Producer a Notice to such effect within the Inspection Period specifying the defect(s) in reasonable detail, with any defect not specified being waived. Producer will then timely deliver substitute Delivery Materials to Sales Agent who will have another Inspection Period. This process will continue with successive periods until either Sales Agent has accepted, or waived acceptance, of *all* Delivery Materials, or the Outside Delivery Date occurs, and nothing in this process will waive Producer's obligation to make Complete Delivery by the Outside Delivery Date. Sales Agent may in its discretion waive Delivery of any particular Delivery Materials and in so doing agrees that Delivery has deemed to occur without them, but this will not waive Sales Agent's right to require Producer upon reasonable Notice to make later Delivery of any waived Delivery Materials.

19. **CHAIN OF TITLE**: Delivery includes providing Sales Agent with *all* documents in the Chain of Title, as identified in the IFTA® Delivery

Schedule, demonstrating Producer's ownership or control of all Distribution Rights and Allied Rights in the Picture throughout the Territory for the Agency Period and any anticipated Distribution Term. Sales Agent will have a period of [twenty-one (21)] days after receipt of *all* documents in the Chain of Title to inspect them for legal sufficiency ("Review Period"). If Sales Agent reasonably disapproves any document, Sales Agent will give Producer Notice within the Review Period specifying the defect(s) in reasonable detail, with any defect not specified being waived. In accordance with Paragraph 33.8, Producer will then timely obtain at Producer's expense necessary corrective documents. If Producer fails to do so, then Sales Agent may do so, charging the cost of so doing as a Servicing Expense. Sales Agent's failure to request or Producer's failure to provide any documents in the Chain of Title will not limit or excuse any of Producer's representations, warranties or indemnities under this Agreement. Sales Agent will have the right in its discretion to waive any defect in any document contained in the Chain of Title for purposes of making any payment to Producer, but such waiver will not waive Sales Agent's right to require delivery of satisfactory Chain of Title documents at a later time.

20. **DELIVERY DATES:**

 20.1. **Initial Delivery Date:** [_____]. Producer must initiate the Delivery process of the Picture within a reasonable time after execution of this Agreement. Producer will undertake all reasonable efforts to complete Initial Delivery of the Picture by no later than the above Initial Delivery Date.

 20.2. **Outside Delivery Date:** [_____]. In any case, Producer must make Complete Delivery of the Picture by *no later than* the date specified above or, if no date is specified, [six (6) months] after the Effective Date ("Outside Delivery Date"). Since the Delivery process includes time periods for inspection and correction, Producer must initiate the process in sufficient time to assure its completion by the Outside Delivery Date.

21. **FAILURE OF DELIVERY:** Producer's failure to make Complete Delivery by the Outside Delivery Date will be a material breach of this Agreement. In such case, Sales Agent, in addition to any other right or remedy, may deem all outstanding Commissions and Recoupable Expenses under any concluded Distribution Agreements to be earned and payable as of such Outside Delivery Date. Sales Agent will also have the right, but not the obligation, to create and manufacture any required Delivery Materials and to use them to service applicable Distribution Agreements as Sales Agent deems appropriate. Sales

Agent may charge and recoup [one hundred and ten percent (110%)] of the creation, manufacturing, shipping and handling costs of so doing as a servicing cost [(*i.e.*, actual cost plus an overhead charge)], which amount will be outside of any cap on Recoupable Expenses. This charge will be in addition to and not a waiver of any right or remedy Sales Agent may have for a Failure of Delivery.

22. **OWNERSHIP OF MATERIALS**:

22.1. **Delivery Materials**: Producer will retain legal ownership of and title to all Delivery Materials and no granting of access to or possession of any Delivery Materials by Producer will constitute a "first sale." Instead, Sales Agent will only hold all Delivery Materials on loan for servicing Distribution Agreements. Upon reasonable request, Sales Agent will provide Producer with Notice of the location of all Delivery Materials. Sales Agent will exercise due care in safe-guarding all Delivery Materials during [the Agency Period and any applicable Distribution Term].

22.2. **Created Materials**: Sales Agent will own title to all materials created or manufactured under its authority from the Delivery Materials, including those under Paragraph 21, subject to an exclusive license to use all such created materials for purposes of this Agreement, while Producer will retain the copyright in all such materials. If such an exclusive license is not allowed under Law in the Territory, then Producer grants to Sales Agent a non-exclusive free license to use all such materials in the Territory during the Agency Period and all Distribution Terms. Upon reasonable request, Sales Agent will provide Producer or its designees with access to any alternate language tracks, subtitled tracks and dubbed versions, masters, advertising and promotional materials including trailers, artwork and other materials created or authorized by Sales Agent from the Delivery Materials. Producer will pay Sales Agent promptly on receipt of invoice for any [third party] costs of providing such materials.

22.3. **Return of Materials**: Upon the later of the expiry of the Agency Period or of the final Distribution Term, Sales Agent will promptly at Producer's direction: (i) return all Delivery Materials to Producer at Producer's expense or provide Producer with a customary certificate of their destruction; and (ii) either sell all then available materials created by Sales Agent to Producer for their unrecouped actual costs of manufacturing, shipping and storage, or provide Producer with a customary certificate of their destruction.

23. **ACCESS TO OTHER MATERIALS**: If Producer has or will conclude a distribution agreement for the Picture with any distributor in the

[U.S. / any other country outside the Territory], Producer will use good faith efforts to obtain for Sales Agent free access to all delivery, publicity and advertising materials for all versions of the Picture created by or for any such distributor, but any failure to do so will not be a breach of this Agreement. Producer will give Sales Agent timely Notice whether Producer has obtained such access, free or otherwise, and the particulars for its exercise, *provided* if Producer has free access to any such materials Sales Agent will also have free access to those materials. Any fee for such access, or clearance or use costs for such materials advanced by Sales Agent, will be treated as a Recoupable Expense [outside any applicable cap].

E. THIRD PARTY PROVISIONS

24. THIRD PARTY PAYMENTS: Producer will be solely responsible for making timely payments to all parties rendering services or materials to the Picture, including all profit participations, guild and union residuals, royalties and reuse fees, and music clearance fees in accordance with Paragraph 25 and Sales Agent will not be responsible for such payments. Producer agrees to execute on demand any side-letter required by any applicable guild or union necessary to allow any collecting organization to collect or pay Royalty Income for the Picture.

25. MUSIC:

 25.1. **Cue Sheets:** As part of Delivery, Producer will supply Sales Agent with one (1) electronic file of a customary music cue sheet detailing the particulars of all music contained in the final version of the Picture and trailer, including the title of each composition, the composer(s), lyricist(s) and publisher(s) (including percentage of ownership if more than one publisher), copyright owner(s), performer(s), arranger(s), usage(s) (whether background instrument, background vocal, *etc.*), the number of such uses, the place of each composition showing the location and duration of each cue by the film footage or HD time code and running time of each cue and the performing rights society involved for each composer and publisher. Sales Agent will undertake to provide such cue sheets to Distributors for filing with the appropriate governmental agency or music rights society in the Territory.

 25.2. **Synchronization and Other Licenses**: Producer will obtain by [Initial] Delivery, and maintain in effect for the Agency Period and any applicable Distribution Term throughout the Territory, all rights needed to synchronize the underlying musical composition(s), to use the sound recording and to use any other musical composition to any music commissioned for the Picture

for all music embodied in the Picture on all its Copies or promotional materials without cancellation or charge to Sales Agent or any Distributor for all applicable Distribution Terms. Producer will be solely responsible for paying all sums needed to obtain and maintain such rights.

25.3. **Mechanical**: Producer will obtain by [Initial] Delivery, and maintain in effect for the Agency Period and any applicable Distribution Term throughout the Territory, all rights needed to make mechanical reproductions of all music embodied sufficient to exploit the Picture consistent with this Agreement on all its Copies or promotional materials, without cancellation or charge to Sales Agent or any Distributor for all applicable Distribution Terms. Producer will be solely responsible for paying all sums needed to obtain and maintain such mechanical rights, *provided* if a mechanical or authors' rights society in a country in the Territory refuses to honor in that country a valid authorization obtained by Producer, then Producer will not be responsible for such sums charged by such mechanical or authors' rights society. [Sales Agent is not responsible for obtaining mechanical rights to the music in the Picture; however any costs for mechanical rights that may be advanced by Sales Agent in its sole discretion will be recouped by Sales Agent as a Servicing Expense outside of any cap.]

25.4. **Performance**: Producer will obtain by [Initial] Delivery, and maintain in effect for all relevant times throughout the Territory, all clearances needed to establish that the non-dramatic ("small") performing rights in each musical composition embodied in the Picture are either: (i) in the public domain in the Territory; or (ii) owned or controlled by Producer sufficient to allow Sales Agent and any Distributor to exploit the Licensed Rights without additional payment for such rights; or (iii) available by blanket license from a performing rights society in the Territory affiliated with the International Confederation of Authors and Composers Societies (CISAC).

26. **PRODUCER REPRESENTATIONS AND WARRANTIES**: Producer represents and warrants to Sales Agent that all of the following are true and correct and will remain so throughout the Agency Period and any applicable Distribution Term: (i) Producer is duly organized and in good standing in [_____] with [Entity No._____] and has full authority to enter into and perform this Agreement; (ii) the Picture is fully original other than incidental stock footage or public domain material; (iii) Producer exclusively owns or controls all Distribution Rights and Allied Rights in the Picture throughout the Territory for the Agency Period and any relevant Distribution Term; (iv) Producer

has not and will not appoint any other sales agent to represent any Distribution Rights in the Picture anywhere in the Territory throughout the Agency Period, and Producer will honor all grants of exclusivity in all Distribution Agreements for their entire Distribution Term; (v) Sales Agent will not be responsible for any claim of residuals under 28 U.S.C. § 4001 or any other law or provision of any collective bargaining agreement; (vi) except as provided in Paragraph 25 for embodied music, by Delivery, Producer will have satisfied all obligations to and obtained all necessary authorizations from writers, producers, directors, composers, performers and all other Persons rendering materials or services for the Picture, to use their contribution to the Picture without cancellation, impairment or further payment; (vii) for embodied music, by Delivery, Producer will have obtained all necessary authorizations from authors, composers, lyricists and performers to use all synchronization, mechanical and performance rights as provided in Paragraph 25; (viii) nothing in the Picture or any Delivery Materials, including its title or embodied music, infringes any intellectual property right (copyright, author's right, neighboring right, patent, trademark, *etc.*) or personal right (defamation, libel, slander, performer's right, right of publicity, moral right, *etc.*) of any Person nor will any exploitation of the Picture violate any Law; (ix) there are no pending or threatened claims, arbitration or litigation, nor any liens, security rights, charges or encumbrances [other than customary guild security interests], affecting the Picture or any Delivery Materials that might impair Sales Agent's free and unencumbered representation of any Distribution Rights or Allied Rights anywhere in the Territory for the Agency Period and any applicable Distribution Term; (x) the Picture (including any available coverage material) will be capable of obtaining an MPAA/CARA rating no more restrictive than "R" or its equivalent in major countries in the Territory; (xi) all documents in the Chain of Title are true and complete copies of the original, valid and enforceable according to their terms; and (xii) Producer has undertaken reasonable efforts to ensure that all suppliers of essential special effects and other digital information embodied in any Delivery Materials have not included any electronic self-help instructions that will cause such digital information to cease operation of its own accord in a manner that materially impairs any use of such Delivery Materials, but this does not apply to electronic Rights Management Information that prevents unauthorized use of the Delivery Materials.

27. **SALES AGENT REPRESENTATIONS AND WARRANTIES**: Sales Agent represents and warrants to Producer that all of the following are true and correct and will remain so throughout the Agency Period: (i) Sales Agent has full authority to enter into and perform this Agreement; (ii) no advertising or marketing materials created by Sales Agent will infringe any intellectual property right (copyright, author's right,

neighboring right, patent, trademark, *etc.*) or personal right (defamation, libel, slander, performer's right, right of publicity, moral right, *etc.*) of any Person, subject to any failure of Producer's representations and warranties applicable to such materials; and (iii) Sales Agent will not conclude any Distribution Agreement subject to Producer's Approval without first obtaining such Approval.

28. INDEMNITIES: Each Party will indemnify, defend and hold harmless the other Party from any third party claim or resulting loss, liability or damage, including reasonable [outside] attorneys' and professional fees, arising from any failure of any of the Party's representations or warranties [or undertakings] contained in this Agreement. Producer will include Sales Agent as an additional insured under Producer's policy of errors and omissions insurance for the Picture and provide Sales Agent with a customary certificate of such coverage as part of Delivery of the Picture.

F. DEFAULT PROVISIONS

29. DEFAULT AND REMEDIES:

29.1. **Notice and Cure**: Each Party will give the other Party Notice of any claimed default under this Agreement. If the defaulting Party fails to cure the default within fourteen (14) days for a monetary default or twenty-one (21) days for a non-monetary default after receipt of Notice, the aggrieved Party may pursue any available right or remedy for such uncured default.

29.2. **Recoverable Damages**: Each Party may only seek to recover incidental or direct damages occasioned by any default. Each Party waives any right to seek special, consequential or punitive damages, including "lost profits" from any default. This waiver is an independent covenant that survives the failure of essential purpose of any other remedy, even if limited.

29.3. **Producer Cancellation**: Producer will have the right to give Notice to Sales Agent of its intent to cancel this Agreement for uncured default by Sales Agent in failing to pay when due [the first / any] installment of the Advance. However, except in such situation, Producer will have no right to terminate, cancel or rescind this Agreement or any authority granted to Sales Agent, nor to seek any injunction or equitable remedy or prevent Sales Agent's representation of the Picture, Producer's sole remedy in all such cases being limited solely to an action at law for an accounting or Recoverable Damages. A "cancellation" means a termination of this Agreement for cause, *i.e.*, for an uncured material default.

29.4. **Sales Agent Cancellation**: Sales Agent will have the right to give Notice to Producer of its intent to cancel this Agreement at any time after any uncured material default by Producer.

29.5. **Effect of Cancellation**: In case of cancellation, each Party will retain all its rights and remedies due for any performance rendered up to the time of cancellation, including all claims for damages, Commissions, and Recoupable Expenses. [In addition, with respect to any existing Distribution Agreements, either: (i) Sales Agent will continue to service all Distribution Agreements substantially negotiated or concluded by Sales Agent up to the time of cancellation, including collecting all Gross Receipts and making recoupments under Paragraph 11.2 attributable to such Distribution Agreements, but Sales Agent may not negotiate any new Distribution Agreements; or (ii) alternatively, if the Parties mutually agree, Producer will assume all Distribution Agreements substantially negotiated or concluded by Sales Agent up to the time of cancellation and make all payments of Sales Agent's Commission and Recoupable Expenses from Gross Receipts as earned under such Distribution Agreements.] Sales Agent may include in any Distribution Agreement a provision that Producer will have no right to terminate, cancel or rescind such Distribution Agreement, or to seek any equitable relief to enjoin or restrain the Distributor's exploitation of the Picture, Producer's sole remedy for any breach of the Distribution Agreement being limited to monetary damages.

29.6. **Equitable Relief**: Producer agrees that the Distribution Rights are of a unique artistic or intellectual value, the loss of representation of which cannot be fully compensated by monetary damages, so that Sales Agent will have the right to seek equitable relief, including an injunction, for a default by Producer. Nothing in this Agreement prevents Producer from seeking equitable relief for any attempted exploitation of any Distribution Rights or Allied Rights in the Picture outside the scope of this Agreement or any applicable Distribution Agreement.

29.7. **Set-Off**: Sales Agent may set-off and recoup from Producer's Share whenever due any overpayment of Producer's Share [or any other amount due Producer from Sales Agent under this Agreement].

30. **ARBITRATION**: Any dispute arising under this Agreement, including with respect to any right or obligation that survives termination or cancellation of this Agreement, will be administered and resolved by final and binding arbitration under the IFTA® Rules for International Arbitration in effect as of the Effective Date of this Agreement ("IFTA® Rules"). The IFTA® Rules are available online at the following address: www.ifta-online.org. Each Party waives any right to adjudicate any dispute in any other court or forum *except* that a Party may seek interim relief as allowed by the IFTA® Rules. The arbitration will be held in the Forum and under the Governing Law designated in this Agreement, or,

if none is designated, as determined by the IFTA® Rules. The arbitration will be decided in accordance with the Governing Law. The Parties will abide by any decision in the arbitration and any court having jurisdiction may enforce it. The Parties submit to the jurisdiction of the courts in the Forum for interim relief, to compel arbitration or to confirm an arbitration award. The Parties agree to accept service of process in accordance with the IFTA® Rules and agree that such service satisfies all requirements to establish personal jurisdiction over the Parties. The Parties waive application of the Hague Convention for Service Abroad of Judicial and Extrajudicial Documents in Civil or Commercial Matters with respect to the procedures for service of process.

G. GENERAL PROVISIONS

31. CREDIT: Sales Agent will be entitled to add [at its unrecoupable expense] its logo before the main credits of the Picture and in any related advertising, marketing and publicity released in the Territory [and an additional credit in the form of "_____" / in the main credits / end credits / as may be mutually agreed by the Parties].

32. NOTICES:

 32.1. **Notice:** A Notice means any communication required or allowed under this Agreement. All Notices must be in a record authenticated by the sender. Notice sent by personal delivery or mail will be effective when received. Notice sent by fax or e-mail will be effective when the sender receives an acknowledgement showing receipt by the recipient. A Notice of Termination sent by fax or e-mail must be accompanied by Notice sent by non-electronic means to be effective.

 32.2. **Place to Send Notice:** All Notices must be sent to a Party at its address on the Cover Page, except a Party may change its place for notice by Notice duly given. If a Party is no longer located at its place for Notice, the sender may give Notice by sending Notice to the receiving Party's last known address and providing a copy to a public official, if any, in the jurisdiction where such address is located designated to receive notice for absent parties, such as a Secretary of State, Company Commissioner or other appropriate authority.

 32.3. **Notice Time Periods:** All time periods in this Agreement based on Notice run from the date the recipient receives, or is deemed to have received, such Notice.

32. ASSIGNMENT AND DELEGATION:

 32.1. **Producer:** Except as provided in this Paragraph, Producer may not assign this Agreement, or rights under it, or delegate any

duties, in whole or in part, voluntarily or involuntarily, whether outright or for security, without prior Notice of Sales Agent's consent, and any attempt to do so without such prior Notice will be void and of no effect. For these purposes, an assignment includes an outright transfer, the granting of any lien or security interest, and a sale of substantially all of the assets of Producer or a conveyance of a majority of the membership interests or voting equity securities of Producer. As a condition to giving any consent, Sales Agent may require the assignee or delegate to assume in an authenticated record all obligations of Producer under this Agreement. However, once Producer has made Complete Delivery, Producer may assign, outright or for security, without the need for Sales Agent's prior consent, any portion of Producer's Share by giving Sales Agent Notice of the assignee and place for payment. Any assignment or delegation allowed under this Paragraph will be binding on and inure to the benefit of the assignee or delegate, but will not release Producer from its obligations under this Agreement.

32.2. **Sales Agent**: Except as provided in this Paragraph, Sales Agent may not assign this Agreement, or rights under it, or delegate any duties, in whole or in part, voluntarily or involuntarily, whether outright or for security, without prior Notice of Producer's consent, and any attempt to do so without such prior Notice will be void and of no effect. For these purposes an assignment includes an outright transfer, the granting of any lien or security interest, and a sale of substantially all of the assets of Sales Agent or a conveyance of a majority of the membership interests or voting equity securities of Sales Agent. As a condition to giving any consent, Producer may require the assignee or delegate to assume in an authenticated record all obligations of Sales Agent under this Agreement. However, Sales Agent may without prior Notice of Producer's consent: (i) make an assignment or delegation to any affiliated, parent or subsidiary company of Sales Agent; (ii) [provided that Sales Agent is not then in default,] make an assignment to an entity which acquires substantially all of Sales Agent's assets and which assumes in an authenticated record all of Sales Agent's obligations under this Agreement; (iii) assign or grant a security right in any portion of Sales Agent's Commission or Recoupable Expenses; or (iv) authorize or appoint subagents for any Territories or Distribution Rights in accordance with Paragraph 13.2, provided the subagent agrees to be bound by this Agreement. Any assignment or delegation allowed under this Paragraph will be binding on and inure to the benefit of the assignee or delegate but will not release Sales Agent from its obligations under this Agreement.

33. MISCELLANEOUS:

33.1. **Entire Agreement**: This Agreement represents the entire understanding of the Parties regarding its subject matter, superseding all prior written or oral negotiations, understandings, representations or agreements between them, if any. Each Party expressly waives any right to rely on such prior negotiations, understandings, representations or agreements, if any.

33.2. **Modification**: No modification of this Agreement is effective unless evidenced by a record authenticated by both Parties.

33.3. **No Waiver**: No waiver of any right or remedy under this Agreement will be effective unless contained in a record authenticated by the Party making the waiver. The exercise of any right or remedy will not waive any other right or remedy. No waiver of any default will be a waiver of any right or remedy for any other default.

33.4. **Remedies Cumulative**: All remedies are cumulative; resorting to one remedy will not preclude resorting to any to any other remedy at any time.

33.5. **Attorneys' Fees**: The Prevailing Party in any dispute or arbitration under this Agreement [will / will not] be entitled to recover reasonable [outside] attorney's fees incurred in prosecuting or defending the case. This provision supersedes any contrary provision in the IFTA® Rules.

33.6. **Terminology**: In this Agreement "and" means all possibilities, "or" means any or all possibilities in any combination, and "either...or" means only one possibility. "Including" means "including without limitation"; "must" or "will" means a Party is obligated to act or refrain from acting; "may" means a Party has the right, but is not obligated, to act or refrain from acting.

33.7. **Security Interest**: To secure Sales Agent's rights to recoup its Commission, Recoupable Expenses, [Interest] and the Advance, Producer grants Sales Agent a continuing Security Interest in all Distribution Rights in the Picture throughout the Territory and for any applicable Distribution Term in accordance with the attached Security Interest Documents consisting of [a security agreement / mortgage of copyright and security interest with description of collateral].

33.8. **Additional Documents**: Upon reasonable request each Party will execute and deliver any additional documents as are necessary to evidence, secure or perfect the other Party's interest under this Agreement or to carry out its terms, and each Party authorizes the filing of such documents with appropriate public authorities.

33.9. **E-Commerce**: No record relating to this Agreement, including this Agreement itself or any Notice, may be denied legal effect,

validity, or enforceability solely because an electronic signature or electronic record was used in its formation or transmission.

33.10. **Governing Law**: This Agreement will be governed by and interpreted under the laws of [California]. The predominant purpose of this Agreement is providing services with respect to intellectual property and not a sale of goods.

33.11. **Forum**: The exclusive Forum for conducting any arbitration or otherwise resolving any dispute under this Agreement will be [the County of Los Angeles, California] and for any other disputes under this Agreement the forum will be [the courts located within the County of Los Angeles, California]. The effectiveness of this exclusive forum selection clause will be determined by the Governing Law of this Agreement.

33.12. **Severability**: If any provision of this Agreement is determined to be invalid or illegal under any applicable Law, the remaining provisions of this Agreement will nonetheless remain in full force and effect, unless the invalid or illegal provision was a material part of the consideration for a Party to enter into this Agreement. In such case, upon reasonable request by either Party, both Parties will negotiate in good faith in an attempt to modify this Agreement to comply with the applicable Law and to effectuate the original intent of the Parties as closely as possible, failing which either Party may seek to rescind this Agreement for a material failure of consideration to the extent allowed by applicable Law.

33.13. **Counterparts**: This Agreement may be executed in counterparts, each of which will be an original but all of which together will form one instrument.

If the above provisions correspond to your understanding, please sign this letter below where indicated.

[Sales Agent]

By: _____

Its:

Accepted and agreed:

[Producer Company Name]

By: _____

Its:

Dated: _____

Delivery Schedule

This Delivery Schedule consists of two parts, a Delivery Check-List which identifies the delivery requirements for elements that are defined and specified on the Delivery Elements Description negotiated by the Parties.

Specifications

In using this Delivery Schedule, "Producer" and "Sales Agent" means the Parties, and "Picture" means the motion picture, identified on the attached Sales Agency Agreement. All Delivery Elements must conform to the Picture as it is fully described in the Sales Agency Agreement.

Code

The Code on the Delivery Check-List indicates the corresponding paragraph on the Delivery Elements Description.

Element

The Element on the Delivery Check-List indicates the delivery element on the Delivery Elements Description. It is the fully defined and specified element which is subject to delivery.

Stage

The Stage on the Delivery Check-List indicates the stage of delivery as follows:

- *I* or *Int.* or *Initial*: The element must be delivered as part of Initial Delivery;
- *C* or *Com.* or *Complete*: The element must be delivered as part of Complete Delivery;
- *Waived*: Delivery is not required, but Sales Agent may request delivery at a later time;
- *N/A*: No delivery is ever required.

Method

The Method column on the Delivery Check-List indicates the method of delivery as follows:

- *P* or *Phy.* or *Physical*: Actual physical delivery is required;
- *A* or *Acc.* or *Access*: Delivery may be by Laboratory Access Letter;
- *C* or *Cer.* or *Certificate*: Delivery by Access Certificate is required;
- *Loan*: Delivery on loan for thirty (30) days;
- *E* or *Electronic:* Electronic delivery over the Internet is allowed.

Physical Delivery means actual physical delivery to such delivery location as Sales Agent may reasonably specify, such as Sales Agent's main offices or a nearby recognized laboratory.

Access means delivery means of a Laboratory Access Letter in the form attached to the Sales Agency Agreement at a recognized laboratory reasonably acceptable to Sales Agent.

Certificate means delivery of an Access Certificate in the form attached to the Sales Agency Agreement at a recognized laboratory reasonably acceptable to Sales Agent which certifies the required technical quality of the elements.

Loan means physical delivery of the elements to Sales Agent on loan for the designated period to be returned to Producer at the end of such period.

Electronic means that electronic copies of the elements may be sent to Sales Agent over the Internet in a format readable by Sales Agent's computers, but electronic delivery only occurs when Sales Agent sends a return receipt of acknowledgment.

Delivery Check-List

Code	Element	Stage	Method
Section 1.A	**Theatrical Film Elements**		
1.A.1	Answer Print		
1.A.2	Original Negative		
1.A.3	Interpositive		
1.A.4	Internegative		
1.A.5	Check Print		
1.A.6	Video Mastering Print		
1.A.7	Unused Trim & Outtakes		
1.A.8	Textless Title Backgrounds		
1.A.9	Other Materials		
Section 1.B	**Theatrical Sound Elements**		
1.B.1	Sound Negative		
1.B.2	Dolby Stereo Soundtrack		
1.B.3	Six-Track Stereo Soundtrack		
1.B.4	Magnetic Sound Master		
1.B.5	Sound Stems		
1.B.6	Magnetic Music & Effects Track		
1.B.7	Music Tapes		
Section 2	**Theatrical Trailer Elements**		
2.B.1	Composite Print		
2.B.2	Negative Materials		
2.B.3	Textless Internegative and Print		
2.B.4	Magnetic Sound Masters		
2.B.5	Magnetic Music and Effects Tracks		
2.B.6	Other Materials		

Code	Element	Stage	Method
Section 3	**Video and Audio Materials**		
3.A	NTSC Digital Master		
3.B	PAL Digital Master		
3.C	Viewing Cassette		
3.D	Reference Cassette		
3.E	Music and Effects Audio Track		
3.F	Music Tape		
3.G	Textless Title Backgrounds		
3.H	Trailer and Promo Materials		
3.I	Closed Captioning		
3.J	Other Materials		
Section 4	**Protection Elements**		
4.A	Picture Elements		
4.B	Sound Elements		
4.C	Video Masters		
4.D	Audio Recordings, Tracks and Masters		
4.E	Other Film Elements		
4.F	Work Materials		
4.G	Other Materials		
Section 5	**Records and Documentation**		
Section 5.A	**Servicing Materials**		
5.A.1	Shooting Script		
5.A.2	Combined Dialogue and Action Continuity		
5.A.3	Censorship Dialogue List		
5.A.4	Final Footage Record		
5.A.5	Final Main and End Credits		
5.A.6	Title Materials		
5.A.7	Paid Ad Credits		
5.A.8	Video Packaging Credits		
5.A.9	Dubbing & Subtitling Restrictions		
5.A.10	Third Party Payment Materials		
5.A.11	Music Cue Sheet Materials		
5.A.12	Music License Materials		
5.A.13	Synopsis		
5.A.14	Cast and Technical Personnel List		
5.A.15	Publicity Materials		
5.A.16	Promotional Materials		
5.A.17	Key Art		
5.A.18	Black & White Stills		
5.A.19	Color Transparencies		
5.A.20	Other Materials		
Section 5.B	**Legal Documentation**		
5.B.1	E&O Certificate		
5.B.2	Title & Copyright Reports		
5.B.3	Copyright Registration		
5.B.4	Chain of Title		
5.B.5	Rights Agreements		
5.B.6	Talent Agreements		
5.B.7	Technology Licenses		

Code	Element	Stage	Method
5.B.8	MPAA/CARA Rating Certificate		
5.B.9	IATSE Seal		
5.B.10	Anti-Piracy Documents		
5.B.11	ISAN Registration		
5.B.12	Tax Forms		
5.B.13	Other Materials		
Section 5.C	**Additional Documentation**		
5.C.1	Script Supervisor's Notes		
5.C.2	Editor's Line Script		
5.C.3	Daily Film Code Sheets or Book		
5.C.4	ADR and Wild Line Recording Logs		
5.C.5	Conductor's Score of all Music		
5.C.6	Music Scoring Logs		
5.C.7	Music Re-recording Cue Sheets		
5.C.8	Sound Effects Re-recording Cue Sheets		
5.C.9	Dialogue Re-recording Cue Sheets		
5.C.10	Negative Cutter's Key Sheets		
5.C.11	Laboratory Access Letter		
5.C.12	Insurance Documents		
5.C.13	Other Materials		

Delivery Elements Description: to be provided by Parties.

IFTA® Laboratory Access Letter for Sales Agent

DATE:		**Document ID:**	
PRODUCER:	**SALES AGENT:**	**LABORATORY:**	
PICTURE:		**AGENCY PERIOD:** **APPLICABLE DISTRIBUTION TERM(S):**	
MATERIALS: [] See attached list			

Pursuant to an existing Sales Agency Agreement, Producer has authorized Sales Agent to represent certain Distribution Rights in the Picture for the Agency Period identified above. In order to allow Sales Agent to represent the rights, Producer is instructing Laboratory to provide Sales Agent access to the Materials identified above, and Laboratory agrees to accord Sales Agent such access, on the following terms:

1. **Acknowledgment:** Laboratory acknowledges that Producer has on deposit in Producer's name with Laboratory's facility at the address indicated above, those Materials for the Picture specified above.
2. **Ordering Materials:** Laboratory is authorized and instructed to honor, and subject to receiving satisfactory credit arrangements agrees to honor, at prices not exceeding its then prevailing rates for like work, all orders of Sales Agent and any authorized Distributors for internegatives, interpositives, positive prints, video masters, digital elements and other laboratory services and materials relating to the Picture during the Agency Period and applicable Distribution Terms. Laboratory agrees to deliver to Sales Agent on request such Materials as Sales Agent may order.
3. **Laboratory Charges:** Laboratory's charges for services or Materials will be solely for the account of the ordering Party. Laboratory will not hold Producer liable for charges incurred by Sales Agent or any authorized Distributor, and will not hold Sales Agent or any authorized Distributors liable for charges incurred by Producer. Laboratory will not refuse to honor the order of any Party due to unpaid charges of another party and will not assert a lien or claim against any Materials ordered by one Party due to unpaid charges of another Party.
4. **Moving Materials:** During the Agency Period and applicable Distribution Terms, Laboratory will not allow any of the Materials to be removed from its facility without the prior written consent of both Producer and Sales Agent, except Laboratory may move on a temporary basis working materials, excluding any negatives, to any special effects facilities used in the ordinary course of Laboratory's business. During the Agency Period and applicable Distribution Terms any Party may remove positive prints, duplicate negative materials, interpositives, masters, digital elements or other material made by Laboratory from the Materials for the account of such Party.
5. **Instructions Irrevocable:** The instructions contained in this Access Letter are irrevocable and may not be modified, except by a record authenticated by Producer and Sales Agent, or their respective successors or assignees.

Agreed and accepted:

PRODUCER	SALES AGENT	LABORATORY
By: _____	By: _____	By: _____
Its:	Its:	Its:

Schedule of Security Interest Documents

* Security Agreement
* Short-Form Security Agreement
* UCC-1 Attachment: Description of Collateral

Simplified Sample of a Security Agreement

This Security Agreement is made as of _____ between [Producer] ("Debtor") and [Sales Agent] ("Secured Party") with reference to the following facts:

A. Debtor and Secured Party have entered into a Sales Agency Agreement as of [the same date as this Security Agreement] for Secured Party's exclusive representation of certain rights in the motion picture currently entitled [*Picture*] (the "Picture").
B. Under the Sales Agency Agreement, Secured Party has agreed to pay Debtor an Advance against and recoupable from Producer's Share, if any, payable to Debtor under such Sales Agency Agreement.
C. The Parties desire to secure the right of Secured Party to receive the payments and make the recoupments, including the Advance allowed under the Sales Agency Agreement, to represent the Picture, and to exercise its rights and remedies under the Sales Agency Agreement on the terms and conditions of this Security Agreement.

The parties therefore agree as follows:

1. **Collateral**: The "Collateral" is any and all of the following:

 (a) *General Intangibles, Accounts, Payment Intangibles and Claims*: All of Debtor's right, title and interest: (i) under copyright, trademark, patent or other intellectual property rights in the Distribution Rights in the Picture throughout the Territory for any Distribution Term, whether now existing or later arising, under the Sales Agency Agreement; (ii) all agreements and understandings necessary or convenient to the exercise of such right, title or interest, including those with persons rendering services or materials in connection with the Picture; (iii) all of Debtor's rights to receive any payment or Producer's Share under the Sales Agency Agreement, including all related payment intangibles and accounts; (iv) all rights under any Distribution Agreement or other license agreement substantially negotiated or concluded made by Secured Party under the Sales Agency Agreement, including all rights to payment, royalties, accounts, payment intangibles, general intangibles or claims arising under them; and (v) all rights under any infringement or piracy action, arbitration or proceeding with respect to any Distribution Rights in the Picture throughout the Territory for the Term.
 (b) *Goods and Tangible Property*: All of Debtor's right, title and interest in and to: (i) all goods, equipment and physical materials Delivered to Secured Party under the Sales Agency Agreement, including film, sound and video elements, and all documents, advertising,

publicity and servicing materials; and (ii) all goods, equipment and physical materials created or manufactured by Secured Party in accordance with the Sales Agency Agreement, including field elements, masters, ad/pub and servicing materials.

(c) *Proceeds*: All proceeds, whether in cash, check, draft, note, compromise of rights agreement, or other tangible or intangible property realized by Debtor directly or indirectly from any sale, lease, license, transfer, disposition or exploitation of any of the above.

2. **Secured Obligations and Rights.** The Secured Obligations and Rights are: (i) the exclusive right of Secured Party to represent the Distribution Rights in the Picture throughout the Territory during the Agency Term as set forth in the Sales Agency Agreement; (ii) the right of Secured Party to be paid or recoup its Commission, Recoupable Expenses, Advance and any Interest from Gross Receipts, if any, earned under the Sales Agency Agreement; and (iii) all other rights and remedies of Secured Party under the Sales Agency Agreement, including the right to damages for any attempt by Producer to cancel or terminate the Sales Agency Agreement or enjoin Sales Agent's representation of the Picture other than as may be allowed under the Sales Agency Agreement.

3. **Grant of Security Interest**: In order to secure Debtor's full, faithful and timely performance of all the Secured Obligations and Rights, effective as of the Effective Date of the Sales Agency Agreement or signature of this Security Agreement, whichever is earlier, Debtor grants and assigns to Secured Party a continuing Security Interest in the Collateral. This Security Interest will run with the Collateral and be binding on any of Debtor's successors or assigns in any part of the Collateral.

4. **Resort To Security Interest**: Secured Party may resort to its Security Interest in the Collateral if Debtor or any successor in interest attempts to cancel, terminate, rescind or disaffirm the Sales Agency Agreement or any Rights granted to Secured Party for any reason other than as expressly allowed in the Sales Agency Agreement, or if Debtor is otherwise in uncured material default under the Sales Agency Agreement.

5. **Rights and Remedies of Secured Party**: Secured Party and its assignees will have all the rights and remedies of a secured party under the Law governing secured transactions in the jurisdiction of the Governing Law for the Sales Agency Agreement, including, without limitation, any available remedies of offset and specific performance. To the fullest extent allowed by such Law, Secured Party will be entitled to recover all of its costs and expenses incurred in resorting to or enforcing its Security Interest, including reasonable [outside] attorney's fees.

6. **Debtor's Representations and Warranties**: Debtor warrants and represents to Secured Party that:

 (a) Debtor has the right and authority to execute and deliver this Security Agreement;

 (b) Debtor has not granted any other security interest in the Collateral which might interfere with or have priority over the Security Interest granted in this Security Agreement [except for customary security interests to talent guilds or production lenders, each of which shall be promptly disclosed in writing by Debtor to Secured Party];

 (c) Debtor has not made any other agreements or understandings that might otherwise interfere with the rights granted to Secured Party in this Security Agreement;

 (d) Debtor is a [corporation / limited liability company / _____] in good standing duly organized under the laws of _____ _____ with company identification number _____ _____. Debtor is an individual who's principal residence is _____ _____.

7. **Debtor's Covenants**: Debtor covenants with Secured Party that:

 (a) Debtor will not change Debtor's [jurisdiction or organization / principal residence] without giving Secured Creditor at least ten (10) day's prior Notice of Debtor's intent to do so along with a statement of the intended new location.

 (b) At all times upon reasonable request from Secured Party, Debtor will identify to Secured Party Debtor's current jurisdiction organization or principal residence.

 (c) Upon reasonable request, Debtor will execute, acknowledge and deliver such other instruments as may be necessary or convenient to confirm, perfect or enforce the Security Interest, including the attached UCC-1 Financing Statement and Short-Form Security Agreement. Debtor authorizes Secured Party to conclude and file with appropriate public authorities to the full extent allowed by Law any such other instruments, including any UCC-1 Financing Statements or continuation statements.

 (d) Debtor will take commercially reasonable efforts to insure, protect and preserve the Collateral while the Security Interest is in effect.

8. **Notices**: All notices under this Security Agreement will be in writing and delivered by regular mail, hand delivery or courier to the following addresses:

Secured Party:	Debtor:
[Sales Agent]	[Producer]
[Sales Agent Address]	[Producer Address]

Each party may change its place for notice by notice duly given.

9. **Release**: Secured Party agrees to promptly file a release of its Security Interest (such as a UCC-3 Termination Statement) upon the satisfaction of the Secured Obligations or expiry of the Sales Agency Agreement.

10. **Governing Law/Forum**: This Security Agreement will be governed by the same Law and the same Forum as set forth in the Sales Agency Agreement.

11. **Miscellaneous**: Defined Terms if not defined where they first appear in this Security Agreement are defined in the Sales Agency Agreement.

Secured Party:	Debtor:
[Sales Agent]	[Producer]
By: _____	By: _____
Its:	Its:

Short-Form Security Agreement

For valuable consideration, receipt of which is acknowledged, [Producer] ("Debtor") grants and assigns to [Sales Agent] ("Secured Party") a continuing Security Interest in and to the Collateral described on the attached Description of Collateral with regard to the motion picture currently entitled [*Picture*] upon the terms and conditions of that certain Security Agreement between the parties dated as of the same date as this Short-Form Security Agreement.

The Motion Picture was registered for copyright in the United States Copyright Office on _____ under the name _____ _____ showing _____ as author(s) [of a work for hire] and _____ as copyright claimant(s), and given U.S. Copyright Office Registration Number PA _____.

The address for notice to each party is:

Secured Party:	Debtor:
[Sales Agent]	[Producer]
[Address]	[Address]

In Witness Whereof, the Parties have executed this Security Agreement as of [Date] in [City, State, Country].

Secured Party: Debtor:

By: _____ By: _____

Its: Its:

[Attach Notary Seal for Debtor's Signature]

Description of Collateral

The "Collateral" means any and all of the following with respect to that certain Sales Agency Agreement made as of [Date] between [Producer] ("Debtor") and [Sales Agent] ("Secured Party") regarding the motion picture currently entitled [*Picture*] (the "Picture").

(a) *General Intangibles, Accounts, Payment Intangibles and Claims*: All of Debtor's right, title and interest: (i) under copyright, trademark, patent or other intellectual property rights in the Distribution Rights in the Picture throughout the Territory for any Distribution Term, whether now existing or later arising, under the Sales Agency Agreement; (ii) all agreements and understandings necessary or convenient to the exercise of such right, title or interest, including those with persons rendering services or materials in connection with the Picture; (iii) all of Debtor's rights to receive any payment or Producer's Share under the Sales Agency Agreement, including all related payment intangibles and accounts; (iv) all rights under any Distribution Agreement or other license agreement substantially negotiated or concluded made by Secured Party under the Sales Agency Agreement, including all rights to payment, royalties, accounts, payment intangibles, general intangibles or claims arising under them; and (v) all rights under any infringement or piracy action, arbitration or proceeding with respect to any Distribution Rights in the Picture throughout the Territory for the Term.

(b) *Goods and Tangible Property*: All of Debtor's right, title and interest in and to: (i) all goods, equipment and physical materials Delivered to Secured Party under the Sales Agency Agreement, including film, sound and video elements, and all documents, advertising, publicity and servicing materials; and (ii) all goods, equipment and physical materials created or manufactured by Secured Party in accordance with the Sales Agency Agreement, including field elements, masters, ad/pub and servicing materials.

(c) *Proceeds*: All proceeds, whether in cash, check, draft, note, compromise of rights agreement, or other tangible or intangible property realized by Debtor directly or indirectly from any sale, lease, license, transfer, disposition or exploitation of any of the above.

Sales Projections and Participation Statement

Sales Projections: Generic Example

TERRITORY	Ask	Minimum
ENGLISH SPEAKING		
Australia/New Zealand	20,000	7,500
South Africa	15,000	4,000
United Kingdom	50,000	15,000
Sub-Total	**35,000**	**11,500**
EUROPE		
Benelux	20,000	5,000
France (FST)	100,000	25,000
Germany	125,000	50,000
Greece/Cyprus	15,000	5,000
Italy	8,000	40,000
Portugal	10,000	4,000
Scandinavia	25,000	10,000
Spain	100,000	20,000
Sub-Total	**403,000**	**159,000**
LATIN AMERICA		
Pan Latin America	100,000	40,000
Sub-Total	**100,000**	**40,000**
ASIA		
Pan Asian Pay TV	30,000	10,000
China	20,000	5,000
Hong Kong / Macao	10,000	1,500
India	40,000	10,000
Indonesia	15,000	7,500
Japan	50,000	0
Malaysia	15,000	0
Philippines	10,000	0
Singapore	3,500	0
South Korea	12,000	0
Taiwan	10,000	0
Thailand	15,000	0
Sub-Total	**230,500**	**34,000**

TERRITORY	Ask	Minimum
ASIA MINOR		
Israel	5,000	2,500
Middle East	25,000	7,500
Turkey	20,000	10,000
Sub-Total	**50,000**	**20,000**
EASTERN EUROPE		
Bulgaria	3,000	1,500
CIS/Baltics	20,000	10,000
Croatia/Slovenia/ Serbia	10,000	3,000
Czech	10,000	5,000
Slovak	5,000	2,500
Hungary	15,000	5,000
Poland	15,000	7,500
Romania	10,000	5,000
Sub-Total	**88,000**	**39,500**
TOTAL	**906,500**	**304,000**

Note:
The above projections are estimates only. No representation is being made that the projections will be realized. Actual results may vary materially from the projections for numerous reasons, including, but not limited to, the final cast and creative elements of the picture. These projections are strictly confidential and, without the prior written consent of Sales Agent, may not be shared or disseminated.

Participation Statement

NUMBER: 263	CUMULATIVE SINCE
TITLE: Picture X	INCEPTION
PARTICIPANT:	
CURRENT PERIOD: AS OF 12/31/2012	

FOREIGN RECEIPTS:		
BENELUX	$	2,500
BULGARIA		1,000
CHINA		4,000
CZECH, HUNGARY, SLOVAK		5,000
CZECH, EX-YUGO.		15,000
FRANCE		90,000
GERMANY		15,000
GERMANY		36,132
GERMANY		8,160
GREECE		18,000
HONG KONG		3,000
HUNGARY		12,000
ISRAEL		3,000
ITALY		120,000
JAPAN		80,000
MID EAST		10,000

(Continued)

(Continued)

NUMBER: 263 TITLE: Picture X PARTICIPANT: CURRENT PERIOD: AS OF 12/31/2012	CUMULATIVE SINCE INCEPTION
PAN ASIA	25,000
PAN LATIN AMERICA	55,000
POLAND	2,000
POLAND	6,000
POLAND	4,000
PORTUGAL	2,000
ROMANIA	12,000
RUSSIA	5,000
RUSSIA	25,000
RUSSIA	5,000
RUSSIA	1,000
SCANDINAVIA	3,250
SINGAPORE, MALAYSIA	1,000
SLOVAKIA	5,000
S. KOREA	2,500
SPAIN	90,000
TAIWAN	2,000
TAIWAN	4,000
THAILAND	20,000
UKRAINE	2,000
U.K.	3,896
U.K.	20,000
U.K.	5,000
TOTAL FOREIGN RECEIPTS	723,438
U.S.A.	350,000
TOTAL RECEIPTS	1,073,438
LESS: DISTRIBUTION FEE 15%	
5% – U.S. Sales Agency Fee	17,500
15% – Foreign Sales Agency Fee	108,516
TOTAL DISTRIBUTION FEE	126,016
NET RECEIPTS LESS COMMISSIONS	947,422
LESS: MG, DISTRIBUTION COSTS AND MARKETING FEES	
MINIMUM GUARANTEE	0
MARKETING AND DISTRIBUTION COSTS	25,000
MATERIAL EXPENSES	724
TOTAL COSTS AND EXPENSES	25,724

Sample Collection Agreement

Distribution of Collected Gross Receipts

All collected gross receipts arising from the exploitation of the film shall be distributed by _____ Bank (Collection Agent) as follows:

1. To _____ ("Sales Agent"), whose account information is provided below, until such time as Sales Agent has received Twenty-Five Thousand Dollars ($25,000) in gross receipts.

2. Thereafter, the remainder of all collected gross receipts from exploitation of the picture outside of North America ("Foreign Gross Receipts") to Sales Agent of its sales commission of fifteen percent (15 percent) of all collected Foreign Gross Receipts calculated retroactively from first dollar and on a going forward basis, pursuant to the terms of the sales agency agreement between Sales Agent and Producer.

3. Concurrent with #s 1 and 2 above, all remaining gross receipts (i.e., eighty-five percent (85 percent) after payment of #1 above) from the exploitation of the picture outside of the North America ("Foreign Gross Receipts") and all remaining gross receipts from the exploitation of the picture in North America ("NA Gross Receipts"), shall be disbursed to _____ ("Producer"), whose account information is provided below.

4. All Distribution contracts entered into by Sales Agent shall provide contractually that all remittances in relation to the Picture, "_____," shall be directed to this Collection Account as follows:

> Bank:
> Address:
> SWIFT CODE:
> ABA number:
> Beneficiary:
> Beneficiary Account Number:
> Ultimate Beneficiary:
> Ultimate Beneficiary Account Number:

5. _____ Bank may rely on the accuracy of the joint written notifications provided to USB AG by Producer and Sales Agent. Any fees incurred by Collection Agent shall be borne by Producer.

Beneficiaries:

_____ Bank (Collection Agent), Address: _____

and

_____ ("Sales Agent") Address: _____ payable to:

c/o _____ Bank

Account Number: _____

Routing Number: _____

and

_____ ("Producer") Address: _____ payable to:

Bank:

Address:

ABA Routing:

Acct Number:

Acct Name:

Sample Writer Option Purchase Agreement

[Company Name]
[Company Address]

[Date]

[Writer Name]
[Writer Address]
[Writer Phone Number]
[Alternate Contact Information]

Re: "[Project Title]" Screenplay Purchase Agreement

Gentlemen:

This will confirm the terms and conditions of the agreement between [Company Name] ("Purchaser"), on the one hand, and [Writer Name] ("Artist"), on the other hand, relating to that certain original motion picture screenplay currently entitled "[Project Title]", written by [Writer Name], based on a story by [Story By Artist If Applicable], and solely owned and controlled by Artist (such original motion picture screenplay, including, without limitation, all characters, plots, elements, and stories contained therein as well as the title thereof and any and all treatments, literary properties, and screenplays based thereon, and any and all existing and future drafts, versions, and adaptations thereof are referred to collectively as the "Property").

1. *Purchase.* Artist hereby grants Purchaser all exclusive and irrevocable perpetual rights in the Property referred to in Paragraph 6 below, subject to the terms and conditions hereof. Artist hereby confirms, represent and warrant that all payments due have been received.

2. *Payments.*

 (a) The "Purchase Price" shall be the sum of $[Amount].

 (b) Rental Rights Compensation. For good and valuable consideration, the receipt and sufficiency of which hereby are acknowledged,

Artist agrees that to the extent the laws of the United States or of one or more of its member states or any other country provide for a rental, lending, or similar right, all such rights are hereby irrevocably transferred and assigned to Purchaser throughout the Universe in Perpetuity.

3. *Credit for Writing the Property.* If Artist is not in uncured material Default of his obligations, warranties, and representations to Purchaser, Artist will be accorded the following credit, subject to Purchaser's customary exclusions and policies and subject to any collective bargaining or other agreement applicable to Purchaser and/or Purchaser's successors which may adversely affect Purchaser's right to accord the following credit, on screen (if there are main title credits for the producer and director; if not then in the end titles), and in the billing block contained in all paid advertising issued by or under Purchaser's direct control which utilizes a billing block (including posters, one sheets and home video packaging) (and Purchaser shall advise the Picture's distributors of the credit obligations set forth herein) ("Paid Ads") but subject to any Paid Ads exclusions of Purchaser and any distributor:

(a) "Written By" Credit. Subject to Artist completing all drafts as requested by Purchaser, and there being no other writers hired to perform any revisions, in which case, credit for screen authorship shall be determined by Purchaser in good faith, Artist shall receive "written by" credit for the Picture as follows "Written by [Writer Name]" on a card in the main titles of the Picture.

(b) Other Credit Matters. Except as otherwise set forth herein, all other aspects of credit shall be in Purchaser's sole discretion. All references in this Agreement to the title of the Picture shall be deemed to mean the "regular" title unless reference is specifically made to the "artwork" title. No causal and inadvertent failure by Purchaser to comply with the credit requirements hereunder nor any failure by any third party to so comply, shall be deemed a breach hereof, provided, however, that upon written notice from Artist, Purchaser will use reasonable efforts on a prospective basis, to correct any omission or failure to give the required credits hereunder, to the extent the same is within Purchaser's reasonable control or ability. Purchaser will contractually require all third parties in direct privities of contract to observe and perform the credit obligations to Artist in connection with the exercise of any rights in the Picture.

4. *Rights.* Pursuant to the terms of this agreement, all rights in the Property and the copyright thereto, inclusive of, but not limited to, all motion picture, television and all other rights, including but not

limited to all allied and ancillary rights, in and to the Property have been irrevocably granted, transferred and assigned to Purchaser, in perpetuity and throughout the universe, without any further act necessary on the part of Purchaser or Artist. Such rights shall include, without limitation, all theatrical rights, television rights [whether filmed, taped or otherwise recorded, and including series rights, subscription, pay, cable and sequel, remake, advertising and pro-motion rights (including the rights to broadcast and/or telecast by television and/or radio or any other process, now known or hereafter devised, any part of the Property or any adaptation or version thereof, and announcements of and concerning same)]; all rights to exploit, distribute and exhibit any motion picture or other production pro-duced hereunder in all media now known or hereafter devised; all rights to make any and all changes to and adaptations of the Property (and Artist hereby waives all moral rights); publication rights (e.g., "making of", picture books) in all productions based upon the Property, character, merchandising, commercial tie-in, character, soundtrack, music publishing and exploitation rights; the right to use Artist's name, approved likeness and approved biographical material in connection with exploitation of the rights granted hereunder; and all other rights customarily obtained in connection with literary purchase agreements, provided Artist promptly approves such likeness and/or biography or in lieu thereof, provides Purchaser with an approved version for use. Artist reserves no rights whatsoever in the Property.

5. *Pre-production.* Artist acknowledges that Purchaser may, during the Initial Period of the Option, as extended, but is not obligated to, undertake pre-production and production activities in connection with any of the rights to be acquired hereunder including, without limitation, the commissioning and preparation of revisions, treatments and/or screenplays based on the Property. Artist agrees that Artist shall render services and perform a free "polish" per Purchaser's notes, at such time as Purchaser may require. In the event the Purchaser requires additional rewrites after the delivery of said polish, Purchaser and Artist shall negotiate the terms of such rewrites in good faith.

6. *Representations and Warranties.* The parties acknowledge that the Writers Guild of America has no jurisdiction over this Agreement nor is the WGA Agreement otherwise applicable, Artist represents and warrants that Artist is the sole and exclusive author, owner and proprietor, throughout the universe of all rights (including all rights of copyright), title and interest of every kind and nature in and to the Property and the story, characters and elements contained therein; that Artist has the full and sole right and authority to enter into this Agreement and make the grant of rights made herein; that no third party has the right (and will not have the right except as provided in this Agreement) to produce any production based, in whole or in part,

upon the Property; that the Property (other than material in the public domain or material furnished by or on behalf of Purchaser) is wholly original with Artist and that Artist is the sole author thereof; that, to the best of Artist's knowledge, no claims or litigation exist or will exist at any time relating to the Property or purporting to question or adversely affecting the rights granted herein; that the Property does not and will not to the best of Artist's knowledge or that which Artist should have known in the exercise of reasonable prudence violate the rights of privacy or publicity of, or constitute a libel or slander against, or violate any common law or other rights of any person or entity; that Artist has not made, nor will Artist make, any grants of any nature whatsoever, which will materially prevent, conflict or interfere with Purchaser's full and complete exercise and enjoyment of each and all or the rights granted or agreed to be granted to Purchaser hereunder, nor will Artist in any way encumber or hypothecate said rights or any of them, or do or cause or permit to be done any act or thing by which said rights or any of them might, in any way, be impaired.

7. *Indemnification.* Artist agrees to and does hereby confirm Artist's obligation to indemnify and hold harmless Purchaser, its successors, licensees, assigns and parent, subsidiary and affiliated companies and the principals, shareholders, directors, officers, employees, attorneys, agents, successors, licensees and assigns of each of the foregoing from and against any and all claims liabilities damages costs or expenses (including, without limitation, reasonable outside attorneys' fees and costs) inconsistent with and/or arising as a result of any breach of any representation, warranty, covenant or agreement made by Artist under this Agreement. The Initial Period (as extended under paragraph 3 above) shall be automatically suspended and extended during the pendency of any claim or litigation involving, relating to any breach of any representation, warranty or agreement made by Artist hereunder, provided, such extension shall not exceed six (6) months unless litigation is commenced with respect to such matter giving rise to such extension. Purchaser shall defend, indemnify and hold Artist harmless from and against any liability, claim, cost, damage or expense (including reasonably attorney's fees and costs whether or not in connection with litigation) arising out of: a) any material added to the Property by Purchaser or under Purchaser's authority not written by Artist and b) the development, production, distribution and exploitation of the Picture or any element thereof, provided, however, that the claim giving rise to this indemnity is not based upon a breach by Artist of any of Artist's agreements, warranties and representations contained in this Agreement. To the extent Purchaser's Errors and Omissions Insurance Policy and General Liability Insurance Policy permits such coverage, Artist shall be named as an "Additional Insured" party thereunder, but subject to all terms and conditions

of such policy, including without limitation, policy limits and deductibles.

8. *No Obligation to Proceed*. Subject only to the payment of any contractually required amounts due Artist, and the according of any required credit and performing the obligations to Artist under Paragraph 5 above, hereunder, nothing contained herein shall be in any way obligate Purchaser to use services hereunder or the results and proceeds thereof, or to produce, release distribute exhibit or otherwise exploit the Picture.

9. *Copyright*. All rights granted to Purchaser under this agreement shall be irrevocably vested in Purchaser (including, without limitation for the full term of copyright protection everywhere in the world and any and all renewals thereof), and shall not be subject to termination, rescission or revocation by Artist or any other party for any reason or cause, nor shall said rights be subject to termination or reversion by operation of law or otherwise, except to the extent, if any, that the provisions of any copyright law or similar law relating to the right to terminate grants of, and/or recapture rights in, literary property may expressly apply.

10. *Relationship*. Nothing contained in this agreement will be construed to make Artist and Purchaser partners, joint venturers or agents of one another, or give Artist any interest whatsoever in any of the results and proceeds derived from the exercise of the rights granted or agreed to be granted hereunder. Nothing contained herein will be deemed to obligate Purchaser to produce the Picture or make any other use of any right, title, or interest in and to the Property acquired by Purchaser hereunder. Each party hereto has been represented and advised by independent legal counsel in the negotiation, preparation and execution of this agreement.

11. *Further Assurances*. Artist shall execute and deliver to Purchaser, upon Purchaser's written request, such further reasonable documents consistent with this agreement as may be reasonably required by Purchaser to further evidence or carry out the purposes and intent of this Agreement (including, without limitation the Grant of Option, the Short Form Assignment (which shall be effective only upon exercise of the Option and payment of the Purchase Price) and the Author's Certificate, if required (which shall be effective only upon exercise of the Option and payment of the Purchase Price) attached hereto, all of which shall be executed and notarized by Artist concurrently with execution hereof, and Artist hereby irrevocably appoints Purchaser as Artist's attorney-in-fact (which appointment is coupled with an interest and therefore irrevocable) with full power of substitution and delegation to execute, verify, acknowledge and deliver any and all documents which Artist fails to promptly execute, verify, acknowledge and/or deliver to Purchaser, after receipt of Purchaser's written request

therefore and a reasonable opportunity to review and negotiate same in good faith. Artist authorizes Purchaser to date and file in the US Copyright Office, the Short Form Assignment of Rights, as of the date of exercise of the Option. Purchaser will provide copies of all documents executed pursuant to this power of attorney.

12. *Termination Interest.* If, at any time Artist, or any other party succeeding to Artist's termination interest, or otherwise claiming by or through Artist or any other party so empowered by law, is deemed to have any right to terminate any or all or Purchaser's right hereunder (the "Subject Right") pursuant to the Copyright Act or any other laws of the United States or any of its subdivisions or of any foreign country or government, nothing in this agreement will be deemed to preclude said party from freely exercising said right to terminate: provided, however, Artist hereby agrees to grant Purchaser a right of exclusive first negotiation and a separate right of last refusal and agrees not to sell, license or otherwise dispose of the Subject Rights to any party (other than Purchaser) on terms less favorable than those terms contained in Artist's or such party's last offer to Purchaser unless Artist first has offered such less favorable terms to Purchaser in writing and Purchaser has not, within five (5) days after the offering of such terms to Purchaser, accepted them. Purchaser will not be required to meet any non-monetary terms which are not as readily performed by Purchaser as by any other party.

13. *Remedies.* Artist agrees that the services to be rendered by him hereunder and the rights and privileges granted to Purchaser hereunder are of a special, unique, unusual, extraordinary and intellectual character involving skill of the highest order which give them a peculiar value, the loss of which may not be reasonably or adequately compensated by damages in action at law, and that a breach of this Agreement by Artist might cause Purchaser to suffer irreparable injury and damage. Artist hereby expressly agrees that Purchaser will be entitled to seek injunctive and other equitable relief to prevent or cure any breach of this Agreement. Purchaser's resort to injunctive relief or equitable relief, however, will both be construed as a waiver of any right which Purchaser may have against Artist for damages or otherwise. A waiver by either party of any breach of this Agreement shall not be deemed a waiver of any prior or subsequent breach hereof. All remedies of either party shall be cumulative and the pursuit of any one remedy shall not be deemed a waiver of either remedy. In the event of any breach or alleged breach of this Agreement by Purchaser, Artist's sole remedy shall be the recovery of money damages, and Artist shall not have the right to terminate or rescind this Agreement or to enjoin or restrain the use of or the exhibition, distribution, advertising or exploitation of the Picture or any other use or exploitation of the Property or any rights therein, whatsoever. No act or omission of Purchaser hereunder shall constitute an event of default

unless Artist shall first provide Purchaser with Written notice setting for the such alleged breach or default and Purchaser shall not cure the same within fifteen (15) business days after its receipt of such notice.

14. *Successors and Assigns.* This Agreement shall be binding and inure to the benefit of Purchaser's respective licensees, successors and assigns. Purchaser may assign or transfer all or any part of Purchaser's interests under this agreement to any responsible person or entity. Purchaser shall remain liable for all executory obligations under this Agreement unless such assignment and/or transfer is made to: (i) a firm, financially responsible corporation or entity owned or controlled by Purchaser which assumes in writing any executory obligations to Artist hereunder; and/or (ii) to a "major" studio, distributor, or Network or other similar financier entity which assumes the executory obligations to Artist hereunder in writing. In either of such events Purchaser shall be relieved of all executory obligations under this Agreement and Artist agrees to look solely to such assignee/transferee for performance of all executory obligations under this Agreement. Artist may not assign any of Artist's rights or obligations hereunder, other than the right to receive payment.

15. *Miscellaneous.* This Agreement constitutes the entire agreement between the parties and supersedes any and all prior written or oral agreements between the parties relating to the subject matter hereof and cannot be modified or amended except by written instrument signed by the parties hereto. This Agreement supersedes and replaces all other agreements in respect of the Property executed by Artist and Purchaser. The parties acknowledge that neither party has executed this Agreement in reliance on any representation or promise made by the other party or any of said party's representatives other than those expressly contained in the Agreement. Due to the large body of law in the state of California pertaining to entertainment contracts and the need for uniform interpretations of all agreements pertaining to the Picture, the parties have agreed that the internal laws of the State of California shall govern and control this Agreement. Each of the parties hereto submits to the exclusive jurisdiction of the State and Federal courts located in Los Angeles County, Los Angeles, California for adjudication of any and all disputes arising under this Agreement. Each of the parties hereto agrees to accept service of process for any judicial or other proceedings hereunder by registered mail. The heading or articles, sections and other subdivisions or this Agreement are inserted solely for the purpose of convenient reference. Such headings shall not be deemed to govern, limit, modify or in any other manner affect the scope, meaning or intent of the provisions of the Agreement. This Agreement may be executed in counterparts which, taken together, shall constitute the whole of the agreement as between parties. Any signed copy of this Agreement or of any other

document or agreement referred to herein, or copy or counterpart thereof, delivered by facsimile transmission, shall, for all purposes, be deemed an original signed copy notwithstanding that one or more parties signature appears as a copy or tele-facsimile copy, and such copy or tele-facsimile copy signature(s) shall be binding upon each party in the same manner as enough an originally signed copy had been delivered.

Please confirm that you have read, understand and agree to the foregoing by executing this Agreement in the space provided below.

Very Truly Yours,

[COMPANY NAME]

By: _____

Its: _____

ACCEPTED AND AGREED TO:

[WRITER NAME]

[WRITER SOCIAL SECURITY NUMBER]

Short Form Assignment of Rights

For good and valuable consideration, the receipt and adequacy of which is hereby acknowledged [Writer Name] ("Assignor"), whose address is [Writer Address] [Writer Phone], hereby transfers and assigns all of Assignor's Rights as defined below to [Company Name] ("Assignee").

The undersigned Assignor represents and warrants that Assignor owns all right, title, and interest in to an original Screenplay (the "Work") presently entitled "[Project Title]" written by Assignor, including without limitation, the sole and exclusive theatrical motion picture rights, the television motion picture and television rights relating thereto, the right to produce, distribute, and otherwise exploit the Work and any and all derivative works based upon said Work in all media now known or hereafter devised, in perpetuity, and throughout the Universe and all copyrights and copyrightable interests relating to the foregoing, all rental and lending rights under national laws (whether implemented pursuant to the E.C. Rental and Lending Rights Directive or otherwise) which Assignor now or hereafter become entitled to with respect to the Work and/or any derivative work based thereon, and agree that a sufficient and adequate portion of the fixed and contingent compensation specified in the "Agreement" (as defined

below) has been allocated as equitable remuneration for the assignment to Assignee of said Rental and Lending Rights and that such allocation constitutes full and complete consideration for the assignment of said Rental and Lending rights. Assignor agrees that said compensation together with any and all payments due under any applicable collective bargaining agreement includes payment in full for such assignment of said Rental and Lending Rights. Assignor acknowledges that the Work may be adapted, revised, edited and/or combined with other works. Assignor waives any and all so-called "Moral Rights" of authors or "Droit Morale" applicable in any jurisdiction. The foregoing rights shall collectively be referred to herein as "Assignor's Rights." Assignor also assigns to Assignee any and all right which Assignor may now have or may hereafter have in any revisions of said Work by Assignor.

Assignor further represents and warrants that Assignor has not made and will not make, any grant or assignment with respect to Assignor's Rights that will materially conflict with or impair the complete enjoyment of the rights and privileges assigned and transferred hereunder.

Assignor agrees to execute and deliver and cause to be executed and delivered to Assignee any and all documents and instruments consistent herewith and reasonably necessary to effect and complete the transfer to Assignee of all rights granted pursuant to the Agreement. In the event Assignor fails to execute and deliver such other documents and instruments promptly following presentation thereof to Assignor and expiration of a period of five (5) business days after presentation (during which time, Assignor shall have the right to review and negotiate the language of said document), Assignee is hereby authorized and appointed Attorney-In-Fact of and for the Assignor to make, execute and deliver any and all such documents and instruments. It is understood that Assignee's aforementioned powers as Attorney-In-Fact of the Assignor are powers coupled with an interest are irrevocable. This Assignment and the provisions hereof shall be binding upon Assignor, and his heirs, assigns and successors.

This Assignment shall be subject to the terms and conditions of that certain Agreement ("Agreement") between Assignor and Assignee dated [Date], with respect to the acquisition of rights in said Work. The assignment of Assignor's Rights to Assignee hereunder is irrevocable and in the event of any breach of the Agreement by Assignee, Assignor's remedies shall be limited to an action at law for damages. In no event shall Assignor have the right to terminate and/or rescind the Agreement and/or this Short Form Assignment of Rights and/or to enjoin or interfere with the Work, any and all derivative works based upon the Work nor to enjoin or interfere with any and all publicity and/or advertising with respect thereto, nor any and all exploitation of any of the foregoing Work, derivative works, advertising and/or publicity.

In witness whereof, the Assignor has duly executed this Assignment as of this [Date] day of [Month, Year].

[Writer Name]

Author's Certificate

I, the undersigned,

[Writer Name]
[Writer Address]
[Writer Phone]
[Alternate Contact]

declare that I am the sole author of an original script currently entitled "[Project Title]".

I hereby authorize [Company] and/or its assignees to produce, distribute, and otherwise commercially deal with a motion picture based on said script in all media in the whole universe. This authorization is given for perpetuity commencing on [Date].

[Writer Name]

Sample Writer Work For Hire Agreement

[Project Name]
Date of Agreement:
Between : [Company 1] (hereinafter called "Grantor")
and
[Company 2] (hereinafter called "Producer")

1. *Property:* feature film script materials (all existing drafts) presently known as "[Project Title]" (the "Property") written by [Writer Name] ("Writer"), the rights to which are owned and controlled by Grantor. Grantor shall provide all applicable chain-of-title documentation confirming Grantor's effective ownership of the Property as a condition precedent of this agreement.
2. *Initial Option Term:* [Date].
3. Initial Option Fee: [Amount], payable upon execution hereof.
4. *Purchase Price:* [Purchase Price], less the initial Option Fee paid, payable on exercise of Option, which shall be in any case no later than upon commencement of principal photography.
5. *Intentionally deleted.*
6. *Optioned Rights:* Grantor hereby expressly and irrevocably conveys, grants and assigns to Grantee, for the duration of the Option Term, the sole and exclusive option (the "Option") to acquire the right to develop, produce, advertise and exploit one or more film and/or television production based on the Property, and to exploit the Production in all media now or hereafter devised throughout the universe in perpetuity, including all ancillary and electronic rights. (the "Optioned Rights"). The Optioned Rights may be more fully described as follows:

 (a) Development/Production Rights: Producer/Grantee shall have the right to develop, produce, and exploit in all media now or hereafter devised throughout the universe in perpetuity, one or more theatrical and/or non-theatrical productions, including without limitation, theatrical motion pictures, television movies and/or mini-series, television series, webcasts, sequels, prequels,

remakes, and/or spinoffs thereof (each a "Production" and collectively the "Productions") based on the Property and all component elements thereof. Sole and exclusive right to use, adapt, translate, subtract from, add to, manipulate, enhance, and change the Property and any and all titles thereof or any other title by which it (or any part thereof) has been, or may at any time be, known, in the making of and/or as part of, or in conjunction with, the Productions and to combine the Property in any manner with any other work or works in the making of the Productions.

(b) Ancillary Rights: Subject to Producer/Grantee's exercise of this option agreement and Grantor's receipt of payment, in full, Producer/Grantee shall have the sole and exclusive right to create and exploit any and all allied and ancillary rights based on or derived from the Property and/or the Productions, including without limitation soundtrack albums and other sound recordings on CD, DVD or other recording medium, Internet websites, music publishing, musical groups, audiocassettes, literary and/or print publishing (including coloring books, comic books, coffee table books, "making of" books and the like), live stage, radio, public display and/or public performance, amusement and theme parks, CD-Rom and Interactive adaptations, and by way of the exercise of so-called "merchandising rights", which expression shall have its customary industry meaning, but which rights expressly include the right to license, manufacture, sell and otherwise exploit goods (including without limitation, toys, electronic devices, and apparel) and services of any kind depicting or reproducing the name, characters, likenesses, designs, theme, scenarios or other elements of the Property and/or Productions or the right of representation, reproduction or performance of the Property, and/or Productions, or any part or element thereof.

(c) Advertising Rights: Subject to Producer/Grantee's exercise of this option agreement and Grantor's receipt of payment, in full, Producer/Grantee shall have the right during the legal term of unrestricted copyright: (i) To make, publish, and to copyright, or cause to be made, published, and copyrights, in the name of Grantee or its nominees, in any and all languages, and throughout the universe, excerpts from the Property not exceeding 1000 words with or without illustrations of any kind; (ii) To broadcast and transmit by radio, and/or television, excerpts from, and condensations of, the Property or any part thereof, and/or of the Productions, to a maximum of ten (10) minutes; and (iii) To use, on a non-exclusive basis, Grantor's name, approved portrait, approved picture, approved likeness, and/or biographical material in connection with any of the rights granted in this Agreement, provided that no commercial tie-ups, merchandising or endorsements shall be made by

Grantee using such portrait, picture, likeness and/or biographical material without the prior written consent of Grantor.

(d) Exploitation Rights: Subject to Producer/Grantee's exercise of this option agreement and Grantor's receipt of payment, in full, Producer/Grantee shall have the sole and exclusive right to rent, lease, distribute, sub-distribute, license or otherwise exploit by any means whatsoever, whether now known or hereafter devised, the Property, the Productions, the Ancillary Rights, or any part of any thereof, throughout the universe, in perpetuity, in all media now known or hereafter created as applicable, and the right to register, renew and/or extend copyright in the Productions, or in any of the results and proceeds of the Optioned Rights (including without limitation, music, merchandise, and the like), in the name of Grantee, in perpetuity, or for such lesser period of time as may be permissible in accordance with copyright laws in subject jurisdictions.

7. *Screen Credit:*

(a) Writer shall receive a writing credit in the main credits. Subject to the foregoing obligations, The Writer's credit may be shared with other writers contributing to development of Productions. Subject to the foregoing obligations, all aspects of such screen credit, including without limitation, the size, placement, nature, and duration, shall be at Grantee's sole election, provided that they shall be no less favorable than accorded to other equivalent credited parties. Additionally, the placement of Grantor's credit shall be subject to the requirements of any guild having jurisdiction over the applicable Production, and further subject to legislative or regulatory requirements of government or private sector agencies having jurisdiction over the Productions, or the screen credits therein contained, as a requirement of accessing financing, or of certification of the Productions as meeting domestic content requirements. Grantee agrees to provide such credit on all paid advertising controlled by Grantee, with the usual exclusions (including without limitation, congratulatory ads, corporate ads, and the like).

(b) No inadvertent failure on the part of Grantee to provide the aforementioned screen credit, or paid ad credit, shall be a breach of this Agreement, provided that Grantee shall use good faith efforts to prospectively cure any such failure upon notice in writing from Grantor.

8. *Grantor's Representations and Warranties:*

(a) based solely in reliance on the Writer's representations and warranties provided in the Underlying Rights Agreement, that the Property is wholly original with Writer;

(b) the Property is exclusively owned and/or controlled by Grantor;

(c) based solely in reliance on the Writer's representations and warranties provided in the Underlying Rights Agreement, that The Property does not, and any permitted use by Grantee hereunder will not, violate, conflict with, or infringe upon any rights whatsoever, including without limitation, any copyrights, privacy rights, publicity rights, statutory or common law rights (including without limitation, rights relating to libel and slander) of any third party, whether such third party is an individual, body corporate or other legal entity such as a trust or estate;

(d) the Optioned Rights are exclusively controlled by Grantor, and Grantor has not heretofore granted, nor will Grantor hereafter grant, all or any portion of the Optioned Rights to any third party;

(e) Grantor has the right, and is fully empowered and/or authorized to grant the Option and convey the Optioned Rights to Grantee, subject to, and in accordance with, the terms and conditions hereof, without the permission of any third party, which Option and Optioned Rights shall be enjoyed by Grantee free from any interruption or disturbance other than as expressly provided for herein;

(f) there is no claim, litigation, or other proceeding outstanding, pending, or, to the best of Grantor's knowledge, threatened against Grantor in connection with the Property, and based solely in reliance on the Writer's representations and warranties provided in the Underlying Rights Agreement, there is no claim, litigation, or other proceeding outstanding, pending, or, to the best of Grantor's knowledge, threatened against the Property or any of the Optioned Rights therein, nor any cause for any such claim, litigation or other proceeding, and Grantor agrees to advise Grantee immediately upon acquiring actual or constructive knowledge of any such claim or litigation;

(g) based solely in reliance on the Writer's representations and warranties provided in the Underlying Rights Agreement, the Property is protected under copyright in one or all of Canada, the United States, or those countries which are signatory to the Berne and Universal Copyright Conventions;

(h) based solely in reliance on the Writer's representations and warranties provided in the Underlying Rights Agreement, the Property is not in public domain in any country where copyright protection is afforded, nor will Grantor permit the Property to become public domain in any such country;

(i) when fully executed, this Agreement shall constitute a legal, valid, and binding obligation of Grantor, enforceable against Grantor in accordance with its terms.

9. *Moral Rights:*

(a) Grantor hereby waives any and all moral rights which Grantor may have in and to the results and proceeds of Grantee's permitted uses of the Optioned Rights and/or the Property, including without limitation the Productions and any goods and services created in connection with the Ancillary Rights, as such rights may now or in the future have by legislative enactment, or otherwise at law, or in equity. Grantor warrants that an equivalent waiver of moral rights has been secured from Writer.

(b) The rights and remedies of Grantor in the event of a breach of this Agreement by Grantee, shall be limited to the right, if any, to recover damages in an action at law, and in no event shall Grantor be entitled by reason of any such breach to terminate this Agreement and Grantor shall not be entitled to and hereby waives the right in such event to seek, obtain, enforce, authorize, or participate in any action, proceeding, or claim for equitable or injunctive relief or to enjoin, restrain, or interfere with the exploitation of the Optioned Rights, or the results and proceeds thereof.

10. *Force Majeure:* All time periods herein provided, as applicable in the circumstances, shall be extended for force majeure as follows:

(a) If during the period prior to the commencement of principal photography of the Production there is a lockout, strike or other work stoppage by the WGC, or any other guild, or association having jurisdiction over the creation of any writing materials contracted for by Grantee in connection with the Property ("Labor Dispute"), then the Term shall be extended for the duration of such Labor Dispute, to a maximum of six (6) weeks.

(b) If during the period of pre-production, or principal photography there is an accident; fire; explosion; casualty; epidemic; act of God; earthquake; flood; torrential rain; strike; walkout; picketing; labor controversy; civil disturbance; embargo; riot; act of public enemy; war or armed conflict (whether or not there has been an official declaration of war); unavailability of essential materials and supplies, equipment, transportation, power or other commodity; failure or delay of any transportation agency, laboratory or other furnisher of essential supplies, equipment or other facilities; enactment of any law, any judicial or executive order or decree; the action of any legally constituted authority; and the incapacity or unavailability or default (including refusal to perform) of the director or any principal cast member or other event or cause of the nature of force majeure beyond the control of Grantee, other than a Labor Dispute as defined above, materially hampers, interferes with or delays the

commencement of the Production then all time periods provided for in this Agreement, including without limitation the Term, shall be extended by the amount of time corresponding to the event of force majeure, provided that no such extension shall last more than six (6) weeks.

11. *Miscellaneous:*

(a) Binding Agreement. This Agreement constitutes a binding agreement and is the entire agreement among Grantor and Grantee and supersedes all prior negotiations and communications, whether written or oral; representations and warranties, whether written or oral; and documents and writings, whether signed or unsigned, with respect to the subject matter hereof.

(b) Assignment. This Agreement may not be assigned by either of the parties hereto without the express written consent of the other parties hereto, such consent not to be unreasonably withheld. Notwithstanding the foregoing, Grantee may assign this Agreement without Grantor's consent provided that: (i) Grantee shall remain primarily liable to Grantor; or (ii) Grantee's assignee shall assume all of Grantee's obligations to Grantor in writing. Grantee shall use good faith efforts to provide Grantor notice of such assignment.

(c) Waiver of Terms. Any party may waive the benefit of any term, condition, warranty or covenant in this Agreement or any right or remedy at law or in equity, but only by an instrument in writing signed by the party to be charged. No waiver by any party of any breach hereof shall be deemed a waiver of any preceding, continuing or succeeding breach of the same, or any other time hereof.

(d) Counterparts. This Agreement may be executed in one or more counterparts, each of which shall constitute an original hereof and which together shall constitute one agreement.

(e) Further Documents. Each party shall execute and deliver such other documents or instruments as may be necessary or desirable to evidence, give effect to or confirm this Agreement, and any of the terms and conditions hereof. The parties contemplate entering into a more formal long form agreement governing the terms and conditions of the subject matter herein. Until such long form agreement is entered into, if ever, this agreement shall constitute a binding agreement between the parties.

(f) Severability. Nothing contained in this Agreement shall be construed so as to require the commission of any act contrary to law, and if any provision of this Agreement is held to be invalid or illegal under any material statute, law, ordinance, order or regulation, such provision shall be curtailed and limited only to

the extent necessary to bring it within the legal requirements and such curtailment or limitation shall not affect the validity of the remainder of this Agreement or any other provisions hereof.

(g) Currency. All dollar amounts referred to in this Agreement shall be deemed to refer to United States dollars, unless expressly stated to the contrary.

(h) Withholdings. Grantee may deduct and withhold from the compensation payable hereunder any amounts of money required to be deducted or withheld by Grantee under the provisions of any statute, regulation, ordinance or order, or hereafter enacted, requiring the withholding of or deducting of compensation. To the extent that Grantee fails to deduct and withhold from compensation payable to Grantor hereunder any amounts of money required above to be deducted or withheld, Grantee may nevertheless retain or withhold such amounts of money from any compensation or payments to which Grantor may thereafter become entitled hereunder.

(i) Governing Law. This Agreement will be governed and construed exclusively in accordance with the laws of [State and County] applicable therein and the parties hereby irrevocably attorn to the exclusive jurisdiction of the courts of [State and Country].

In witness whereof, the parties have caused this Agreement to be executed as of the date first above written.

[COMPANY 1]

Per: _____

[COMPANY 2]

Per: _____

Sample Writer Step Deal Agreement

[Writer Step Deal]
[Address]

As of [Date]

[Writer's Name]
[Address]

Re: "[Title of Picture]"—Story Outline, First Draft Screenplay, Second Draft Screenplay and a Polish

Dear [Writer's Name]:

This will confirm the terms and conditions pursuant to which [Engaging Entity] ("Company") engages [Writer's Name] ("you" or equivalent) to perform certain writing services in connection with a proposed theatrical motion picture (the "Production"). As a condition precedent to this engagement, you shall sign and deliver to Company executed copies of this agreement ("Agreement"). Company shall have no obligation to you unless or until you do so.

1. *Services/Delivery of Work:* Company hereby engages you to write, on a "pay or play" basis, a story outline for the Screenplay ("Outline"), a complete first draft Screenplay ("First Draft Screenplay"), a second draft Screenplay (a "Revision") and one polish ("Polish") thereof (and collectively, the "Work") incorporating therein Company's notes, instructions, and directions for modifications to such Work. The Work will be based upon an original idea by [Name]. Such writing services shall be rendered in accordance with Company's reasonable directions and requests as well as Company's rules and regulations of which you are notified, in writing, in advance. The Work will be written and delivered to Company upon reasonable dates as set forth below.

 The dates designated by Company for Delivery hereunder are as follows:

(a) Commencement of Services: Upon execution hereof.

(b) Delivery of Outline: On or before [Date].

(c) Delivery of First Draft Screenplay: Eight (8) weeks from the date of Company's approval of the Outline.

(d) Delivery of Revision: Three (3) weeks from commencement of services for same and receipt of any notes and instructions of Company with respect to same.

(e) Delivery of Polish: Two (2) weeks from commencement of services for same and receipt of any notes and instructions of Company with respect to same.

Each stage of the Work shall be delivered to Company's U.S. Agent, [Address], Attention [Agent Name], on or before the designated delivery date specified above for such stage (time being of the essence). [Agent Name] is Company's sole designated representative in connection with your services hereunder and is the sole Company representative empowered to give you instructions and notes on behalf of Company in connection with your services and the Work. To constitute complete "Delivery" hereunder, the First Draft Screenplay, Revision and the Polish shall be delivered as aforesaid and shall each be: (i) complete and final in all respects, with a beginning, middle and end; (ii) of first class quality suitable for a first class television production; and (iii) delivered to Company in customary Screenplay script format with an accompanying computer disc containing the text of the particular stage of the Work in a customary word processing format.

2. *Results and Proceeds:* The results and proceeds of your services hereunder, including, without limitation, the Work, shall be rendered on a work-for-hire basis and Company shall be the author and sole owner of the Work for all purposes, whatsoever, including, without limitation, copyright. Without limitation, Company and Company's assigns and licensees may exploit the Work in any and all media, whether now known or hereafter devised or improved, perpetually, and throughout the Universe without obligation to you or to any third party whomsoever, except Company shall perform the express obligations required by Company hereunder. All of Company's rights hereunder are irrevocable and your rights in the event of any breach hereof by Company shall be limited to an action at law for damages. In no event will you have the right to rescind this Agreement or to enjoin or interfere with the Work, the Production, any and all derivative works based upon any of the foregoing and any and all publicity, advertising and exploitation thereof. You assign to Company, in perpetuity, all rights in the Work not otherwise vested in Company (if any) including, without limitation, any and all rental and lending rights under national laws (whether implemented pursuant to the E.C. Rental and Lending Rights Directive or otherwise) which you now or hereafter

become entitled to with respect to the Work and/or Production and you further agree that a portion of the "Guaranteed Compensation" hereunder is full and complete consideration for the assignment of said rights, including, without limitation, such Rental and Lending rights and the following "Guaranteed Compensation", as set forth below, includes payment thereof for such assignment. The Work may be adapted, revised, edited and/or combined with other works. You waive any and all so-called moral rights of authors or Droit Morale applicable in any jurisdiction. You do not reserve any rights in the Work or Production, whatsoever.

3. *Guaranteed and Contingent Compensation Obligations of Company:* Provided you are not in material uncured default hereunder, the following payment obligations shall apply:

(a) Guaranteed Compensation: In full consideration of your services, the results and proceeds thereof and for all rights herein granted in the Work and with respect to the foregoing, Company shall pay you and you shall accept the sum of [Amount in Words] Dollars (US$[Amount in Figures]) (the "Guaranteed Compensation"), payable as follows:

(i) [Amount in Words] Dollars (US$[Amount in Figures]) upon execution hereof (it being acknowledged that Company shall have no obligation hereunder unless or until such time as this Agreement and all exhibits are executed by you and are delivered to Company and counter-signed), satisfaction of any conditions precedent, and commencement of your writing services for the Work;

(ii) [Amount in Words] Dollars (US$[Amount in Figures]) upon completion and Delivery of First Draft Screenplay;

(iii) [Amount in Words] Dollars (US$[Amount in Figures]) upon completion and Delivery of the Revision;

(iv) [Amount in Words] Dollars (US$[Amount in Figures]) upon completion and Delivery of the Polish.

(b) Contingent Compensation: Company shall make the following additional, contingent payments and perform the following obligations, subject to the occurrence of the applicable condition specified:

(i) Production Bonus. In the event the Production is produced based in whole or in substantial part upon the Work, Company shall pay you a "Production Bonus" as follows, payable within ten (10) business days following the final determination of writing credit for the Production: If you receive sole "screenplay by" or "written by" credit for the Production in accordance with paragraph 9 hereof and no other screenwriter has been engaged to render substantial writing services in

connection with the Picture, Company shall pay you a Production Bonus in the amount of [Amount in Words] Dollars (US$[Amount in Figures]). In the event you share such "screenplay by" or "written by" credit for the Production in accordance with paragraph 9 hereof and/or another screenwriter has been engaged to render substantial writing services in connection with the Picture, the foregoing payment required by this sub-paragraph shall be reduced by one half. In the event that no such "screenplay by" or "written by" credit is awarded to you in accordance with paragraph 9 hereof, you shall not be entitled to any Production Bonus. In the event you are the sole writer of the Production and no other writer has been engaged to render writing services in connection with the Production, such Production Bonus shall be due and payable within ten (10) business days following commencement of principal photography of the Production in lieu of the date of final determination of the writing credits for the Production.

(ii) Budget Bonus. In the event the final approved direct cost budget of the Picture exceeds [Amount in Words] Dollars (US$[Amount in Figures]), an additional [Amount in Words] Dollars (US$[Amount in Figures]) shall be added to and paid along with any sole credit Production Bonus to which you are entitled to receive under paragraph 3 (b) (i) above, or an additional [Amount in Words] Dollars (US$[Amount in Figures]) shall be added to and paid along with any shared credit Production Bonus to which you are entitled to receive under paragraph 3 (b) (i) above. Final, approved direct cost budget means the final budget approved by the completion guarantor (or financier, if none) of the Picture, less all financing costs, bank fees, interest, completion bond costs, contingency, overhead and deferments.

(c) Wire Instructions: All payments hereunder may be made by check or by wire transfer to the following account: [Wire Instructions]

4. *Travel:* If Company requires that your services be rendered at a location more than Fifty (50) miles from _____ (a "Location"), Company will provide you with: One (1) economy class (if available and if used) roundtrip air transportation to and from such Location, economy class ground transportation to and from airports and hotels, economy class hotel accommodations (room and tax only) and a per diem to be negotiated in good faith, taking into account the cost of living at such Location.

5. *Name and Likeness:* You hereby grant to Company the right to use your name, approved likeness, and approved biography in connection with

the Production and the advertising, promotion, and other exploitation thereof, including any and all subsidiary and ancillary rights therein such as, but not limited to, soundtrack album, publication rights, merchandising and commercial tie-ups (provided you will not be depicted as using or endorsing any product, commodity or service without your prior written consent), but Company shall be under no obligation to use any of the foregoing whether or not the Work is used. You shall cooperate with Company on a reasonable basis in obtaining any necessary approved likenesses and an approved biography for Company's use hereunder.

6. *Warranty/Indemnity:* You warrant and represent that the Work is:

(a) Wholly original with you in all respects and no part thereof shall be taken or based upon any other literary or dramatic or any other work, other than any public domain material;

(b) To the best of your knowledge, nothing contained therein shall in any way, infringe or violate the copyright or common law rights or literary, dramatic, or any other rights of any third party of any kind or nature or constitute a defamation, invasion of privacy, or violation of any contractual right of any third party whatsoever; that no part of the rights therein agreed to be conveyed have, in any way, been encumbered, conveyed, granted, or otherwise disposed of and the same, to the best of your reasonable knowledge and belief, are free and clear of any and all liens, or claims, whatsoever; and

(c) You shall indemnify and hold Company, its successors, licensees, and assigns harmless with respect to any and all liability costs and expenses (including, without limitation, reasonable outside attorney's fees whether or not in connection with litigation) arising out of a breach of any of the foregoing warranties and representations. Company shall indemnify, defend and hold you harmless against any liability, claim, cost, damage, or expense (including costs and reasonable attorney's fees whether or not in connection with litigation) arising out of or in connection with your use of any material supplied to you by Company and/or arising out of or in connection with material added to the Work and/or Production by Company or at Company's direction and/or otherwise arising out of the development, production, distribution, and/or exploitation of the Production other than claims which arise out of or are in connection with a breach or alleged breach by you of any of the agreements, warranties, or representations contained in this Agreement. When obtained, Company will cause you to be named as additional insured on Company's errors and omissions and general liability policies for the Production, subject to all exclusions, terms and conditions of said policies.

7. *Further Documents:* You agree to execute further documents, consistent with this Agreement, as may be reasonably required by Company, at any time, in order to evidence, maintain, perfect or establish Company's rights in and to the Work. In the event of your failure to so execute any such additional document(s), following review and a reasonable opportunity to comment upon said document(s), Company shall be deemed to be your attorney-in-fact for such purpose and Company or its designee may execute the same in your name on your behalf. Company shall provide copies of any documents executed pursuant to the above power of attorney, but Company's casual or inadvertent failure to do so shall not constitute a breach of this Agreement. Without prejudice to Company's right to require execution of further documents, you shall execute and deliver to Company: (i) the Certificate of Authorship (ii) Assignment of All Rights and (iii) French Authors Certificate attached to this Agreement, the provisions of which are incorporated herein by this reference, concurrently with execution this Agreement.

8. *No Obligation to Use Work:* Nothing herein shall in any way obligate Company to use the Work (or any portion thereof) or any other results and proceeds of your services in the Production or otherwise require Company to produce, exhibit, advertise, distribute or otherwise exploit the Production. For avoidance of doubt, Company shall remain obligated with respect to any indemnity and insurance obligations under paragraph 6 c. above notwithstanding the above, and Company will continue to observe any required credit obligations to you under paragraph 9 below.

9. *Credit:*

 9.1 Screen Credit and Paid Advertising Credit. Your entitlement to screen credit and paid advertising credit in connection with the Production shall be determined by Company using the same credit guidelines used by the Writers Guild of America, West in credit arbitrations. Any credit to which you are entitled shall be given "on-screen" and in paid advertising to the same extent that Company would be obligated to accord such credit if Company were signatory to the Writers Guild of America Basic Agreement ("WGA Agreement"). Notwithstanding the foregoing, if Company or any successor becomes signatory to the WGA Agreement and the Writers Guild of America ("WGA") obtains jurisdiction over the determination of writing credits for the Picture, you will be bound by any determination of writing credits for the Picture made by the WGA.

 9.2 Other Credit Matters. Except as otherwise set forth herein, all other aspects of credit shall be in Company's sole discretion.

All references in this Agreement to the title of the Production shall be deemed to mean the "regular" title unless reference is specifically made to the "artwork" title. No causal and inadvertent failure by Company to comply with the credit requirements hereunder nor any failure by any third party to so comply, shall be deemed a breach hereof, provided, however, that upon receipt of written notice from you, Company will use reasonable efforts on a prospective basis, to correct any omission or failure to give the required credits hereunder, to the extent the same is within Company's reasonable control or ability. Company shall advise the Production's distributors of the credit obligations set forth herein.

10. *Assignment:* Company shall have the right to assign any or all of its rights hereunder to any other person, firm, or corporation (an "Assignee" herein). Provided that the Assignee is (i) a firm, corporation, or entity owned or controlled by Company (or its principal(s)) which assumes in writing any executory obligations to you hereunder; and/or (ii) to a "major" studio, distributor or U.S. Network which assumes in writing the obligations of Company hereunder, Company shall be relieved of all obligations under this Agreement. In such event, you agree to look, solely, to such assignee, only, for full performance of all of the obligations of Company hereunder including, without limitation, any liability for the failure to so perform such obligations. Upon such assignment to: (i) a firm, corporation or entity owned or controlled by Company which assumes in writing any executory obligations to you hereunder; and/or (ii) to a "major" studio, distributor or U.S. Network which assumes in writing the obligations of Company hereunder, such Assignee shall be substituted for Company for all purposes under this Agreement and Company shall be released from all liability with respect to such obligations so assumed. With respect to all other assignments (other than those specified above), Company shall remain primarily liable for full performance of all of Company's obligations hereunder.

11. *Additional Provision(s):*

(a) Provided you receive sole "written by" or "screenplay by" credit with respect to the Production hereunder, you shall be entitled to a VHS video cassette copy (or DVD copy if manufactured and made available to the general public) free of charge, when copies thereof are made available to the general public, for your personal home use.

(b) You are familiar with the provisions of Sections 317 and 507 of the Communications Act of 1934, as amended, and the rules and regulations of the Federal Communications Commission ("FCC"), and you warrant that you shall not insert or include in the

Production any literary, dramatic, or other material, the nature of which would require an announcement or disclosure in order to comply with the provisions of said Sections 317 or 507 or the rules and regulations of the FCC, unless Company has given its prior written consent specifically to such inclusion or insertion and provision has been made for the appropriate announcement or disclosure, or both, as the case may be. You shall furnish to Company, at Company's request, such affidavits and/or statements as Producer may require with respect to said Sections 317 or 507 and FCC rules and regulations.

(c) Company is not a signatory to any Guild or Union covering your services and this Agreement is not subject to any Guild or Union agreement, and the WGA Agreement shall not be applicable to this Agreement.

12. *Other Terms:* All other terms and conditions shall be in accordance with Company's standard writer's agreement, the terms and conditions of which shall be subject to good faith negotiations within customary parameters of Company in light of your stature and experience in the entertainment industry; however the failure to agree upon any such changes or upon any upon other matter or agreement left for future negotiation, shall not affect the validity or effectiveness of this Agreement. Without limiting the foregoing, it is understood that Company has all customary suspension and termination rights in the event of default, incapacity, or in the case of the occurrence of any "force majeure" event in accordance with customary industry parameters for agreements of this type. Copies of all notices shall be given to Company's legal counsel [Name and Address of Legal Counsel]. Due to the large body of entertainment law governing agreements such as this in the state of California and due to the need for uniform interpretation of all agreements relating to the Production, the parties agree that California Law shall govern this Agreement, and the interpretation and performance thereof.

Kindly confirm your agreement by signing below.

Very truly yours,
[Engaging Entity]

By: _____

Its: _____

Agreed and Accepted:

[Writer's Name]

Certificate of Authorship/Results and Proceeds

I, [Writer's Name] ("I" or "me") hereby certify that I wrote and revised a Screenplay and contributed services and materials for the theatrical motion picture now known as "[Picture]" (which together with all past and future versions or revisions of the same written by me and the results and proceeds of my services shall be referred to, herein, collectively, as the "Work") as an employee-for-hire, pursuant to a direct commission from [Engaging Entity] ("Producer") contained in an agreement between myself and Producer (the "Agreement") dated as of [Date of Writer Agreement], in which I did not reserve any rights in or to the Work, which I wrote in the performance of my duties thereunder and during the regular course of my employment. The Work was specifically ordered and commissioned by Producer pursuant to the Agreement, for use as part of a motion picture or other audio-visual work, and as such is a "work-made-for-hire" for Producer as such term is used in the United States Copyright Act, and Producer is and shall be the sole and exclusive owner and author of the Work for all purposes throughout the universe in perpetuity. Accordingly, Producer is the author of the Work (including all drafts and revisions thereof) and is entitled to all rights therein and thereto (including all copyrights and all extensions and renewals thereof) with the right to make such changes and uses thereof as it may determine as such author. I acknowledge and hereby assign to Producer, in perpetuity, and throughout the Universe, for a separate consideration, the receipt and sufficiency of which is hereby acknowledged, any and all rights, whatsoever, without limitation or exclusion, if any, not otherwise vested in Producer pursuant to the foregoing, whether now existing or hereafter arising, including, without limitation, all so-called "Separated Rights" (if applicable) and all Rental and Lending rights under national laws (whether implemented pursuant to the E.C. Rental and Lending Rights Directive or otherwise) which I may now or hereafter become entitled to with respect to said Work and/or any derivative work based thereon and I agree that a sufficient portion of all sums payable pursuant to the Agreement and/or any applicable collective bargaining agreement have been allocated as consideration for the assignment to Producer of said rights and acknowledge that payment thereof constitutes full and complete consideration in full for said assignment of said rights, provided Producer shall remain obligated to pay me all additional sums which may be required to be paid in respect of the exploitation of such rights under any such applicable collective bargaining agreement (if any). I acknowledge that the Work may be adapted, revised, edited, and/or combined with other works. I waive any and all so-called moral rights of authors or droit morale applicable in any jurisdiction.

I acknowledge that my remedies, in the event of any breach of the Agreement by Producer shall be limited to an action at law for damages and in no event shall I have the right to terminate or rescind the Agreement

or this instrument or to enjoin or interfere with the Work, any and all derivative works based on the Work nor to enjoin or interfere with any and all publicity and/or advertising with respect thereto, nor any and all exploitation of any of the foregoing Work, derivative works, advertising and/or publicity. All of Producer's rights in the Work are freely assignable by Producer and its successors and assigns.

This instrument is governed by and is subject to the Agreement in all respects.

Dated: As of [Date of Writer Agreement]

[Writer's Name]

Author's Attestation

I, the undersigned [Writer's Name]

whose address is

Being the original author of the original screenplay entitled "[Title of Picture]" (the "Screenplay"), authorize _____ to produce, distribute and exploit a film entitled based on the Screenplay.

The present authorization is given for perpetuity worldwide commencing on [Date of Writer Agreement].

[Signature]

[Writer's Name]

Sample Post-production Schedule

February

Sunday	Monday	Tuesday	Wednesday	Thursday	Friday	Saturday
				1	2	3
4	5	6	7	8	9	10
11	12	13	14	15	16	17
18	19	20	21	22	23	24
25	26	27	28			

Shoot

Cutting room starts

Editor Cutting Assembly

March

Sunday	Monday	Tuesday	Wednesday	Thursday	Friday	Saturday
				1	2 Shoot	3
					Editor Cutting Assembly	
4	5	6	7 Shoot	8	9	10
			Editor Cutting Assembly			
11	12	13	14 Shoot	15	16	17
			Editor Cutting Assembly			
18	19	20	21 Shoot	22	23	24
			Editor Cutting Assembly			
25	26	27 Shoot	28 End Shoot	29	30	31
			Editor Cutting Assembly			

April

Sunday	Monday	Tuesday	Wednesday	Thursday	Friday	Saturday
1	2	3	4	5	6	7
		Editor Cutting Assembly			Assembly Done	
8	9	10	11	12	13	14
15	16	17	18	19	20	21
22	23	24	25	26	27	28
29	30					

May

Sunday	Monday	Tuesday	Wednesday	Thursday	Friday	Saturday
		1	2	3	4	5
6	7	8	9	10	11	12
13	14	15	16	17	18	19
20	21	22	23	24	25	26
27	28	29	30	31		

June

Sunday	Monday	Tuesday	Wednesday	Thursday	Friday	Saturday
					1 Director's Cut Done	2
3	4	5	6 Studio Notes	7	8	9
10	11	12	13 Studio Notes	14	15	16
17	18	19	20 Studio Notes	21	22	23
24	25	26	27	28	29	30

Locked reels to dubbers

Make Composer QTs

Sound EDLs

EDLs/Reference tape outputs

CGI/titles/roller

July

Sunday	Monday	Tuesday	Wednesday	Thursday	Friday	Saturday
1	2	3	4	5	6	7
			Tracklay Week 1			
			CGI/titles/roller			
8	9	10	11	12	13	14
			Tracklay Week 2			
			Foley record			
			CGI/titles/roller			
15	16	17	18	19	20	21
			Tracklay Week 3			
			ADR			
			CGI/titles/roller			

22	23	24	25	26	27	28
	Cut in CGI/titles/roller on AVID		Tracklay Week 4			
			On line HD master			

29	30	31
	Tracklay Week 5	
	Color timing	

August

Sunday	Monday	Tuesday	Wednesday	Thursday	Friday	Saturday
			1	2	3	4
				Tracklay Week 5		
				Color timing		
5	6	7	8	9	10	11
			Tracklay Week 6			
			Color timing		Music to be delivered to dub	
12	13	14	15	16	17	18
	Video textlesses					

19	20	21	22	23	24	25
			Sound Layback to Video Master			
	Music super Q sheets					
26	27	28	29	30	31	
	QC's and redos					
		Post Production Script				
		Make video delivery dubs				

Sample Delivery Schedule

Exhibit "B": Delivery Requirements

I. Picture/Sound Items

All materials must be conformed to the international version credits and contain company logo(s). Agent shall deliver the requisite logos/credits as required by Agent to Owner via DVD-R or HDcamSR for inclusion in HD master when requested by Owner. All materials should be shot with a resolution of 2K or 4K. All sound elements should be delivered in NTSC 29.97 NDF which conforms to HDcamSR feature masters (1080 23.98). Materials to be delivered to: [Name and Address].

A. *Stereo Printmaster (Full English Mix):* One (1) DVD-R containing .wav files and a ProTools® session of the Dolby Surround encoded stereo two-track (LT/RT) printmaster of the original language soundtrack of the Picture ("Printmaster"). The Printmaster shall be in perfect synchronization with the Picture.

 (i) One (1) DVD-R containing .wav files and a ProTools® session of the 5.1 Printmaster configured L, R, C, LFE, LS, RS, of the original language soundtrack of the Picture. The 5.1 printmaster shall be in perfect synchronization with the Picture.

B. *Music and Effects Track:* Sound effects on this dub must be fully filled and mixed and in perfect synchronization with the Picture.

 (i) One (1) DVD-R containing .wav files and a ProTools® session of the six track (5.1) discrete music and effects (L, R, C, LFE, LS, RS and dialogue guide track).

 (ii) One (1) DVD-R containing .wav files and a ProTools® session of the two track stereo music and effects.

C. *Dialogue, Music and Effects:* (i) One (1) DVD-R containing .wav files and a ProTools® session of each of the 5.1 dialogue, music, and effects stems, and (ii) one (1) DVD-R containing .wav files and a ProTools®

session containing separate stereo dialogue, stereo music and stereo effects tracks. Each stem must be in perfect synchronization with the Picture.

D. *Multi-Track Recordings:* A Laboratory Access Letter with a detailed inventory list granting Agent access to all original multi-track recordings of the original music score (if required by Agent).

E. *Alternate Picture and Sound Material:* A Laboratory Access Letter with a detailed inventory list granting access to Agent to all "cover shots," alternate scenes/alternate dialogue so that the Picture can be conformed to rating, censorship requirements and/or television and airline exhibition (if required by Agent).

F. *Music:* CD of Original Musical Score (including all uncut source cues) of the Picture in stereo if recorded in stereo.

II. Video Items

All materials must be conformed to the international version credits and contain company logo(s). Materials to be delivered to:

A. *High Definition Master 1920x1080 (1080p, 23.98):* Two (2) High Definition masters of the Feature in the following formats: 16×9 Full Frame (1.78 aspect ratio) and one 16×9 (1.33 aspect ratio). Master should be scene-to-scene color corrected with pan and scan as necessary. Master must conform in all respects to broadcast television standards throughout the world. If the Picture contains subtitling over action (including main and end title sequence), Agent shall be provided with a text-less section at the tail of the master(s). Additionally, if the Picture is NOT produced in the English language, Owner will also deliver English subtitled masters in the above mentioned formats. Each video Master shall have the following audio configuration:

Channel 1: Stereo Left—Original composite mix
Channel 2: Stereo Right—Original composite mix
Channel 3: Final M/E Left
Channel 4: Final M/E Right
Channel 5: Left
Channel 6: Right
Channel 7: Center
Channel 8: LFE
Channel 9: Left Surround
Channel 10: Right Surround
Channel 11: mono dx
Channel 12: mono fx

B. *PAL and NTSC Digital Masters:* One (1) PAL and NTSC first-generation Digital Betacam down-conversion master created from above High

Definition Masters (item A.) of the Feature in the following formats: 16×9 PAL and NTSC Anamorphic and 4×3 PAL and NTSC Fullframe. Master should be scene to scene color corrected with pan and scan as necessary. Master must conform in all respects to broadcast television standards throughout the world. If the Picture contains subtitling over action (including main and end title sequence), Agent shall be provided with a textless section at the tail of the Master(s). Additionally, if the Picture is NOT produced in the English language, Owner will also deliver English subtitled masters in the above mentioned formats. Each video Master shall have the following audio configuration:

Channel 1: Stereo Left—Original composite mix
Channel 2: Stereo Right—Original composite mix
Channel 3: Final M/E Left
Channel 4: Final M/E Right

III. Television/ Version (if Applicable)

All materials must be conformed to the international version credits. Materials to be delivered to:

A. *HDcamSR masters*, 16×9 1:78 and 4×3 Pillar Box with same specs as feature.
B. *Two (2) broadcast quality Digital Betacam NTSC video masters* (one 16×9 1:78 and one 4×3 1:33) and two (2) broadcast quality Digital Betacam PAL digital videotape masters (one 16×9 1:78 and one 4×3 1:33) of the television/airline version of the Picture which conforms to standards and practices and length requirements for the United States and foreign free television and airline exhibition of the Picture. Program shall contain all or any part of the alternative scenes and/or dialogue and/or eliminations and/or additions for the purpose of conforming to an acceptable television/airline version.
C. *Sound Materials:*

 a. 6+2 M&E
 b. 6+2 English Mix; and
 c. Stereo D,M &E (with stereo dialogue, stereo music, and stereo effects and fully filled stereo effects)

IV. Trailer Items

Materials to be delivered to:

A. *Stereo Printmaster (Full English Mix):* One (1) DVD-R containing .wav files and a ProTools® session of the Dolby Surround encoded stereo two-track (LT/RT) printmaster of the original language soundtrack of the Trailer ("Printmaster"). The Printmaster shall be in

perfect synchronization with the Trailer. Trailer will appear on all tapes after textless titles.

(i) One (1) DVD-R containing .wav files and a ProTools® session of the 5.1 Printmaster of the original language soundtrack of the Trailer. The Stereo printmaster shall be in perfect synchronization with the Trailer.

B. *Music and Effects Track:* Sound effects on this dub must be fully filled and mixed and in perfect synchronization with the Trailer.

(i) One (1) DVD-R containing .wav files and a ProTools® session of the stereo discrete music and effects plus dialogue guide track.

(ii) One (1) DVD-R containing .wav files and a ProTools® session of the two track music and effects.

C. *Split Tracks Master:*

(i) One (1) DVD-R split tracks master containing .wav files and a ProTools® session containing Narration/Dialogue/Music/Effects on separate mono tracks; and

(ii) Stereo NDM&E. Even if narration does not exist, it shall be formatted as such, with channels 1 and 2 as MOS.

D. *High Definition Master 1920×1080 (1080p, 23.98):* One (1) High Definition master of the Trailer in the following formats: 16×9 full screen (1.78 aspect ratio) and one 16×9 (1.33 aspect ratio). Master should be scene-to-scene color corrected with pan and scan as necessary. Master must conform in all respects to broadcast television standards throughout the world. If the Picture contains subtitling over action (including main and end title sequence), Agent shall be provided with a text-less section at the tail of the master(s). Additionally, if the Picture is NOT produced in the English language, Owner will also deliver English subtitled masters in the above mentioned formats. Each video Master shall have the following audio configuration:

Channel 1: Stereo Left—Original composite mix
Channel 2: Stereo Right—Original composite mix
Channel 3: Final M/E Left
Channel 4: Final M/E Right
Channel 5: Left
Channel 6: Right
Channel 7: Center
Channel 8: LFE
Channel 9: Left Surround
Channel 10: Right Surround
Channel 11: mono dx
Channel 12: mono fx

E. *PAL and NTSC Digital Masters:* One (1) PAL and NTSC standard first-generation Digital Betacam transfer master of the Trailer in the following formats: 4×3 PAL and NTSC Fullframe. Master should be scene-to-scene color corrected with pan and scan as necessary. Master must conform in all respects to broadcast television standards throughout the world. If the Picture contains subtitling over action (excluding main and end title sequence), Agent shall be provided with a texted master and all additional textless material. Each video Master shall have the following audio configuration:

Channel 1: Stereo Left—Original composite mix
Channel 2: Stereo Right—Original composite mix
Channel 3: Final M/E Left
Channel 4: Final M/E Right

V. Publicity and Advertising Items

Unless otherwise noted, all written material shall be in the English language. All materials must be conformed to the international version credits. Materials to be delivered to:

A. *Color Photography:* No less than One Hundred (100) original color high resolution digital photographs with a copy of each image on diskette in a high-resolution format as approved in advance of delivery to Agent by all persons possessing approval rights over such negatives, together with written proof of such approval. In addition, Agent shall receive access to all color photography connected with the Picture. A notation identifying the persons shall accompany images and events depicted therein and shall be suitable for reproduction for advertising and publicity purposes.
B. *Intentionally Deleted.*
C. *Textless Artwork Transparency:* One (1) final original 8×10 Textless Artwork on Diskette in a high-resolution format containing all artwork to be used for the one sheet poster and all advertising. Delivery of Key Art as photoshop layers on DVD-r is acceptable.
D. *Intentionally Deleted.*
E. *Credit Block:* A diskette in a high-resolution format of the contractually correct billing block which shall represent exact placement, wording and size of each paid advertising credit, together with all pertinent accompanying high-resolution logos.
F. *Biographies:* One (1) copy on diskette in current Word format of each of the principal players, writers, individual Owner(s), director and key technical personnel (director of photography, production designer, costume designer, composer, editor) prepared by the publicist assigned to the Picture.

G. *Stories/Articles:* One (1) original copy with a copy on diskette in Word 4.0 format, if available, of any publicity kits, stories and articles written by the unit publicist or journalists on various aspects of events during production of the Picture, which are deemed by the unit publicist to be suitable for column placement and feature stories, if any, involving the principal players, supporting players, writer(s), and special interest material that the unit publicist has reason to believe will be of use in marketing the Picture.

H. *Production notes:* One (1) original typewritten copy with a copy on diskette in Word format of notes on the production of the Picture prepared by the unit publicist, including history of the production; illuminating comments by the cast and key filmmakers about the Picture, its significance and its special claims on the interest of the moviegoers. All Production Notes shall be read and approved by Owner, the director and anyone else so designated by the Owner before they are delivered to Agent.

I. *Synopsis:* Copy in current Word format of a brief and a long synopsis in the English language of the story of the Picture (250 words and one typewritten page in length).

J. *Advertising Materials:* One (1) copy of all advertisements, paper accessories and other advertising materials, if any, prepared by Owner or by any other party in connection with the Picture, including samples of one-sheet posters and individual advertising art elements and transparencies necessary to make proofs thereof. Also, (if available) a Digital Betacam master of the electronic press kit (EPK) (narration on separate channel) and access to all elements used to create the EPK; television and radio spots. Access and use of publicity and advertising materials created for any media and/or territory outside the media and territories licensed hereunder. For any media and/or territory that is not licensed to Agent in this Agreement, Owner agrees to give Agent access to and use of, or cause Agent to get access to and use of:

(i) foreign language dubbed or subtitled versions of the Film; and

(ii) all Film advertising original art material or transparencies, including, but not limited to key art, video box cover artwork, EPKs, television spots, DVD extra materials, etc.; and

(iii) all FILM publicity material; and

(iv) any website and websites materials; and

(v) all DVD or Home Video Extras

either created by the Owner or Owner's sub-licensees, including, all at no additional cost to Agent and whether such materials are created by Owner or Owner's licensees. In connection with the foregoing, Owner agrees to permit or secure permission for Agent to make or have made, at actual cost, copies of any said material for use in the Licensed Territory and by Agent its licensees *if available.*

K. *Materials to create DVD Extras:* Any original materials (preferably on HDCamSR (1080,23.98)) including, but not limited to EPKs, video interviews, behind-the-scenes footage *if available.*

L. *Website and Internet Promotional Sites:* If requested, owner will transfer control and exclusive access to any and all websites, URLs, Myspace or similar web pages related to the film that Owner has created or owns or controls to Agent for the Term of the Agreement.

VI. Documentation

All paperwork shall be delivered in the English language. All materials must be conformed to the international version credits. Materials to be delivered to:

A. *Combined Continuity and Spotting List:* One (1) copy in current Word or Excel format in the English language of a detailed, final dialogue and action continuity and spotting list of the Picture (Feature and Trailer) containing all dialogue, narration and song vocals, as well as a cut by cut description of the Picture action, conformed to the Answer Print. If the Picture was recorded in a language other than English, the Continuity shall contain a literal English translation (Feature and Trailer). *A dialogue list with timings is acceptable.*

B. *Dialogue List:* One (1) copy in current Word format of a complete combined dialogue list of the Feature and Trailer.

C. *Literary Materials:* A copy of the any story, screenplay and/or final lined shooting script of the Picture and other literary materials relating to the Picture.

D. *Music Cue Sheet:* One (1) copy in Word or Excel format of a music cue sheet (in substantially the form of Schedule "BB" attached hereto) showing the particulars of all music contained in the Picture and the Trailer delivered hereunder, including title of each composition; the names of composers; publishers and copyright owners; the usages (whether instrumental, instrumental–visual, vocal, vocal–visual or otherwise); the place for each composition showing the film footage and running time for each cue; the performing rights society involved any other information customarily set forth in music cue sheets.

E. *Music Contracts/Licenses/Assignments:* Each of the contracts, licenses, license confirmation letters or assignments specified below that conveys to Owner the right to use the music, lyrics or recordings, as applicable, in the Picture, in whole or part, in all media now known or hereafter devised, throughout the universe in perpetuity without payment of any further compensation for the grant of such rights and shall include the right to use the music, lyrics or recordings, as applicable, in connection with the advertising, promotion and publicity of the

Picture, in or out of context of the Picture subject only to payment of fees to applicable performing rights societies.

(a) Music and Lyric Contracts: Duplicate originals or legible copies of all contracts covering the acquisition and performance of all music and lyrics utilized in connection with the Picture.

(b) Music Licenses: A copy of valid licenses paid for by Owner for the full period of copyright for the synchronous recording of all copyrighted music and recordings in the Picture and the performance thereof in the licensed territory throughout the entire Term of the Agreement.

Further, each of the contracts, licenses, license confirmation letters or assignments that conveys to Owner the right to use film clips, posters, photographs, art work trademarks, products, logos, and other intellectual property that appears or is included in the Picture.

F. *Composer Agreement(s):* One (1) copy of the original fully executed contract for the services of the composer of the musical soundtrack of the Picture and the sync license from the publisher.

G. *Credit Statement:* One (1) copy in current Word or Excel format of a statement of credits applicable to the Picture setting forth the names and credit obligations of Owner with regard to all persons to whom Owner is contractually obligated to accord credit on the screen, in any paid advertising, in paperback books, on sound recordings and on videocassette packages. The Credit Statement shall include verification of the writing credits set forth therein by the appropriate writers' guild. The credits set forth on the Credit Statement shall conform in every instance to the standard credit requirements of Agent, including without limitation, those requirements set forth in the Agreement (if applicable). The Credit Statement should also set forth all name and likeness usage with regard to all persons to whom Owner has contractually accorded such provisions.

H. *Screen Credit Requirements:* One (1) copy in current Word or Excel format of a list of the main and end credits of the Picture with an approved lay-out illustration of the screen and advertising credits with relative size and prominence in percentage.

I. *Director's Guild Credit Approval:* If the Picture was produced under the jurisdiction of the Director's Guild of America ("DGA"), a letter from the DGA approving (a) the list of screen credits for the Picture submitted to the DGA pursuant to Article 8–201 of the DGA Basic Agreement, and if appropriate (b) the credits included in the paid advertising campaign material submitted to the DGA pursuant to Article 8–210 of the DGA Basic Agreement.

J. *Cast List and Crew List:* One (1) copy in current Word or Excel format of a list indicating the name of the character portrayed by each player, including appropriate contact numbers; and one (1) copy of a list of all

technical personnel (including their title and assignment) involved in the production, including appropriate contact numbers.

K. *Licenses/Contracts/Assignments:* Duplicate originals of all licenses, contracts, assignments and/or other written permissions from the proper parties in interest permitting the use of any product, musical, literary, dramatic, copyrighted, trademarked and other materials of whatever nature used in the production, exploitation or advertising of the Picture.

L. *Dolby License:* Executed copy of the License Agreement for use of Dolby Sound (if used) in connection with the Picture, if applicable.

M. *Editor's Codebook:* Duplicate original or computer diskette of the entire complete codebook. Codebook will include all key numbers, scene numbers, lab roll numbers, camera roll numbers and sound roll numbers with corresponding dates *if available.*

N. *Employment Agreements:* Duplicates of all documents relating to the employment of all personnel engaged to render services in connection with the Picture, including but not limited to the individual Owner(s), director, screenwriter(s), actors, musical performing artist(s), below-the-line crew, technicians and administrative staff.

O. *Residuals Information:* Not applicable—Owner shall be solely responsible for payment of all residuals, reuse fees or other participation in the Picture.

P. *Dubbing Restrictions/Approvals:* One (1) copy in current Word or Excel format of a statement of: (1) any limitation on use of photographic or non-photographic likenesses (2) any restrictions as to the dubbing of the voice of any player including dubbing dialogue in a language other than the language in which the Picture was recorded (if applicable).

Q. *MPAA Rating Certificate:* A Certificate evidencing a rating from the Motion Picture Association of America ("MPAA") that is not more restrictive than that specified in the Agreement (if applicable).

R. *MPAA Title Registration:* Evidence that the title of the Picture has been registered under the rules of the MPAA Title Registration Bureau and that pursuant to such registration procedures, Owner has the right to use the title of the Picture (if applicable).

S. *Certificates of Origin:* Fifteen (15) original Certificates of Origin (substantially in the form of Schedule "DD" attached hereto) certified and signed by a notary or Commissioner for Oaths, together with confirmation from the appropriate governmental agency (if origin is outside of the United States). *Not applicable.*

T. *French Authorship Certificate:* Two (2) original fully executed French Authorship Certificates (substantially in the form of Schedule "EE" attached hereto) (if applicable).

U. *Tax Exemption Forms:* IRS Form 6166 (if applicable). The 6166 Form is needed for the licensee of each individual right so as to avoid a 25% tax withholding (per Article VIII of the Double Taxation Convention

with the U.S.) on transfers of money from certain countries to the United States. In the event that Owner cannot provide a 6166 Form, then Agent shall be entitled to be Owner in the territory needed such form and shall provide its own IRS Form 6166.

V. *Copyright Information:* Detailed information with regard to the copyright proprietor of the Picture, the precise copyright notice to be affixed to all advertising and packaging. Owner shall provide Agent with one copy of the U.S. Certificate of Copyright Registration.

W. *Short Form Assignment:* One executed copy of the Short Form Assignment of Distribution Rights.

X. *Chain of Title:* One (1) copy of all documents evidencing Owner's right to produce, distribute and exploit the Picture including all transfer-of-rights agreements from the author and all other parties to the Owner. A short summary of all these documents should be included.

Y. *Errors and Omissions Policy:* A copy of a "Motion Pictures Owner and Agent Errors and Omissions" insurance policy from an insurance company acceptable to Agent secured prior to the commencement of principal photography of the Picture, which names Agent and each of the parties indemnified in the Agreement as additional insured. The policy shall provide insurance against any and all claims relating to the Picture and shall have limits of at least US$1,000,000.00 with respect to any one claim relating to the Picture, US$3,000,000.00 with respect to all claims relating to the Picture in the aggregate and the deductible of the Policy shall not exceed US$10,000.00. The Policy shall be for an initial period commencing as soon as reasonably practicable and in no event later than commencement of principal photography of the Picture and terminating no earlier than 3 years from Owner's delivery of the Picture hereunder, with an option for an additional year and shall be delivered together with evidence indicating that the premium for the Policy has been paid in full for the applicable term. Producer shall not be required to secure the Policy until such a time as a US distribution has been made.

Z. *Copyright Report and Title Report and Opinion and Script Clearance Report:* A current (i.e., issued within two months of the date of the Agreement) Copyright Report and Opinion and Title report and Opinion issued by [Company Name] and a script clearance report from an established reputable script clearance company such as [Company Name]. All of the latter items must show no encumbrances, liens, conflicting interests and the right to clear use of the script, the title, and the rights granted to Purchaser.

Full Non-union budget

Acct No	Category Description	Page	Total
11–00	STORY, RIGHTS & CONTINUITY	I	10,165
12–00	PRODUCER	I	82,500
13–00	DIRECTOR	I	29,500
14–00	CAST	I	116,556
15–00	STUNTS	3	6,000
17–00	TRAVEL & LIVING	3	28,150
19–99	**A-T-L Total Fringes**		**29,289**
	TOTAL ABOVE-THE-LINE		**302,160**
20–00	PRODUCTION STAFF	4	7,200
21–00	EXTRAS & STAND-INS	4	7,200
23–00	SET CONSTRUCTION	4	12,200
24–00	SET DRESSING	4	5,000
25–00	PROPERTY	5	3,000
26–00	WARDROBE	5	10,150
27–00	CAMERA	5	22,050
28–00	LIGHTING	6	16,000
29–00	SET OPERATIONS	7	8,250
30–00	PRODUCTION SOUND	7	4,622
31–00	MAKEUP & HAIR	7	5,760
32–00	SPECIAL EFFECTS	8	13,250
34–00	PICTURE VEHICLES	8	3,000
35–00	TRANSPORTATION	8	20,490
36–00	LOCATION	9	35,900
40–00	FILM & LAB	10	37,170
49–99	**TOTAL B-T-L FRINGES**		**14,057**
	TOTAL PRODUCTION		**225,349**
50–00	EDITORIAL	11	5,500
51–00	MUSIC	11	1,500
52–00	POST SOUND	11	9,000
53–00	POST FILM & LAB	11	10,000
54–00	OPTICALS	11	10,000
59–99	**TOTAL POST FRINGES**		**0**
	TOTAL POST PRODUCTION		**36,000**

Acct No	Category Description	Page	Total
60–00	INDIANA PRODUCTION SERVICES PACKAGE ALL INCLUSIVE	12	88,711
61–00	INSURANCE	12	21,000
62–00	OVERHEAD	12	500
64–00	FEES & CHARGES	12	4,700
69–99	**Total Fringes**		**0**
	TOTAL OTHER		**114,911**
	Total Above-The-Line		**302,160**
	Total Below-The-Line		**376,260**
	Total Above- and Below-The-Line		**678,420**
	Grand Total		**678,420**

Acct No	Description	Amount	Units	X	Curr	Rate	Subtotal	Total
11–00 STORY, RIGHTS & CONTINUITY								
11–01	SCRIPT & RIGHTS							
	SCREENPLAY PURCHASE	1	Allow	1		8,000	8,000	
	Total							8,000
11–11	CLEARANCES							
	ACT ONE	1	Flat	1		1,000	1,000	
	Research Expenses	1	Allow	1		300	300	
	TITLE SEARCH	1	Allow	1		275	275	
	COPYRIGHT	1	Allow	1		90.0	90	
	Total							1,665
11–12	XEROX & MIMO							
	Script copies	1	Allow	1		500	500	500
	Total							
Account Total for 11–00								**10,165**
12–00 PRODUCER								
12–02	PRODUCERS							
	Executive Producer	1	Flat	1		82,500	82,500	82,500
	Total							
Account Total for 12–00								**82,500**
13–00 DIRECTOR								
13–01	DIRECTOR							
	Director	1	Allow	1		25,000	25,000	
	2nd Unit Director	1	Flat	1		4,500	4,500	
	Total							29,500
13–03	ASSISTANT							0
Account Total for 13–00								**29,500**

14-00 CAST

14-01						
STARS						
Z Star	1		Flat	1	82,500	82,500

SAG SCHEDULE B						
ASSUME LOAN OUT						

Y Star	2		Weeks	1	933	1,866
X Star	1		Flat	1	4,400	4,400

ASSUME LOAN OUT						

Total						88,766
14-02	SUPPORTING CAST & STUNTS					

	SAG MODIFIED LOW BUDGET SCAL					
	ALLOW 10 HOUR DAYS - NO OT					
	FRINGED AS INDIVIDUALS					
	ASSUMED LOCAL HIRES					

						0
A Star	1		Week	1	933	933
B Star	4		Days	1	268	1,072
C Star	6		Days	1	200.17	1,201
D Star	2		Weeks	1	933	1,866
E Star	2		Days	1	268	536
						5,608
Overtime	20		%	1	5,608	1,121
Total						6,730
14-03	DAY PLAYERS					

(Continued)

(Continued)

Acct No	Description	Amount	Units	X	Curr	Rate	Subtotal	Total

	SAG Modified Low Budget Agreem							
	SAG Scale rates & Hours							
	SAG Daily scale + 10%: 294.80							
	DAILIES: 10HRS / $368.50 daily,							
	FRINDGED AS INDIVIDUALS							
	ASSUMED LOCAL HIRES							

	1st Star	2	Days	1		268	536	
	2nd Star	3	Days	1		268	804	
	3rd Star	2	Days	1		268	536	
	4th Star	1	Day	1		268	268	
	5th Star	1	Day	1		268	268	
	6	7	Days	1		209.86	1,469	
	7	7	Days	1		209.86	1,469	
	8	1	Day	1		268	268	
	9	1	Day	1		268	268	
	10	1	Day	1		268	268	
	11	2	Days	1		268	536	
	12	1	Day	1		268	268	
	13	1	Week	1		933	933	
	14	1	Day	1		268	268	
	15	1	Day	1		268	268	
	16	1	Day	1		268	268	
	17	1	Day	1		268	268	
	18	1	Day	1		268	268	

Account	Description		Unit			Rate	Amount	Total
	19	—	Day	—		268	268	
	20	—	Week	—		933	933	
	21	—	Week	—		933	933	
	22	—	Day	—		268	268	
						11,633	11,633	
	Overtime	20	%			11,633	2,326	
	Total							13,960
14–10	LOOPING	—						
	LOOPING ALLOWANCE CAST	1	Allow	—		5,000	5,000	
	Total							5,000
14–15	OTHER CHARGES							
	BASKETS	—	Allow	—		100.0	100	
	SAG Mileage	—	Allow	—		2,000	2,000	
	Total							2,100
Account Total for 14–00								**116,556**
15–00 STUNTS								
15–55	STUNT EQUIPMENT	—						
	STUNT EQUIPMENT	—				3,000	3,000	
	Total							3,000
15–05	STUNT ADJUSTMENTS	—						
	STUNT ADJUSTMENTS	—				3,000	3,000	
	Total							3,000
Account Total for 15–00								**6,000**
17–00 TRAVEL & LIVING								
17–01	AIRFARE	—						
	ALLOW	1	Allow	—		10,000	10,000	
	Total							10,000
17–03	Star Perks	—						
	ALLOW	1	Allow	—		10,000	10,000	
	Total							10,000
17–04	GROUND TRANSPO							

(Continued)

(Continued)

Acct No	Description	Amount	Units	X	Curr	Rate	Subtotal	Total
	ALLOW	1	Allow	1		5,000	5,000	
	Total							5,000
17–05	PER DIEM							
	Per Diem – Ken, Nathan, Jim	16	Days	3		50.0	2,400	
	Per Diem – Kirton	15	Days	1		50.0	750	
	Total							3,150
Account Total for 17–00								**28,150**
19–99	**A-T-L Total Fringes**							
	ABOVE THE LINE	19.54%				29,500	5,764	
	SAG-CORPS	14.8%				5,000	740	
	BTL-TX	23.58%				5,000	1,179	
	AGENT	10%				16,633.04	1,663	
	SAG	14.8%				106,007.06	15,689	
	TX-W.C.	82	Weeks			840.89	841	
	FICA	6.2%				17,241.06	1,069	
	MED	1.45%				17,241.06	250	
	TX-FUI/SUI	9.06				17,241.06	1,562	
	PR FEE	0.5%				17,241.06	86	
	TX-WC	82	Weeks			445.18	445	
								29,289
	TOTAL ABOVE-THE-LINE							**302,160**

Acct No	Description	Amount	Units	X	Curr	Rate	Subtotal	Total
20–00 PRODUCTION STAFF								
20–03	2nd ASSISTANT DIRECTOR							
	PREP	6	Days	1		200	1,200	
	SHOOT	6	Days	1		200	1,200	
	Total							2,400
20–07	SCRIPT SUPERVISOR							
	TIMING/PREP	1	Day	1		250	250	
	SHOOT	6	Days	1		250	1,500	
	WRAP	1	Day	1		250	250	
	Total							2,000
20–10	PRODUCTION ASSISTANTS							
	PREP	6	Days	1		100.0	600	
	SHOOT	6	Days	2		100.0	1,200	
	Total							1,800
20–11	Payroll accountant	1	Allow	1		1,000	1,000	
	Payroll accountant							
	Total							1,000
Account Total for 20–00								**7,200**
21–00 EXTRAS & STAND-INS								
21–02	General Extras							

	NON UNION – 10 HR DAYS							
	MIN WAGE: $5.15/HR							
	TOTAL MAN DAYS: 500							

	Extras	75	MDAYS	1		50.0	3,750	
							3,750	
	Total							3,750

(Continued)

(Continued)

Acct No	Description	Amount	Units	X	Curr	Rate	Subtotal	Total
21–11	Mileage	1	Allow	1		1,000	1,000	
	Total							1,000
21–21	Casting Fee - Extras	1	Allow	1		2,500	2,500	
	Total							2,500
Account Total for 21–00								**7,250**
23–00 SET CONSTRUCTION								
23–10	LABOR & MATLS							
	Labor (Paint, const, etc.)	1	Allow	1		10,000	10,000	
	Total							10,000
23–50	Strike/Trash							
	Allow	1		1		1,000	1,000	
	Total							1,000
23–78	Box Rentals							
	Allow	1		1		1,200	1,200	
	Total							1,200
Account Total for 23–00								**12,200**
24–00 SET DRESSING								
24–40	PURCHASES/RENTALS	1	Allow	1		5,000	5,000	
	Total							5,000
Account Total for 24–00								**5,000**

25–00 PROPERTY							
25–02	PROP MASTER						
	PREP	6	Days	—	250	1,500	
	SHOOT	6	Days	—	250	1,500	
	Total						3,000
Account Total for 25–00							**3,000**
26–00 WARDROBE							
26–01	WARDROBE SUPERVISOR						
	PREP	5	Days	—	250	1,250	
	SHOOT	6	Days	—	250	1,500	
	WRAP	1	Day	—	250	250	
	Total						3,000
26–02	WARDROBE PA						
	PREP	3	Days	—	100.0	300	
	SHOOT	6	Days	—	100.0	600	
	Total						900
26–11	ALTERATIONS & REPAIRS	1	Allow	—	750	750	
	Total						750
26–15	CLEANING						
	1	1	Allow	—	500	500	
	Total						500
26–40	WARDROBE PURCHASES						
	Allow	1	Allow	—	2,500	2,500	
	Total						2,500
26–50	WARDROBE RENTALS						
	allow	1	Allow	—	2,500	2,500	
	Total						2,500
Account Total for 26–00							2,500
							10,150

(Continued)

Acct No	Description	Amount	Units	X	Curr	Rate	Subtotal	Total
27–00 CAMERA								
27–02	OPERATORS							
	STEADICAM OP.	2	Days	1		500	1,000	
	Total							1,000
27–03	1ST ASST CAMERA							
	B-CAM	4	Days	1		250	1,000	
	A-CAM							
	PREP	1	Day	1		250	250	
	SHOOT	6	Days	1		250	1,500	
	WRAP	1	Day	1		250	250	
	Total							3,000
27–04	2ND ASST CAMERA							
	B-CAM	3	Days	1		200	600	
	A-CAM							
	PREP	1	Day	1		200	200	
	SHOOT	6	Days	1		200	1,200	
	WRAP	1	Day	1		200	200	
	Total							2,200
27–40	EXPENDABLES							
	Expendables	1	Allow	1		1,000	1,000	
	Lexan	1	Allow	1		200	200	
	Total							1,200
27–50	EQUIPMENT RENTALS							
	CAMERA PKG	1	Week	1		3,500	3,500	
	STEADICAM RIG	2	Days	1		500	1,000	
	VIDEO ASSIST	1	Week	1		500	500	
	Total							5,000

27–60	EQUIPMENT PURCHASES					
	ALLOW	1	Allow	1	350	350
	Total					
27–80	LOSS & DAMAGE					
	Camera repair	1	Flat	1	500	500
	Monitor repair	1	Flat	1	300	300
	L&D	1	Allow	1	500	500
	Total					1,300
Account Total for 27–00						**22,050**
28–00 LIGHTING						
28–01	GAFFER					
	TECH SCOUT	1	Day	1	250	250
	LOAD-IN	0	Days	1	250	0
	PREP	1	Day	1	250	250
	SHOOT	6	Days	1	250	1,500
	WRAP	1	Day	1	250	250
	Total					2,250
28–03	OPERATING LABOR					
	SWING (MPS)	6	Days	1	200	1,200
	ADDITIONAL LABOR	0	MDAYS	1	175	0
	Total					1,200
28–06	ADDITIONAL LABOR					
	RIG/STRIKE LABOR	6	MDAYS	1	175	1,050
	Total					1,050
28–11	GENIE RENTAL					
	GENERATOR	3	Weeks	1	1,000	3,000
	Put-Put Genie	1	Allow	1	250	250
	Total					3,250

(Continued)

(Continued)

Acct No	Description	Amount	Units	X	Curr	Rate	Subtotal	Total
28–40	ELECTRICAL PURCHASES							
	GLOBES	1	Allow	1		1,500	1,500	
	GELS/EXPENDABLE	1		1		1,500	1,500	
	Total							3,000
28–50	ELECTRICAL RENTALS							
	GRIP AND ELECTRICAL PKG	3	Weeks	1		1,500	4,500	
	Total							4,500
28–80	LOSS & DAMAGE	1	Allow	1		750	750	
	Total							750
28–85	OTHER CHARGES							0
Account Total for 28–00								**16,000**
29–00 SET OPERATIONS								
29–01	KEY GRIP							
	TECH SCOUT	1	Day	1		250	250	
	PREP	1	Day	1		250	250	
	SHOOT	6	Days	1		250	1,500	
	WRAP	1	Day	1		250	250	
	Total							2,250
29–03	DOLLY GRIP							
	SHOOT	6	Days	1		200	1,200	
	Total							1,200
29–04	3rd Grip							
	3rd Grip	6	Days	1		175	1,050	
	Total							1,050
29–40	Purchases	1	Week	1		750	750	
	Total							750

Code	Description	Qty	Unit	X	Rate	Subtotal	Total
29–50	Rentals						
	DOLLY INCL. TRACK	1	Week	1	1,000	1,000	
	CONDORS	1	Flat	1	2,000	2,000	3,000
	Total						
25–85	OTHER COSTS						0
Account Total for 29–00							**8,250**
30–00 PRODUCTION SOUND							
30–01	SOUND MIXER						
	PREP	1	Day	1	250	250	
	SHOOT incl sound pkg	6	Days	1	375	2,250	2,500
	Total						
30–02	BOOM OPERATOR						
	SHOOT	6	Days	1	175	1,050	1,050
	Total						
30–40	PURCHASES						
	DAT tape	6	Days	1	12.0	72	
	BATTERIES, ETC.	1	Allow	1	500	500	572
	Total						
30–60	WALKIE TALKIES						
	WALKIES/ACCESS.	1	Week	12	12.5	150	150
	Total						
30–80	LOSS & DAMAGE						
	SOUND L&D	1	Allow	1	350	350	350
	Total						
30–85	OTHER CHARGES						0
Account Total for 30–00							**4,622**
31–00 MAKEUP & HAIR							
31–01	KEY MAKEUP						
	PREP/TESTS	1	Day	1	250	250	
	SHOOT	6	Days	1	250	1,500	

(Continued)

Acct No	Description	Amount	Units	X	Curr	Rate	Subtotal	Total
31–02	Total							1,750
	2nd Makeup hair	6						
	2nd Makeup and hair			1		135	810	
	Total							810
31–40	M/U/HAIR/WIG PURCHASES							
	MAKEUP HAIR PURCH	1	Allow	1		1,000	1,000	
	WIGS	1	Allow	1		1,000	1,000	
	Total							2,000
31–50	RENTALS							
	Chairs/mirrors	1	Week	1		300	300	
	Total							300
31–78	BOX RENTALS							
	ASSISTANTS	6	Days	1		150	900	
	Total							900
31–85	OTHER CHARGES							0
Account Total for 31–00								**5,760**
32–00 SPECIAL EFFECTS								
32–01	SPECIAL FX SUPERVISOR							
	KEY SPFX	5	Days	1		350	1,750	
	Total							1,750
32–02	Operating Labor							
	ASST SFX	5	Days	1		300	1,500	
	Total							1,500
32–40	PURCHASES							
	BREAKAWAYS	1	Allow	1		5,000	5,000	
	SQUIBS, SPARKS, ETC.							
	EXPLOSIONS	1	Allow	1		5,000	5,000	

Account	Description						Total
	Total						10,000
32–60	RENTALS						0
32–85	OTHER COSTS						0
Account Total for 32–00							**13,250**
34–00 PICTURE VEHICLES							
34–05	REPAIRS/PAINT						
	Paint and repairs/weld	1	Allow	1	3,000	3,000	
	Total						3,000
Account Total for 34–00							**3,000**
35–00 TRANSPORTATION							
35–03	DRIVERS						
	DAY PLAYERS						
	SHOOT @ 15 HRS	10	Days	1	150	1,500	
						1,500	
	SHUTTLE VAN	0	Days	20	24.99	0	
						0	
	WATER TRUCK @ 10 HRS	2	Days	1	250	500	
						500	
	MISC	1	Allow	1	3,000	3,000	
	Total						5,000
35–18	LOCAL EQUIPMENT RENTALS						
	CAMERA/SOUND VAN	1	Week	1	300	300	
	SET DRESS CUBE	1	Week	1	365	365	
	PROPS CUBE	2	Weeks	1	300	600	
	MU/WARDROBE COMBO	1	Week	1	950	950	
	SHUTTLE VAN	3	Weeks	1	450	1,350	
	SURVEY VAN	1	Day	1	100.0	100	

(Continued)

Acct No	Description	Amount	Units	X	Curr	Rate	Subtotal	Total
35–19	Total							3,665
	DRESSING ROOMS							
	HONEYWAGON	1	Week	1		1,650	1,650	
	STAR TRAILER	0	Weeks	1		950	0	
	2 BANGERS	1	Week	1		900	900	
35–40	Total							2,550
	GASOLINE & OIL							
	TRUCKS	1	Allow	1		2,000	2,000	
	GENNIE							
35–45	Total							2,000
	REPAIRS/MAINTENANCE							
	Repair/MAINTENANCE	1	Allow	1		1,500	1,500	
	HONEYWAGON SUPPLIES	1	Allow	1		5,000	5,000	
	Dumping	1	Allow	1		275	275	
	Misc Purchases	1	Allow	1		500	500	
	Total							7,275
35–80	LOSS AND DAMAGE							0
Account Total for 35–00								**20,490**
36–00 LOCATION								
36–04	SCOUTING EXPENSES							
	PRE-PRODUCTION:SHOOT	1	Allow	1		20,000	20,000	
	Total							20,000
36–11	FIRE SAFETY OFFICERS							
	SPFX Fire Protection	2	Days	1		350	700	
	Total							700
36–13	SET MEDIC							
	SHOOT	5	Days	1		175	875	
	KIT RENTAL	5	Days	1		25.0	125	
	Total							1,000

Code	Description	Qty	Unit		Rate	Amount	Total
36-17	CATERED MEALS						
	LUNCHES - SUE'S ROOST	5	Days	30	15.0	2,250	
	GAS, ICE, PROPANE	6	Days	1	100.0	600	
	EXTRA'S LUNCH	75	Days	1	10.0	750	
	SECOND MEALS	10	Days	20	10.0	2,000	
	OFF-SET MEALS	1	Allow	1	1,000	1,000	
	Total						6,600
36-23	OFFICE EQUIPMENT						
	Equipment	1	Allow	1	1,500	1,500	
	Total						1,500
36-26	TELEPHONE						
	Phones	1	Allow	1	500	500	
	Total						500
36-30	SHIPPING/POSTAGE						
	COURIER/FED-EX	1	Allow	1	500	500	
	DAILIES SHIPPING	4	Days	1	150	600	
	Total						1,100
36-35	SITE RENTALS						
	SITE RENTALS	1	Allow	1	2,500	2,500	
	Total						2,500
36-36	PERMITS	1	Allow	1	500	500	
	Total						500
36-39	PARKING						
	PARKING	1	Allow	1	500	500	
	Total						500

(Continued)

(Continued)

Acct No	Description	Amount	Units	X	Curr	Rate	Subtotal	Total
36–85	OTHER COSTS							
	Total	1		1		1,000	1,000	1,000
Account Total for 36–00								**35,900**
40–00 FILM & LAB								
40–01	RAW STOCK							
	35mm Film	75,000	FEET	1		0.39	29,250	
	Sales tax (TAX FREE from Media D	8.25	%	0		29,250	0	
	Total							29,250
40–02	PROCESSING							
	DEVELOP	72,000	FEET	1		0.11	7,920	
	Total							7,920
40–50	STILLS - FILM & LABORATORY							0
	PR							
40–85	OTHER COSTS							0
Account Total for 40–00								**37,170**
49–99	**TOTAL B-T-L FRINGES**							
	BTL-TX	23.58%				15,300	3,608	
	SALES TAX	2.25%				5,000	112	
	W.C.	2%				810	16	
	TX-W.C.	82	Weeks			3,478.97	3,479	
	FICA	6.2%				34,785	2,157	
	MED	1.45%				34,785	504	
	TX-FUI/SUI	9.06%				31,035	2,812	
	PR FEE	0.5%				39,385	197	

		8.26%				3,750	310	
		65	Days			780	780	
		82	Weeks			0244140625	82	14,057

TX(X)-FUISUI
TX-TMSTR-PHW
TX-WC

TOTAL PRODUCTION 225,349

Acct No	Description	Amount	Units	X	Curr	Rate	Subtotal	Total
50–00 EDITORIAL								
50–85	EDITOR							
	Editor	1	Flat	1		5,000	5,000	
	Editorial Supplies	1		1		500	500	
	Total							5,500
Account Total for 50–00								**5,500**
51–00 MUSIC								
51–01	TRACKED LIBRARY SCORE							
	Allow	1	Allow	1		1,500	1,500	
	Total							1,500
Account Total for 51–00								**1,500**
52–00 POST SOUND								
52–01	POST SOUND PKG.							
	Loop Group	1	Allow	1		1,500	1,500	
	Total							1,500
52–02	ELEMENTS							
	Elements	1	Allow	1		4,000	4,000	
	Total							4,000

(Continued)

(Continued)

Acct No	Description	Amount	Units	X	Curr	Rate	Subtotal	Total
52–03	Audio License Fees							
	Dolby License	1	Allow	1		3,500	3,500	3,500
	Total							**9,000**
Account Total for 52–00								
53–00 POST FILM & LAB								
53–15	DPS Total Dailies and Video Post							
	Allow	1	Allow	1		10,000	10,000	10,000
	Total							**10,000**
Account Total for 53–00								
54–00 OPTICALS								
54–02	OPTICALS/CGI	1	Allow	1		10,000	10,000	10,000
	Total							**10,000**
Account Total for 54–00								
59–99	**TOTAL POST FRINGES**							**0**
	TOTAL POST PRODUCTION							**36,000**

Acct No	Description	Amount	Units	X	Curr	Rate	Subtotal	Total
60–00 INDIANA PRODUCTION SERVICES PACKAGE ALL INCLUSIVE								
60–01	Indiana Production Services Package							
	Spring Meadow Holdings, LLC	1	Flat	1		88,710.66	88,710	88,711
	Total							**88,711**
Account Total for 60–00								**88,711**
61–00 INSURANCE								
61–01	PRODUCTION PKG.							
	PRODUCTION PKG. INCLUDING E&O	1	Allow	1		21,000	21,000	21,000
	Total							**21,000**
Account Total for 61–00								**21,000**
62–00 OVERHEAD								
62–11	Shipping/Messenger							
	Messenger service	1	Allow	1		500	500	500
	Total							**500**
Account Total for 62–00								**500**
64–00 FEES & CHARGES								
64–02	MPAA Rating							
	MPAA RATING	1	Allow	1		3,500	3,500	
	Dialogue Continuity	1	Allow	1		1,200	1,200	
	Total							4,700
Account Total for 64–00								**4,700**
69–99	Total Fringes							0
	TOTAL OTHER							114,911

(Continued)

Acct No	Description	Amount	Units	X	Curr	Rate	Subtotal	Total
	Total Above-The-Line							302,160
	Total Below-The-Line							376,260
	Total Above- and Below-The-Line							678,420
	Grand Total							678,420

Appendix L

Non-union Top Sheet

Acct No	Category Description	Page	Total
11–00	STORY, RIGHTS & CONTINUITY	1	10,165
12–00	PRODUCER	1	82,500
13–00	DIRECTOR	1	29,500
14–00	CAST	1	117,288
15–00	STUNTS	3	6,000
17–00	TRAVEL & LIVING	3	28,150
19–99	**A-T-L Total Fringes**		**38,552**
	TOTAL ABOVE-THE-LINE		**312,155**
20–00	PRODUCTION STAFF	4	7,200
21–00	EXTRAS & STAND-INS	4	7,250
23–00	SET CONSTRUCTION	4	12,200
24–00	SET DRESSING	4	5,000
25–00	PROPERTY	5	3,000
26–00	WARDROBE	5	10,150
27–00	CAMERA	5	22,050
28–00	LIGHTING	6	16,000
29–00	SET OPERATIONS	7	8,250
30–00	PRODUCTION SOUND	7	4,622
31–00	MAKEUP & HAIR	7	5,760
32–00	SPECIAL EFFECTS	8	13,250
34–00	PICTURE VEHICLES	8	3,000
35–00	TRANSPORTATION	8	20,490
36–00	LOCATION	9	35,900
40–00	FILM & LAB	10	37,170
49–99	**TOTAL B-T-L FRINGES**		**14,057**
	TOTAL PRODUCTION		**225,349**
50–00	EDITORIAL	11	5,500
51–00	MUSIC	11	1,500
52–00	POST SOUND	11	9,000
53–00	POST FILM & LAB	11	10,000
54–00	OPTICALS	11	10,000
59–99	**TOTAL POST FRINGES**		**0**
	TOTAL POST PRODUCTION		**36,000**
60–00	INDIANA PRODUCTION SERVICES PACKAGE ALL INCLUSIVE	12	88,711

(Continued)

(Continued)

Acct No	Category Description	Page	Total
61–00	INSURANCE	12	21,000
62–00	OVERHEAD	12	500
64–00	FEES & CHARGES	12	4,700
69–99	**Total Fringes**		**0**
	TOTAL OTHER		**114,911**
	Total Above-The-Line		**312,155**
	Total Below-The-Line		**376,260**
	Total Above- and Below-The-Line		**688,415**
	Grand Total		**688,415**

Union Comparison Top Sheet

Acct No	Category Description	Page	Total
11–00	STORY, RIGHTS & CONTINUITY	I	33,058
12–00	PRODUCER	I	82,500
13–00	DIRECTOR	I	150,000
14–00	CAST	I	200,180
15–00	STUNTS	3	21,768
17–00	TRAVEL & LIVING	3	29,320
19–99	**A-T-L Total Fringes**		**116,413**
	TOTAL ABOVE-THE-LINE		**633,239**
20–00	PRODUCTION STAFF	5	121,614
21–00	EXTRAS & STAND-INS	5	13,250
22–00	ART DIRECTION	6	26,880
23–00	SET CONSTRUCTION	6	20,784
24–00	SET DRESSING	6	48,447
25–00	PROPERTY	7	37,808
26–00	WARDROBE	7	46,338
27–00	CAMERA	8	116,301
28–00	LIGHTING	9	57,197
29–00	SET OPERATIONS	10	30,196
30–00	PRODUCTION SOUND	11	29,916
31–00	MAKEUP & HAIR	11	55,813
32–00	SPECIAL EFFECTS	12	14,000
34–00	PICTURE VEHICLES	12	3,000
35–00	TRANSPORTATION	12	225,408
36–00	LOCATION	16	69,150
37–00	UNIT COSTS & MEALS	17	62,645
40–00	FILM & LAB	17	37,170
49–99	**TOTAL B-T-L FRINGES**		**223,648**
	TOTAL PRODUCTION		**1,239,565**
50–00	EDITORIAL	19	102,770
51–00	MUSIC	19	1,500
52–00	POST SOUND	19	9,000
53–00	POST FILM & LAB	19	10,000
54–00	OPTICALS	19	10,000
59–99	**TOTAL POST FRINGES**		**25,275**
	TOTAL POST PRODUCTION		**158,545**

(Continued)

(Continued)

Acct No	Category Description	Page	Total
61–00	INSURANCE	21	32,450
62–00	OVERHEAD	21	500
64–00	FEES & CHARGES	21	4,700
69–99	**Total Fringes**		0
	TOTAL OTHER		**37,650**
	Contingency: 2.5%		51,725
	Total Above-The-Line		**633,239**
	Total Below-The-Line		**1,435,760**
	Total Above- and Below-The-Line		**2,068,998**

Standard Terms

Producer's Standard Terms and Conditions

1. **Producer's Rights**: The results and proceeds of Performer's services hereunder, including without limitation all themes, plots, characters, formats, ideas, stories, and all other material composed, submitted, added, created, or interpolated by Performer hereunder (hereafter the "Results and Proceeds"), which Performer acknowledges may have been or may be rendered in collaboration with others, shall be deemed a work-made-for-hire for Producer prepared within the scope of Performer's employment and/or as a work specifically ordered and/or commissioned by Producer, and therefore, Producer shall be the author and copyright owner thereof for all purposes throughout the universe. Producer shall solely and exclusively own throughout the universe, in perpetuity and in all languages all rights of every kind and nature whether now or hereafter known or created in and in connection with such Results and Proceeds including, without limitation, all copyrights (and renewals and extensions thereof), all forms of motion picture, television, digital television, video and computer games, videocassette, video or laser disc, computer-assisted media, character, sequel, remake, sound record, theme park, stage play, merchandising and allied, ancillary and subsidiary rights therein, and the foregoing is inclusive of a full irrevocable assignment to Producer thereof. Producer shall own all rights in the role or character portrayed by Performer, including name, likeness and distinctive characterizations and the right to use Performer's name and likeness in connection with the performance and Picture, for all purposes throughout the universe in perpetuity at no additional cost to Producer unless and except as specified below. Performer shall have no right at any time to portray, exploit, merchandise or make any use of such role or character portrayed by Performer. Performer hereby grants Producer the nonexclusive right in perpetuity throughout the universe to use and permit others to use Performer's name, photograph, likeness, voice (or simulation thereof), and biography in connection with advertising,

publicizing and exploiting the Picture or any part thereof including, without limitation, in commercial tie-ins or tie-ups relating thereto.

2. **Additional Rights:** Performer acknowledges that the following have been separately bargained for as required under the SAG Modified Low Budget Agreement. Throughout the universe in perpetuity and in connection with the Picture, unless otherwise specified under "Special Provisions" above, Performer acknowledges that Producer may use and authorize others to use and display Performer's name, voice and likeness (including the re-use of photography and soundtrack material from the Picture) in connection with the following: souvenir programs, merchandising, commercial tie-ups, animated spin-offs, advertisements, promotions, music videos, soundtrack albums (including the use on the packaging of recordings containing music from the Picture whether or not Performer's performance is including in such recordings), computer and/or interactive software, posters, printed publications of materials from the Picture or upon which the Picture is based or in which characters in the Picture are used, corporate promotions such as in an annual report and Producer may also use images from the Picture or film clips from the Picture (which contain Performer's name and likeness) as well as outtakes, extra footage or "behind the scenes" footage or photos in which Performer appears, in any manner that it elects, including, without limitation, in connection with promotional films or "making of" or similar programs.

3. **Credit:** Provided Performer is not in default hereunder and provided Performer appears recognizably in the Picture as released, Producer shall accord Performer credit in the end titles of the Picture unless otherwise specified under "Special Provisions" above. All other matters pertaining to such credit shall be determined by Producer. No casual or inadvertent failure by Producer, or any failure by any third party, to comply with the foregoing credit provisions shall constitute a breach hereof.

4. **Breach of Contract:** Performer agrees that Performer's services are special, unique, unusual, extraordinary, and of an intellectual character giving them a peculiar value, the loss of which cannot be reasonably or adequately compensated in damages in an action at law and that Producer, in the event of any breach by Performer, shall be entitled to equitable relief by way of injunction or otherwise. In the event of a failure or an omission constituting a breach by Producer of the provisions of this Agreement, Performer hereby agrees to give Producer written notice thereof and afford Producer the opportunity to remedy such breach prospectively prior to filing a grievance with SAG. It is further agreed that Performer's rights and remedies in the event of a failure or an omission constituting a breach or alleged breach of this Agreement shall be limited to Performer's right, if any, to recover damages in an action at law, but in no event shall Performer be entitled by reason of

any such breach to terminate or rescind this Agreement, or to enjoin or restrain the distribution, exhibition or exploitation of the Picture or the advertising or publicizing thereof.

5. **Other Services/Additional Compensation:** Performer agrees to be available, subject to prior professional commitments, for standard pre- and post-production activities including, but not limited to, wardrobe fittings, make-up tests, reshoots, publicity and promotion, dubbing and looping for the minimum applicable additional compensation pre-scribed for such use in the SAG Modified Low Budget Agreement, if any. Any payments required by the SAG Modified Low Budget Agree-ment (or other applicable collective bargaining agreement), in excess of the payments expressly provided for herein, including specifically (but without limitation) any payments that may be due as a result of a commercial tie-in or tie-up relating to the Picture, shall be payable at the minimum rate required by the applicable collective bargaining agreement.

6. **Assignment:** Producer may assign this Agreement or any part thereof to any third party whatsoever. Performer may not assign its rights or delegate Performer's obligations in whole or in part, under this Agree-ment without Producer's prior written approval.

7. **Non-Disclosure:** Performer agrees not to disclose any creative and/or material information whatsoever concerning Performer's performance, the Picture or this Agreement without Producer's express written per-mission.

8. **No Obligation to Use:** Producer is not obligated to use the services of Performer or to develop, produce, distribute, or exploit the Picture, or, if commenced, to continue the development, production, distribu-tion, or exploitation of the Picture in any territory; and regardless of whether or not Producer elects to develop, produce, distribute and/ or exploit the Picture (or to commence same), Producer shall not be obligated to use the services (in whole or in part) of Performer here-under and Performer and Lender, if applicable, shall not be entitled to any damages or other relief by reason thereof.

9. **Miscellaneous:** The execution of this Agreement has not been induced by any representations, statements, warranties or agreements other than those expressed herein. This Agreement embodies the entire understanding, written or oral, in effect between the parties and supersedes any agreement, written or oral that may currently exist between Producer and Performer relating to the subject matter hereof. Under the SAG Modified Low Budget Agreement, Artist waives continu-ous and consecutive employment. This Agreement can be modified only by a written instrument signed by both parties. This Agreement is governed by Texas law and is subject to the exclusive jurisdiction of the federal and state courts located in Dallas, Texas.

SAG Studio Zone Map

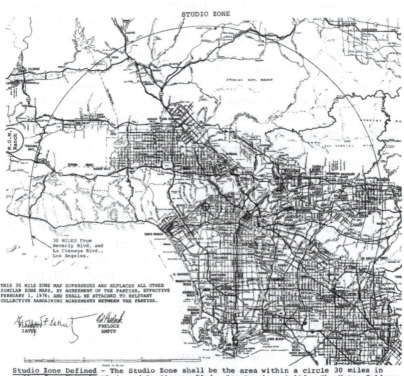

STUDIO ZONE

30 MILES From
Beverly Blvd. and
La Cienega Blvd.,
Los Angeles.

THIS 30 MILE ZONE MAP SUPERSEDES AND REPLACES ALL OTHER
SIMILAR ZONE MAPS, BY AGREEMENT OF THE PARTIES, EFFECTIVE
FEBRUARY 1, 1976; AND SHALL BE ATTACHED TO RELEVANT
COLLECTIVE BARGAINING AGREEMENTS BETWEEN THE PARTIES.

IATSE

PRELOCK
AMPTP

Studio Zone Defined – The Studio Zone shall be the area within a circle 30 miles in
radius from Beverly Blvd. and La Cienega Blvd., Los Angeles, Calif. The Metro-Goldwyn-
Mayer, Inc. Conejo Ranch property shall be considered as within the Studio Zone.
(Circle drawn by AMPTP Research Center)

EXHIBIT "2"

Sample Shooting Schedule

Scheduled

Sheet # / pgs	Scenes	INT/EXT	Description	Day	Numbers	Script page#
Sheet #: 96 2/8 pgs	Scenes: 95	INT	SHOW ARENA CROWD WATCHES GRAND PARADE	Day	7, 9, 16	Script page# 79
Sheet #: 111 2/8 pgs	Scenes: 110	INT	SHOW ARENA SHARON WATCHES SHOW	Day	2, 3, 12	Script page# 86
Sheet #: 166 2/8 pgs	Scenes: 112pt, 113pt	INT	SHOW ARENA CROWD REACTS TO ANNOUNCERS	Day	2, 3, 12	Script page#
Sheet #: 129 2/8 pgs	Scenes: B112	INT	SHOW ARENA CROWD STARTS TO LAUGH	Day	1, 2, 3	Script page#
Sheet #: 167 5/8 pgs	Scenes: AA116pt	INT	SHOW ARENA TOMMY WINS. THE CROWD ERRUPTS	Day	1, 2, 3, 4, 6, 8, 11, 12, 16	Script page#
Sheet #: 118 3 2/8 pgs	Scenes: 117	EXT	ARENA HOLDING AREA TOMMY DECKS NATHAN. SHARON INVITES ALL TO PART	Day	1, 2, 3, 4, 6, 7, 8, 9	Script page# 92
Sheet #: 160 2/8 pgs	Scenes: 101pt, 105	INT	SHOW ARENA STACY RIDES OUT/IN	Day	11	Script page# 81
Sheet #: 161 2/8 pgs	Scenes: A106, A107	INT	SHOW ARENA LENNY RIDES OUT/IN	Day	8	Script page#
Sheet #: 108 6/8 pgs	Scenes: 107	INT	SHOW ARENA - ENTRANCE TUNNEL NATHAN SEES ERIN AND DEREK. DEREK RIDES OUT	Day	1, 3, 4, 6	Script page# 84
Sheet #: 164 2/8 pgs	Scenes: 109pt, A111pt	INT	SHOW ARENA NATHAN RIDES OUT/IN	Day	6	Script page#
Sheet #: 147 4/8 pgs	Scenes: A112	INT	SHOW ARENA JACKIE NOT MOVING	Day	1, 2, 3, 12	Script page# 79
Sheet #: 115 1/8 pgs	Scenes: 114	INT	SHOW ARENA TOMMY SPURS JACKIE	Day	1, 2, 3	Script page# 89
Sheet #: 116 2/8 pgs	Scenes: 115, 116	INT	SHOW ARENA TOMMY RIDES OUT	Day	1	Script page# 89

IF TIME PERMITS-PRESS BOX

End Day # 1 Tuesday, July 22, 2008 -- Total Pages: 7 2/8

Sheet #	Scenes	INT/EXT	Description	Day		Script page#
Sheet #: 97 1 pgs	Scenes: 96	INT	PRESS BOX ANNOUNCERS CALL EVENT	Day	7, 9, 16	Script page# 79
Sheet #: 102 1 pgs	Scenes: 101	INT	PRESS BOX ANNOUNCE STACY	Day	7, 9, 11	Script page# 81
Sheet #: 110 3/8 pgs	Scenes: 109	INT	PRESS BOX ANNOUNCE NATHAN	Day	7, 9	Script page# 86
Sheet #: 145 2/8 pgs	Scenes: A111	INT	PRESS BOX ANNOUNCE NATHAN, SCORE, INTRO TOMMY	Day	7, 9	Script page# 88
Sheet #: 113 3/8 pgs	Scenes: 112	INT	PRESS BOX TOMMY A NO SHOW	Day	7, 9	Script page# 88
Sheet #: 114 1/8 pgs	Scenes: 113	INT	PRESS BOX BURNS RALLIES CROWD	Day	7, 9	Script page# 89
Sheet #: 106 3/8 pgs	Scenes: 105pt, A106pt	INT	PRESS BOX ANNOUNCE STACY IN/LENNY OUT	Day	7, 9	Script page# 83
Sheet #: 117 1 4/8 pgs	Scenes: 115pt, AA116	INT	PRESS BOX TOMMY RIDES/COMMENTARY	Day	7, 9	Script page# 89
Sheet #: 162 2/8 pgs	Scenes: B107 ET AL	INT	SHOW ARENA ALL SCORES AND TIMES	Day		Script page#
Sheet #: 100 1/8 pgs	Scenes: 99	EXT	ARENA ROAD TRAFFIC JAM	Day	1, 2	Script page# 81
Sheet #: 101 5/8 pgs	Scenes: 100	INT	PICKUP TRUCK HEAR CONTEST ON RADIO	Day	1, 2	Script page# 81
Sheet #: 103 5/8 pgs	Scenes: 102	INT	PICKUP TRUCK SHARON DROPS TOMMY OFF	Day	1, 2	Script page# 82
Sheet #: 107 2/8 pgs	Scenes: 106	EXT	ARENA PARKING LOT TOMMY RIDES JACKIE IN LOT	Day	1, 2	Script page# 83
Sheet #: 109 6/8 pgs	Scenes: 108	INT	SHOW ARENA - REGISTRATION SECTION TOMMY CHECKS IN	Day	1, 10	Script page# 84

(Continued)

(Continued)

Scheduled

Sheet #: 144 5/8 pgs	Scenes: A108	INT	ARENA STALL NATHAN HEARS JACKIE TALK	Day	1, 6	Script page#
Sheet #: 112 5/8 pgs	Scenes: 111	INT	ARENA STALL JACKIE GIVES PEP TALK	Day	1	Script page# 86
Sheet #: 165 7/8 pgs	Scenes: B111	INT	ARENA STALL TOMMY HITS HIS HEAD, JACKIE GOES SILENT	Day	1, 10	Script page#
Sheet #: 95 1/8 pgs	Scenes: 94	EXT	SHOW ARENA PARKING LOT ARENA HORSE SHOW	Day	7, 9, 10	Script page# 78
Sheet #: 98 3/8 pgs	Scenes: 97	EXT	SHOW ARENA – PADDOCK AREA NATHAN SADDLES UP	Day	6, 8	Script page# 80
Sheet #: 99 4/8 pgs	Scenes: 98	EXT	SHOW ARENA DEREK CHECKS IN	Day	3, 4	Script page# 80

End Day # 2 Wednesday, July 23, 2008 -- Total Pages: 10 6/8

Sheet #: 151 1/8 pgs	Scenes: 32pt	EXT	WORK OUT ARENA DODGE AND NATHAN'S POV OF TOMMY ON JACKIE	Day	1, XI	Script page#
Sheet #: 11 6/8 pgs	Scenes: 10	EXT	WORK OUT ARENA TOMMY WATCHES PRACTICE	Day	1, 4, 6, 8,	Script page# 11
Sheet #: 18 1 5/8 pgs	Scenes: 17	EXT	WORK OUT ARENA TOMMY FALLS OFF HORSE	Day	1, 4, 6, 8, 16	Script page# 15
Sheet #: 45 3/8 pgs	Scenes: 44	EXT	WORK OUT ARENA BOYS WAIT FOR TOMMY	Day	4, 6, 8	Script page# 42
Sheet #: 51 3 3/8 pgs	Scenes: 50	EXT	WORK OUT ARENA TOMMY SHOWS UP AND WINS	Day	1, 4, 6, 8, 16	Script page# 45

End Day # 3 Thursday, July 24, 2008 -- Total Pages: 6 2/8

Sheet #: 90 2/8 pgs	Scenes: 89	EXT	FIELD MAJOR LEADS HIM TO BARN	Day	1	Script page# 75
Sheet #: 31 1 7/8 pgs	Scenes: 30	EXT	FIELD TOMMY RIDES JACKIE	Day	1, XI	Script page# 26

Sheet # / pgs	Scenes	INT/EXT	Description	Day	Script page#
Sheet #: 35 2 7/8 pgs	Scenes: 34	EXT	WORK OUT ARENA BURNS IMPRESSED WITH TOMMY	Day 1, 4, 6, 8, 11, 16	Script page# 30
Sheet #: 59 1 1/8 pgs	Scenes: 65	EXT	CREEK BED THEY PRACTICE	Day 1	Script page# 53
Sheet #: 127 2/8 pgs	Scenes: 104	EXT	TRIAL COURSE STACY GOES THROUGH COURSE	Day 11	Script page#
Sheet #: 131 2/8 pgs	Scenes: A107	EXT	TRIAL COURSE DEREK GOES THROUGH COURSE	Day 4, 8	Script page#
Sheet #: 143 2/8 pgs	Scenes: A107	EXT	TRIAL COURSE LENNY GOES THROUGH COURSE	Day 8	Script page#
Sheet #: 130 2/8 pgs	Scenes: A110	EXT	TRIAL COURSE NATHAN GOES THROUGH COURSE	Day 6	Script page#
Sheet #: 133 6/8 pgs	Scenes: AA116pt	EXT	TRIAL COURSE TOMMY GOES THROUGH COURSE	Day 1	Script page#
Sheet #: 176 2/8 pgs	Scenes: 89pt	EXT	WOODS - STABLE MAJOR LEADS HIM TO BARN	Day 1	Script page# 75

End Day # 4 Friday, July 25, 2008 -- Total Pages: 8 1/8

Sheet # / pgs	Scenes	INT/EXT	Description	Day	Script page#
Sheet #: 94 1/8 pgs	Scenes: 93	EXT	ROAD HAUL JACKIE DOWN ROAD	Day 1, 2	Script page# 78
Sheet #: 91 1 2/8 pgs	Scenes: 90	EXT	OLD STABLE TOMMY FINDS JACKIE	Day 1	Script page# 75
Sheet #: 93 1 pgs	Scenes: 92	EXT	OLD STABLE LOAD JACKIE INTO TRAILER	Day 1, 2	Script page# 77
Sheet #: 27 1/8 pgs	Scenes: 26	EXT	DILAPIDATED BARN TOMMY SNEAKS UP TO BARN	Day 1	Script page# 23
Sheet #: 23 5/8 pgs	Scenes: C20	EXT	DILAPIDATED BARN JACKIE SEES WHAT'S UP	Day 4, 6, 8, 16	Script page# 21
Sheet #: 124 1 3/8 pgs	Scenes: B20	INT	DILAPIDATED BARN JACKIE HIT BY PAINTBALL, KICKS POST	Day 1, 4, 6, 8, 16, 17	Script page#

(Continued)

(Continued)

Scheduled

Sheet #	Scenes	INT/EXT	Set / Description	Day	Script page#
Sheet #: 28 1 pgs	Scenes: 27	INT	DILAPIDATED BARN TOMMY TALKS TO JACKIE	Day 1	Script page# 23

End Day # 5 Saturday, July 26, 2008 -- Total Pages: 5 4/8
END WEEK ONE -- SUNDAY OFF

Sheet #	Scenes	INT/EXT	Set / Description	Day	Script page#
Sheet #: 3 2 2/8 pgs	Scenes: 2	INT	BRAXTON BARN RICK SAYS GOODBYE	Day 2, 14, 15	Script page# 1
Sheet #: 4 5/8 pgs	Scenes: 3	EXT	BRAXTON BARN TOMMY SEES TRUCK	Day 1, 13	Script page# 3
Sheet #: 5 1/8 pgs	Scenes: 4	EXT	BRAXTON HOUSE SHARON HEARS COMMOTION	Day 1, 2, 13	Script page# 4
Sheet #: 7 2 pgs	Scenes: 6	EXT	BRAXTON BARN SHE ADMITS SELLING HORSES	Day 1, 2, 13	Script page# 4
Sheet #: 152 4/8 pgs	Scenes: A36	EXT	BARN JACKIE TELLS TOMMY TO TRUST HIM	Day 1	Script page#
Sheet #: 44 4/8 pgs	Scenes: 43	EXT	BRAXTON BARN TOMMY HAS WORRIES	Day 1	Script page# 41
Sheet #: 46 3/8 pgs	Scenes: 45	EXT	BRAXTON BARN THEY SET OFF	Day 1	Script page# 42

End Day # 6 Monday, July 28, 2008 -- Total Pages: 6 3/8
SPLINTER UNIT TO SHOOT

Sheet #	Scenes	INT/EXT	Set / Description	Day	Script page#
Sheet #: 125 1/8 pgs	Scenes: A41	EXT	GREENSCREEN GREENSCREEN OF JACKIE SKIING	Day 1	Script page#
Sheet #: 42 3/8 pgs	Scenes: A23	INT	PSYCHIATRIST'S OFFICE (A COUCH IN THE BARN) JACKIE IS PSYCHIATRIST	Day 1	Script page#
Sheet #: 142 1/8 pgs	Scenes: A72	INT	JAIL CELL JACKIE IN JAIL	Day 1	Script page#

MAIN UNIT

Sheet #	Scenes	INT/EXT	Set / Description	Day	Script page#
Sheet #: 38 1 2/8 pgs	Scenes: 37	EXT	BRAXTON PORCH SHARON AND ERIN TALK	Day 2, 3	Script page# 38

Sheet #	Scenes	INT/EXT	Description	Day	Script page
Sheet #: 62 1/8 pgs	Scenes: 61	EXT	BRAXTON HOUSE ESTABLISHING WITH TRUCK	Day	Script page# 56
Sheet #: 141 2/8 pgs	Scenes: A61	INT	BRAXTON HOUSE LIVING ROOM ERIN ON PHONE	Day 3	Script page#
Sheet #: 64 1 7/8 pgs	Scenes: 63	EXT	BRAXTON HOUSE DEREK ASKS ERIN OUT	Day 3, 4	Script page# 57
Sheet #: 65 1 3/8 pgs	Scenes: 64	INT	BRAXTON HOUSE KITCHEN ERIN TELLS HER ABOUT DATE	Day 2, 3	Script page# 59
Sheet #: 8 2 pgs	Scenes: 7	INT	BRAXTON HOUSE KITCHEN ERIN WANTS A TATTOO	Day 1, 2, 3	Script page# 6
Sheet #: 34 1 pgs	Scenes: 33	INT	BRAXTON HOUSE - KITCHEN TOMMY CAN KEEP JACKIE	Day 1, 2, 3	Script page# 29
Sheet #: 43 1/8 pgs	Scenes: 42	INT	TOMMY'S ROOM TOMMY WAKES UP	Day 1	Script page# 41

End Day # 7 Tuesday, July 29, 2008 -- Total Pages: 8 5/8

Sheet #	Scenes	INT/EXT	Description	Day	Script page
Sheet #: 2 1/8 pgs	Scenes: 1	EXT	BRAXTON HOUSE ESTABLISHING	Day	Script page# 1
Sheet #: 26 1/8 pgs	Scenes: 25	EXT	BRAXTON HOUSE TOMMY RIDES HIS BIKE DOWN DRIVEWAY	Day 1	Script page# 23
Sheet #: 89 6/8 pgs	Scenes: 88	EXT	BRAXTON DRIVEWAY MAJOR KNOWS WHERE JACKIE IS	Day 1	Script page# 74
Sheet #: 25 2/8 pgs	Scenes: 24	INT	LIVING ROOM TOMMY & MAJOR RUN OUT	Day 1	Script page# 22
Sheet #: 84 3/8 pgs	Scenes: 83	INT	BRAXTON HOUSE - LIVING ROOM TOMMY AWAKENS. CANT FIND MAJOR	Day 1	Script page# 72
Sheet #: 85 2/8 pgs	Scenes: 84	INT	TOMMY'S ROOM TOMMY LOOKS FOR MAJOR	Day 1	Script page# 72
Sheet #: 86 6/8 pgs	Scenes: 85	INT	BRAXTON HOUSE - KITCHEN TOMMY FRANTIC	Day 1, 2	Script page# 72

(Continued)

(Continued)

Scheduled

Scheduled		INT/EXT	Scene	Day/Night	Day	Script page#
Sheet # 63 1/8 pgs	Scenes: 62	INT	BRAXTON HOUSE - KITCHEN SHARON PUTS AWAY GROCERIES	Day	2	Script page# 57
Sheet # 19 4/8 pgs	Scenes: 18	INT	BRAXTON HOUSE - KITCHEN SHARON CONCERNED	Day	1, 2, 3	Script page# 17
Sheet # 15 2/8 pgs	Scenes: 14	INT	TOMMY'S ROOM TOMMY LOOKS THROUGH BOX	Night	1	Script page# 14
Sheet # 16 1/8 pgs	Scenes: 15	INT	BRAXTON HOUSE - HALLWAY SHARON SAYS GOODNIGHT	Night	1, 2	Script page# 14
Sheet # 9 1 7/8 pgs	Scenes: 8	INT	TOMMY'S BEDROOM TOMMY SAYS PRAYERS	Night	1, 2	Script page# 8
Sheet # 24 5/8 pgs	Scenes: 23	INT	TOMMY'S ROOM TOMMY TALKS TO MAJOR	Night	1	Script page# 22
Sheet # 40 2/8 pgs	Scenes: 39	INT	TOMMY'S ROOM TOMMY TURNS IN	Night	1	Script page# 41
Sheet # 41 1/8 pgs	Scenes: 40	INT	TOMMY'S ROOM TOMMY SLEEPS	Night	1	Script page# 41

End Day # 8 Wednesday, July 30, 2008 -- Total Pages: 6 4/8

Scheduled		INT/EXT	Scene	Day/Night	Day	Script page#
Sheet # 120 2/8 pgs	Scenes: 119	EXT	BRAXTON HOUSE ESTABLISH PARTY	Day	1, 2, 3, 4, 7, 8, 11, 12, 16, 17	Script page# 95
Sheet # 121 5/8 pgs	Scenes: 120	EXT	BRAXTON HOUSE - DESSERT TABLE BURNS AND SHARON TALK	Day	1, 2, 3, 4, 7, 8, 11, 12, 16, 17	Script page# 96
Sheet # 122 1 3/8 pgs	Scenes: 121	EXT	BRAXTON BARN TOMMY & STACY, JACKIE OK	Day	1, 11	Script page# 97
Sheet # 6 1 4/8 pgs	Scenes: 122	EXT	BRAXTON BARN JACKIE STARTS TALKING AGAIN	Day	1, 11	Script page# 98A
Sheet # 39 1 4/8 pgs	Scenes: 38	INT	BRAXTON HOUSE - KITCHEN A TENDER MOM/SON MOMENT	Night	1, 2, 3	Script page# 39
Sheet # 55 1 6/8 pgs	Scenes: 54	INT	BRAXTON HOUSE - KITCHEN - NIGHT SHARON LOOKS OVER FORMS	Night	1, 2, 3	Script page# 51

Sheet # / pgs	Scenes	INT/EXT	Description	Day/Night		Script page#
Sheet #:17 2/8 pgs	Scenes: 16	INT	ERIN'S ROOM / ERIN TRIES FAKE TATTOO	Night	3	Script page# 15

End Day # 9 Thursday, July 31, 2008 -- Total Pages: 7 2/8

Sheet # / pgs	Scenes	INT/EXT	Description	Day/Night		Script page#
Sheet #:92 7/8 pgs	Scenes: 91	EXT	BRAXTON HOUSE / TOMMY RUNS UP AS ERIN LEAVES	Day	1, 2, 3, 4	Script page# 76
Sheet #: 126 1/8 pgs	Scenes: 66pt	EXT	BRAXTON HOUSE / DRIVE OFF IN HORSE CART	Day	3, 4	Script page#
Sheet #: 153 2/8 pgs	Scenes: A61	INT	BRAXTON HOUSE - LIVING ROOM / ERIN IS ON THE PHONE	Day	3	Script page#
Sheet #: 67 3 2/8 pgs	Scenes: 66	INT	BRAXTON HOUSE - LIVING ROOM / DEREK PICKS UP ERIN	Day	1, 2, 3, 4	Script page# 60
Sheet #: 73 1/8 pgs	Scenes: 72	INT	BRAXTON HOUSE - LIVING ROOM / TOMMY WATCHES TV	Night	1	Script page# 68
Sheet #: 173 1/8 pgs	Scenes: AA72	INT	BRAXTON HOUSE - LIVING ROOM WINDOW / INSERT ON TV PLAYBACK	Night		Script page#
Sheet #: 77 1 /8 pgs	Scenes: 76	INT	BRAXTON HOUSE - LIVING ROOM / MAJOR SENSES SOMETHINGS	Night	1	Script page# 69
Sheet #: 79 1/8 pgs	Scenes: 78	INT	BRAXTON HOUSE - LIVING ROOM/KITCHEN / MAJOR RUNS OUT	Night	1	Script page# 70
Sheet #: 75 2/8 pgs	Scenes: 74	INT	BRAXTON HOUSE - LIVING ROOM WINDOW / NATHAN SEES TOMMY SLEEPING	Night	1, 6	Script page# 68
Sheet #: 82 2/8 pgs	Scenes: 81	INT	BRAXTON HOUSE - LIVING ROOM / SHARON COMES HOME	Night	1, 2	Script page# 70
Sheet #: 74 1 /8 pgs	Scenes: 73	EXT	BRAXTON HOUSE / NATHAN PEEKS IN WINDOW	Night	1, 6	Script page# 68
Sheet #: 83 1 2/8 pgs	Scenes: 82	EXT	BRAXTON HOUSE / DEREK DROPS ERIN OFF	Night	3, 4	Script page# 71

(Continued)

Scheduled

Sheet # / pgs	Scenes		Description	Day/Night	Cast	Script page#
Sheet #: 14, 1/8 pgs	Scenes: 13, 55	EXT	BRAXTON HOUSE NIGHT ESTABLISHING	Night		Script page# 14

End Day # 10 Friday, August 1, 2008 -- Total Pages: 7
END WEEK TWO -- SATURDAY & SUNDAY OFF

Sheet # / pgs	Scenes		Description	Day/Night	Cast	Script page#
Sheet #: 21, 1 2/8 pgs	Scenes: 20	EXT	DAVIS HOUSE PARTY IN FULL SWING	Day	1, 2, 4, 5, 6, 8, 12, 16, 17	Script page# 18
Sheet #: 123, 3/8 pgs	Scenes: A20	EXT	DAVIS WOODS BOYS PLAY PAINTBALL IN WOODS	Day	1, 4, 6, 8, 16	Script page#
Sheet #: 137, 2/8 pgs	Scenes: AA20	EXT	DAVIS POOL DODGE OFFERS SHARON A TOUR	Day	2, 5, 12	Script page# 18
Sheet #: 22, 7/8 pgs	Scenes: 21	EXT	DAVIS HOUSE TOMMY STAGGERS BACK	Day	1, 2, 4, 5, 6, 8, 12, 16, 17	Script page# 21
Sheet #: 32, 1/8 pgs	Scenes: 31	EXT	DAVIS HOUSE DODGE PULLS UP	Day	5, 6	Script page# 28
Sheet #: 33, 1 1/8 pgs	Scenes: 32	EXT	DAVIS HOUSE DODGE SEES TOMMY ON JACKIE	Day	5, 6	Script page# 28
Sheet #: 13, 1 pgs	Scenes: 12	EXT	DAVIS HOUSE WHY TOMMY INVITED?	Day	5, 6	Script page# 14
Sheet #: 171, 3/8 pgs	Scenes: 33pt	EXT	DAVIS POOL DODGE ON PHONE TO SHARON	Day	5	Script page#
Sheet #: 169, 1 2/8 pgs	Scenes: A121	EXT	DAVIS HOUSE DODGE COMES HOME, NATHAN IS MAD, PUSHES HIM IN	Day	5, 6	Script page#

End Day # 11 Monday, August 4, 2008 -- Total Pages: 6 5/8

Sheet # / pgs	Scenes		Description	Day/Night	Cast	Script page#
Sheet #: 139, 2 5/8 pgs	Scenes: 35	EXT	TOWN SQUARE BURNS RECRUITS TOMMY	Day	1, 4, 6, 7, 8	Script page#
Sheet #: 37, 1 7/8 pgs	Scenes: 36	EXT	TOWN SQUARE NATHAN CHALLENGES TOMMY	Day	1, 4, 6, 8, 11, 16	Script page# 35
Sheet #: 53, 6/8 pgs	Scenes: 52	EXT	TOWN SQUARE NATHAN AND DODGE COOK UP A PLAN	Day	4, 5, 6, 8, 16	Script page# 49

Sheet #	Pages	Scenes	INT/EXT	Location / Description	Day	Script page#
Sheet #: 172	3/8 pgs	Scenes: A53	EXT	TOWN SQUARE — NATHAN TELLS DEREK THE PLAN	Day 4, 6, 8, 16	Script page#
Sheet #: 10	1 4/8 pgs	Scenes: 9	EXT	TOWN SQUARE — BOYS TEASE TOMMY	Day 1, 4, 8, 11	Script page# 10
Sheet #: 60	2 1/8 pgs	Scenes: 59	EXT	TOWN SQUARE — DODGE CORNERS HER	Day 2, 5	Script page# 54

End Day # 12 Tuesday, August 5, 2008 -- Total Pages: 9 2/8

Sheet #	Pages	Scenes	INT/EXT	Location / Description	Day	Script page#
Sheet #: 29	1/8 pgs	Scenes: 28	EXT	HIGHWAY — DODGE DRIVES	Day 5	Script page# 24
Sheet #: 30	1 5/8 pgs	Scenes: 29	EXT	BRAXTON HOUSE — DODGE SHOWS THE PROPERTY	Day 2, 5	Script page# 24
Sheet #: 12	1 5/8 pgs	Scenes: 11	EXT	BRAXTON HOUSE — DODGE DROPS OFF LETTER	Day 1, 2, 3, 5	Script page# 12
Sheet #: 20	3/8 pgs	Scenes: 19	EXT	FRONT PORCH — SHARON CUTS DODGE SHORT	Day 2, 5	Script page# 17
Sheet #: 47	3/8 pgs	Scenes: 46	INT	BRAXTON HOUSE — DODGE ARRIVES AGAIN	Day 2, 5	Script page# 43
Sheet #: 49	1/8 pgs	Scenes: 48	INT	BRAXTON HOUSE - KITCHEN — SHARON FILLS BUCKET	Day 2	Script page# 43
Sheet #: 154	3/8 pgs	Scenes: A93	EXT	BRAXTON HOUSE — DODGE ENTERS BRAXTON HOUSE	Day 5	Script page#
Sheet #: 155	1/8 pgs	Scenes: B93	INT	BRAXTON HOUSE — DODGE SEARCHES HOUSE	Day 5	Script page#
Sheet #: 156	2/8 pgs	Scenes: C93	INT	BRAXTON HOUSE - KITCHEN — MAJOR GROWLS AT DODGE	Day 5	Script page#
Sheet #: 157	2/8 pgs	Scenes: D93	INT	KITCHEN CLOSET (BATH) — MAJOR CORNERS DODGE	Day	Script page#
Sheet #: 158	1/8 pgs	Scenes: A100	INT	BRAXTON HOUSE - KITCHEN — MAJOR GUARDS CLOSET DOOR	Day 5	Script page#

(Continued)

(Continued)

Scheduled

Sheet #	Scenes	INT/EXT	Description	Day/Night	Cast	Script page#
Sheet #: 159 1/8 pgs	Scenes: B100	INT	KITCHEN CLOSET (BATH) DODGE TRIES TO GET OUT THE WINDOW	Day	5	Script page#
Sheet #: 163 2/8 pgs	Scenes: C107	INT	KITCHEN CLOSET (BATH) DODGE PEEKS, MAJOR LUNGES, DODGE JUMPS BACK	Day	5	Script page#
Sheet #: 174 2/8 pgs	Scenes: D107	INT	BRAXTON HOUSE - KITCHEN DODGE PEEKS, MAJOR LUNGES, DODGE JUMPS BACK	Day	5	Script page#
Sheet #: 168 1 2/8 pgs	Scenes: A120	INT	BRAXTON HOUSE - KITCHEN DODGE COMES OUT OF THE CLOSET	Day	2, 5, 7	Script page#
Sheet #: 48 2/8 pgs	Scenes: 47	EXT	BRAXTON HOUSE STICK SIGN IN YARD	Day	2, 5, 7	Script page# 43
Sheet #: 175 3/8 pgs	Scenes: 34pt	EXT	WORK OUT ARENA BURNS WATCHES BOYS	Day	7	Script page# 30
Sheet #: 50 2 pgs	Scenes: 49	EXT	FRONT DOOR SHARON DOUSES BURNS	Day	2, 7	Script page# 43

END Day # 13 Wednesday, August 6, 2008 -- Total Pages: 9 7/8

Sheet #	Scenes	INT/EXT	Description	Day/Night	Cast	Script page#
Sheet #: 70 1 3/8 pgs	Scenes: 69	INT	BRAXTON BARN TOMMY & JACKIE (DFN)	Night	1	Script page# 65
Sheet #: 87 1/8 pgs	Scenes: 86	EXT	BRAXTON BARN TOMMY RUNS TO BARN	Day	1	Script page# 73
Sheet #: 88 4/8 pgs	Scenes: 87	INT	BRAXTON BARN TOMMY FINDS JACKIE GONE	Day	1	Script page# 74
Sheet #: 54 1 7/8 pgs	Scenes: 53	INT	BRAXTON BARN JACKIE IS QUAKER OATS MULE	Day	1	Script page# 50
Sheet #: 136 1 pgs	Scenes: 70pt	INT	BARN DANCE INSIDE STAIRS DODGE HITS ON SHARON (DFN)	Night	2, 5, 12	Script page# 66
Sheet #: 68 1 1/8 pgs	Scenes: 67	EXT	COUNTRY ROAD - MAGIC HOUR DRIVE & TALK	Day	3, 4	Script page# 64
Sheet #: 69 1/8 pgs	Scenes: 68	EXT	BARN DANCE - SUNSET ARRIVE AT BARN DANCE	Day	3, 4	Script page# 65

Sheet #	Scenes	INT/EXT	Description	Day/Night	Cast	Script page #
Sheet #: 71 1 pgs	Scenes: 70	EXT	BARN DANCE SHARON & LISA TALK	Night	2, 3, 4, 12	Script page# 66
Sheet #: 81 2/8 pgs	Scenes: 80	EXT	DANCE FLOOR BARN DANCE IN FULL SWING	Night	2, 3, 4, 12	Script page# 70
Sheet #: 76 6/8 pgs	Scenes: 75	INT	BRAXTON BARN NATHAN KIDNAPS JACKIE	Night	6	Script page# 69
Sheet #: 78 2/8 pgs	Scenes: 77	EXT	BRAXTON BARN DRIVE OFF WITH JACKIE	Night	6	Script page# 70
Sheet #: 80 2/8 pgs	Scenes: 79	EXT	FRONT YARD MAJOR CHASES TRUCK	Night	6	Script page# 70
Sheet #: 72 2/8 pgs	Scenes: 71	EXT	DRIVEWAY TO BRAXTON HOUSE TRUCK PULLS UP	Night	6	Script page# 68

End Day # 14 Thursday, August 7, 2008 -- Total Pages: 8 6/8

END PRINCIPAL

2nd UNIT

Sheet #	Scenes	INT/EXT	Description	Day/Night	Cast	Script page #
Sheet #: 135 2/8 pgs	Scenes: A95	INT	SHOW ARENA CROWD SHOTS - REAL EVENT	Day		Script page# 79
Sheet #: 149 1/8 pgs	Scenes: A8	EXT	DREAM SEQUENCE TOMMY DRIVES A BOAT	Day	1	Script page#
Sheet #: 57 1/8 pgs	Scenes: 41	EXT	SPEED BOAT ON LAKE TOMMY DRIVES BOAT	Day	1	Script page# 53

DELETED SCENES: 5, 22, 56, 57, 58, 60, 103

Sample Call Sheet

(Front)

Breaking the Press

Production Company, LLC
3333 West Ave.
Dallas, TX 75205

Office: 214.555.5555
Fax: 214.555.5555
Set: 817.555.5555

Exec. Producer:	Chartie McKinney
Producer:	Bobby Patton
Co-Producer:	David Childers
Line Producer:	Sal Grifter
Director:	Andrew Stevens

MONDAY 8/10/09
DAY 1 of 15

SUNRISE/SUNSET:	6:47AM/8:17PM
WEATHER:	Mostly Sunny
	High 96/Low 77
	Wind S 11mph
LUNCH COUNT:	40
BREAKFAST: Ready @	7:00AM
LUNCH: Ready @	1:15PM

GENERAL
CREW CALL: 7:30AM
SHOOTING CALL: 8:30 AM

BREAKFAST WILL BE AVAILABLE 1/2 HOUR
BEFORE CALL.
PLEASE BE READY TO WORK AT CALL.
SEE BELOW FOR DEPT. CALL TIMES.

No forced calls, meal penalties or overtime without prior approval of the UPM!

Scenes	SET	Cast	D/N	PGS	LOCATION
48	**INT - LAKEVIEW HIGH - COMMON AREA**	3, 7, 13, 18, 19	D13	6/8	High School
	Josh walks with Coach Taylor. Sees the girls.	Atmos.			3333 Hilard Drive
80	**INT - LAKEVIEW HIGH - COMMON AREA**	3, 7, 18, 19	D32	2	Garland, TX 75043
	Josh looks to Erin for sympathy. She dumps him.	Atmos.			
59	**INT - LAKEVIEW HIGH - HALLWAY**	3, 7, 18, 19	D18	2 4/8	
	Erin invites Josh to a party.	Atmos.			

Scenes	SET	Cast	D/N	PGS	LOCATION
71	INT - LAKEVIEW HIGH - CLASSROOM	3, 29	D26	3/8	
	Josh falls asleep in History class.	Atmos.			
52	INT - LAKEVIEW HIGH - GYM	3, 13, 14, 15, 34	D16	5/8	
	Practice, Josh gets his shot blocked.	Atmos.			
63	INT - LAKEVIEW HIGH - GYM	3, 13, 14, 15, 34	D20	4/8	
	Josh screws up a play and gets benched.				
70	INT - LAKEVIEW HIGH - GYM	3, 13, 14, 15, 34	D25	3/8	
	Josh is late and threatened with being cut.	Atmos.			
78	EXT - LAKEVIEW HIGH - PARKING LOT	3, 18, 19, 29	D31	1/8	
	Teacher catches Josh smoking pot.	Atmos.			
A48	EXT - LAKEVIEW HIGH			1/8	HOSPITAL
	Various establishing shots of school.	Atmos.			Community Hospital
					300 I-30 E
					Mesquite, TX 75150
			TOTAL	7 3/8	(972) 555–5555

#	CAST	CHARACTER	STATUS	REPORT	MAKEUP/ WARDROBE	READY	NOTES
3	Tom Martin	JOSH CONAHEY	SW	8AM	8AM	830AM	
7	Jessica Batton	ERIN TOTH	SW	730AM	730AM	830AM	
13	Bob Hethter	STANTON TAYLOR	SW	8AM	8AM	830AM	Dress in L.R.
14	Matt Philter	RANDY TOTH	SW	2PM	2PM	230PM	
15	Robert Haste	KEYSHAWN BRIDGES	SW	2PM	2PM	230PM	Dress in L.R.
18	Taylor Topper	HEATHER	SW	730AM	730AM	830AM	
19	Morgan Calvin	MOLLY	SW	730AM	730AM	830AM	
29	Bill Jenson	MR. FALLON	SW	1030AM	1030AM	11AM	
34	Geoff Gosber	GEOFF	SW	2PM	2PM	230PM	Dress in L.R.
	TBD	L.V. BASKETBALL		2PM	2PM	230PM	
	TBD	L.V. BASKETBALL		2PM	2PM	230PM	
	TBD	L.V. BASKETBALL		2PM	2PM	230PM	
	TBD	L.V. BASKETBALL		2PM	2PM	230PM	
	TBD	L.V. BASKETBALL		2PM	2PM	230PM	
	TBD	L.V. BASKETBALL		2PM	2PM	230PM	
	TBD	L.V. BASKETBALL		2PM	2PM	230PM	

BACKGROUND/ATMOSPHERE - UNPAID

BACKGROUND		REPORT	ON SET
30	Students	8A	830A
2	Boys	2P	230P
5	Teachers	8A	830A
1	L.V. Asst. Coach	2P	230P
1	L.V. Trainer	2P	230P

DEPARTMENTAL NOTES

ART DEPT.	
PROPS	Josh's Gym Bag, School Books, Backpacks, Joint, Basketballs
WARDROBE	
HAIR/MU	
GRIP/ELEC.	
CAMERA	Steadicam
SOUND	
VEHICLES	ND Crew Cars

DEPARTMENT CALL TIMES

PRODUCTION	7A	DIRECTOR	730A	SCRIPT	730A
ART	730A	GRIP/ELEC	730A	SOUND	730A
CAMERA	730A	HAIR/MU	715A	TRANSPO	O/C
CATERING	630A	PROPS	730A	WARDROBE	715A

ADVANCE SCHEDULE

Tuesday, August 11th, 2009

SCENES	SET	CAST	D/N	PGS	LOCATION
1	INT - LAKEVIEW HIGH - GYM - STATE FINALS		D39	1/8	High School
3	INT - LAKEVIEW HIGH - GYM - STATE FINALS		D39	1/8	3333 Hllard Drive
5	INT - LAKEVIEW HIGH - GYM - STATE FINALS	1, 2, 3, 4, 5, 6, 7, 8, 9, 10, 11, 13, 14, 15, 18, 19, 22, 23, 26, 27, 34	D39	1/8	Garland, TX 75043
100	INT - LAKEVIEW HIGH - GYM - STATE FINALS		D39	2/8	
102	INT - LAKEVIEW HIGH - GYM - STATE FINALS		D39	3	
104	INT - LAKEVIEW HIGH - GYM		D39	1/8	
			TOTAL	3 6/8	

Wednesday, August 12th, 2009

SCENES	SET	CAST	D/N	PGS	LOCATION
21	INT - WOODROW WILSON HIGH - BASKETBALL COURT	1, 3, 8, 10, 26	D1	4 1/8	High School 2
32	INT - WOODROW WILSON HIGH - BASKETBALL COURT	1, 3, 5, 23	D6	1 1/8	1000 Glasgoven Ave

SCENES	SET	CAST	D/N	PGS	LOCATION
35	INT - WOODROW WILSON HIGH - BASKETBALL COURT	1, 3, 4, 5, 10, 11, 26	D8	1	Dallas, TX 75214
39	INT - WOODROW WILSON HIGH - BASKETBALL COURT	1, 3, 4, 5, 10, 11, 26	D10	1 6/8	
39pt	INT - WOODROW WILSON HIGH - BASKETBALL COURT	1, 3, 4, 5, 10, 11, 26	D10	2/8	
			TOTAL	8 2/8	

Production Supervisor: David J. Patton **Line Producer:** Sal Grifter **1st AD:** Jeff West

(Back)

GENERAL CREW CALL: 7:30AM

JESUS' PARABLE OF THE PRODIGAL SON

Shoot Day: 1 of 15
Day: MONDAY
Date: 8/10/09

NO FORCED CALLS WITHOUT THE PRIOR APPROVAL OF THE PRODUCER!

#	TITLE	NAME	CALL
	PRODUCTION		
1	Producer	Bobby Paschall	
1	Co-Producer	David Chapman	
1	Line Producer	Shawn Griffith	
1	Producer's Assistant	Harper Robinson	
1	Director	Andrew Stevens	
1	1st Assistant Director	Jeffrey Weiss	
	2nd Assistant Director		
	2nd 2nd Asst Director		
1	Set PA	Landon Wurst	
1	Set PA	Trevor Wineman	

#	TITLE	NAME	CALL
	MAKE UP/HAIR		
1	Key Hair/Make Up	Sheila Moore	
	Add'l Make Up/Hair		
	WARDROBE		
1	Costume Designer	Jamie Puente	
1	Wardrobe Assistant	Joyce Danielson	

#	Role	Name
1	Script Supervisor	Eve Butterly
CAMERA		
1	Director of Photography	Ken Blakey
	Camera Operator	
1	1st Asst. - A Camera	Eric Fleetwood
1	2nd Asst. - A Camera	Raul Erivez
1	1st Asst. - B Camera	Raul Erivez
1	1st Asst. - Add'l Cam.	Jordan Boston Jones
1	Loader	Matt Aines
1	Steadicam Operator	George Niedson
1	Still Photographer	
GRIP		
1	Key Grip	David McSwain
1	Best Boy Grip	

#	Role	Name
ART DEPARTMENT		
1	Production Designer	Eric Whitney
	Set Decorator	
	Leadman	
1	On Set Dresser	Craig Cole
PROPS		
1	Property Master	Tim Thomaston
	Property Assistant	

CATERING / CRAFT SERVICE

1	Caterer	Set Outfitters
1	Chef	Adrian Creasey
	MEAL COUNT =	
	BREAKFAST	Ready @
	LUNCH	Crew Ready @

ELECTRIC

1	Gaffer	Craig Belfield
1	Best Boy Electric	
1	Swing	

SOUND

1	Sound Mixer	Tyler Faison
1	Boom Operator	George Paterakis

STUNTS

	Stunt Coordinator

SPECIAL EFFECTS

	SPFX Coordinator

LOCATIONS

Role	Name
Locations Manager	
Asst. Loc. Manager	
Locations Assistant	

TRANSPORTATION

	
Honeywagon Driver	
Transpo	Adam Doughty

SECURITY

	
Security	

MEDIC

	
Medic/EMT	

PRODUCTION OFFICE

		
1	Production Coordinator	Ashley Shuck
	Asst. Prod. Coord.	

MISC

DEPARTMENTAL NOTES & INSTRUCTIONS

QUOTE OF THE DAY:

Sample Production Report

Production Company name and address *PictureName* DAILY PRODUCTION REPORT

#	SET	LOCATION
B81	INT. DON DUPREE'S OFFICE	Location address
87pt1	INT. DON DUPREE'S OFFICE	
24	INT. DON DUPREE'S OFFICE	
30	INT. DON DUPREE'S OFFICE	
31pt2	INT. DON DUPREE'S OFFICE	
35pt2	INT. DON DUPREE'S OFFICE	
35pt2	INT. DON DUPREE'S OFFICE	
106pt	INT. DON DUPREE'S OFFICE	
XX	INT. KITCHEN	
40	INT. DON DUPREE'S OFFICE	

TODAY'S SCHEDULED WORK IS CONPLETED

SCRIPT SCENES, PAGES		
	SCENES	PAGES
Total Previous	25	19 7/8
Completed Today	7	8 6/8
Total to Date	32	28 5/8
Total In Script	115	98 1/8
Added	2	2 3/8

MEDIA			
	CAMERA (GB)	SOUND ROLLS	CF CARDS
Previous	692.34	9	26
Today Total:	303.08	3	6
Episode Total	995.42	12	32
Added Scenes:	40,B81		
Scenes not completed:			

Deleted	-1	-3/8	Scenes moved to another day	
Revised Total	116	100 1/8	Scene Omitted	77
Total to do	83	69 4/8		

CREW CALL	SHOOTING CALL	FIRST SHOT	LUNCH OUT	LUNCH IN	BACK IN	FIRST SHOT	2ND MEAL OUT	2ND MEAL IN	CAMERA WRAP	LAST OUT
9:00A	10:00A	9:53A	3:00P	3:10P	3:40P	5:12P	N/A		7:10P	9:06P (ART)

CAST
S=START H=HOLD TR=TRAVEL

#	CAST	CHARACTER	STATUS	MU/WARD TIME	WORK TIME			MEALS		MPV	
					REPORT ON SET	DISMISS ON SET	MU/ WARD OUT	OUT	IN	L	W
8	Names of Actors	DON	WF	9:48A	10:12A	7:12P	7:30P	3:00P	3:30P		
9		BRADLEY	WF	9:06A	10:12A	6:06P	6:18P	3:00P	3:30P		

BACKGROUND BREAKDOWN

#	RATE	IN TIME	MEAL IN	MEAL OUT	WRAP	MPV	ADJ
0							
0	TOTAL BACKGROUND						

PRODUCERS

#	TITLE		CALL	WRAP	MPV
1	Director	Names of personnel	9:00A	7:12P	
1	Line Producer		O/C		

PRODUCTION

#	TITLE	CALL	WRAP	MPV
1	Production Manager	O/C		
1	1st A.D.	9:00A	7:12P	
1	2nd PA	8:30A	9:12P	
1	Set PA	9:00A	8:30P	
1	Set PA	8:30A	9:00P	
1	Set PA/Intern	9:00A	8:30P	
1	Script Supervisor	9:00A	8:12P	

MAKEUP DEPT

#	TITLE		CALL	WRAP	MPV
1	Key Make Up Artist	Name of personnel	9:00A	7:36P	

WARDROBE DEPT

#	TITLE	CALL	WRAP	MPV
1	Costume Designer	9:00A	7:42P	

ART DEPARTMENT

#	TITLE	CALL	WRAP	MPV
1	Production Designer	9:00A	9:06P	
1	Art Director/Set Decorator	9:00A	9:06P	
1	Set Decorator/Property	9:00A	9:06P	

TRANSPORTATION

#	TITLE	CALL	WRAP	MPV
1	Transportation Coordinator	O/C		
1	Driver	7:30A		
1	Driver	7:30A		

#	TITLE	CALL	WRAP	MPV
	CAMERA			
1	Director of Photography	9:00A	8:00P	
1	A-Cam 1st AC	9:00A	8:00P	
1	B-Cam Op/Steadi Cam	9:00A	8:00P	
1	B-Cam 1st AC	9:00A	8:00P	
1	2nd AC	9:00A	8:18P	
1	DIT	11:00A	8:18P	
	SET LIGHTING			
1	Gaffer	9:00A	9:00P	
1	Best Boy Electric	9:00A	9:00P	
	GRIP			
1	Key Grip/Driver	9:00A	9:00P	
1	Best Boy Grip	9:00A	9:00P	
	SOUND			
1	Sound Mixer/Boom Op	9:00A	8:30P	

#	TITLE	CALL	WRAP	MPV
	CRAFT SERVICES			
1	Craft Service	9:00A	8:12P	
	ADDITIONAL CREW			
1	Set Medic	9:00A	9:00P	

PRODUCTION REPORT NOTES

Safety meeting at call.
Lead actor arrived 48 minutes late causing production delay.
Mike X is replaced by Tom X as key grip. Rod X is new Best Boy grip.
Alex X (Best Boy electric) reinjured cut on his left leg during load out. He was treated by set medic and continued work.

Sample Composer Agreement

This agreement ("Agreement") is made on _____, 20, between [*Producer/ Production Entity Name:*] _____("Producer") and [*Composer's Name:*] _____ ("Composer") as music composer in connection with the television production currently entitled [*Program Title:*] _____ ("Program"). In consideration of the conditions contained herein, the parties hereto agree as follows:

1. Composer's Services. Composer shall write, compose, orchestrate, arrange, conduct, perform, record, mix, and produce such original musical compositions, original musical score, and original sound recording of the same (the "Music") as Producer may require for inclusion in the soundtrack(s) of, and the trailers for, the Program. Composer shall render services in connection with any added scenes, changes, additional sound recording or any retakes of the Program upon Producer's request. Composer shall perform all services as and when reasonably required by Producer in connection with the Music, including but not limited to, those services customarily performed by composers, arrangers, orchestrators, conductors and soundtrack producers in the television industry. Composer shall render services hereunder on a non-exclusive, first priority basis commencing on such date as Producer shall designate for the Program and continuing through the date that all Delivery Requirements in Paragraph 2 below have been satisfied.

2. Delivery Requirements. Composer shall complete the recording and mixing of the Music, and obtain Producer's final approval of same, so that Composer shall deliver the recorded Music to Producer, in time for preparation and dubbing, on or before
 [*date:*] _____, or such dates as Producer shall require, on [*format:*] _____, or such form as Producer shall require for all original and duplicate master recordings. Collectively, the foregoing materials shall sometimes be referred to herein as the "Delivery Materials." Time of delivery is of the essence of this Agreement.

3. Budgetary Requirements. Composer acknowledges that the amounts payable as specified in this Paragraph 3 include all amounts necessary

to create and deliver the Music and Delivery Materials including, without limitation, any and all compensation and fees payable to musicians, arrangers, and vocalists and the preparation, rehearsal, performance, recording, mixing and synchronization thereof; the cost of studio rental, recording engineers and crew; any payments which are required to be made pursuant to any applicable law or regulation or the provisions of any collective bargaining agreement; and equipment and instrument rental and cartage and all amounts due to Composer to compensate for his/her services rendered and rights granted hereunder. Composer shall be solely responsible for all costs in excess of the amounts payable as specified herein.

a. Subject to Composer performing all obligations hereunder, and in full consideration for any and all services rendered by Composer and all rights granted hereunder, Composer shall be entitled to receive the following with respect to the Program and rights hereunder: _____ Dollars ($_____), payable to Composer in the following manner:

(i) ____ Dollars ($_____) upon the commencement of services hereunder or signature of this Agreement, whichever occurs later.

(ii) ____ Dollars ($_____) upon completion of all services hereunder with respect to the Program and the timely delivery to and acceptance by Producer of the Music and the Delivery Materials.

4. Additional Covenants of Composer. Composer agrees that it shall:

a. Render its services hereunder to the full extent of its creative and artistic skill and technical ability, at such times and such places and in accordance with such regulations, directions and requests as Producer shall reasonably require;

b. Comply with all rules and regulations from time to time in force at all studios and at all other places where Composer shall render services hereunder;

c. Not disclose to any party information relating to the subject matter of this Agreement or to the activities of Producer with respect to the Program or otherwise;

d. Not incur any liability or expense on Producer's account without Producer's prior written approval, and if such approval is given, Composer will provide Producer with any information necessary to satisfy such obligation, including copies of any necessary agreements.

5. No Obligation to Use Music or Exploit Program. Nothing contained in this Agreement shall be deemed to require Producer or its assigns to publish, record, reproduce or otherwise use the Music, any part

thereof, or any of the proceeds of Composer's services hereunder, whether in connection with the Program or otherwise.

6. Grant of Rights. Composer agrees that Producer shall own without limitation, throughout the universe, exclusively and in perpetuity, free and clear of any and all claims, liens and encumbrances, all rights, title and interest of every kind whatsoever, whether now known or unknown, in and to all music written, composed, recorded, orchestrated, arranged or adapted by Composer in connection with the Music, the master recordings embodying the Music, and the results of the Composer's services hereunder, without any obligation or liability to pay Composer any compensation therefor except as explicitly provided herein. Without limiting the generality of the foregoing, Composer acknowledges that included within the above-referenced rights and interests are (a) all worldwide copyrights, allied, and neighboring rights, in and to the Music, the compositions and sound recordings embodied within the Music, and such results and proceeds, and all renewals and extensions thereof, (b) all music publishing rights, and (c) all rights and interests of every kind now or hereafter existing under and by virtue of any common law rights. The Music has been specifically ordered or commissioned by Producer for use as part of the Program, and the Music is a work made for hire and the Producer shall be deemed the author of all the Music for purposes of applicable copyright law. If for any reason the Producer is not deemed the author of the Music, Composer hereby assigns all such results and proceeds and all rights therein (including, without limitation, all copyrights therein) to Producer irrevocably and in perpetuity.

7. Publicity. Producer may use, and permit others to use, Composer's name, likeness, and biographical material in and in connection with the Program, the Music, a television series derived from the Program, if any, and the sale, distribution and advertising thereof. Producer and its assignees shall have the sole and exclusive right to issue publicity concerning the Program and concerning Composer's services with respect thereto.

8. Warranties. Composer represents and warrants that it has the right to enter into this Agreement and to grant Producer all rights herein granted, that Composer has not entered into or will enter into any agreement of any kind (including, without limitation, recording agreements) which will interfere in any way with the complete performance of this Agreement by Composer, that all musical material delivered by Composer hereunder (including, without limitation, the Music and the Delivery Materials) is original with Composer and does not infringe upon or violate any copyright or common law or statutory right of any person, firm, or corporation.

9. Credit. Provided that the Music or a substantial part thereof is incorporated in the version of the Program exhibited to the public,

Composer shall receive screen credit (if screen credits are included in the Program), substantially as follows:

*[preferred credit:]*_____

Subject to the foregoing, all other characteristics of such credit or any other credit shall be determined by Producer in its sole discretion. No casual or inadvertent failure by Producer to comply with the credit requirements set forth above, nor any failure by third parties to so comply, shall constitute a breach of this Agreement by Producer.

10. Notices. All notices which either party is required or may desire to serve hereunder shall be in writing and shall be served to the addresses specified herein.

11. Federal Communications Act. Reference is made to Section 507 of the Federal Communications Act which makes it a criminal offense for any person in connection with the production or preparation of a picture or program intended for broadcasting to accept or pay, or agree to accept or pay, money, service or other valuable consideration for the inclusion of any matter or thing as a part of such picture or program, without disclosing the same to the producer thereof prior to the telecast of such picture or program. Composer warrants and agrees that Composer has not and will not accept or pay any money, service, or other valuable consideration for the inclusion of any plug, reference, product identification, or other matter in any material prepared or performed by Composer hereunder.

12. Indemnification. Composer shall at all times defend, indemnify, save and hold harmless Producer, its successors, licensees and assigns, and the officers, agents, employees, directors, officers, representatives and shareholders of each of the foregoing, from and against all claims, losses, liabilities, judgments, costs, expenses and damages (including without limitation, attorneys' fees and legal costs) arising out of or in connection with any breach or alleged breach by Composer of any warranty, covenant, representation or agreement made or to be performed by Composer hereunder, and Composer shall reimburse Producer, on demand, for any payment made by Producer, at any time after the date hereof (including after the date this Agreement terminates), with respect to any liability or claim to which the foregoing indemnity applies.

13. Independent Contractor. The Composer warrants that he or she is an independent contractor and is not an employee of the Producer. As an independent contractor, the Composer is responsible and liable for any income tax, unemployment insurance, FICA (Social Security), or any other payment normally associated with an employee relationship.

14. Assignment and Succession. Producer shall have the right to assign this Agreement at any time to any person or entity. Neither this Agreement nor any rights hereunder are assignable by Composer at any time to any person or entity. This Agreement inures to the benefit

of Producer's successors, assigns, licensees, grantees, and associated, affiliated and subsidiary companies.

15. Miscellaneous.

 a. This instrument constitutes the entire agreement of the parties hereto relating to the subject matter specified herein. This Agreement can be modified or terminated only by a written instrument executed by both Composer and Producer or Producer's successors and assigns.

 b. This Agreement will in all respects be governed by and interpreted, construed and enforced in accordance with the laws of the State of _____. Any action arising out of or relating to this Agreement, its performance, enforcement or breach will have jurisdiction and venue in a state or federal court situated within the State of _____; and the parties consent and submit themselves to the personal jurisdiction of said courts for all such purposes.

IN WITNESS WHEREOF, the parties hereto have executed this Agreement as of the date specified above.

PRODUCER COMPOSER

Signature Signature

Title Social Security #

Address